W9-ACP-772

The Eye's Mind

Literary Modernism and Visual Culture

KAREN JACOBS

CORNELL UNIVERSITY PRESS

Ithaca and London

First published 2001 by Cornell University Press
First printing, Cornell Paperbacks, 2001

Printed in the United States of America

Library of Congress Cataloging-in-Publication Data

Jacobs, Karen, 1961–
 The eye's mind : literary modernism and visual culture / Karen Jacobs.
 p. cm.
 Includes bibliographical references and index.
 ISBN 0-8014-3749-0 (alk. paper)—ISBN 0-8014-8649-1 (pbk. : alk. paper)
 1. Modernism (Literature) 2. Literature, Modern—20th century—History and criticism. I. Title.
 PN56.M54 J33 2001
809'.9112—dc21

 00-010647

Cloth printing 10 9 8 7 6 5 4 3 2 1
Paperback printing 10 9 8 7 6 5 4 3 2 1

Contents

Acknowledgments vii

1. Introduction: Modernism and the Body as Afterimage 1

PART I: THE EYE IN THE TEXT 45

2. The Eye's Mind: Self-Detection in James's *The Sacred Fount* and Nabokov's *The Eye* 47

3. Two Mirrors Facing: Freud, Blanchot, and the Logic of Invisibility 79

PART II: THE BODY VISIBLE IN THE LENS OF AMERICAN SOCIAL SCIENCE 109

4. From "Spyglass" to "Horizon": Tracking the Anthropological Gaze in Zora Neale Hurston 111

5. One-Eyed Jacks and Three-Eyed Monsters: Visualizing Embodiment in Ralph Ellison's *Invisible Man* 145

PART III: AUDIENCE AND SPECTACLE 201

6. Spectacles of Violence, Stages of Art: Walter Benjamin and Virginia Woolf's Dialectic 203

7. Modernist Seductions: Materializing Mass Culture in Nathanael West's *The Day of the Locust* 243

Postscript: From "Our Glass Lake" to "Hourglass Lake": Photo/graphic Memory in Nabokov's *Lolita* 264

Bibliography 281

Index 303

Acknowledgments

It is a pleasure to be able to thank the extraordinary teachers, friends, and colleagues whose intellectual companionship I have enjoyed and valued over the years since I first conceived of this book. Elizabeth Abel's ongoing faith, keen insight, and vision have challenged me from the first distant notion of this project to its present completion. I have happily relied on Martin Jay's immense knowledge of visual culture, as well as his critical reading of individual chapters. Carolyn Porter's guidance and wit buoyed me through the early stages of writing. All of the chapters are much the better for the shrewd and generous readings of Mitchell Breitweiser, Anna Brickhouse, Kathleen Chapman, Michael du Plessis, Katherine Eggert, Anne Goldman, Jeremy Green, Laura Green, Richard Halpern, Liza Kramer, David Levin, Lori Merish, Tim Morton, Franny Nudelman, Catherine Robson, Terry Rowden, Charlotte Sussman, and Elizabeth Young. Sue Zemka has been an indispensable reader and friend on whose canny insights I have come consistently to rely. Not the least of Kerry Walk's contributions to my visual preoccupations has been her substantial expansion of my eyeball collection, and her imaginative influence marks the whole book. Mary Pat Brady and Kate McCullough's scrupulous reading of chapters represents only a fraction of the time and care they have been ready to lend in every sphere, and their insight and friendship have been invaluable.

My ideas have been shaped in myriad ways by exchanges with Mark Bauer, Marty Bickman, Jean Gallagher, Sidney Goldfarb, Donna Goldstein, Bruce Holsinger, Suzanne Juhasz, Jo Ellen Green Kaiser, Mary Klages, Flossie Lewis, Cathy Preston, Beth Robertson, Jeffrey Robinson,

David Simpson, and Eric White, and I'm grateful to have had such engaged and stimulating partners in conversational crime. I am indebted to the talented graduate students in two visual culture seminars (fall 1996 and fall 1998) who willingly adopted my obsessions; their perceptive thinking helped me to clarify long-standing questions about visual politics and had an important impact on the book. Special thanks are due to Robin Calland, Michael Fitch, Jordan Landry, and Patrick Pritchett for provocations and good offices, both. At crucial stages I benefited from the skilled research assistance of Sarah Cohen, and of that unstinting and dynamic duo, Sara Fall and Laura Nash. Thanks also to the superlative staff of Cornell University Press who have contributed in so many ways to the production of this book. I am grateful for permission to reprint from the following sources. Portions of Chapter 2 appeared previously as "The Eye's Mind: Henry James' *The Sacred Fount* and Vladimir Nabokov's *The Eye*, in *Languages of Visuality: Crossing between Science, Art, Politics, and Literature*, ed. Beate Allert (Detroit: Wayne State University Press, 1996), 187–214. Portions of Chapter 3 appeared previously as "Two Mirrors Facing: Freud, Blanchot and the Logic of Invisibility." *Qui Parle* 4, no. 1 (Fall 1990): 21–46. Portions of Chapter 4 appeared previously as "From 'Spyglass' to 'Horizon': Tracking the Anthropological Gaze in Zora Neale Hurston," *Novel: A Forum on Fiction* 30.3 (1997). Copyright NOVEL Corp. © 1997.

It is hard to imagine having completed this book without the support of family members and the friendship of those precious "civilians" for whom this work will always remain strange. Thanks to my parents, Alayne and Robert Jacobs, for their encouragement and belief in this project, and to my wonderful brothers, Andy and Dan Jacobs, for their love. I also thank Charles and Sophia Garrity for their thoughtfulness and care, which have been sustaining in every way. To Sydnie Boral, Cathy Bowman, Karen Hewitt, Wendy McLaughlin, Kimberly Moses, Liz Ozol, Kate Sher, Andy Steckel, and Robin Wechkin, each of whom has enlarged my perspective in immeasurable ways, my deep gratitude for the gift of your friendship. To Lauren Grossman, my inspired ally in the love and art of seeing, I owe special thanks.

My debt to Jane Garrity, with whom sharing every aspect of this work has been love's labor, truly is beyond measure; together we have "looked and looked our infant sight away."

The Eye's Mind

CHAPTER ONE

Introduction

Modernism and the Body as Afterimage

"The act of writing begins with Orpheus's gaze"—so contends Maurice Blanchot at the close of his 1955 essay, "The Gaze of Orpheus," about the backward glance which condemns Orpheus's bride, Eurydice, to the underworld for the second and final time (1981, 140). As a late-modernist portrait of a gendered and visual economy leading inevitably, it seems, to the production of literary texts, Blanchot's essay can be understood as a kind of retrospective metanarrative, encapsulating the ways in which the gaze and its objects collude to produce meaning in many modernist texts. On the one side resides the subject lens, whose cultural transparency and symbolic agency are conjoined in the union of look and word;[1] on the other side lingers the silent object to which it is wedded, the precarious but necessary body destined to disappear. The gaze deployed in this relation may be characterized at once as a means of knowing and as a weapon of embodiment, suggesting an anxious recognition of the fundamental dependency and antipathy between the two. Within the long Western tradition of the disembodied observer dating from Descartes,[2] seers, and the knowers into whom they seem effortlessly to evolve, have been defined by their transcendence of the body—a body which, however, it remains their chief object to discover beyond themselves in another. The observer's claim to a transparent body is predicated, in other words, on the disavowal of its own embodiment along with the production of a reviled cor-

[1] I follow Homi Bhabha in equating "transparency" with the successful naturalization of a discourse of power; see Bhabha 1994, 109–11.
[2] Richard Rorty has supplied perhaps the most sustained analysis of this tradition in *Philosophy and the Mirror of Nature* (Rorty 1979).

poreality in the Other, whose embodiment at once qualifies it as an object of knowledge and disqualifies it from epistemological possibility and subjective complexity itself. By the turn of the twentieth century, however, lines of fracture in this fantasy of the transparent subject—lines which were perhaps always visible[3]—begin to deepen and multiply, a phenomenon which coincides with the escalating dominance of the image and a growing uneasiness about its penetration and mediation of every sphere of social life. The modernist period is remarkable for its increasing cognizance of the body, itself grasped as an image, behind the neutral lens of the observer; the period may be understood as registering the emergence of that body as a kind of afterimage, exposed in repeated betrayals of its situated partiality, its culturally determined distortions, its will to dominance and even violence, that cumulatively have became the basis for anti-Enlightenment critique.[4] Yet if the modernist period marks a moment of eroding faith in epistemological prerogatives for those privileged, observing subjects most identified with them, it may equally be regarded as a moment when those Others who had been historically conceived as cultural bodies or objects sought to realign themselves with a viable, "pure," subject gaze.

The Eye's Mind explores the emergence of these new kinds of visual relations as they are represented in American, British, and French modernist texts from 1900 to 1955. It does so through an engagement with three related cultural developments contemporary with the rise of modernism: the first, the impact of newly skeptical philosophical discourses of vision in the first half of the twentieth century (those encompassed by psychoanalysis, Marxism, and existential philosophy, among others) which lead to what Martin Jay has called a "crisis in ocularcentrism"; second, the accelerating impact of visual technologies, such as photography and film, which intersect with the development of consumer culture and alter the ways in which perception was conceptualized, produced, and exploited; and third, the emergence of anthropology and sociology as academic disciplines at the turn of the century, which together consolidate new visual techniques and ways of knowing, most notably, through the participant-

[3] Slavoj Žižek has restated this point with special emphasis, arguing that "The point, of course, is not to return to the *cogito* in the guise in which this notion has dominated modern thought (the self-transparent thinking subject) but to bring to light its forgotten obverse, the excessive, unacknowledged kernel of the *cogito*, which is far from the image of the transparent Self." While my own argument strives to excavate this "forgotten obverse" in modernist fictions, I continue to use Cartesianism as a shorthand for the dominant model of subjective transparency with which Descartes is chiefly associated. See Žižek 1999, 2; and, for Žižek's more expanded comments on the fantasy formations that have arisen from the *cogito*, see "Cogito: The Void Called Subject," in Žižek 1993, 9–82.

[4] Horkheimer and Adorno may be the first to systematically level such a critique in *Dialectic of Enlightenment*, and the critique has become the standard jumping off point for distinguishing postmodernist positions from those of their modernist forbears.

observer method. I follow a materialist methodology by presuming that such new visual discourses, techniques, and technologies lead, in the modernist period, to the emergence of new, distinctly modernist kinds of observers and visual relationships. My eight chapters are linked by an argument about the diminished faith these otherwise disparate writers share regarding the capacity of vision to deliver reliable knowledge, as they critique the forms of violence that vision inevitably seems to entail. As the modernist observer's posture of neutral detachment is continually denaturalized and subjectivized from the beginnings of the twentieth century, and the realist novel is gradually overtaken by the rise of modernism, I ask, how does "the eye in the text" renegotiate its relation to forms of knowledge and power?

It is in the context of intellectual history and material culture, and the growing interdisciplinary consensus that the modern observer is distinguishable in significant ways from its predecessors, that I situate the modernist novel and its epistemological commitments. Reconceiving modernist fiction as an intimate participant in the period's broad and ambivalent preoccupation with visual perception opens up a wide range of writers publishing in the modernist period whose work can fruitfully be understood within an expanded conception of modernist cultures, a representative sample of which I will examine here.[5] The book addresses, then, both the work of "high modernists" such as Vladimir Nabokov, Virginia Woolf, and (more distantly) Ralph Ellison and Maurice Blanchot and the work of others such as Henry James, Zora Neale Hurston, and Nathanael West, who have occupied a somewhat ambiguous position relative to the modernist canon for lack of the full-blown experimental narrative techniques often seen as synonymous with modernist practice. By creating a dialogue between American, French, and British modernisms, I aim to foreground the affinities between traditions typically considered in isolation, thereby challenging the trend in which modernism is acknowledged as an international movement but nonetheless analyzed in strictly nationalist terms.[6] While this book provides new perspectives on literary texts, more broadly it distinguishes forms of viewing distinctive to mod-

[5] Other subgenres that fruitfully may be examined within an analysis of modernism and visual culture are modernist detective fictions, such as Faulkner's *Sanctuary*; modernist pornographic texts, such as Bataille's *Story of the Eye*; the entirety of modernist literature on passing; and those modernist works self-consciously mimicking "visual" techniques, such as Gertrude Stein's *Three Lives*.

[6] As Astradur Eysteinsson has argued, "While everyone seems to agree that as a phenomenon modernism is radically 'international' (although admittedly in the limited Western sense of that word), constantly cutting across national boundaries, this quality is certainly not reflected in the majority of critical studies of modernism. Such studies are mostly restricted to the very national categories modernism is calling into question, or they are confined to the (only slightly wider) Anglo-American sphere"; see Eysteinsson 1991, 89; Williams 1989.

ernism as a literary movement and considers them in light of ongoing debates about the "gendering" and "racing" of modernism, asking how the diverse constructions of modernist observers are imbricated in the production of Others.

Whereas many previous book-length literary studies of the primacy of the visual in modernism have focused on the perceived special relationship between literature and the visual arts (through movements such as Cubism), whether through analyses of its imagery or through formal comparisons of aesthetic technique,[7] none explores the emergence and representations of the new kinds of observers created by changing cultural conditions. While "visual culture"[8] has come into rapid prominence in the last decade as an area of study through attention to visual paradigms in philosophy, science, cultural studies, and critical theory, there is still no study that looks comprehensively at the impact and representations of visual culture in arguably the most synthesizing of all discourses, and in a period which witnessed such a confluence of significant changes—that is, the literature of modernism.[9] This approach is crucial because it allows us

[7] See, for example, Caws 1981, 1989; Schwarz 1997; Sitney 1990; Steiner 1982; Torgovnick 1985.

[8] The term "visual culture" has become the accepted designation for the visual character and preoccupations of the modern period, encompassing a broad range of social and cultural processes, relations, and representational forms. W. J. T. Mitchell provides a useful definition of visual culture as a "new social/political/communicational order that employs mass spectacle and technologies of visual and auditory stimulation in radically new ways" (1995, 207). The field engages new philosophies of representation, as well as developments in literary theory and art history toward the construction of new ways of thinking about visual relations, including habits of perception and the cultural construction of vision. Despite this inclusive approach, anthologies that invoke the term have had a tendency to privilege visual objects over visual discourses, but this likely reflects disciplinary habits rather than arguments. I understand the scope and aims of this study, therefore, to be consistent with those included within visual culture, broadly defined. See Mitchell 1995; Walker and Chaplin 1997; Bird et al. 1996; Jenks 1995; Mirzoeff 1998; Heywood and Sandywell 1999.

[9] There are several interdisciplinary anthologies as well as book-length works that devote limited attention to modernist literature in relation to visual culture, but their overall focus is not literary. See, for example, Allert 1996; Brennan and Jay 1996; Jay 1993; Jenks 1995; Krauss 1993; and Levin 1993.

There is now also a very useful book on the politics of seeing in postmodern American writing by Josh Cohen. However, in his effort to distinguish the "spectacular culture" of the postmodern from its modernist predecessors, Cohen overlooks the significant presence *within* modernist literature of the attributes he isolates—from the crisis of perceptual mastery, and the "discovery" of the situatedness of vision within the body, to the linkage of the feminine with a culture of the image which disrupts masculine perception. Moreover, Cohen's emphasis on gender divisions to the exclusion of other subject/object divisions (such as those produced by race), as I hope to show, obscures a more fundamental split between embodiment and transparency which underlies them all. This more primary divide incarnates itself in the displacement of embodiment onto a range of gendered and racial others by those seeking to align themselves with a jeopardized philosophical tradition of subjective transparency. The "*reversible* relations between masculine subject and feminine object in the field of vision" that Cohen identifies with the "encroaching hegemony of spectacle" (Cohen 1998, 7) in postmodern American fiction are not only visible, I argue, in James's turn of the century novels, but are also regularly reconstituted within a racialized matrix in such later modernist works as Hurston's and Ellison's. Although I share Cohen's larger sense of the di-

to see literature as responsive to a broader set of influences than the narrow and often purely formally conceived aesthetic sphere. Determinations about modernist politics have often been predicated on assessments of its form, equating its opacity with elitism and solipsism or, conversely, with the progressive project of defamiliarization and subversion.[10] Feminist assessments have also tended to divide along Manichean lines, with some of them understanding male modernist form as a strategy of detachment from the feminine while others, notably Kristeva, see in it a challenge to linguistic coherence, a repository of feminine excess.[11] These various valorizations of form, I believe, threaten to obscure equally important assessments of the ideological content of modernist texts. As Andreas Huyssen points out with reference to Kristeva, "Even though the French readings of modernism's 'feminine' side have opened up fascinating questions about gender and sexuality which can be turned critically against more dominant accounts of modernism, it seems fairly obvious that the wholesale theorization of modernist writing as feminine simply ignores the powerful masculinist and misogynist current within the trajectory of modernism" (Huyssen 1986, 49). I will be centrally concerned, therefore, with the ideological investments of narrative representations themselves.[12] Nevertheless, form will be of significant interest here: by reframing the question of modernist form in the larger context of developments in visual culture, this book rephrases at least one part of the question of modernist politics, asking whether and how we can see modernist experiments with form—in particular, the varied forms of the modernist novel—as an outcome of its perspectival commitments.

Why the novel? Because it is "popular"—by which I mean to convey several things. Of course, it would be specious to suggest that given the

visibility of modernist from postmodern visual subcultures, my argument about their differences here stresses their disparate imaginations of subjectivity, particularly in relation to the regulatory forces of surveillance and spectacle: whereas modernist fictions retain a concept of the subject as basically intact and available—although *subject to* a range of disciplinary and imagistic "internalizations"—postmodern works such as Blanchot's and the later Nabokov's regard the subject as a system of signs. The permeable and secondary nature of this new subject relative to the primacy of signs renders the very idea of an interior questionable. Postmodern texts part ways with their modernist forbearers, then, not simply because of the escalating culture of the image (which Nathanael West bemoaned long before Mailer), but because of the erosion of an interiorized account of the subject in favor of one conceived of as an effect of signifying practices.

[10] New Critics and Marxists too numerous to mention have come down on both sides of this issue. For useful summaries of these debates, see DeKoven 1991; Eysteinsson 1991.

[11] See, for example, Felski 1995; Gilbert and Gubar 1988; Kristeva 1980.

[12] Alice Jardine provides an important model for this approach in her analysis of the ways French theorists have employed notions of "the feminine" to describe a "space of otherness" elided by monologic thinking. As Jardine defines it, " 'woman' [is] that *process* diagnosed in France as intrinsic to the condition of modernity; indeed, the valorization of the feminine, woman, and her obligatory, that is, historical connotations, as somehow intrinsic to new and necessary modes of thinking, writing, speaking"—and, I would add, viewing; see Jardine 1985, 25.

novel's unrivaled supremacy as a popular form since the turn of the century, one must simply bow to the enormity of its influence and grant it commensurable weight. Most of the novels under discussion here were not in fact popular, either in a statistical sense or as an indicator of their accessibility. I understand the significance of the novel's popularity more narrowly as an index of its ideological typicality.[13] I am persuaded first of all by a conception of the novel as a kind of vast discursive container, filled with semiautonomous, contradictory languages derived from diverse social strata. These heterogeneous linguistic characteristics resist the connotative stripping and compression of poetic language which, as M. M. Bakhtin has expressed it, "*must immerse itself in Lethe, and forget its previous life in any other contexts*" (Bakhtin 1981, 297). Even those modernist novelists who make conspicuous use of poetic compression, spatial form, even a contempt for the popular—here, James, Nabokov, Woolf, and Ellison, preeminently—neither overcome the traces of popular idioms and discourses in their work nor strive to overcome them, reliant as they are on such popular genres as detective fiction, the diary, the case history, and the newspaper for their materials, as well as for the narrative tensions born of such genres' varied rules of recognition. For all of "the modernist novel's" frequently vaunted formal innovations, difficulty, and aspiration to stylistic singularity, it's necessary to acknowledge how historically situated the well of discourses from which it draws remains, without reducing the huge range of its particular incarnations to an unlikely monolith. Whatever their individual ambitions to achieve an ideal unity of form, modernist novels, like other novels, must be understood as an arena in which discursive battles inevitably are being waged. Perhaps uniquely among literary genres, then, the novel may be read symptomatically.

To speak of the novel in this way, as a linguistic *reflection* of a social world and, through the possibilities of individual accent and inflection, as a potential innovator of language, is to beg a political question about its location within discourses of power. Is it possible or desirable, in other words, to place the novel's linguistic practices politically? It seems worth heeding David Minter's warning against a critical approach to the modernist novel intent upon "forc[ing] works of art back into the nexus of power relations from which they come . . . as tools of the status quo" (Minter 1994, xvii).[14] Equally worth recalling is D. A. Miller's memorable referendum on a style of reading the Victorian novel he calls "the subver-

[13] I don't mean to suggest that a comparable study of modernist poetry would not reveal important facets of modernist visual culture, but only that the novel offers some formal advantages for the discrimination of social discourses. For an outstanding survey of twentieth-century theory on the novel, see Hale 1998.

[14] Although Minter avoids the term "modernist," he is writing about novels from 1890 to 1940; see Minter 1994.

sive hypothesis": "even if it were true that literature exercises a destabilizing function in our culture," Miller contends, "the current consensus that it does so does not" (Miller 1988, xi). The goal of comprehending the novel's hybrid languages through the crude lenses of complicity or critique may be less valuable, I would suggest, than the attempt to track the myriad, irreducible ways cultural and technological changes are processed into its symbolic form. Such caution seems all the more imperative for this project given the range of novelistic subgenres I'm clustering under the umbrella of modernism, each of which may claim distinctive historical, formal, and in some cases national trajectories that complexly intersect with modernism as a literary dominant: the detective novel (James, Nabokov); the dialect novel (Hurston); the symbolist novel (Ellison); the experimental novel (Woolf); the satiric novel (West); the postmodernist novel (late Nabokov); and the postnovelistic récit (Blanchot).

In order to chart the territory encompassed by "the eye's mind" and its bodily byproducts, I want to begin, in the first part of this Introduction, by sketching the hallmarks of the dominant account of vision's key role in the unfolding narrative of modernity: the consolidation, beginning in the seventeenth century, of the "scopic regime" that Martin Jay has called "Cartesian perspectivalism" (Jay 1988a) and its gradual erosion—a process which acquires a decisive momentum in the twentieth century. Taking its bearings from art and philosophical history and, specifically, from challenges to Renaissance notions of perspective and Cartesian ideas of subjective rationality, Cartesian perspectivalism is characterized by a monocular, disembodied, objective, and ahistorical vision. From the nineteenth century onward, Cartesian perspectivalism comes under increasing assault, its assumption of a detached, neutral observer discredited by a competing scopic regime traceable to the Baroque. This Baroque model, or what has been called *la folie du voir*, takes a distorting, "anamorphosistic" mirror as its visual figure and privileges unreadability and impenetrability; it is this model of compromised transparency which comes to achieve dominance in the twentieth century. Revealing the conventional rather than natural status of vision, the ascendancy of this model precipitated a widespread distrust of a sense heretofore regarded as "the noblest of senses," and from which we derive our most powerful cultural metaphors for knowing.[15] As David Michael Levin has expressed it in one of the more pessimistic constructions of twentieth-century visuality, "every presence manifesting in the field of vision is essentially reduced to the ontology of a mere thing," making vision both an instrument of domination and "the most reifying of all our perceptual modalities" (1988, 65).[16]

[15] Descartes so designates vision (1965, 65); see also Jonas 1966.

[16] The question of whether there is anything inherently dominating about vision is, of course, a matter of some dispute. For an argument against such a position, see Houlgate

Historians have debated whether discoveries in philosophy and optical research (with their affiliated origins) or the technological multiplication of images were chiefly responsible for this Western crisis of confidence in the eye; my approach here is to attend to both. In the second and third parts of this Introduction I ground the intellectual history of Cartesian perspectivalism and its undoing in the specific material cultural forms—chiefly photography and ethnographic film—which provide selective windows into the production of new visual practices. Although photography was invented in 1839 and therefore predates the modernist period, I privilege it here over other visual technologies more strictly contemporary with modernism because its dissemination—as a technology, and ultimately, as an epistemology and ontology—is critical to our understanding of virtually every other twentieth-century form of visual culture. Photography is central to a comprehension of the rise of film, advertising, photojournalism, and amateur photography, which together expand the production and circulation of its techniques; it is pivotal to the history of modern painting, whose redirection away from realism is typically regarded as a response, in part, to photography; it is imbricated in the practices of the social and hard sciences and the shaping of disciplinary institutions as they each attempt to penetrate and quantify the body through photo technologies and their analogues; and it informs the configurations of social spectacle and the consumer marketplace according to the new forms of hypervisibility to which it contributed. Any genealogy of the twentieth-century observer, furthermore, must take account of the recodifications of subject/object relations made possible by their reification in photographic images which, from the medical to the pornographic, collectively work to redefine the truth of the body as a sight.[17] I pursue the vi-

1993, 87–123. Paul Virilio offers a suggestive material reference for this perspective by marking the parallel and interdependent developments of the technologies sustaining warfare and cinema, in an analysis which effectively projects the gaze-as-weapon beyond the realm of metaphor; see Virilio 1989.

[17] For further discussion of this transformation effected by photography and its associations with eroticism, see "Reconsidering Erotic Photography" (Solomon-Godeau 1991).

It's not entirely incidental that nearly all of the writers I discuss in this book were engaged in some way with photographic/cinematic technologies. Sara Blair has argued that James's "documentary stance" was strongly informed by photography and stereographic technology and, in particular, the photographs of Lewis Wickes Hine (Blair 1996, 163–210). Hurston included photographs in her ethnography of Haiti and Jamaica, *Tell My Horse*, and she was employed as a story consultant for Paramount Pictures in 1941–42. Ellison worked as a freelance photographer during a portion of the composition of *Invisible Man*, and he uses the photographic lens as an image of his complex subjectivity (see Chapter 5). The first edition of Woolf's *Three Guineas* included, in addition to frequent references to photographs of mutilated bodies and destroyed houses, actual photos of English judges and other figures of patriarchal power (see Carlston 1998, 158ff.); and in the essay "Gold and Iron" (1919) Woolf uses the image of the developing photograph as an analogy for the writing process. Benjamin also employs photographic development as a key metaphor for his project of reencountering the past, suggesting that the past "has left images of itself in literary texts that are comparable to those which light imprints on a photosensitive plate. Only the future pos-

sual construction of subject/object relations further in the third part of the Introduction by exploring the parallel historical development of the social sciences with photography and film, paying particular attention to the development of ethnographic cinema and the ways in which such films schooled Western spectators in the conventions of seeing Others as racialized, feminized, dehistoricized bodies. I conclude, in the fourth part, with a précis of the following chapters and a brief characterization of their interrelations.

Through the joint investigation of intellectual history and material culture, I seek to provide contexts for grasping the epistemological postures of viewing that are adopted and represented in modernist texts. Understanding the discourses surrounding photography and its offspring in the modernist period assists in grasping the representational strategies of modernist writers, whose presentation of narrative "vision" must be understood pictorially as well as abstractly, within a spectrum of possibilities inevitably delimited by culture. Whereas naturalist and realist texts, with their disembodied narrative omniscience inseparable from an allegiance to a universal and accessible visual language, typically are legible within a positivist epistemology consistent with mainstream photographic discourse, modernist texts depart from this positivist faith. While in its most extreme incarnation, the modernist observance of the embodied and partial nature of vision takes the form of multiperspectivalism, with its implicit acknowledgment of the limits of isolated points of view, in the majority of cases that I examine here we find a confrontation with the situated confines of the visual, along with compensatory forms of linguistic excess though which these texts aim to repair visual deficits, coinciding with relatively conventional strategies of narration and representation. Like their realist and naturalist counterparts, then, modernist novelists use the metaphor of the lens as a means of conceptualizing the relations between seeing and knowing, self and Other; but unlike realists and naturalists, they continually betray their veiled cognizance of the constructed character of the visual and its seductive power through its affiliations with the image.

The Body under Erasure: Historicizing the Transparent Gaze

I want to dwell for a moment on the philosophical point of origin of this argument in order to fix more precisely the valence of the scopic

sesses developers active enough to bring these plates out perfectly" (quoted in Buck-Morss 1991, 250). As I will explore in later chapters, West and Nabokov extensively reference photography and film in their novels. West, of course, wrote screenplays for Hollywood in the 1930s; and *The Day of the Locust* and *Lolita* were themselves made into films, Nabokov collaborating on the screenplay.

regime encompassed by Cartesian perspectivalism and its attendant epistemologies. My interest in Cartesianism as a scene of discursive origins, beyond its utility as a heuristic device, lies in its defining engagement with the constellation of vision, reason, and embodiment that continues to have resonance for modernism. The term "Cartesian perspectivalism," which, to recall, joins Renaissance notions of perspective with Cartesian ideas of subjective rationality, is, as Martin Jay is careful to note, only a shorthand for the dominant scopic regime of the modern era (Jay 1993, 69–70). Both qualifications—the shorthand and the fact that it is the *dominant* but not exclusive regime—deserve notice, since together they suggest both a strategic simplification of Descartes and an acknowledgment of the broader spectrum of visual regimes in play during the period. The genuine complexity of Descartes's views, beyond the schematic of monocular and detached neutrality for which they are usually invoked, is arguably responsible for the remarkable diversity of philosophical positions which find their ancestry there. Jay has indicated many of the reference points for the myriad and, in some cases, outright contradictory views that Descartes's visual emphasis has yielded:

> Descartes may thus not only be responsible for providing a philosophical justification for the modern epistemological habit of "seeing" ideas in the mind, but may also have been the founder of the speculative tradition of identitarian reflexivity, in which the subject is certain only of its mirror image. . . . If, as is often claimed, Descartes could become the warrant for rationalist and sensationalist philosophies, claimed by idealists and materialists alike, he was no less able to give encouragement to both speculative and empirical concepts of vision. (Jay 1993, 70, 80)

Alternatively, Dalia Judovitz has argued that Descartes, despite his interest in the science of optics, otherwise undermined the role of vision in his writings in response to a distrust of illusion so abiding that it extended to "the visible world as a whole"; Descartes, she suggests, experienced the deceptiveness of vision as incompatible with his commitment to rationality (Judovitz 1993).

I draw attention to this conceptual latitude in order to recall the otherwise occluded fact that among the foundational positions that may be unearthed from Cartesian dualism is a bedrock ambiguity about the status of the body. Descartes's infamous assertion of the division between mind and body is arguably far less stable and certain than is typically acknowledged. From the beginning, that is, we might understand the specter haunting Cartesian rationality to be a primary question: as the eye inspects the reflections of nature that have come to reside within the

mind,[18] is it the *mind*'s eye that sees or the *body*'s? Descartes's rather desperate expedient, the pineal gland, which he regarded as mediating between these two poles, is clearly an imaginary solution to the otherwise intractable ambiguity of the immaterial gaze. Yet his account of the function of this mysterious gland is instructive for tracking the shadow of embodiment in his argument. In the Fifth Discourse of *La Dioptrique* (1637), Descartes describes the moment when the eye sees a painting:

> It is manifest that a painting is immediately formed . . . on the inner surface of the brain that looks towards its concavities. And from there I could easily take that picture as far as a certain little gland . . . [which] may at times pass from there along the arteries of a pregnant woman into some determined member of the child in her womb and form there those birthmarks which are the cause of such wonderment to all Learned Men. (Descartes 1965, 100)[19]

The products of the eye would seem to be made flesh here, both in their transitional form as the traveling "picture" and in their destination as "birthmark." The gaze functions then as an instrument of embodiment, literally leaving its (dark) mark on the Other who, residing in the body of a pregnant woman, is simultaneously a hidden part of the self. It seems consistent with the equivocal effort to represent and repress embodiment in this passage that Descartes should choose a pregnant woman—the most emphatically embodied of subjects—as his prototype, whose body serves, moreover, as an "object lesson" for the delectation of male expertise. The passage provides a succinct encapsulation of the equivocal terms of bodily suppression in Descartes, where the embodiment of the gaze, however seemingly overcome by the faculties of mind, is likely to resurface elsewhere and is, indeed, lodged in and as the body from the start. Read as a narrative of subjective transparency predicated not only upon bodily suppression but also bodily *production*, we can find in Descartes the antecedents for contemporary visual paradigms in which the bodily presences of self and Other are more fully acknowledged.

Revisiting the scene of Cartesian doubt portrayed in the *Meditations* (1641), Susan Bordo attempts to historicize Descartes's dream of absolute epistemic objectivity within the cultural turmoil of the seventeenth century, in an argument that offers a broader cultural context for the relations between vision and embodiment in Descartes (Bordo 1987). As-

[18] This particular description is Richard Rorty's (Rorty 1979, 45). For an overview of the role visual metaphor has played in the genealogy of modern philosophies of self-reflection, see Sandywell 1999.

[19] Although Luce Irigaray and Martin Jay both quote this passage (Irigaray using it as an epigraph), neither comments on the arguments implicit in Descartes's imagery. Jay notes that *La Dioptrique* was left unpublished because of the Church's condemnation of Galileo in 1633. See Irigaray 1985, 180–90; Jay 1993, 71, 76–77.

serting the congruity of aesthetics with other dominant forms of cultural knowing, Bordo develops the contrast between medieval and Renaissance pictorial conventions to illustrate a moment of cultural transition within which Cartesianism is legible. Against a medieval culture of *absorption*—a mobile integration of self and world personified by the spectacle of internally ordered individual details in medieval painting—she positions a modern culture of *locatedness*—a separation and freezing of the relations of self and world through the spatiotemporal fixity of Renaissance perspective's singular "point of view." Bordo further traces the emergence of locatedness as a central category of thought in the new sense of historical particularity in the seventeenth century, against an earlier emphasis on spiritual unity and eternal values. Understanding absorption and locatedness to be associated with both individual and cultural developmental stages, Bordo attempts a psychoanalysis of culture in which the demise of the "sympathetic" relations of absorption in favor of the isolate particularity of locatedness enacts a "drama of parturition," a separation from "the mother-world" that resonates both with the child's journey toward autonomy and the larger culture's: "The development of the human sense of locatedness can be viewed as a process of cultural parturition, from which the human being emerges as a decisively separate entity, no longer continuous with a universe that has become decisively 'other' to it. . . . This cold, indifferent universe, and the newly separate self 'simply located' within it, form the experiential context for Cartesian epistemological anxiety" (Bordo 1987, 70, 73).[20]

Although I remain skeptical of Bordo's analogy between cultural and individual development, the power of her historical account usefully denaturalizes our own scopic regime at the same time that it provides a rich context for understanding the terms of the Cartesian repudiation of embodiment.[21] Because she regards absorption and locatedness as inescapably gendered possibilities, Bordo views the locatedness implicit in

[20] Luce Irigaray's meditation on Descartes in ". . . And If, Taking the Eye of a Man Recently Dead, . . ." should be mentioned here, since it anticipates Bordo's to a surprising extent; Irigaray also characterizes the Cartesian subject as engaged in a developmental trajectory from childish attachments to adult autonomy secured by an illusionary "I":

The basis for representation must be purged of all *childish* phantoms. . . . About the other, the Other. Saying "no" to everything is the crucial way to be assured that one is really (like) oneself. Otherwise, there will always be doubts about what relates to the self and what to the other. . . . But now, by a stroke of almost incredible boldness, it is the singular subject who is charged with giving birth to the universe all over again. . . . Once *the chain of relationships, the cord,* has been *severed,* together with ancestry and the mysteries of conception, then there is nothing left but the subject who can go back and sever them all over again whenever he likes. In a speculative act of denial and negation that serves to affirm his own autonomy" (Irigaray 1985, 181–82).

[21] Indeed, Bordo goes so far as to suggest that the emphasis on the visual, per se, is not modern: "The examination of medieval art prompts us to entertain the possibility that the

Cartesian rationality as a "flight from the feminine," the separation from which produces a psychic reaction of anxiety and its palliative: disavowal. The Cartesian fantasy of individuation and the transparency to which it leads, then, repudiate feminine embodiment and connectedness for a masculinized, objectivist reconstruction of knowledge; in this schema, a feminized nature is defined by its lack or absence of mind, a defect on which is based the rationale for its domination. Bordo sees Descartes's quest for the perfection of the intellect as a rite of "purification" that inevitably issues in dualism, with an impure, locatable body cast off in favor of a transparent mind. In this, the eye and its invisible gaze are foundationally allied with transparency, operating in every sense as the abstract, monocular "vanishing point" of Renaissance perspective. That gaze defensively repudiates—even as it constructs—a (feminized) body conceived as an obstacle to transcendence, one which must therefore be mastered to prevent its absorption or incorporation.

Yet if Bordo emphasizes the gender polarities of the Cartesian visual paradigm—with femininity enlisted to personify the outcast body and masculinity serving as privileged representative of the transparent, reasoning observer—other, frequently racialized configurations of these positions have of course shaped (and continue to shape) post-Cartesian visual economies. From Descartes in the seventeenth century to Jean-Paul Sartre and Maurice Merleau-Ponty in the twentieth, we can trace a trajectory of crisis in the belief in subjective transparency, one increasingly cast in relational terms in which the repressed embodiment of the observer becomes the displaced embodiment of the observed, finally returning, as it were, to reassert its material presence in uncertainly valued forms. In what follows, I want to revisit the conceptual landmarks of this trajectory, in a territory which by now may be sufficiently familiar to warrant a summary treatment.

Michel Foucault, to begin, can be credited with writing the history of the subject in relation to the optics of power, in which the gaze comes to serve as a multifaceted tool of social regulation. In his earlier works, whether tracing the transformation of madness into spectacle from the asylum to the psychoanalytic couch, or describing the visual domination accompanying the rise of modern medicine, with its pretense to an empirically exact clinical gaze itself constituted by existing structures of visibility, Foucault's critique of the regulatory force of vision and its impact on the modern era has been sweeping. But it is in his later work, *Discipline and Punish*, in which he details the shift from the externalized spectacle of punishment to the "internalized" structure of self-scrutiny, that Foucault's

medieval perceptual world may have been one within which the visual world was far more prominent than in ours" (1987, 66).

vision of the origins of disciplinary society culminates—a world in which the invisible gaze of the panoptic seer and its dispersed powers of surveillance produce fully self-regulating subjects.[22] In an attempt in part to contextualize Foucault's analyses, Martin Jay situates them within a larger "denigration of vision" in twentieth-century French thought.[23]

Attending to the intersection of new technologies of vision with philosophical, scientific, and aesthetic discourses, Jonathan Crary's influential genealogy of the formation of the modern observer attempts to chart a decisive shift between 1810 and 1840, the period just prior to the development of photography. Crary challenges the continuity of the historical model which conceives of the seventeenth-century camera obscura as a straightforward antecedent of the photographic camera—whether that evolution is seen as progress toward representational verisimilitude or as an enduring apparatus of political and social power. A radical reconfiguration of the observer by the 1840s, Crary argues, in which a classical observer with visual authority is supplanted by a decentered observer with a metonymic relation to visual "instruments," fundamentally alters the landscape in which the formal analogies between the two technologies might be viewed. This rupture of "point of view," in which perception is detached from its dependence on the body, prefigures ruptures associated with modernist practice. Modernism, for Crary, is not a reaction against but inseparable from scientific and economic developments (Crary 1990).[24]

The shift in perception to "unconscious optics," or from the aesthetic contemplation of wholes to the consumption of fragments that Walter Benjamin identified with the invention of photography and film (Benjamin 1969, 237), anticipates Guy Debord's concerns in his formulation of "spectacle"—the unified face put on modern conditions of production and the alienated social relations it produces.[25] Charting the degradation

[22] See Foucault 1975, 1977, 1988.

[23] See Jay 1986, 175–204; 1993. Donald M. Lowe's ambitious attempt to understand class-based modalities of perception from the end of the eighteenth to the beginning of the twentieth-centuries, combining phenomenology, Marxism, Foucault, and communication theory, predates Jay's and should also be mentioned here. Lowe understands the years 1905–15 as a key moment of transition from a singular to multiperspectival perceptual field, a shift amounting to a perceptual revolution; see Lowe 1982.

[24] Although somewhat peripheral to my immediate concerns, Crary's 1999 study of the remaking of attention from 1880 to 1910, in the wake of the collapse of both classical models of vision and unified models of mind, makes a fascinating follow-up to his earlier work. Crary argues that the disciplinary imperatives that shape attentiveness in this period provide a complementary history to Benjamin's better-known narrative of the emergence of "reception in a state of distraction." Attempting to foreground the spectrum of bodily experiences that inform *perception* (as opposed to the relatively less embodied gaze) as a key component of attentiveness, the book shows how this newly attentive subject may be situated at the intersection of Foucault's internalized discipline and Debord's isolating spectacle, despite their otherwise abiding differences in philosophical orientation.

[25] Crary draws attention to the absence of conventional historical parameters in Debord's account. From the evidence of Debord's later reassessment of the spectacle in *Comments on*

of being into having, having into appearing, that the spectacle epitomizes, Debord's critique of the role of visibility in the construction of spectacle is predicated on the inseparability of the subject and object of the gaze. Itself defined as "capital to such a degree of accumulation that it becomes an image," the spectacle "concentrates all gazing," and "naturally finds vision to be the privileged human sense." Debord identifies a modern spectator who is at once the natural heir of the Cartesian tradition, one hostage to the "precise technical rationality" of a project which aimed to comprehend all activity in terms of the categories of seeing, and the exposer of its falsifying terms (Debord 1983, paras. 34, 3, 19).

It is in these contexts, then—shifts in the scientific, philosophical, and aesthetic discourses about vision and its role in the reorganization of economic and social power—that I will initially be situating the modernist novel and its preoccupations. The conflicts between Foucault's disciplinary society, highlighting the subject's internalization of the look of surveillance, and Debord's society of the spectacle, imagining its subjects' perpetual and passive gaze, and between Crary's dislocation of the viewing body and Jay's subjectivized, distorting viewer, are productive for my project. My purpose, to borrow a phrase from Jay, is to identify a "differentiation of visual subcultures" within modernism that expresses a range of responses, rather than erect a monolithic model which consolidates them. Perhaps, in the case of Foucault and Debord, surveillance and spectacle are really two sides of the same coin.[26] At the same time, I want to call attention to the pervasive gender and racial blindness of each of these frameworks; as Robyn Wiegman's analysis of the gendering and racialization of the medical gaze and Rachel Bowlby's and Anne Friedberg's studies on the gendering of consumption have forcefully shown, who is looking at whom or at what is of more than casual importance in the intricate negotiations of social power.[27]

Within these historical contexts I will be concerned with two other discourses—Marxism and psychoanalysis—whose involvement with visual metaphor and visual power are widely acknowledged. Whether in concert with the mechanical apparatus of the camera obscura or the psychic apparatus of the Oedipus complex, as a site of internalization through consumption or externalization through projection, the gaze has operated discursively as a gendering, ideological machine—this is particularly true of psychoanalysis, a discourse whose development overlaps historically with the modernist period. Drawing upon each of these traditions both for ideological content and for analytic tools (while attending to the in-

the Society of the Spectacle (Debord 1990), Crary calculates that Debord dates its origins to the late 1920s. See Crary 1988b, 98, 100. T. J. Clark likewise argues that modernism and the spectacle evolved at the same time; see Clark 1984, 9–10.

[26] I am not, of course, the first to suggest this; see, for example, Crary 1988b, 105.

[27] See Wiegman 1995; Bowlby 1985; Friedberg 1993; Poovey 1986.

evitable slippage between those two modes), I will be occupied with several key, interrelated figures which theorize paradigmatic viewing subjects.

The image-projecting camera obscura stands within Marxism as a central metaphor for the production of ideology, as a site of mediations which can be understood to constitute both the seer and the world seen as historical productions. The camera obscura stands in a reciprocal relation to the commodity fetish, which acts as both personification and screen for ideology; the subject projects ideology onto the material world of the fetish, which in turn imprints itself back on consciousness.[28] Moreover, the "social hieroglyphic" of the fetish, which conceals the human labor of its production in its appearance as a "natural" part of the social order, engenders a "reified" subject whose stance with regard to the products of its commodified labor is increasingly passive and contemplative.[29] These apparently mutually reinforcing exchanges can be viewed, as Althusser does, as analogous to unconscious processes, acting upon subjects in an "imaginary relation to their real conditions of existence" (Althusser 1971, 162).

In such theories of optical internalization, projection, and repression, Marxism and psychoanalysis seem to speak with a common voice. In Freud's developmental narratives, the pivotal forces of castration anxiety and penis envy are rendered as explicitly visual moments, the internalization of which forms male and female subjectivity.[30] The formation of the split subject is conceived as a specular moment of projection in Lacan's mirror stage (Lacan 1977). Like the commodity fetish in Marx, Freud's eroticized fetish is produced through an act of optical repression of the "real" character of objects (Freud 1928). And the force of visual desire—scopophilia—is critical to psychoanalytic accounts of narcissism, voyeurism, and exhibitionism. All of these psychoanalytic paradigms, of course, have been subjected to extensive feminist scrutiny and revision. Luce Irigaray has exposed the male specular bias in Freud's representational system, in which the female body functions as a placeholder to ensure the male subject position (Irigaray 1985). Relying on this framework, feminist film theorists from Laura Mulvey to Mary Ann Doane have also insisted that the female body has primarily one meaning to an always male viewer—castration—that can be addressed either through exposure and

[28] As W. J. T. Mitchell has shown, the viability of the camera obscura as a metaphor for ideology has been contested; the definition I offer here is based on Mitchell's interpretation, as is my account of the relations between the camera obscura and the fetish. See Mitchell 1986, 174–78.

[29] Carolyn Porter summarizes Lukács's account from "Reification and the Consciousness of the Proletariat" in Porter 1981, 23–30.

[30] See "Femininity" (1933), in Freud 1965; and "The Passing of the Oedipus Complex" (1924), in Freud 1959.

devaluation of woman's lack or its disavowal via fetishism;[31] the gendered terms in which theories of narcissism, voyeurism, and exhibitionism have been cast have likewise been examined and challenged. I use these discussions of the gender and agency of the gaze to further interrogate the core concepts of Marxism and psychoanalysis.

I will be concerned, finally, with other modernist accounts of the gaze which work to interrogate and undermine Cartesian disembodiment, such as Sartre's and Merleau-Ponty's.[32] In these two culminating yet antithetical accounts of a prereflective subject, we can measure the distance traversed from the high-altitude isolation of the disembodied Cartesian seer; in its stead, each offers a "return of the body" to the subject of philosophical discourse and its objects. In *Being and Nothingness* (1943) Sartre emphasizes the violence of the subject's objectification through the Other's eyes: the ascendancy of the Other's perspectival universe functions as a usurpation in which the self is subjected to a reduction to "a pure reference to the Other" (Sartre 1956, 349); the challenge for the self in this exchange is to recover through the operations of "responsibility" a subjective perspective which exceeds the meanings imposed on it by the Other; but the shameful recognition of the absence of complete self-knowledge produced by the Other's gaze must first be overcome. Sartre reveals the violence of that gaze, furthermore, to have a specifically gendered and sexualized character,[33] made manifest in his comparison of the "violation by sight" with the "unveiling" of a feminized nature, and with man's "deflowering" through his gaze the immaculate "virgin" who is his object (738). Merleau-Ponty also proposes a theory of an embodied gaze, but one which depends on his rejection of the bifurcation of subject and object. In "The Intertwining—The Chiasm,"[34] Merleau-Ponty conceives of

[31] This is, of course, a vast and complicated field; see, for example, Mulvey 1975; Doane 1987; Heath 1978; Silverman 1988. For an analysis of gender and fetishism outside the context of film theory, see Apter 1991.

[32] See Merleau-Ponty 1968; Sartre 1956. I highlight these two salient accounts for their conceptual power, disparate conclusions, and because of their importance to future chapters. There is, however, a complex philosophical history of the development of embodied, culturally mediated accounts of vision which precedes them, which I can do no more than gesture toward here. Twentieth-century accounts of the embeddedness of the eye may claim, for example, the Nietzsche of *Genealogy of Morals* and *Zarathustra* as their ancestor (where, in an apt phrase, he mocks "immaculate perception"); Henri Bergson argues in *Matter and Memory* that the body can't simply be analyzed from the outside, since the body is itself the center of perception; Heidegger offers a critique of the visual primacy following from the reorientation of man to the center of the world he projects in "The Age of the World Picture."

[33] The Sartrean gaze, too, has an implicitly racialized character, as I attempt to show in Chapter 5.

[34] "The Intertwining—The Chiasm" was published posthumously from papers dated from 1959 to 1960, but Merleau-Ponty began publishing essays on perception and the body beginning with *Phenomenology of Perception* (1945); for a fuller account of this chronology, see "Editorial Note," in Merleau-Ponty 1968, xxxiv–xxxix.

the seer as at once a thing among things and what sees or touches them. Merleau-Ponty understands sight, like touch, to reside foremost in the body, so that the act of seeing produces a "double belongingness" to the order of subject and object, distance and proximity, at once. Merleau-Ponty's utopian alternative to Sartre's gaze of violation equates the "inexhaustible depth" of the embodied seer with an ever broadening plurality where the binary codes of seeing and being seen collapse under the weight of truly multiple determinacy. Although with dramatically different results, Sartre and Merleau-Ponty together suggest the completeness of the undoing—or more precisely still, the unmasking—of Cartesian perspectivalism in philosophical discourse by mid-century, with the inescapable predominance of the embodied eye. What remains is to bring these philosophical formulations into conversation with those discourses surrounding the material visual practices that were contemporary with them—discourses from which they are arguably both inseparable and, more surprisingly, completely at odds.

Perspective Machines and the Crafting of the "Interior Gaze"

It remains one of modernism's more fascinating paradoxes that the era of epistemological doubt it ushered in coincided with the growing dominance of photography—a technology that since its appearance in 1839 seemed literally to validate the confident, monocular objectivity of Cartesian perspectivalism through a mechanically assisted, prosthetic gaze, the purity of which promised to erase all obstacles separating seeing from knowing.[35] During the same period that Sartre and Merleau-Ponty chose to grapple with the subjectivizing consequences of vision's embodiment, theorists and practitioners of photography were emphasizing the medium's capacity for objectivity precisely on the basis of its independence from the body. The prevalent modernist position on photography—that meaning, objectively captured, resides in the photographic image where it is universally legible—suggests a certain displacement of the positivist equation of seeing and knowing that was eroding elsewhere in philosophical discourse onto the photograph. Given the lengthy history of iconoclasm in the Western tradition, as W. J. T. Mitchell has described it (Mitchell 1986), a second, equally striking paradox follows from this displacement: not only is the modernist era of epistemological doubt commensurable with an allegiance to images, it would seem in fact to be dependent on them as a means of knowing a world "conceived and

[35] Various explanations have been extended to explain this paradox, among them, Jean-Louis Comolli's observation that the camera's superior capacity to capture images deprived the eye itself of its privilege; see Comolli 1980.

grasped," as Heidegger put it in 1938, "as a picture" (Heidegger 1977, 129).[36] The widespread promotion and circulation of the image and the simultaneous pervasive denial of its inevitably subjective and discursive character are comprehensible only when we take account of the apparently unique qualities of the *photographic* image compared with its predecessors, given that the photograph, as Roland Barthes notes, functions specifically as "a message without a code" (Barthes 1982, 196).

With its widening proliferation from the turn of the century, I will argue, photography promised, by virtue of its seeming technological superiority, to be the mechanism through which to purify both the gaze and the image from the contaminations and seductions to which they were otherwise prey. But that promise was inevitably compromised by the ways images, regardless of their means of production, are conceived and used. Through their narrative epistemologies, modernist writers demonstrate how fully they are heir to this conflict embedded in photography's scientific and aesthetic dimensions—its optical truths and visual pleasures—a conflict which their realist and naturalist counterparts tentatively resolve by emphasizing the documentary nature of their projects. What distinguishes the *modernist* literary response from its predecessors stems from a *crisis* of belief in the continuity between seeing and knowing, and a commensurate cognizance of the subjective mediations of embodied visuality. The characteristic modernist response to the tensions between documentary and visionary modalities epitomized in photographic discourse is a kind of visual relation that I call the "interior gaze"—a gaze that brokers a working compromise between the two modalities by valuing concealed truths. Inherited from the social sciences, this "interior gaze" is a form of disavowal of the subjective character of gaze and image which relocates visual truths to an "interior"—literal or conceptual—where they can be recovered only by a properly expert vision. The interior gaze thus preserves, within the epistemological positions variously occupied by narrators and characters in modernist texts, a positivist fantasy of the availability of visual truths by strategically conceding their difficulty of access. Behind this compromise, emerging as a kind of afterimage, stands a defining ambivalence regarding the subjective character of the visual, one I would suggest is related to what Susan Sontag has called the "true modern primitivism"—the modernist promotion of images of their own making into fetishistic truths (Sontag 1977, 161).[37] Arguably, however, the efforts of modernist writers to salvage a reliable visual model of knowledge are

[36] As Christopher Pinney notes, within four years of photography's appearance, Feuerbach was bemoaning the fact that our era "prefers the image to the thing"; see Pinney 1992, 77–78.

[37] Sontag's phrase is suggestive of modernism's multifaceted fascination with "primitivism."

destabilized from the start because of the more limited capacity of language to carry the burdens of mimeticism than the photographic image.[38] That limitation may go some way toward explaining the modernist propensity for linguistic excess as compensation for its perceptual limits.

By elucidating this defining conflict to which literary modernism thus responds, I hope to measure the distance separating prevalent discourses about photography in the modernist period from what we have come to regard as its material effects; in so doing, I follow John Tagg, among others, in understanding photography as a mode of cultural production made legible only through particular discursive contexts, a mode in which, as Victor Burgin has put it, "meaning is perpetually displaced from the *image* to the discursive formations which cross and contain it" (Tagg 1988, 63; Burgin 1982, 215–16). Susan Sontag and Roland Barthes are among the earliest and most perceptive analysts of the myriad ways photography has contributed to the changing of visual codes. Sontag's shrewd essays collected in *On Photography* remain the most complete but critically neglected articulation of these changes through their account of photography's provision of a new grammar and ethics of seeing. The penetration of photographic images into the fabric of social life redefined the world, Sontag suggests, as an "anthology of images" (1977, 3), in a series of appropriations and translations yielding unprecedented forms of knowledge and power. The labile interpolation of the photograph into the realms of surveillance and evidence assured its absorption into the techniques and institutions of bureaucratic rationality. It achieved this, in part, by altering the scale of the world, not only through miniaturization but also, with the close-up and the panorama, by bringing the distant into proximity and recontextualizing the detail. Photography necessitated fresh grounds of discrimination, dividing the viewable spectacle of the world into objects now deemed worthy, and unworthy, of photographing. By producing new and newly respectable sorts of spectators and voyeurs who are defined by a more vitiated participation in the events they document, photography both certifies and limits experience. For Sontag, the more intractable subject/object relations ritualized by photography have a predatory potential: like the gun it superficially resembles, the camera penetrates, violates.

Photography's seeming capacity to trace with light and *preserve* a world may serve as a defense against the anxieties born of temporality and loss; but it offers, Sontag argues, only "imaginary possession of a past that is unreal" (1977, 9). This artifice underlies even the most intimate imagistic chronicles, such as the family snapshots that narrate a history of connectedness; from this logic of pseudo-presence Sontag draws the conclusion

[38] For more on the intersections of American fiction and photography through the end of the modernist period, see Shloss 1987.

that the photograph serves, finally, as a memento mori associated with mortality and loss. Certainly Barthes's exercise in mourning that is *Camera Lucida* validates this perspective, in which he develops a "thanatology of vision" as he mourns his mother's death through her absent presence.[39] Barthes's analysis of the photograph's characteristic fusion of spatial immediacy with temporal anteriority contributes to his assertion of the medium's "attachment" to loss (Barthes 1977, 44). Following Walter Benjamin, who notes in his 1934 essay "The Author as Producer" (Benjamin 1978, 24) photography's propensity to transfigure its objects into instruments of enjoyment—even when they depict tragedy and suffering— Sontag also dwells on the consequences of photography's built-in aestheticizing distance. Such a distancing function may be related to the democratization photography achieves over unique experiential forms, which yield their distinctiveness to the leveling translations of the image; thus, photography familiarizes the exotic as it exoticizes the familiar. Sontag comprehends this as a form of nominalism that lends itself at once to a false sense of the world's immanence, and to an aesthetic consumerism in which modernity itself is increasingly defined by the production and consumption of photographic images. Sontag's arguments about image addiction and the eroding distinction between the real and representational, with the real acquiring the qualities of the image, anticipate those of Jean Baudrillard and his diagnosis of the hyperreal (Baudrillard 1988a, 1988b). Like Baudrillard, Sontag relies implicitly on a critique of a capitalist logic of consumption, in which the seductions of circulating images facilitate the substitution of consumer for political choice; existing power structures continue meanwhile to thrive, with photographic spectacle palliating the powerless as its surveillance techniques work to sustain the powerful.

By rehearsing these views at some length, I don't mean thereby to present them as orthodoxy, since any one of them might profitably be challenged or refined. I would argue, however, that cumulatively, Sontag's and Barthes's conceptions successfully render any claims for the intrinsic truth of the photographic image untenable, a claim itself unlikely to generate much controversy precisely because these ideas may by now have acquired the empty prestige of the commonplace.[40] What interests me here is the remarkable consistency with which writers in the first half of the century—albeit with rare exceptions like Walter Benjamin—avoided or

[39] The phrase is Martin Jay's (1993, 456).

[40] This remains true, I would suggest, despite Barthes's greater emphasis on the denotative function of photographs in *Camera Lucida*. Compared to Walter Benjamin, who credited the medium with producing a distracted viewer, to be sure, but one whose new expertise might lead to strategies of demystification, Sontag's apocalyptic view seems to foreclose that possibility. For further discussion of Barthes, Benjamin, and the distinction between photographs and images, see Burnett 1995, 32–71.

suppressed these insights in their discussions of photography. Although Rosalind Krauss has argued convincingly for the repressed presence of an "optical unconscious" found in such photographic movements as surrealism from the 1920s to the 1950s, which resisted the precision optics and rationalized logic of visual modernism, they nevertheless remain minor undercurrents (Krauss 1993).[41] As Joel Eisinger has described the decade of the 1930s, "the apparently inherent realism of the photographic medium obscured [its] stylistic qualities. . . . Writers in the thirties implicitly thought that categories of photography, such as news photography or art photography, were determined by the inherent and stable qualities of the photographs themselves" (Eisinger 1995, 80–81). Eisinger's observations, as I'll show below, are pertinent for understanding the several decades preceding and following the 1930s as well. How is it, I want to ask, given the resurrection of the long-buried body in early-twentieth-century philosophical discourse, that any cognizance of the constructive and discursive power of photography was seemingly unavailable to modernist photographers and theorists? Or, to put it another way: what were the ideological underpinnings of this failure of recognition?

One answer surely lies in the history of the medium's use: Suren Lalvani has provided a detailed history of the critical role photography played in the rationalization and regulation of bodies beginning in the mid-19th century. Photographs were used to make visible patterns of pathology and deviance through an iconography of criminality, insanity, and sexual transgression, and to discriminate the bourgeois from the worker's body through the conventions of portraiture and through such techniques of measurement as motion studies which were intended to contribute to the efficient functioning of the normative body (Lalvani 1996). Photography, then, was from the start aligned with the emergent social sciences and their representational projects, which were devoted to the diagnosis, isolation, and regulation of otherness; cumulatively, photography facilitated the capacity of these projects to link optical empiricism with the production and discernment of truth.[42] To be sure, photography's foundational involvement with disciplinary techniques resists reduction to one-sided subject/object relations that rely on schematic "from-the-top-down" conceptions of power; following Foucault's observations of the unevenness and mobility of power relations and their dis-

[41] Allan Sekula makes a corollary argument for the Symbolist-influenced avant-garde photography in the United States in the first quarter-century as an alternative to the commitments of Straight Photography; see Sekula 1983, 125.

[42] Shawn Smith's excellent work on the constitution of racialized, middle-class identities in the nineteenth century through the convergence of scientific and commercial photography complements Lalvani's emphasis; see Smith 1999. For a valuable analysis of the "subject-effects" of photography, or the ways in which it serves as a supplement to identity, see Lury 1998.

courses, we can more profitably understand the gazes of observer/observed as interpenetrating if not entirely symmetrical. Pierre Bourdieu, for example, has shown the ways in which amateur photographers from different social classes used popularly defined aesthetics to assist in establishing their own distinctive class identities (Bourdieu 1990). Indeed, the frequent observation of the formal affinities linking the camera with Bentham's surveillance machine, the panopticon—with each device directing a light source to a focused cell in order to facilitate the subject's gaze—reinforces Foucault's point that panoptic power is ultimately internalized, and thus made independent of its originary apparatus. Be that as it may, practitioners and observers of photography in the modernist period generally adhered to a model of knowledge production reliant upon the discrete and stable opposition of objective observer and passive object of knowledge.

Modernist aesthetic discourse retains and refines the positivist faith in the camera image's optical fidelity. Typical of this aestheticist view is André Bazin's classic modernist articulation of photographic realism, "The Ontology of the Photographic Image" (1945), in which he argues that by so effectively assuming the mantle of mimeticism, photography had at once freed painting from its "resemblance complex" and was itself enabled to pursue its own essentially objective character. Bazin understood the truth of the photographic image as the twin consequence of the mechanical, "automatic" nature of its production and its "indexical" relation to the real—that is, its method of "taking of an impression" of the real as trace (Bazin 1975, 144, 3). For Bazin, photography legitimately changed the psychology of the image by leading us to accept the copy as real. No less a critical luminary than Clement Greenberg contributed to such an understanding of photography as the capturer of imagistic truths by declaring in 1946, in the aptly titled essay "The Camera's Glass Eye" (295), that photography's special "area of competence" lay in its naturalism (Greenberg 1946). The trajectory of twentieth-century American photographic movements generally conforms to this discursive template, in which the medium resolves its early struggle to liberate itself from the conventions of painting through attempts to realize what was considered its formal essence; thus, after the turn of the century the subjective and painterly manipulations of Pictorialism yielded to the Straight Photography that dominated in America through the 1920s, the avowed intent of which was to restore the purity of the photographic image. Although Straight Photographers like Paul Strand, Ansel Adams, and Edward Weston may have emphasized universality and transcendence as the ultimate goals of their aggressively unornamented works, they betrayed some anxiety about the medium's "unqualified objectivity," as Strand put it in 1917, even as they insisted on it; Adams, for instance, saw fit to chide Weston for

the crime of investing his images, however unconsciously, with "secondary implications."[43]

Yet, in America, the little-interrogated popular consensus that the medium was intrinsically neutral apart from an artist's will or vision largely prevailed even among professional photographers repeatedly confronted with the evidence of photographic subjectivism manifested in its most characteristic formal features, such as its frame. Such beliefs conditioned the production and positive reception of the documentary photography of the Depression with its emphasis on authenticity, and its attempt to redress official silence about social conditions by capturing the truth of appearances. The late 1930s inaugurated the spectacular success of mass circulation magazines devoted to telling their stories primarily through photographic images, such as *Life* magazine in America (1936) and *Picture Post* in Britain (1938). Significantly, these magazines also served as propaganda venues in the war and postwar efforts; Farm Security Administration photos, for instance, appeared in the popular press, and the Roosevelt administration used such images to garner support for agricultural recovery policies through (highly sanitized) depictions of the rural poor. In the mid-1940s and the 1950s, photography's presence in the mass cultural venues of journalism, advertising, and the amateur hobby business was as ubiquitous as the widespread faith in the medium's veracity (Eisinger 1995; Reed 1997). As late as 1955, in an address previewing Edward Steichen's watershed Museum of Modern Art photographic exhibition, *The Family of Man*, a show ultimately seen by nine million people in sixty-nine countries, Nelson Rockefeller articulated the show's premise by celebrating "the essential unity of human experience, attitude and emotion" conveyed unmediated "through pictures" (Sekula 1983, 137, 140).[44] Yet popular discourses enshrining photographic objectivity and universality served, as they arguably still do, to mask the far more situated terms of its production.

Such observations of photography's alleged "universal language" may be regarded, as Allan Sekula has argued, rather more insidiously as cloaking a capitalist will to expansion and conquest within their normalizing agenda (Sekula 1983, 127). Geoffrey Batchen has shown, moreover, that the tensions between modernist conceptions of photographic essence and a postmodernist insistence on discursive formations may be more apparent than real, since the uncertainty about photography's identity was

[43] See Strand 1980, 142; Adams, quoted in Eisinger 1995, 68. Alfred Stieglitz, of course, is a significant exception to this trend. A devotee of Bergson, Stieglitz subscribed to a more interiorized and intuitive conception of vision and sanctioned more "subjective" photographic products. It's interesting to consider the parallels between Straight photography and Imagism, a poetic movement perhaps equally committed to connotative "purity."

[44] For a book-length study of *The Family of Man* exhibition, see Sandeen 1995.

present even prior to its invention in the very terms of the *desire* to photograph; because it brings into play such oppositions as activity and passivity, presence and absence, time and space, fixity and transience, observer and observed, photography may be regarded as representing, in microcosm, "the deconstructive dynamic of an entire epistemology" (Batchen 1997, 181). Sekula's formulation of photographic discourse is particularly useful for exposing the repressed elements embedded within this cultural dialectic. Focusing on the threat and promise of machine technology epitomized by photography—an antinomy with enormous resonance for modernism, given its fascination with technology mitigated by its nostalgic aestheticism—Sekula stresses their fundamental interdependency. The poles of photography's foundational dialectic—those contrasting optical truths and visual pleasures—are caught between the claims of bourgeois science, with its positivist rhetoric of the truth of appearances and technological determinism, and those of bourgeois art, allied with a romantic metaphysics of cultish auteurism and an attendant belief in the subjective imagination. By the second half of the nineteenth century, Sekula concludes, "a fundamental tension developed between uses of photography that fulfill a bourgeois conception of the *self* and uses that seek to establish and delimit the domain of the *other*. Thus every work of photographic art has its lurking, objectifying inverse in the archives of the police" (Sekula 1983, 124).

The tensions Sekula identifies here between optical truths and visual pleasures and the intersubjective relations they yield are precisely those, I am suggesting, which literary modernism inherits. The continuity between the two is also striking; one might argue that the imaginative range of the mythic "man of genius" can only be fully exercised in the orbit of the pathologized subject of the mug shot as the two take up their positions on either side of the camera lens. The stratified relations between observer and observed formalized by the photographic lens reveal also a gendered character, continuous with that which structures the Cartesian visual economy as well as later discourses of visual power. Citing the example of Marx's analogy of the seductive character of women and commodities which can be controlled only by aggressive possession, Rachel Bowlby has described their joint affiliation with the culture of the image and consumer forms of subjectivity. The "natural" affinity of woman and the image, Bowlby explains, is an outgrowth of women's increased presence in the commodity-dominated public sphere from the nineteenth century onward, along with her narcissistic investment in the values of appearance (Bowlby 1985, 26–32). Anne Friedberg is also attentive to the visual and gendered ramifications of developing consumer culture, particularly through women's growing power as shoppers and tourists since the mid-nineteenth century. Friedberg notes that the decline of the male

flaneur, with the disappearance of the Paris arcades, coincides with the rise of the department store and the emergence of the flaneuse, from the chrysalis of the streetwalker, as the prototypical consumer.[45] Andreas Huyssen's influential argument (Huyssen 1986) about the modernist identification of woman with mass culture as a strategy by which male modernists sought to secure their own high-culture purity also posits an intimate connection between femininity and the image; each—femininity because of the threat of engulfment, and the image through its promotion of dreams and delusions—jeopardizes the male self's autonomy and motivates his conceptual elision of the two.

We can observe the modernist effort to collapse the distinction between visionary and documentary projects in Nancy Armstrong's account of its "iconophobia," a response manifested in its assault on conventional body images, realism, and traditional subject matter, in an aesthetic strategy intended to distance modernist productions from those of a feminized mass culture (N. Armstrong 1998, 47–48).[46] But Armstrong complicates the relationship between woman and image still further: behind each of these anathematized categories, she suggests, stands a larger fear, not of femininity or mass culture per se but of the mystifying power of the copy, one which "obscured and, if sufficiently popular, would eventually replace the original in the public imagination" (48). Armstrong focuses on the ways Straight Photographers tried to strip images of their contaminating semiotic baggage, not to produce a "perfect copy" within the rubric of realism, but in order to redefine the copy as an original—that is, as an expression of a uniquely *artistic* vision. Photographers measured their achievement in this process of "optical predation," as Armstrong calls it, in which defamiliarization serves as an initial stage in a larger strategy of visual appropriation, in strikingly gendered terms, registering the success or failure of their attempts as a gain or loss of masculinity (53, 52). The ultimate aim remained to reclaim as masculine those domains formerly associated with femininity, including the female body itself privileged as a synecdochical site, by investing them with aesthetic particularity (54). Extrapolating to the literary, I would add, the practice of appropriation through aestheticization provides another means of grasping the cultural imperatives driving the elaborateness of modernist style. Gender is clearly pivotal in the ways the gaze is conceptualized in these transactions, but surpasses a simple opposition of male gaze to female object through modernists' attempts to redefine gender categories

[45] Friedberg is following Baudelaire's description of the flaneur here, from *Les Fleurs du Mal*; see Friedberg 1993, 32–37.

[46] The term "iconophobia" is perhaps misleading, since Armstrong seems to suggest that modernists, in their attempts to detach images from objects, are primarily concerned simply with creating their "original" iconography.

in the process (62). In order to wed the visionary with the empirical, furthermore, fiction writers as well as photographers represented the idea of visual truth as a quality irreducible to visual surfaces, and thus requiring an expert, artistic gaze capable of perceiving and bringing to visibility an inner truth. It is precisely such an "interior gaze" that may be regarded as a kind of modernist compromise with empiricism, adapting its methods to illuminate and represent a subjectively conceived interior.

Taxonomies of Ethnographic Spectacle

What is striking is the degree to which these aesthetic aims, expressed not only in photographic discourse but also in literary modernism, resemble the clinical ambitions of nineteenth-century taxonomic projects. As Walter Benjamin discerned in 1936, the camera transforms its user into a virtual surgeon, who "diminishes the distance between himself and the patient by penetrating into the patient's body" through the paradoxically detached proximity of his lens (Benjamin 1969, 23–24). Modernist aesthetics may be regarded as the legitimate if distant offspring of those discourses and practices that aspired to penetrate bodily surfaces in order to make accessible more hidden zones of visibility. Such social science discourses and practices are relevant to modernism, not only in the sense in which T. S. Eliot adapted Frazer's *The Golden Bough*, that is, as sources of anthropological and mythological detail that lent allusive richness to modernist texts, but in a more primary way, as a method of knowledge. Social science discourses and practices provide a window not only into modernist visualizing techniques, in other words, but also into their objects of knowledge, because they helped to establish conventional occupants—gendered and also racialized—for the positions of observer and observed. When it is remarked that "recourse to exotic others" served, as Michèle Richman among others has noted, "as a revitalizing mechanism for modern literature" (Richman 1990, 185),[47] then, we should recall the ways in which such literature supplied its "human resources" by rejuvenating historically inflected subject/object relations derived from nineteenth-century racialism, arguably in order to reclaim its own jeopardized place as subject-lens.

According to nineteenth-century racialism, bodily surfaces testified to interior truths or essences—signs of difference which it remained the object of the observer to discover and classify. Robyn Wiegman has described the nineteenth-century shift in attention within race science

[47] Edward Said, Marianna Torgovnick, and Michael North have also offered powerful arguments exploring modernism's use of exoticized Others and "the primitive." See Said 1993; Torgovnick 1990; North 1994; see also Barkan and Bush 1995.

from the surface of the body to its depths or interior, as "a simultaneous strengthening of the corporeal as the bearer of race's meaning *and* a deepening of that meaning as ultimately lodged beyond the assessing gaze of the unaided eye" (1995, 23)—a process the inevitable subjectivity of which perhaps requires little comment. Significantly, a nineteenth-century discourse of *sexual* difference was retooled to articulate race in this crafting of the body's meaning; on the basis of similarities in skull and brain size, craniologists famously forged a "visible" link between women and the "lower races," leading to an understanding of those races as corresponding to a "female" type. This perceived relationship between blacks in particular and women persists well into the twentieth century, and we can find a version of it in the views of the most influential race theorist of the Chicago school of sociology, white sociologist Robert E. Park. In the important textbook he edited with Ernest W. Burgess, *Introduction to the Science of Sociology* (1921), Park describes "the Negro" as "the lady among the races," on the basis of "his" expressive nature (Burgess and Park 1921, 136). Wiegman argues that these discourses of sexual and racial difference each are animated by "the crisis of subject-object relation that underlies the rise of the disciplines and their methodological quest for transcendence" (1995, 49)—one which threatened to reduce white masculinity to its own corporeal particularities, thus depriving it of its cultural transparency. Of course, by reserving corporeality for the nonwhite and female other, such discourses worked to reclaim that transparency for the white male subject. Wiegman notes that this production of the feminized black body functioning as *the* body for culture served to disqualify African Americans and women from a universal subject position imagined by Enlightenment political theory as unmarked and disembodied—one that could be occupied, in other words, only by white men (49–50).

The modernist preoccupation with interiority in the twentieth century is surely related to the proliferation of technologies intended to bring more and more of the body into view. Tim Armstrong has described the array of new devices expediting bodily penetration and visibility that appeared in the twentieth century, from the stethoscope and speculum and the invention of x-rays to the myriad new instruments of measurement which highlighted the body's mechanical and perceptual limits; these devices furthermore helped to redefine the body within a rubric of lack which provided a mandate for prosthetic compensations (T. Armstrong 1998, 2–3). Armstrong understands this commitment to bodily intervention as a distinctively modernist attempt to render the body part of modernity through biological, mechanical, and behavioral techniques. Such procedures, again, were inevitably gendered: Armstrong describes the discursive feminization of the body's interior, as it becomes more rou-

tinely subject to male surgical penetration and intervention, along with the concomitant masculinization of bodily disciplines (5–6). I would suggest that the racialization of the relations fostered by these new visual technologies is also overdetermined, although the respective "primal scenes" of gendered and racial constitution undoubtedly differ. If the iconography of the male gaze as a mechanism of penetration directed toward the female body has an inevitably sexual character, the picture called up by the white "scientific" gaze trained upon the nonwhite body is overwhelmingly "colored" by the taxonomies of social science and the imagery they yielded, from the classification of body parts in phrenology and comparative anatomy to the reified status of that body codified in the ethnographic portrait. In the twentieth century, such imagery of the non-white body becomes the subject of a burgeoning photographic and cinematic expression, which suggests both the material collaboration between visual technologies and visual disciplines and their fundamental epistemological compatibility. As Christopher Pinney has observed, anthropology and photography "derive their representational power from nearly identical semiotic procedures" (Pinney 1992, 74).

First and foremost among those procedures must be counted the participant-observer method, the conventions of which, according to James Clifford, had won international acceptance by the mid-1930s, and which conceived of its ideal practitioner as a kind of neutral, detached lens on exotic worlds.[48] The intent of the participant-observer method was to produce a wealth of empirical ethnographic data made possible by the field-worker's divestment from his own cultural biases and assumptions in order to see from a monolithically conceived "native point of view."[49] Like photography, then, as Pinney argues, anthropological method may be regarded both as a culmination of the Western quest for visibility and scrutiny and as encapsulating its moments of unease through the tensions it epitomizes between its iconic and indexical functions, its aesthetic and mimetic ambitions, and its dream of invisibility invariably betrayed by its all-too-visible authority. To the formal analogy frequently drawn between the camera and the panopticon, Pinney adds a substantive one particular to the Western project of documenting other peoples: each constructs its object of knowledge in disciplinary terms relative to a transparent subject-lens which itself represses the evidence of that production (Pinney 1992, 75–76). James C. Faris has characterized such photographic practices as both archival and nostalgic—expressing the impulse to preserve "primi-

[48] For a full discussion of the history of the participant-observer method in anthropology, see Clifford 1983.
[49] As late as 1967, a research guide on the uses of photography in visual anthropology opens with an epigraph from Zola's classic essay on naturalist principles, "The Experimental Novel"; see Collier 1967.

tive" cultures frequently comprehended developmentally as evidence of an idealized cultural "childhood"—thereby mimicking anthropology's more global documentary impulses (Faris 1992, 255).[50] Photography thus occupies a crucial position within a matrix of vision, Western knowledge, and power, as it epitomizes Western technological and epistemological prowess. Pinney explains the gradual fading away of photographs as a regular feature of the postwar anthropological monograph as a consequence of the discipline's having so fully absorbed its idiom that its literal presence was no longer required (81); instead, the anthropologist—much like the writers of realist and naturalist fiction, I would add—had "taken on to his own person the functions of a plate glass . . . prepared to receive and record messages" (82). Given such unabashedly empirical predilections, perhaps the most compelling developing parallel between twentieth-century anthropology and photography—and, in a less direct way, literary modernism—is their growing preoccupation with interiority as a more primary zone of truth. Just as we saw in the context of medical discourses, Pinney observes that "from the turn of the century onwards," anthropological truth is likewise subject to "a gradual displacement onto an invisible, internalized world of meaning," such as a concern with social structure, that may function as the social body's equivalent to the individual human body's mysterious interior (78);[51] this displacement has much to tell us about the "flight to the interior" of the period's aesthetic discourses as well.

Like its photographic forbearer, film technology both informs and colludes with literary modernism, playing a significant role in the early-twentieth-century project of producing and circulating images of cultural Others, and arguably functioning, as Fatimah Tobing Rony has suggested, as "a primary means through which race and gender are visualized as national categories" (Rony 1996, 9). Compared with the relatively solipsistic engagement sustained by the viewers of photographs, the collective nature of film spectatorship may be credited with film's potential to exert a greater measure of ideological control. At the same time, film has offered new "modes of embodied existence" to film actors and spectators by putting a "purchase on fugitive physicality" as Tom Gunning has elegantly

[50] Faris draws a parallel between the visual practices connecting anthropologist and native with those which tether consumers to capital: "capitalist production has universalized the prurient gaze of the detached ethnographer" (1992, 256).

[51] The case is, of course, considerably different in France. Michèle Richman notes the ways in which French intellectual life has been marked "by a convergence between the nascent human sciences and cultural avant-gardes" (184) in the modernist period, but in a direction independent of positivism; this convergence may be most prominent in the work of Georges Bataille, Roger Callois, Michel Leiris, and the "sacred sociology" of the Collège de Sociologie; see Richman 1990.

phrased it (1995, 20).[52] Anne Friedberg provides a history of some of these new strains of physicality through her genealogy of the "mobilized 'virtual' gaze" of cinematic spectatorship; the phrase is meant to acknowledge the paradoxical character of how "we calmly and adventurously go traveling" through film while never leaving our seats.[53] The gaze, then, comes to acquire the "mobility" ceded by an increasingly immobile, passive consumer. Notable for the received rather than direct character of its perception because more saturated by the mediation of representations, the mobilized virtual gaze has it roots in nineteenth-century flânerie and travel, shopping and tourism, museums and other organizations of the look which subsequently culminated in the "imaginary flânerie" of cinema. The origins of the cinematic gaze, then, must be comprehended in relation to earlier incarnations of *mobility*—a narrative which stands as an alternative to understandings of cinema that follow from Foucault's account of panoptic confinement, with the mechanical and fictitious relations it sustains between (at least theoretically) stationary seers and their objects. Film spectators, Friedberg asserts, fit only metaphorically into Foucault's model since, as invisible subjects, they can't serve as objects of surveillance; nor can they function as panoptic seers since their visual omnipotence is only imaginary, and fails to issue in self-scrutiny. In place of Jeremy Bentham's panopticon that he conceived in 1791, Friedberg locates two other optical inventions roughly contemporary with it which she alleges serve as a more compelling antecedent for the mobilized virtual gaze of cinema—the panorama (1792) and the diorama (1823), each of which were collectively observed spectacles positioning viewers at the center of moving images that "transported" them visually but not bodily.

Friedberg's conclusions about the origins of the mobilized virtual gaze in such machines of display and consumption may be seen as complementary to the analysis of ethnographic spectacle and its social science roots which follows—a relationship to which Walter Benjamin lends rhetorical support with his clinical description of the flaneur "botonizing on the asphalt"—a phrase which links tourism and consumerism with the project of classification (Benjamin 1973a, 36). As Friedberg herself puts it, "the same impulses that sent flâneurs through the arcades, traversing the pavement and wearing thin their shoe leather, sent shoppers into the department stores, tourists to exhibitions, spectators into the panorama, diorama, wax museum, and cinema" (Friedberg 1993, 94). While the trajectory Friedberg traces from panorama to cinema stresses the construc-

[52] See also Sobchack 1997, 37.

[53] The phrase is Walter Benjamin's from "The Work of Art in the Age of Mechanical Reproduction"; quoted in Friedberg 1993, 47.

tion of the visual orientations of subjects prepared to receive those spectacles, the trajectory linking the ethnographic exhibition and social science taxonomies with the racial film emphasizes the construction of the Other-as-object by and through the gaze. Corresponding roughly to the emphases of Debord and Foucault, the two trajectories arguably provide still more material basis for asserting the complementarity of spectacle and surveillance in the period leading up to and including modernism.

The early decades of the twentieth century were notable for the production and circulation of racially preoccupied American films, facilitated by a national film distribution system by 1909, which crossed the borders of what would later be established as distinctive film genres. By the mid-1920s, according to Eliot Weinberger, cinematic representations of racial and cultural difference had evolved into three genres: the anthropological film, which normally took as its task the recording of a single aspect of a culture; the fictional romance, featuring indigenous people; and the "documentary," a term coined in a 1926 review of Robert Flaherty's second film, *Moana*, to describe its representation of events in the life of a Polynesian family (Weinberger 1994, 4–5). The blurriness of the distinctions between these genres, however, is easily suggested by a film like *Moana*, for instance, for which Flaherty cast a fake "family," selected for its members' collective cosmetic appeal, and dressed them—or in the case of the women, undressed them—in anachronistic costumes. The increasing expense of making such films made the expedient of shooting off-location gradually more imperative, with a commensurate increase in precariously anchored cultural portraits, not to say, plain old artistic invention. Nevertheless, the rhetoric surrounding the production of these films remained committed to empirical purity. As respected ethnographic filmmaker Timothy Asch has put it, "The camera can be to the anthropologist what the telescope or microscope is to the biologist" (quoted in Weinberger n.d., 11). In the 1930s, Margaret Mead thought that "objective" filmmaking would replace subjective field notes, and went on to produce such films as the 1942 classic, *Balinese Character*, with Gregory Bateson. Behind these beliefs, claims Weinberger, stands a fantasy of invisibility—one perhaps endemic to the film medium—the embodied underside of which continually threatens to be exposed.[54] This is evident in some of the technical innovations attempted by ethnographic filmmak-

[54] Stanley Cavell has stressed the significance of movie audience's invisibility to actors on screen, a condition which leads to film's power as a "magical reproduction of the world"; the inverse of this potent combination of transparency and idealized identification Cavell finds in the film viewer's mechanically induced helplessness and in the imperative of passive absorption; and he understands the pleasures of invisibility as part of the modern need for privacy and anonymity. See Cavell 1979, 26, 101.

ers, whose quest to perfect observational purity sometimes took the form of simply letting the camera run unedited in order to capture a stream of data seemingly innocent of point of view.

What remains arresting about such artifacts—aside from their unspeakable tedium—is their uncanny anticipation of avant-garde film techniques such as those practiced by Andy Warhol in *Sleep* (1963), who used the unedited camera for precisely the opposite purpose, to capture the subjective character of duration. Indeed, there are numerous other grounds on which one might expose, behind the avowedly empirical face of such films, an "interior" far more resonant with aesthetic practices and preoccupations. James Clifford, for example, has identified a parallel between the ethnographic and surrealist impulses to see culture as an artificial arrangement to be analyzed, an attitude fostered by two world wars that together rendered the world "permanently surrealist" (Clifford 1988, 119).[55] Clifford avers that a surrealist vision, whether acknowledged or not, is always present in ethnographic works via the practice of collage, which relies upon decontextualized juxtaposition to achieve its effects (146). Anne Grimshaw similarly notes efforts to suture perceptual fragments into the larger whole of ethnographic film, and characterizes the shift from static to multiperspectival camera as indebted to Cubism (Grimshaw 1997, 49). Weinberger goes so far as to declare ethnographic film's resemblance to fascist art, pointing to their shared motifs of courageous individualism, celebration of folk wisdom, and idealization of the erotic savage body (Weinberger 1994, 7). The intermingling of "scientific" and aesthetic epistemologies can be found still more constitutively in the indebtedness of early entertainment films, such as D. W. Griffith's *Birth of a Nation* (1915), to the racial iconography of ethnographies.

Fatimah Tobing Rony has powerfully demonstrated the representational continuum linking the scientific research film, the ethnographic film, and the commercial entertainment film in the modernist period. The blurring of boundaries between these diverse film subgenres suggests the power of the cultural imperative to produce portraits of the racial Other and an equally powerful impulse to dignify the productions of the cultural imaginary under cover of an empirical veneer. The scientific research film may be epitomized by the chronophotography of the French anthropologist Félix-Louis Regnault, who conducted time-motion studies of, for example, West African performers at the Paris Ethnographic Exposition of 1895 with the intent of establishing an evolutionary typology of the races based on movement. Through comparisons of running, jump-

[55] Clifford notes that Apollinaire coined the term "surrealism" in 1917, fresh from the trenches.

33

ing, walking, and other physical expressions, Regnault hoped to expose allegedly unmediated bodily truths.[56] As it had elsewhere, photographic technology enabled visual penetration into the heretofore unseeable, making these studies of sequentially arrested movements possible. With its conspicuous interminglings of science with spectacle, the time-motion studies, along with the nineteenth-century ethnographic exhibition and the anthropological archive, should be seen, Rony suggests, as precursors to the cinematic form; their collective distinctiveness chiefly resides in their greater potential to destabilize visual relations than the more rigidly dichotomized visual codes sustained in film proper.[57] The characteristic visual bias of these pre-cinematic forms, Rony argues, transforms the world into a museum display of evolutionary and racial evidence, the exhibition of which simultaneously makes visible the spectacle of Western control. These forms schooled Western spectators, furthermore, in how properly to see the ethnographic subject—as a racialized, dehistoricized body, crude perhaps, but potentially more vigorous than the modern European body now enervated by the excesses of civilized refinement and its rarified spectatorial practices. The Other's body, then, at once functioned as a pathological mirror of the European and as an icon of a more "authentic" body, whose nudity among other tabooed practices could serve as a medium of transgressive identification for Westerners.

The visual practices which worked to establish conventional ways of seeing the Other from around the turn of the century "fused," Rony contends, "into a cinematic picturesque, creating a conceptual bridge between racial 'inscription' and . . . the 'taxidermic' mode of ethnographic cinema" (Rony 1996, 79), the latter of which aims to represent the dead as if living, in a poetics of resurrection of (seemingly) lost, or invented, cultural forms with inevitable resonances for the project of salvage ethnography. Rony uses Robert Flaherty's classic *Nanook of the North* (1922)—a film so successful that it enjoyed worldwide release—to exemplify the taxidermic mode of the lyrical ethnographic film, since Flaherty's goal in *Nanook* was to represent the Inuit as they had been in the past. *Nanook* draws on earlier cinematic forms like the travelogue, which can be credited with naturalizing white penetration and discovery of foreign contexts, as well as visual tropes, such as the panoramic view, that have been

[56] Chronophotography typically is seen as a prototype of film, since it's not meant to be projected. Regnault's conception of a transparent body was not the only view; Franz Boas understood bodily movement as bearing the imprint of culture, which could be made legible through attentive study; see Ira Jackinis, "Franz Boas and Photography" (quoted in Rony 1996, 67).

[57] Throughout her argument, Rony is attentive to the possibilities for agency and reversal on the part of performers/observed, noting performers' return of the gaze in ethnographic exhibitions and other scenes of display, as well as the conventions which dictated subjects' neglecting to gaze directly at the camera (24, 41–43).

seen as invitations to exploration and habitation; and it looks forward to the production of the "racial films" of the 1920s and 1930s, which engage the tensions between modern and primitive in more "fictional" contexts that expose the fluidity between fantasied and "real" cultural spaces. Rony discerns in *Nanook*'s own ambivalent romance with modern primitivism a representational logic which culminates in the monstrous hybridity explored in films like the immensely popular *King Kong* (1933), a film produced and directed, not incidentally, by the well-known ethnographic filmmakers Merian Cooper and Ernest Schoedsack.[58] Elizabeth Young has shown the ways in which white racial anxieties were transcribed into the *Frankenstein* films of the 1930s, where the monster's delinquency, criminality, inferiority, and subhumanity converge in a frightening reinscription of black stereotypes; the monster's primitive appearance and grotesque embodiment make him a symbolic cousin, Young argues, of King Kong, whose coding of the myth of the Black rapist is expressed in his abduction of the helpless Fay Wray (Young 1991). *King Kong* and films like it, I'm suggesting, both mirror existing discourses about race, self, and Other and actively produce habits of viewing that sustain and further them.

Images of the white primitive proved equally compelling to audiences of the modernist period, as Marianna Torgovnick's reading of Edgar Rice Burroughs's *Tarzan* books and their film adaptations makes clear. Some twenty-three *Tarzan* novels appeared from 1912 through the thirties, and roughly fifty films were produced, beginning in 1917. The *Tarzan* series conveys both the allure of the noble savage as trope and the capacity and desire of the white man to occupy it. Tarzan's license to personify whites' primitivist fantasies is arguably undergirded by his English, aristocratic pedigree, and a body of "instincts" and experiences that collectively serve to naturalize patriarchal and racist social arrangements, even in the jungle. Despite their periodic lip service to the evils of colonialism, Torgovnick argues, the *Tarzan* novels reinscribe colonialist principles through their eroticized narratives of penetration of the "heart of the dark continent," thereby demonstrating both the allure and limits of transgressive identification with Others and the precaution not to sacrifice on the altar of fantasy, as it were, too large a measure of real cultural power (Torgovnick 1990).[59]

The fascination with the "primitive" cumulatively conveyed by the sci-

[58] They produced and directed *Grass* (1925) and *Chang* (1927), for example; see Rony 1996, 159.

[59] That the effects of such films on modernist fiction exceed the purely atmospheric is demonstrated, for example, by *The Day of the Locust*, in which Nathanael West depicts the aspiring actress Faye Greener as drawing inspiration for her cinematic fantasies from a Tarzan movie poster; see West 1962, 105–6.

entific, ethnographic, and commercial entertainment films and their pre-
cinematic precursors in the modernist period—a fascination wedding
nostalgia for a lost purity of natural origins with a paternalistic repudia-
tion of savagery and the vestiges of "cultural childhood"—may be under-
stood simply as the cultural mirror image of modernism's ambivalence to-
ward technology as a source both of possibility and betrayal: each pits a
notion of modernity against a conception of nature that highlights hopes
and fears about cultural and technological progress as well as diverse per-
ceptions of the gains and losses attendant on the seemingly inexorable
process of "becoming modern." The accelerated mechanical reproduc-
tion and circulation of photographic images and their successors in the
modernist period, along with the forms of intersubjective mediation
which they produce, give decisive shape to this abiding modernist am-
bivalence in which the fetishization of images serves to designate a com-
plex epistemology and iconography of observers and observed. These im-
ages are linked with femininity and configurations of racial difference
both connotatively, as we find in the association of femininity and the im-
age, and representationally, in literal depictions of women and cultural
Others. The impact of such images must be understood as at once reflec-
tive and productive—reflective of habits of viewing, such as those com-
prised by the gaze of race science, that precede and inform them; and
productive of the reified identity positions born of the increasingly repet-
itive and collective character of spectatorship. The tensions sustained be-
tween the optical truths and visual pleasures produced by these varied
perception machines model a characteristically modernist response—the
crafting of an interior gaze trained upon its mysterious object, the subjec-
tive nature of which is inseparable from its purported expertise. This spe-
cies of modernist perception, then, contains within itself the means to ex-
pose its reciprocal character—to bring the body of the observer, in other
words, into focus, from where it lay obscured behind the positivist face of
Cartesian perspectivalism.

Situating the Authorial Gaze

The modernists writers I examine below inherit the culturally charged
divisions between visionary and documentary modes epitomized by this
discursive history, divisions which become increasingly invested with ques-
tions of embodiment and transparency as their efforts to suppress the
body behind the figurative camera lens wear thin. The modernist dis-
avowal of subjective visuality through the interior gaze may be regarded as
an attempt to retain the position of cultural transparency under attack
from diverse philosophical quarters and, thus, to remain on the "right"

side of that lens. Because of their different positionings with regard to cultural transparency from the start, however, the strategies employed by these writers, and the visual economies they both work within and manipulate, of course vary considerably. For James, Nabokov, West, and Blanchot, the sheer acknowledgment of the embodied and situated nature of vision constitutes the shared sense of crisis in their texts, a crisis each attempts to resolve through varying strategies of displacement; most typically, male characters seek to displace their own embodiment onto female characters who are frequently identified with mass culture and the seductions of the image and finally are made, in one way or other, to disappear. For Hurston, Woolf, and Ellison, on the other hand—writers already culturally defined, however disparately, as bodies—the facts of embodiment serve as a place of departure, and motivate their diverse imaginings of more transcendent forms of what might be called their "visionary optics." For Hurston and Ellison, this optic designates their characters' imaginary returns to the moment of Romanticism with its restructured vision of a transcendental merger of self and world, personified by Emerson's transparent eyeball as the ideal seer; for Woolf, it means a reconceptualizing of history as a space of mystical revelation, linked particularly with femininity, in a vision which resonates powerfully with Walter Benjamin's transformative dialectical image. In such varied but culturally legible ways, these novelists live out the contradictions between philosophical acknowledgments of subjective, embodied visuality and empiricist denials of them so pervasive in photographic and social science discourses.

There is, of course, no grouping of texts, however representative or inclusive, that could exhaustively express the heterogeneous field of visual forces in play in the modernist period, the chief contours of which I've attempted to sketch here. Instead, I have in each of the three parts of this book adopted a strategy of productive juxtapositions, pairing theoretical with literary texts and reading two or more novels against one another in order to differently highlight three conceptual problems of special significance for modernist visuality: the changing status of the authorial gaze in the modernist period, the construction of objects of the gaze and their links with the problem of embodiment, and the representation of viewing subjects or spectators and their intervention into questions of agency. In bringing these varied works into conversation with one another, I aim to emphasize the ways in which shared discourses cut across the boundaries of fictional and nonfictional genres. At the same time I wish to avoid homogenizing the distinctive imaginative "resolutions" each text brings to these issues. The historical approaches which emerge from this stress on conceptual affinity vary. In Part I, for example, I pair the earliest of the novels I discuss (James's *The Sacred Fount*, 1901) with the latest of my literary texts (Blanchot's "The Gaze of Orpheus," 1955) in order to indicate

37

both the range and continuity of the ways the gaze is linked with the project of writing across the period. In Part III, by contrast, the selection of two texts in close historical proximity (Woolf's *Between the Acts*, 1941, and West's *The Day of the Locust*, 1939) allows me to contrast depictions of spectatorship that are resonant with two national traditions—English village theater and America's Hollywood film industry. The three parts of the book only loosely correspond to the more tidy divisions between visual discourses, techniques, and technologies around which I've organized this Introduction, for the reason that most of these novels indulge in the sort of discursive promiscuity which contributes both to their complexity and pleasure. Part II (on Hurston's *Their Eyes Were Watching God*, 1937, and Ellison's *Invisible Man*, 1952), with its large debt to visual techniques, perhaps most closely adheres to a disciplinary schema, but even here the picture is richly complicated by Hurston's and Ellison's numerous other sources and preoccupations.

In Part I, "The Eye in the Text," then, I begin by asking how the modernist interior gaze is linked with the project of modernist writing—a gaze best understood both as a position and a method determining what can be known and therefore narratively rendered, and at what intersubjective cost. These two chapters most directly engage with philosophical debates, from the critique of Cartesian perspectivalism to the intersubjective and embodied vision of Merleau-Ponty, and with key visual paradigms from the period's dominant metanarrators, Marx and Freud. They are centrally concerned, too, with the gendered consequences of such materials, exploring the mutual dependence of embodiment and subjective transparency as ontological positions and the accounts of speech and silence that seem to emerge from them. Despite their differences in genre (Blanchot's "The Gaze of Orpheus" is a short essay, the others are novels), these texts, to varying degrees, exhibit the quality of metanarratives— parables of narrative production and authorship which self-consciously reflect upon the processes, visual and textual, of their own making. Together, these chapters work to establish one line of argument central to this study: that, regardless of their degree of success, authorial and characterological gazes mutually implicate one another in their shared quest to occupy a privileged position of subjective transparency, over and against their aggressively embodied objects; and, precisely to the extent that this fantasy falters, modernist writing may be regarded as a compensatory project, the excesses of which are traceable to a sense of epistemological crisis. In response to the representational problems posed by their cognizance of visual indeterminacy, in other words, these writers and their narrative proxies approach the problem of representation through strategies of linguistic excess and paradox.

In Chapter 2, "The Eye's Mind: Self-Detection in James's *The Sacred*

Fount and Nabokov's *The Eye,*" I consider the critique of the detached, om-
niscient posture of the Cartesian spectator and its role in literary realism
along with novels preoccupied with the power and limits of surveillance. I
review and evaluate the visual theory associated with Cartesian epistemol-
ogy and its relationship both to the omniscient narrator of traditional re-
alism, and the more partial visual knowledge presented by the "private
eye" of detective fiction. It is against this philosophical backdrop that I sit-
uate the innovations of James's elaborate parody of authorship, *The Sacred
Fount* (1901). I examine the subjective, unreliable model of viewing James
represents, particularly the forms of violence entailed by the narrator's
aestheticization and commodification of his objects. I further demon-
strate the formal consequences entailed by the gap between seeing and
knowing in the novel, drawing connections between the linguistic inde-
terminacy in *The Sacred Fount* and the formal experiments to decenter nar-
rative vision in late James. Finally, I track the solipsistic breakdown of the
division between the narrator's and character's gazes in Nabokov's self-re-
flexive detective novel, *The Eye* (1930), in which the operations of the nar-
rator's supervisory eye are confined to his obsessive quest to discover the
identity of a man who turns out to be himself. As I explore the political di-
mensions of this new, self-reflexive model of viewing, I argue, following
Foucault, that *The Eye*'s narrator unquestionably participates in the "fan-
tasy of surveillance" said to characterize the function of the realist narra-
tor, but fails adequately to represent the forms of discipline, regulariza-
tion, and supervision normally associated with that narrative authority.

In Chapter 3, "Two Mirrors Facing: Freud, Blanchot, and the Logic of
Invisibility," I read Blanchot's narrative of artistic development in "The
Gaze of Orpheus" (1955) alongside the narratives of male and female de-
velopment provided by Freud and Lacan. By unraveling some of the
shared theoretical strands which link these two works, my aim is to look
both backward and forward historically: to uncover the vestiges of a nar-
rative constellation involving vision, gender, and embodiment that
proved so powerful for literary modernism, as well as a revisionary narra-
tive from "a past to come" which strives to rework the positional violence
of its predecessor.[60] I begin by revisiting Freud's developmental narra-
tives, where I follow the pivotal role vision plays in the distribution of male
symbolic agency and transparency compared with female exclusion and
embodiment. I use this classic articulation of a modernist visual paradigm
to read Blanchot's "The Gaze of Orpheus," exploring its parallel formula-
tions of vision, gender, and embodiment. But Blanchot's essay is not sim-
ply a reprisal of this dominant narrative, a point I make by way of Ovid
and Merleau-Ponty. By excavating the potential moments of intersubjec-

[60] The phrase is Blanchot's (1982b, 17).

tivity in these latter writers, I aim to expose the "other" or dialectical mirror of the dominant Freudian story, and to identify its own muted presence in Blanchot. But each of these models, I will finally suggest, along with the notion of subjectivity which they ironically share, is vitiated by Blanchot's ascendant impulse: to show the ways in which all subjects are superseded by language, rendering them disappearing shadows compared with its superior and ubiquitous presence. "The Gaze of Orpheus" thus serves as an exemplary transitional text, epitomizing—as it departs from—modernist visual paradigms and measuring the distance from James's Orphic metanarrative from the turn of the century.

The two chapters in Part II, "The Body Visible in the Lens of American Social Science," share a focus on the ways discourses of race have been produced through the techniques and institutions of American anthropology and sociology from the turn of the century, as well as the resources Zora Neale Hurston and Ralph Ellison employed in the 1930s to the 1950s to refashion them. These chapters specifically explore the dynamics of the racialized gaze, from Hurston's appropriation of the "spy-glass of anthropology," through which she views her own community, to Ellison's manipulation of the photographic lens as a metaphor for the imbricated projects of literary naturalism and American race science. Part II concerns itself with the ideas of several key figures whose visual techniques strongly influenced cultural perceptions of race, as they worked to construct penetrable, racialized bodies, including Franz Boas's participant-observer method and Robert E. Park's concepts of racial temperament and "high visibility." The chapters also examine Hurston's and Ellison's parallel returns to an aesthetic and philosophical predecessor of modernism in Ralph W. Emerson, whose ideas provide the means to recover a position of cultural transparency jeopardized by the contemporary racial discourses available to them. For all their profound differences in style and sensibility, the shared preoccupation of Hurston's and Ellison's protagonists with disembodiment as a potential source of personal and political agency furthers my argument about the modernist impulse to displace embodiment onto objects which are made to disappear—even when those objects conspicuously include themselves.

Chapter 4, "From 'Spyglass' to 'Horizon': Tracking the Anthropological Gaze in Zora Neale Hurston," considers the representational conflicts and consequences of Hurston's appropriation of anthropology for a dual project: to reclaim African-American expressive forms such as dialect and folklore for her artistic work and to inscribe those forms within predominant white definitions of culture. I begin with Boasian anthropology, whose participant-observer method, theory of cultural relativism, and critique of the comparative method of anthropology cumulatively reframe primitivist discourse in ways that are at once enabling and disabling for

Hurston. Using this framework, I read *Their Eyes Were Watching God* (1937) as Hurston's attempt to revise anthropological method in ways that initially privilege active participation in and celebration of African-American folk culture. I argue, however, that Janie Crawford's transformation from folk heroine to visionary at the conclusion of the novel demonstrates the ways in which Hurston's revision moves beyond a critique of anthropological methods and toward an idealist model of individual transcendence. I then trace the roots of that model to a second, historically anterior, and perhaps unanticipated discursive source, Emersonian Romanticism, through which I delineate the specifically transcendentalist terms in which Janie's transformation from folk heroine to visionary artist is effected. We may see the appeal of Emerson's disembodied seer through which Hurston elevates Janie at the end of the novel, therefore, as an imaginary, if not outright false, resolution to the real social contradictions Hurston inhabited, a "solution" which paradoxically suggests the intractable nature of black embodiment as an ontological problem for her.

In Chapter 5, "One-Eyed Jacks and Three-Eyed Monsters: Visualizing Embodiment in Ralph Ellison's *Invisible Man*," I consider the intricate relations between the several discourses which most influenced Ellison's development of invisibility as a racial construct in *Invisible Man* (1952). I begin by considering American sociology's deterministic conception of the consequences of the black body's visibility, and its roots in another discourse exploring the visible economies of the body, comparative anatomy. Ellison's rejection of that sociological view is made possible, I argue, with the help of three other discourses he was centrally engaged with throughout the 1940s—folklore, Emersonianism, and Sartrean existentialism— each of which theorizes a far less problematic agency for the subject. Folklore provides the evidence to dispute the accusation of African-American cultural impoverishment leveled by social science; however, it is also easily assimilable to prevailing ideas of cultural development that rank it below more individuated or "advanced" forms. Emerson, too, provides a partial blueprint for the poet's valuing and transforming of folk materials in terms resonant for Ellison, but his commitment to racial hierarchy compromises the efficacy of his more palatable views and exposes the continuity between Emerson's beliefs and later sociological conceptions of racial difference. As does Emerson, Sartrean existentialism offers a theory that affirms the human capacity to comprehend and shape its own history through a doctrine of self-created meanings that challenges sociology's racial determinism; however, Sartre's conception of subject/object relations cannot accommodate the ways in which historical constructions of race complicate those relations. Seen in the context of these discourses, Ellison's selection of invisibility as his governing metaphor begins to appear as overdetermined as it is inevitable, and as vexed.

Part III, "Audience and Spectacle," contrasts two national "traditions" involving the (re)production and consumption of social spectacle in Virginia Woolf's and Nathanael West's novels—of English village theater and the Hollywood movie industry—as it meditates upon their respective functions. These chapters measure the impact of new technologies on the experience of spectatorship. In Woolf's novel, the audience of an annual village pageant is reshaped by an aesthetics of distraction promulgated by the collaboration of warplanes with theatrical experiment; in West's, a painter attempts to reclaim the mass audience of Hollywood film and celebrity for high art, only to be conscripted, too, by its seductive power. With the novels' conspicuous stagings of conflict between distinctive cultural spheres, this part necessarily interrogates the divide between high art and mass culture that each text represents, seeking a deeper understanding of the ways those strata are differently gendered and valued. While each chapter takes its interpretive bearings from discourses emerging from a Marxist tradition—from Benjamin's concept of dialectical images to Debord's notion of a "society of the spectacle"—their disparate conclusions about the political possibility scripted within new visual relations are striking. Whereas Woolf, much like Benjamin, finds amidst the disruptive collisions of varied cultural materials the potential for spectators to experience a "flash" of demystifying insight into their historical and political moment, West seems to discover only the conditions for mass culture's feminizing cannibalization of "higher" masculine forms, and its restructuring of a newly passive, nearly borderless observer. Together, these chapters take the modernist observer most dramatically into the public sphere, from whence we can adduce how uncertainly its gaze measures against the growing dominance of the image and its appropriation and consolidation by institutions of power.

In Chapter 6, "Spectacles of Violence, Stages of Art: Walter Benjamin and Virginia Woolf's Dialectic," I read the representation of aesthetic spectacle in *Between the Acts* (1941) through the lens of Walter Benjamin's redemptive optics—his theories of constellation and the dialectical image as the visual means for producing the "flash" of historical insight that can lead to social transformation. In their final works—Benjamin's uncompleted study of the nineteenth-century Paris Arcades, the *Passagenwerk*, and Woolf's unfinished novel—each struggles to reconcile two crucial, but perhaps insuperably incompatible, strains in their thought: a mystical idealism epitomized by their shared belief in a collective unconscious and a historical materialism expressed by their attempts to document a (largely shared) set of social conditions and their consequences. Just as they yoke together conceptual premises whose assumptions are at odds, Benjamin and Woolf also create formal constructs from materials of disparate origins; this reliance on the quotation, the fragment, and the ruin

is a means at once of salvaging overlooked cultural materials and constructing from them new wholes. For both Woolf and Benjamin, such procedures serve as a way to reconceive historical narratives, wrenching them into new if momentary configurations from which genuine historical knowledge might be glimpsed. In *Between the Acts*, crisscrossed by the warplanes which surround and make up the fabric of its composition, we encounter the crowd as theatrical audience. Its distracted consideration of the annual village pageant which serves as both history lesson and entertainment raises fundamental questions about whether aesthetic spectacle can further political aims by exposing ideological biases and galvanizing the audience into significant political activity. By presenting fragmentary aesthetic technique as a means of forming new, internally dynamic wholes, *Between the Acts* holds out Woolf's modicum of hope that spectacle can serve a didactic purpose without surrendering fully its aesthetic integrity.

Chapter 7, "Modernist Seductions: Materializing Mass Culture in Nathanael West's *The Day of the Locust*," suggests that West's 1939 Hollywood novel takes a dimmer view. In this chapter I follow the parallel trajectories of individual and collective forms of aesthetic production and consumption, respectively represented by Tod Hackett's paintings and the Hollywood movie industry. Whereas Tod Hackett, the modernist artist in *The Day of the Locust*, seeks to document the consumers of social spectacle while remaining himself an outsider, I argue, following Debord and Baudrillard, that the Hollywood image factory resourcefully retools masses and artist alike into compliant partners in the aestheticized politics of consumption. Tod's desire to represent without reproducing the materials of the image industry—to maintain a distinction between his own production of aesthetic images and mass culture's proliferation of commercial images—dictates his need to find strategies with which to contain those materials. Tod pursues these strategies by attempting to distance himself from his subjects, the mass consumers of those images, who are consistently betrayed by its created desires and false promises. But as the instability of the borders between high and low becomes apparent—or, to put it differently, as the text develops the troubling analogy between aesthetic and commodity production—West transforms the high/low cultural divide into explicitly gendered territory, so that high art's fall into mass culture is represented as an inevitable process of seduction. Tod's desire for the representative of mass culture, the actress-whore Faye Greener—a desire that contaminates his objective posture and thus his art—is thereby naturalized and threatens to obscure its commodified roots. *The Day of the Locust*, then, signals a crisis point for the modernist observer who would attempt to preserve an aesthetic sanctuary of purity and autonomy.

In the Postscript, "From 'Our Glass Lake' to 'Hourglass Lake': Photo/graphic Memory in Nabokov's *Lolita*," I turn to a novel which still more decisively marks a transition out of modernist visual relations. Nabokov's *Lolita* (1955) constructs through photographs a semiautonomous narrative which reverberates with the novel's chief preoccupations—the nature of memory, evidence, and the voyeuristic imagination—in ways that both disrupt the trope of the photograph as mirror and constitute the photograph as text. Photographs are critical to Humbert Humbert's construction of fabricated intimacies and histories, just as they can be used to illustrate an absurd etiology in the case history of an incurable pedophile. Humbert Humbert's consciousness is itself modeled on the camera lens, being subject to elaborate "projections" and "focal adjustments." In a world reconstituted as image, *Lolita* represents and demands of its readers a voyeuristic and aestheticizing gaze linked with tourism and consumerism, whose potential for predatory violence is everywhere apparent. In the novel's embrace of the discursive dimensions of the photograph—those that foreground the ways its claims to objectivity and mimeticism are necessarily contaminated by interpretive frames— we can find "evidence" of Nabokov's playful derision of the realist mirror as a representational model; instead, we find that behind the "innocent" face of any representational mirror stands an intractably embodied, interpretive center. In this restaging of an essentially modernist revelation about the subjective underpinnings of perception in ways that challenge the very distinction between self and world, *Lolita* marks a moment of changing visual codes and visual relations, one that cannily anticipates a postmodern view.

Part I

THE EYE IN THE TEXT

The Eye's Mind

Self-Detection in James's *The Sacred Fount* and Nabokov's *The Eye*

Realism's Specular Mirror

In *Signatures of the Visible*, Fredric Jameson untangles the structural components through which realism maintains its representational hold:

> "Realism" is a peculiarly unstable concept owing to its simultaneous, yet incompatible, aesthetic and epistemological claims, as the two terms of the slogan, "representation of reality," suggest. These two claims then seem contradictory: the emphasis on this or that type of truth content will clearly be undermined by any intensified awareness of the technical means or representational artifice of the work itself. Meanwhile, the attempt to reinforce and to shore up the epistemological vocation of the work generally involves the suppression of the formal properties of the realistic "text" and promotes an increasingly naive and unmediated or reflective conception of aesthetic construction and reception. . . . Yet no viable conception of realism is possible unless both of these demands or claims are honored simultaneously, prolonging and preserving—rather than "resolving"—this constitutive tension and incommensurability. (Jameson 1990, 158)

Jameson's division of realism into aesthetic and epistemological modes— or form and content—can be compared with the components of Cartesian spectatorship, a model which repeatedly has been described as hegemonic in Western thought.[1] The Cartesian spectator's visual perception produced by the body (i.e., binocular vision) can be opposed to the rep-

[1] See Jay 1988a, 3–11; Rorty 1979, 38.

resentations of that perception comprehended by the mind; the negotiation between the embodied, literal eyes of perception and "the mind's eye" in the Cartesian model, like the negotiation between form and content in the realist text, involves suppression of the purely mechanical, material operations of optics, on the one hand, and of the relativistic potential of vision's contingency upon individual observers on the other. The "constitutive tension" Jameson identifies with the simultaneity of aesthetic and epistemological modes in realism can be seen as equally sustained in the Cartesian model, as Richard Rorty, for example, defines it: "In Descartes's conception—the one which became the basis for 'modern' epistemology—it is *representations* which are in the 'mind.' The Inner Eye surveys these representations hoping to find some mark which will testify to their fidelity" (Rorty 1979, 45). It is the elision of these discrete stages of perceiving, representing, and recognizing the world of objects that marks the Cartesian spectator's transcendent, universal view. The enormity of that view, as Paul Ricoeur puts it, entails "a vision of the world in which the whole of objectivity is spread out like a spectacle on which the *cogito* casts its sovereign gaze" (Ricoeur 1974, 236). The subject of that gaze, critiqued, as Martin Jay has summarized it, as an "ahistorical, disinterested, disembodied subject entirely outside of the world it claims to know only from afar" (Jay 1988a, 10), has been described as a monocular "mirror of nature" (Rorty 1979, 45) associated with the detached objectivity of science and the transcendence of a "god's-eye-view."

What is so striking about these various attributions is how closely they resemble, or indeed, could be said to describe, the narrator of realist fiction, who invisibly presides over the fictive world that the work represents as transparently available. As Mark Seltzer defines it, the realist narrator's detached posture conceals the mechanisms of power implicit in its sovereign view: "Perhaps the most powerful tactic of supervision achieved by the traditional realist novel inheres in its dominant technique of narration—the style of 'omniscient narration' that grants the narrative voice an unlimited authority over the novel's 'world,' a world thoroughly known and thoroughly mastered by the panoptic 'eye' of the narration" (Seltzer 1984, 54). Seltzer is borrowing from Foucault when he alludes to the disciplinary society and its techniques of surveillance and supervision which the realist novel both internally represents, practices, and, as a social form itself, perpetuates. If we are willing, as I'm suggesting, to see the transcendent Cartesian spectator and the omniscient realist narrator as both historically overlapping and theoretically contingent, understanding the realist narrator as the virtual embodiment of the assumptions of Cartesian spectatorship, we can raise questions about how far those "tactics of supervision" continue to obtain as each of those traditions is eroded. That is, as the Cartesian spectator's posture of neutral detachment is increas-

ingly denaturalized and subjectivized at the beginnings of the twentieth century, and the realist novel is gradually overtaken by the rise of modernism, how does "the eye in the text" renegotiate its relation to forms of knowledge and power?[2]

One way of initially thinking about this question is to turn to a subgenre of realism, detective fiction, in which the deployment of this "eye" defines its operations, and in which narrative omniscience is modified or problematized. Detective fiction, to the extent that it is motivated by the exposure of a "truth"—the revelation of criminal acts—focalizes and hyperbolizes the relation between narrative envisionment and knowledge by bridging the detached distance of traditional realism. Detective fiction disrupts the aesthetic and epistemological balance sustained by realism by emphasizing the *forms* of knowing and the difficulties of access to the truth; and it revises the coincidence of subject positions through which the reader and realist narrator collude. These defections work to construct, against an omniscient, detached, disinterested gaze, a visual model which reveals its proximate interestedness, its desire, its compromised access to objective "truth," its inherent perversity.

In detective fiction, the narrative landscape is transformed from transparency to translucency, in which the realist narrator's unmediated access to objects is deferred in a temporary suspension of a realist contract normally restored at the end. The panoptic powers of an omniscient narrator typically are concentrated in the person of the detective, with the difference that those powers themselves become the subject of scrutiny, rather than the invisible medium in which the text unfolds; the resulting surplus of "evidence" and corresponding interpretive excess it produces will retrospectively be ordered, with clues either privileged as truths or discarded as false leads. In detective fiction, then, as D. A. Miller has argued: "Whether one has an overabundance of signs, or an excess of unattached meanings, the easy equatability of sign and meaning has been troubled" (1980, 479). But in detective fiction, the initial undecidability of signs, and the linguistic or aesthetic excess with which it is associated, is always recontained, like the crime itself, through the production of the criminal, the "truth," and the restoration of social order. This "depletion of signifiers," as Miller puts it, produces coherence through the exile of excess and restores the narrative world to transparent availability.

In addition to disrupting realism's balancing act between aesthetics and

[2] It's worth repeating that I'm invoking the Cartesian spectator here heuristically, in its dominant aspect as a figure for subjective transparency and detached neutrality, but, in so doing, I don't wish to occlude the presence of its underside of embodied partiality which so conspicuously surfaces in James's and Nabokov's texts. Instead I mean to call attention to the fantasy structures upon which the Cartesian subject depends to repress the evidence of its embodiment—structures which aren't uniquely present in the modernist novel but, I argue, make far more regular appearances there.

epistemology at this structural level, detective fiction redefines the detached, omniscient posture of the realist narrative's "gaze." In literary texts, of course, such a gaze is a linguistically constructed, representational one, and comes into being through the reader's identification with or visualization of the narrator's view. In this sense, we might think of the realist narrator and the reader as coextensive, the realist narrator functioning as a kind of proxy for the reader. Slavoj Žižek's description of the function of filmic proxies with whom viewers identify is a useful way of conceptualizing this textual relation: "Such a logic of fascination by which the subject sees in the object (in the image it views) its own gaze, i.e., by which, in the viewed image, it 'sees itself seeing,' is defined by Lacan . . . as the very illusion of perfect self-mirroring that characterizes the Cartesian philosophical tradition of the subject's self-reflection."[3] For Lacan, such a relation is an "illusion" because it elides the antinomy between the eye and the gaze. As Žižek summarizes it:

> The eye viewing the object is on the side of the subject, while the gaze is on the side of the object. When I am looking at an object, the object is always already gazing at me, and from a point at which I cannot see it. . . . The whole point of Lacan's argument is to oppose to the self-mirroring of philosophical subjectivity the irreducible discord between the gaze qua object and the subject's eye. (Žižek 1989a, 35)

Whereas in realism this antinomy is dissolved by positing two "eyes" or subject positions which align the reader with the narrator, detective fiction offers quite different terms, by establishing forms of identification between the reader's and characters' delimited views. Just as the reader of detective fiction attempts to mimic the detective's gaze, however ineptly, the detective tries, as his most valued epistemological technique, to identify with the gaze of the criminal, to see as he sees, in order to solve the crime. The detective, then, and by extension the reader, align themselves with a gaze which is on the side of the object; as Žižek puts it, "such a coincidence of gazes," as opposed to the subject's viewing eye, "defines the position of the pervert" (37).

Detective fiction thus breaks up "the illusion of self-mirroring" that defines the operations of Cartesian spectatorship in conventional realist narration; and it undermines the forms of knowledge upon which those models depend in still other ways. Knowledge in detective fiction is revealed as contingent rather than omniscient, relying as it does upon the successful interpretation of signs; as the detective's eponymous instru-

[3] Žižek is talking about nostalgic film here, and the way viewers "see themselves seeing" in the innocent, naive gaze of the filmic proxy, but this is arguably only an extreme version of a standard process of identification (Žižek 1989a, 43).

ment, the magnifying glass, and favored technique, identification, make clear, only the intimately proximate, interested gaze will solve the crime. In these ways, then, though hardly exhaustively, the narrative techniques of detective fiction suggest that behind the image of the transcendent Cartesian spectator stand varying and notably embodied forms of subjectivization. Compared with the supervisory functions that Seltzer identifies with realism's omniscient prerogatives—its "unlimited authority" over "a world thoroughly known and thoroughly mastered by the panoptic 'eye' of the narration"—detective fiction overlooks far more circumscribed horizons, thereby compromising the sovereign, regulatory force through which the realist text has been linked with the social order. Moreover, by problematizing realist narrative authority—dislocating its attendant knowledge and mastery, and the equatability of signs and meanings—detective fiction seems to anticipate many of the innovations associated with modernist practice.

While I'm not arguing that detective fiction should be understood as a precursor to modernist narrative innovations in any strict sense, I am suggesting that modernist texts regularly employ and call attention to many of its conventions and strategies. If these conventions are not what make modernism "modernist" precisely, they do provide relatively stable windows into some of the revised forms of spectatorship modernism embraces, as well as some of their linguistic and ideological consequences. We can trace such limited forms of indebtedness in the two modernist texts I consider here, Henry James's 1901 novel, *The Sacred Fount,* and Vladimir Nabokov's *The Eye* (appearing first in Russian in 1930), for each is derivable, to differing degrees, from the detective genre.[4] *The Sacred Fount* portrays the relentless inquiry of James's narrator into the particulars of others' erotic lives through his pursuit of clues about possible sexual relations. In its rather spectacular failure to expose a definitive "truth," to disclose the "crime" of unsanctioned sexual activity, *The Sacred Fount* abjures the gesture of recontainment which controls excess in detective fiction; instead, the text's embrace of that excess can be seen as part of an early formulation of modernist paradigms and practices. The omnipresence of the obsessive, voyeuristic gaze in James becomes the ve-

[4] It's interesting to note that Nabokov's original title for his autobiography, *Conclusive Evidence* (published as *Speak, Memory*), also resonates with the theme of detection, and in ways that anticipate the conflation of legal testimony with the memoir that we find in *Lolita*. Also worth noting given the concerns of this chapter is the original title of the work that immediately follows *The Eye*, published in Russian as *Kamera Obskura* in 1932, and in English as *Laughter in the Dark* in 1938 (Nabokov 1991). In its likening of the blinded Albinus's face to an enormous eye mirroring his thoughts (276), and by comparing his "picture gallery" of memory to the "darkness of . . . cinema" (256–57), *Laughter in the Dark* reiterates the iconography of doubly mediated vision in terms comparable to *The Eye*, which I link to the Marxian understanding of the camera obscura as a figure for ideological production. See Nabokov 1966; 1991.

hicle for an extended critique of the possibility of the detached, disinterested, omniscient vision of the Cartesian spectator and the supervisory force with which it is associated. Although such a critique was certainly available piecemeal well before the turn of the century (see Crary 1990, 1999), it acquires sufficient momentum and centrality in James's later work to justify reading its constitutive features collectively as a metanarrative of modernist authorship. As the novel revises downward its confidence in the ability—and also the propriety—of transforming seeing into knowing, it insists that the ontological necessarily precedes and shapes the epistemological in ways that themselves warrant close investigation. Such an argument bears fundamentally on any assessment of the "success" of narrative vision, whether that vision is measured quantitatively by the amount of knowledge or truth that it produces, or qualitatively by the viability of its methods—by the disciplinary character, for instance, of its interior gaze. Because the novel exposes how the narrator's material being defines his vision, and in particular, how his desiring but prohibited gaze seeks to penetrate and repossess especially female secrets, *The Sacred Fount* may be regarded, furthermore, as an *Orphic* metanarrative—a story that makes the sacrifice of femininity by the male gaze the chief condition of male artistry. But the narrator is a highly ambiguous Orpheus. His very failure to possess a truth through which to recontain and validate the excesses of vision becomes the basis for his successful production of a new aesthetic—albeit of visual indeterminacy rather than mastery. What is "sacrificed" in the novel, then, is the concept of uncontaminated narrative vision along with its embodied vehicle, the narrator—and not his would-be Eurydice—rendering the narrator himself a self-reflexive object of feminization.

Looking ahead to Nabokov's investigations of the interior gaze in *The Eye* from the vantage point of James's turn-of-the-century experiment, we can observe the continuity of the modernist novel's preoccupation with "expert" detection as well as the further destabilization of subject/object divisions that the exposure of vision's embodiment entails. *The Eye* reveals that the "interior" illuminated most successfully by the exercise of this disciplinary, interior gaze is the subject's own—an interior which is moreover only tentatively distinguishable from its purported objects of analysis. Displacing to the very heart of its concept of self the subject/object relations that James's narrator stages at least nominally as a gendered drama of self and other, *The Eye* makes literal what remains a tendentious implication in *The Sacred Fount*: the aggressively self-reflexive character of embodied vision. In *The Eye*, the narrator's repeated attempts to discover the identity of the man who turns out to be himself can unquestionably be contextualized within the "fantasy of surveillance" said to characterize the realist narrator's position; but his failure to do more than inventory a se-

ries of partial *images* of himself confronts us with a model of panoptic power the stability and success of which appear to be infinitely deferred. That these images span a range of sex/gender positions (albeit all within the larger rubric of masculinity) suggests that the Orphic rite of possession/penetration of the feminine has been subsumed into an *auto-*erotic exercise. By offering such a fractured and provisional model of the subject at the same time as depicting the world that the subject inhabits as its arbitrary extension, *The Eye* unsettles the distinctions of self and world, masculine and feminine, upon which the ideal and disembodied eye normally depends. It thus fundamentally challenges any neat equation of the male subject's narrative authority with disciplinary structures, save in the ways those structures have already been trained upon the self as an object of discipline, where they are internalized and oriented toward self-supervision.

The Eye's ultimate "object" would seem to be that of locating itself within two dominant regimes of power that subsist in tension within the modernist literary imagination: the surveillance epitomized by the narrator's self-scrutiny, and the spectacle betrayed by the proliferating images of self over which he can claim the power of discovery, but not of invention, authenticity, or control. What makes these twin regimes definably modernist is their preservation, despite their momentary acknowledgments of its instability, of a concept of subjectivity that is still basically intact and available—although *subject to* a range of disciplinary and imagistic "internalizations." Although Nabokov's modernist exploration of visual indeterminacy in *The Eye* anticipates many of the preoccupations revisited in its postmodernist successor, *Lolita* (as I explore at length in the Postscript), it nevertheless recuperates its embodied seer to dwell upon vision's anxieties and pleasures for the self in ways that suggest its uneasy allegiance to depth models. Nabokov's later text abandons these modernist constraints as it instead regards the subject as a system of signs. The permeable and secondary nature of this new subject relative to the primacy of signs, moreover, renders the very idea of an interior questionable. Such a gap between an *interiorized* subject and one conceived of as an *effect* of signifying practices is a defining one for the texts that mark the historical parameters of this study; and it serves as one significant standard of measure of the distance separating James's Orphic metanarrator in *The Sacred Fount* from Blanchot's, more than half a century later.

From Crystal Cage to Crystal Palace: James's The Sacred Fount

Beginning at the train station from which the unnamed narrator is conveyed to a weekend party at Newmarch, a fashionable estate, *The Sacred*

Fount devotes itself to the narrator's attempt, as Rebecca West has trenchantly put it, "to discover whether there exists between certain of his fellow-guests a relationship not more interesting among these vacuous people than it is among sparrows"—he never does (West 1953, vii). In this elaborate parable and parody of failed spectatorship, equivocal artistry, or triumphant voyeurism, depending on one's point of view, the narrator's scrutiny of the erotic relations of his fellow guests exposes nothing so much as the politics of the gaze itself as an issue. The social world of Newmarch functions as a highly regulated, self-contained social laboratory, a "crystal cage" (James 1953, 200) in which the narrator can test, through dedicated observation, his vampiristic "law"—that one romantic partner unknowingly drains the youth, beauty, or intelligence from the "sacred fount" of the other, a lover whose painful knowledge of the sacrifice is mollified by love. The narrator derives the theory from the case of the Brissendens: the older Grace has apparently sapped the youth from the much younger, but now visibly older, Guy—or, as he is generally referred to, "poor Briss." Using the Brissendens as his model, he tries to determine whether the formerly acute May Server is responsible for the dramatic improvement of the formerly stupid Gilbert Long; since each is unmarried, the social consequences of discovering such a relation are potentially more serious than those attending his perception of the Brissendens. The narrator's method for testing his hypothesis rests upon his own observations and those of several others whom he takes selectively into his confidence; the novel, then, consists almost entirely of talk, of a series of partial collaborations between the narrator and his satellites, whose contributions can be taken either as corroborating testimony or as the joint outcome of the narrator's influence and their suggestibility. The narrator's accumulation of "evidence," punctuated by egoistic outbursts at his own perceptual prowess, culminates in a lengthy contest of conclusions with Grace Brissenden, his primary confidant, at the close.

The narrator's unsavory prurience and his inability definitively to substantiate his theory or arrive at a "truth" have been taken by many critics not only as proof of his unreliability but also as discrediting the posture of detached observation itself in an attempt "to annihilate the distinction between subjective and objective reality."[5] This seems to me the right approach, given that attempts to resolve or decode *The Sacred Fount* into an unambiguous narrative, a detective story that finds its man, tend to devolve into the same kinds of obsessive exercises in conjecture and inference of which the narrator himself appears guilty.[6] Beginning with the po-

[5] See Cameron 1989, 159; Porter 1981, 34–35.

[6] See Blackall 1965; Moon 1988; Reany 1962; Stein 1971; Tyler 1963. To my mind, the most suggestive of these readings is Tintner's (1995, 224–40). Tintner argues that the solution to what James himself characterized as the text's "consistent" joke lies in the narrator's mistaken search for a *heterosexual* vampire intent upon draining the youth or beauty from

sition that *The Sacred Fount*'s narrator contaminates his objective posture
with subjective contents, what I hope to examine is precisely how the dis-
tinction between "subjective and objective reality" is eroded. *The Sacred
Fount*, I will argue, can be read as a virtual anatomy of subjectivization,
offering, in the place of a detached, neutral observer, a highly unstable
self-reflexive erotics of viewing, able to deliver knowledge only about the
viewing subject itself; it thus operates as an elaborate send-up of the disin-
terested narrative postures of realism and Cartesian spectatorship.[7] *The
Sacred Fount* ultimately replaces the providential eye, epitomized by the
Cartesian camera obscura as a model for visual verisimilitude,[8] with one
more closely identifiable with its Marxist reformulation, in which the cam-
era obscura, as ideological machine, comes to constitute both seers and
the world seen equally as sites of mediation. The novel thus stands as
something of a watershed in James's fiction, in that he uncovers poten-
tialities in the observer—those of narcissistic distortion and violence—
which he attempts to contain in the three works of the Major Phase.

The representation of Newmarch as a "crystal cage," suggesting at once
transparency, material value, and incarceration, is a figure for individual
perceivers, each caught and looking out from his own "cage" and avail-
able to the scrutiny of others; as well as for the privileged social commu-
nity of Newmarch as a whole, imprisoned in a network of social expecta-
tions and conventions, and operating on the imperative, as the narrator
puts it, "to be really what we looked" (157). That *The Sacred Fount* operates
within this metaphor of panoptic confinement, rather than producing it
at the end as its means of recontainment and resolution, suggests that
mechanisms of internalized social regulation are already in place. Inside
that "cage," other central external symbols of social order and power, the
law and the state, are reassigned to internal agency. In place of the law,

his/her partner. There is certainly precedent for comprehending vampire plots via homo-
sexual relations, given the ways in which homosexuality, and lesbianism in particular, has
been linked to vampirism, as Sue-Ellen Case, for example, has shown (although Tintner
doesn't herself pursue that linkage). Still, Tintner's argument, like that of others, relies
heavily on inference and innuendo to achieve its "resolution." Stressing the plot's ends over
its means, even if the conclusions are "true" in a teleological sense, is to neglect the over-
whelming phenomenal experience of reading the novel, which remains everywhere defined
by perceptual indeterminacy. See Case 1991, 1–20.

[7] My reading is thus in sympathy with Susan M. Griffin's interesting work on the ways the
late novels of Henry James were influenced by the functionalism of his brother William, an
approach which stressed the active, selective, and interested qualities of perception gov-
erned by an orchestrating subject, compared with an earlier associationist view characteriz-
ing perception as atomistic and passive (Griffin 1991). For further discussion of Henry
James's adaptation of his brother William's pragmatism in specifically perceptual directions,
and particularly his work on consciousness and subjectivity outlined in *The Principles of Psy-
chology*, see Ryan 1991, 75–88.

[8] The camera obscura is an image-producing device, typically consisting in a darkened en-
closure with an aperture through which the external world is projected, in inverted form, on
one surface of the interior.

that "objective" standard of social consensus the detective works to en-
force, the narrator divines what he deems to be a natural law of human re-
lations which doesn't restore order so much as posit a manifestly unjust
one, dictating gain at another's expense; though he attributes the agency
of his law to higher forces, it's clearly of his own invention. The figure of
the "crystal palace" (205), by which the narrator metaphorizes the edifice
of his thought, also relocates an external image of state power to the solip-
sistic interior, transforming him into a kind of all-seeing monarch in a
world in which the individual imagination is sovereign. While in his con-
ceptions of "natural law" and "palace of thought," the narrator attempts
to situate power at the perimeters of a social world he observes as from a
great height, neither actually escapes its determinations; indeed, it is on
the strength of his assurance that he and his fellow guests share consistent
and legible social behavior—or, to put it differently, internalized forms of
self-regulation—that he can base his faith on their readability. He can
thus abjure the ignoble "detective and the keyhole" as his means of sub-
stantiating his theory in favor of "psychological evidence" (66).

If the social world of Newmarch offers itself, as the narrator would have
it, transparently to his gaze, it's because he is of that world, not outside of
it. But there are really two sides to the notion of transparent readability—
it requires both an objective seer and an unmediated world of objects to
work; and both sides of the equation are called into question by *The Sacred
Fount*. About halfway through the novel, the narrator expresses the ideal
of transparency during a tableau in which all of Newmarch's guests are
assembled:

> I think the imagination, in those halls of art and fortune, was almost in-
> evitably accounted a poor matter. . . . I said to myself during dinner that
> these were scenes in which a transcendent intelligence had after all no appli-
> cation, and that, in short, any preposterous acuteness might easily suffer
> among them such a loss of dignity as overtakes the newspaper-man kicked
> out. We existed, all of us together, to be handsome and happy, to be really
> what we looked—since we looked tremendously well; to be that and neither
> more nor less, so not discrediting by musty secrets and aggressive doubts our
> high privilege of harmony and taste. We were concerned only with what was
> bright and open, and the expression that became us all was, at worst, the
> shaded but gratified eye, the air of being forgivingly dazzled by too much lus-
> tre. (James 1953, 156–57)

To fulfill the requirement "to be really what we looked," the narrator sug-
gests, requires both a measure of willful blindness on the part of an ob-
server—the suspension of "transcendent intelligence" and "preposterous
acuteness"—and a heroic self-discipline on the part of its objects to
achieve the (absent) depth that surface requires—to eradicate "musty se-

crets and aggressive doubts." Paradoxically, then, transparency, in order to participate in the class aspiration for a "dazzling" surface fully to represent depth, demands a vision stripped of its powers of penetration, one which is alive only to the effects of social convention and not its causes. This static and openly limited model of vision, so well expressed by the image of "the shaded but gratified eye," already curtails the purview of the Cartesian model; even the exiled newspaperman, who might seem the best candidate for that model, is backed by the interpretive power of the imagination rather than objective apprehension as the potential means to peel back surfaces in the text. It is presumably only an imaginatively assisted perception that enables the narrator to say about Lady John: "I could mark these emotions, and what determined them, as behind clear glass" (102). Our choice then, is between two forms of "transparency"—either the shaded eye which refuses depth, or the imaginatively assisted eye which produces it. And what is the imagination, if not the receptacle for the accumulated knowledge of the social world, the tool of social regulation itself?

The problematization of transparency is reflected in the text's iconography, in which varying metaphors of light predominate. Against the "light of reason" which illuminates the Cartesian model, *The Sacred Fount* emphasizes instead its subjective aspects. Thus, when the narrator's confidants refer to the "great light" shed by his idea, his "torch in darkness" (64), they are also following his "burning" obsession, associated with destruction and desire; later, the narrator describes his arrival at a sense of certainty as a "flight into luminous ether" (255), a figure suggesting intangibility and ephemerality. And finally, the narrator describes light as part of the crucible in which he forges his particular brand of perception: "I shall never forget the impressions of that evening," he reports, "nor the way, in particular, the immediate effect of some of them was to merge the light of my extravagant perceptions in a glamour much more diffused" (156). Illumination in the text, then, perpetually reminds us of this subjective admixture of impression and perception, and of its metaphoric affiliation with the destructive element of fire.

Throwing light on a subject, it becomes clear, is an insufficient guarantor of knowledge, too, because of the way characters are said habitually to screen themselves with others. The narrator understands Lady John to be Gilbert Long's "screen" who masks the real woman who has lent him her wit (36); he believes Gilbert Long to be the screen which produces "the appearance of a passion" for Lady John (106); and so on. If the narrator believes some characters to function as screens who block his perceptual access, others seem to work as projection screens who, mirrorlike, reflect him back to himself. In a scene in which both sorts of screening are in play, the narrator lectures Lady John about the "use" she's making of her

"screen": " 'Will you allow me to say frankly that I think you play a dangerous game with poor Briss, in whom I confess I'm interested? I don't of course speak of the least danger to yourself; but it's an injustice to any man to make use of him quite so flagrantly' "; later, he complains of the way she is "sacrificing" him (175, 178). If anyone is "playing a dangerous game" with others without their knowledge it is of course the narrator, who uses the rhetoric of sacrifice to outline his plans for poor Briss and others later in the text. In the same vein, the narrator's charges of, for example, Grace Brissenden's "simplified egotism" (71) or Lady John's "extravagantly vain" ways appear to be transparent instances of self-description.

The narrator's expectation of a transparent social world, of a *crystal cage*, is doomed to failure because access to that world is so complexly mediated; if he chooses to see more than the superficial vision that "the shaded but gratified eye" promises, he surveys a field refracted by opaque and specular screens obscuring subjects and objects alike. As if to acknowledge his tenuous positioning there, the narrator frequently imagines himself the potential object of another's gaze. In such a moment of self-consciousness, he reflects: "I daresay that . . . my cogitations—for I must have bristled with them—would have made me as stiff a puzzle to interpretive minds as I had suffered other phenomena to become to my own" (92). Elsewhere, the prospect of becoming a visual object appears less hypothetical; while watching people from a balcony, he wonders "if, in the interest of observation, I mightn't snap down the electric light that, playing just behind me, must show where I stood. I resisted this impulse" (201–2). By imagining himself in this way, the narrator seems temporarily to occupy the perverse position that Žižek describes, where, "as a stratagem to evade his constitutive splitting, the subject itself assumes the position of an object instrumental to the enjoyment of the Other" (Žižek 1989a, 36). But it's not a position he lingers in for long; instead, the narrator prefers to adopt the pretense, if not precisely the methods, of a detached scientific observer. As he puts it in a typical moment: "however slight the incident and small the evidence, it essentially fitted in" (James 1953, 202). The possibility of such a reversal, however, serves as a nagging reminder of the precariousness of the sovereignty of the narrator's gaze and the position to which it aspires, beyond the range of the gazes of his objects of study.

So far I have been looking at what might be called structural problems that attend the process of observation in *The Sacred Fount*—those which would constitute any social "laboratory," such as Newmarch, or any particular observer. The construction of subjects and objects through a network of social conventions; the contamination of "pure" perception with impressions and the imagination; the intervention of mediating "screens"; the self-reflexivity of projection; the potential reversibility of subject and

object positions—these difficulties are each of a different order than the purely solipsistic or idiosyncratic problems epitomized by the (inconclusive) accusation of madness leveled at the narrator at various points in the text. Such a division of perceptual variables into the inherent and the contingent raises the question of the extent to which the narrator can be taken as a representative or merely as an exceptional observer within *The Sacred Fount*. To address this question, let me turn now to those subjective modes which seem peculiar to the narrator alone, by considering one of the only real incidents in the text—the analysis of the painting referred to as *The Man with the Mask* which the narrator, May Server, Gilbert Long, and Ford Obert collectively examine. As a static object, the painting affords a less mercurial interpretive ground than the changeable human behavior the narrator and others chiefly try to perceive; and because we are afforded four simultaneous but independent views, we can begin to distinguish collective from individual interpretive problems. What the painting accomplishes, I will argue, is to normalize perceptual (and textual) indeterminacy among the characters and for the reader, and to pathologize, by contrast, the mechanisms by which the narrator attempts to control it, as he aims to achieve and maintain certainty.

The painting depicts the "pale, lean, livid face" of a young man, in old world black dress, holding a mask in one hand; it is, the narrator assures the group, "the picture, of all pictures, that most needs an interpreter" (55). The painting promises to work as a kind of textual anagram, as it materially brings together internal and external points of reference. It initially functions as a lightning rod for interpretive controversy:

> "Yes, what in the world does it mean?" Mrs. Server replied. "One could call it—though that doesn't get one much further—the Mask of Death."
> "Why so?" I demanded while we all again looked at the picture. "Isn't it much rather the Mask of Life? It's the man's own face that's Death. The other one, blooming and beautiful—"
> "Ah, but with an awful grimace!" Mrs. Server broke in.
> "The other one, blooming and beautiful," I repeated, "is Life, and he's going to put it on; unless indeed he has just taken it off."
> . . . "And what does Mr. Obert think?"
> He kept his eyes on [Mrs. Server] for a moment before replying. "He thinks it looks like a lovely lady."
> "That grinning mask? What lovely lady?"
> "It does," I declared to him, really seeing what he meant—"it does look remarkably like Mrs. Server." (56)

Unable to agree on the most basic affective features of the painting—is the mask "blooming and beautiful" or displaying "an awful grimace"? Is the man removing or putting on the mask? Does it portray a man or a

woman?—the group, though never with complete consensus, tries to resolve the elements in the painting by assigning to them external sources; the mask is identified as May Server, the face is later declared that of poor Briss. And indeed, the text adds a certain weight to these designations. Later, the narrator will describe May Server's "terrible little fixed smile" (148), which he believes she wears to cover up her depleted intellectual resources, as a "grimace" which becomes "blurred as a bit of brushwork spoiled" (133) from the strain of keeping it up; the "pale, lean, livid face" fits comfortably with other characterizations of the enervated poor Briss.

But of course to read the painting in this way creates far more interpretive problems than it solves. On the one hand, the painting can be seen to take up the question of social masks in the novel, expressing the problem of reading them, distinguishing them from a subject's "authentic" face, and adducing their directionality—are they revealing or concealing a hidden depth? On the other hand, the painting seems to work as an encoded materialization of the narrator's theory, in which the haggard donor of the sacred fount holds, in Dorian Grey fashion, the improved face of its recipient; but the novel's positioning of poor Briss and May Server in these respective roles won't quite fit, since each of them is designated a loser in the game of amorous transfusion—only Grace Brissenden's face, presumably, should fit the mask held by poor Briss. Finally, we can view the painting as an image of the sympathy that the narrator believes he has discerned between poor Briss and May Server, in their shared roles as victims; but of course, that reading squares poorly with the opposition suggested by the imagery of face versus mask. The indeterminacy of the meaning of the painting offers itself, inevitably, as a figure of interpretative indeterminacy in the novel at large. Even the coincidence that the face and mask in the painting happen to resemble not one but two of Newmarch's guests goes nowhere—attempts to decode the coincidence lead only to duplicating the game of speculation and inference that is the narrator's questionable method. The painting, like the narrative at large, suffers from a *surplus* of meanings, each of which is only partially substantiated, and therefore partially adequate; ultimately, the possible meanings of the painting fade and the incident takes its place as just another observational opportunity for the narrator.[9] For all concerned, then, a gap

[9] It's interesting to compare the function of this painting with the Bronzino in which Milly Theale recognizes herself in *Wings of the Dove*. Rather than making of visibility an interpretive problem and a potentially indiscreet window into the secrets of others, the Bronzino becomes the ultimate icon of discretion. By making the identification between Milly and the painting so physically and psychologically complete, it can functionally substitute for her in the narrative, while her dying body is secured from the vulgar, prurient gaze of others. The painting critically assists in James's preference, expressed in his preface, for the "*indirect* presentation of his main image." Milly confronts the painting, seeing "the face of a young woman, all magnificently drawn, down to the hands, and magnificently dressed; a face al-

opens up between seeing and knowing, both because the object itself is internally ambiguous, its meaning unavailable to straightforward apprehension, and because those meanings the groups brings to bear upon it are so clearly extrinsic—despite their alleged resemblance, May Server and poor Briss were not the actual models for the painted figures.

The painting provides an object lesson in the power of multiple mediating screens to complicate and defer the meaning of aesthetic objects, establishing indeterminacy as the perceptual norm. *The Sacred Fount* replays this cautionary note in a later scene, albeit inversely, when the narrator transforms the people of Newmarch into the stuff of painting, that is, by aestheticizing them. But the narrator's aestheticizing practices, among the other subjective forms he brings to bear, have the effect not of exposing indeterminacy but of covering it over. As he gazes at May Server shortly before viewing the painting, the narrator describes her: "she might have been herself—all Greuze tints, all pale pinks and blues and pearly whites and candid eyes—an old dead pastel under glass" (51); at dinner, the narrator compares poor Briss with an "old Velasquez" (158); later, he views his "opposed couples balanced like bronze groups at the two ends of a chimney-piece . . . playing a part in [his] exhibition" (182–83). The aesthetic terms in which the narrator renders his observations are both transformative and appropriative, as the objects of his gaze are recast as the products of his imagination. The aestheticization of the operations of his own intelligence completes this process, in which the objects of his scrutiny, not merely objectified, are internalized as the creatures of his imagination. As the narrator reviews his theory at the piano recital, he deems May Server to be "still the controlling image for me, the real principle of composition" (167) in his mental creation; or, as he puts it still more strongly: "To see all this was at the time, I remember, to be as inhumanly amused as if one had found one could create something" (104). If we are tempted, as many critics have been, to understand this process merely as an account of artistic genesis, we should note that sight is equated here only with the *possibility* of artistic creation. At most, we should read the narrator's perversely "inhuman amusement" as a parody of the artistic process and recall that, despite his reliance on the rhetoric of aestheticization, his goal is the acquisition of knowledge, not the creation of a product—and even in this he fails.

most livid in hue, yet handsome in sadness and crowned with a mass of hair rolled back and high, that must, before fading with time, have had a family resemblance to her own. The lady in question, at all events, with her slightly Michaelangelesque squareness, her eyes of other days, her full lips, her long neck, her recorded jewels, her brocaded and wasted reds, was a very great personage—only unaccompanied by a joy. And she was dead, dead, dead. Milly recognized her exactly in words that had nothing to do with her. 'I shall never be better than this' " (James 1965, 144).

Just as the aestheticization of the narrator's gaze and its objects confronts us with the subjective powers of mind, the veiled eroticism of that gaze confronts us insistently with the desiring, observing body. The narrator's "anxiety" and "absurd excitement" (94), his "mystic throb" (127), grow with his "ridiculous obsession" (89), leaving him "groan[ing] . . . as if for very ecstasy" (216). As he puts it to Ford Obert, explaining his desire to escape the excesses of Newmarch: "You excite me too much. You don't know what you do to me" (215). The narrator also projects sexual content onto the objects of his scrutiny, as becomes clear in his description of poor Briss in an encounter with his wife: "as a response to her," the narrator relates, poor Briss displays "the gush of the sacred fount. . . . [I]t rose before me in time that, whatever might be, for the exposed instant, the deep note of their encounter, only one thing concerned me in it" (198–99). Finally, the narrator's own "sacred fount" threatens to erupt into an image of bodily pleasure, as he describes his attempt to penetrate May Server's secret: "But if, though only nearer to her secret and still not in possession . . . so it equally came to me that I was quite near enough, at the pass we had reached, for what I should have to take from it all. She was on my hands" (134). Although the narrator's desire is most conspicuous for its promiscuous abundance, his gendered rhetoric of possession/penetration is worth noting here, particularly since he will later identify May Server as his "controlling image" (167). However, the self-referential character of the narrator's eroticism and his specifically voyeuristic pleasure may well represent the most outstanding aspects of his desire, as he suggests by his admission to himself: "It would have been almost as embarrassing to tell [the other men] how little experience I had had in fact as to have to have had to tell them how much I had had in fancy" (101). The gaze itself and the imaginative architecture which upholds it clearly serves as the narrator's chief object of pleasure.

In his 1918 essay "On Narcissism," Freud describes the autoerotic origins of narcissism and its linkage to early forms of libidinal development, in which "the libido withdrawn from the outer world has been directed on to the ego." He defines the narcissistic state which follows as a series of "characteristics which, if they occurred singly, might be put down to megalomania: an over-estimation of the power of wishes and mental processes, the 'omnipotence of thoughts,' a belief in the magical virtue of words, and a method of dealing with the outer world—the art of 'magic'—which appears to be a logical application of these grandiose premises" (Freud 1959, 32–33). It's striking how nearly the narrator's own characterization of his adventure anticipates Freud's 1918 account of narcissism. The narrator tells us:

I had positively encountered nothing to compare with this since the days of fairy-tales and of the childish imagination of the impossible. *Then* I used to

circle round enchanted castles, for then I moved in a world in which the strange "came true." It was the coming true that was the proof of the enchantment, which, moreover, was naturally never so great as when such coming was, to such a degree and by the most romantic stroke of all, the fruit of one's own wizardry. I was positively—so the wheel had revolved—proud of my work. I had thought it all out, and to have thought it was, wonderfully, to have brought it. (James 1953, 128–29)

The narcissist, then, confronts a world believed to be of his own making or "the fruit of [his] own wizardry," where thought is credited with a productive power which acquires proprietary value as "my work"; and this sense of production and ownership profoundly informs the text's representation of seeing and knowing. Understanding his own vision as a form of currency, the narrator consistently conceives of the materials from which he constructs it in terms of value and exchange. The result of the narrator's narcissism, then, is a vision which commodifies, as regularly as it aestheticizes and sexualizes, its objects.[10] The narrator's vampiristic "law," of course, is the prototype of this relation. Taking her cue from the narrator, Grace Brissenden elaborates that law:

> "One of [the romantic pair] always gets more out of it than the other. One of them—you know the saying—gives the lips, the other gives the cheek."
> "It's the deepest of all truths. Yet the cheek profits too," I more prudently argued.
> "It profits most. It takes and keeps and uses all the lips give." (80)

The same thing—taking, keeping, and using—could be said of the narrator's obsessive desire to see and know; as he himself puts it: " 'The obsession pays, if one will; but to pay it has to borrow' " (23). In this same vein, the narrator describes the theoretical woman whose losses account for Gilbert Long's gain as an empty display window who has "put up the shutters and closed the shop" (37); in yielding to Ford Obert's request for information, the narrator responds " 'What, if I do,' I asked with an idea, 'will you give me?' . . . 'And what then,' I went on, 'will you take from me?' " (205); and in the narrator's final conversation with Grace Brissenden, he wonders "I might pay for her assurance, but wasn't there something of mine for which *she* might pay?" (242). While the other char-

[10] Agnew has noted the language of exchange quite clearly (1983, 89–90). But unlike Agnew, who sees this rhetoric in the larger context of consumer culture in James, I think it's important to see the novel's interest in commodification as part of an interrelated network of subjective forms that mediate the narrator's gaze. Jonathan Freedman provides one powerful way of integrating the connotative mixture of commodification, degeneracy, eroticism, violence, and madness that cumulatively inform *The Sacred Fount's* depiction of perception by associating it with the movement of British aestheticism and, particularly, of aesthetic decadence in the period, a reading which complements my own emphasis on the philosophical underpinnings of perception in the novel. See Freedman 1990.

acters may exchange matters of more substance, for the narrator, vision functions as the chief currency in this economy; unsubstantiated, it threatens to be deprived "of all value as coin" (313). For even though this narcissist persists in the fantasized "joy of determining, almost of creating results" (214), he seems to require the confirmation or, at least, the appreciation of others to put a purchase on his "creation."

The language of economic exchange in *The Sacred Fount* just makes explicit the pattern of instrumental use to which the narrator puts nearly all his fellow guests, always trying to get better than he gives. Ultimately, that language points to the sort of violence the narrator felt constrained to avoid early on before his imagination, having internalized its aesthetic objects, became his sole standard of value. We can see this shift decisively take hold in his final confrontation with Grace Brissenden, in which his vision has to survive in a now-competitive marketplace. Threatened by the imminent destruction of his "crystal palace" at the hands of her rival theory, he explains: "There was no point at which my assurance could, by the scientific method, judge itself complete enough not to regard feeling as an interference and, in consequence, as a possible check. If it had to go I knew well who went with it, but I wasn't there to save *them*. I was there to save my priceless pearl of an inquiry and to harden, to that end, my heart" (296). It's significant and characteristic that the narrator invokes the detached posture of the scientific method and its repudiation of feeling at the same moment as he imbues his inquiry with a subjective criteria of value as "the priceless pearl." The rhetoric of trade and sacrifice—"I wasn't there to save *them*"—too, is clearly far from disinterested, suggesting rather the desperate maneuverings of a man attempting to salvage the fruits of his labor. As he puts it elsewhere: "I couldn't save Mrs. Server, and I couldn't save poor Briss; I could, however, guard, to the last grain of gold, my precious sense of their loss, their disintegration and their doom; and it was for this I was now bargaining" (273).

Far from employing the disinterested methods of an objective science, we've seen that the narrator adds to the structural elements of perceptual indeterminacy that are globally attributed in the text his own distinctive stamp. The forms of aestheticization, sexualization, and commodification he practices threaten collectively to obscure the confrontation with interpretive indeterminacy initially staged by *The Man with the Mask*. Each of these modes, moreover, is easily subsumed under the rubric of the narcissistic "fairy tale" to which the text finally if obliquely alludes, the Orpheus myth, a story in which Orpheus's gaze becomes an instrument of violence by sacrificing his bride, Eurydice, to the underworld for the sake of a knowledge tentatively linked to art. As a means at once of acknowledging and disowning this violence, just as he did with Lady John's "use" of poor Briss earlier in the text, the narrator attributes agency elsewhere, project-

ing onto Grace Brissenden a gaze which is really the outcome of his own methods. About Grace Brissenden's analysis of May Server, he describes that it "had the effect of relegating to the dim shades the lady representing it, and there was small soundness in her glance at the possibility on the part of this person of an anxious prowl back . . . [T]o mention her had been to get rid of her" (246). Although the narrator positions Grace Brissenden as the vehicle of this Orphic "glance" through which she exchanges a female body for her own aesthetic agency, the mythic reference is, of course, his own, and functions more readily as self-description. That the narrator undertakes such a displacement is further evidence of his unwillingness to view his own aesthetic project as vampiristic, despite his intentness on draining the intact proprieties from his feminine and feminized objects in order to replenish his own imaginative reserves. *The Sacred Fount*'s invocation of the Orpheus myth at this late stage in the text holds out the promise of a resolution of sorts, by organizing its perceptual elements into a coherent narrative; but it forecloses on that resolution, first, by representing it as projection; second, by failing to recuperate the violence represented by the sacrifice of May Server through the production of reliable knowledge; and third, by falsely advertising the gaze primarily as a resource of the female subject. In a way, *The Sacred Fount* remains most faithful to the end of the Orpheus story, in which the singer is torn to pieces by a group of angry maenads; "go[ing] utterly to pieces" (297) himself at Grace Brissenden's hands, the narrator takes the possibility of narrative coherence and interpretive resolution with him.

As the narrator's theory and, indeed, his very sense of himself as a subject come apart at the seams, so too do his two dominant perceptual fantasies—that of the transparency of the social world, and of his narcissistic construction of it. The notion of transparency the narrator began with, in which he expected the world to reveal itself "as behind clear glass" is now revised to express the absence of meaning rather than its accessibility; as he complains to Grace Brissenden: " 'We put it, the whole thing, together, and we shook the bottle hard. I'm to take from you, after this,' I wound up, 'that what it contains is a perfectly colorless fluid?' " (261). Later, he appeals to her sense of mercy for his imaginative labors: " 'Remember,' I pleaded, 'that you're costing me a perfect palace of thought!' . . . she replied: 'Oh, those who live in glass houses—' " (311); the cliché expresses both the narrator's culpable vulnerability—he "shouldn't throw stones"—and, by neatly deflating his "crystal palace" to a "glass house," turns the perceptual tables on a narrator now left humbled and exposed, fallen from his sovereign heights and restored to the field of the social order below. Finally, the narrator's narcissistic belief that he inhabits a world of his own making is likewise discredited; as Grace Brissenden asserts about the "horrors" the narrator sees:

"It isn't, perhaps, so much that you see them—"
I started. "As that I perpetrate them?"
She was sure now, however, and wouldn't have it, for she was serious. "Dear no—you don't perpetrate anything. Perhaps it would be better if you did!" (299)

Having been thus summarily divested of both omniscience and omnipotence, the narrator implies that his own "sacred fount" has run dry—"I didn't after all—it appeared to be part of my smash—know the weight of [poor Briss's] years," he confesses, "but I knew the weight of my own. They might have been a thousand" (318). It's important to see that, however drastically reduced he appears, the narrator has merely taken his place as a normative viewing subject here. The subjective excesses peculiar to the narrator, really only extreme versions of those by which all subjects are constructed in the novel, deluded him into believing that the visible world was openly available to him; upon his dethronement, he, like the reader, must confront the layers of mediation which keep the possibility of a stable, objective knowledge of that world always at arm's length.

To put it somewhat differently: *The Sacred Fount* expresses the difference between, and brings into conflict, the Cartesian and Marxist versions of the meaning of the machine they each transform into visual metaphor, the camera obscura. "For Descartes," as Jonathan Crary describes it, "the images observed within the camera obscura are formed by a means of a disembodied cyclopean eye, detached from the observer. . . . Founded on the laws of nature (optics) but extrapolated to a plane outside of nature, the camera obscura provides a vantage point onto the world analogous to the eye of God" (Crary 1988a, 47, 48). This is the sort of eye—albeit outside of the social rather than the natural world—that *The Sacred Fount*'s narrator has aspired to embody, and it is precisely this providential visuality that the text exposes as solipsistic delusion. In its stead, the text offers a model closer to Marx's conception of the camera obscura as a figure for the operations of ideology, in which both the inverted image that the machine produces and the viewer's apprehension of it are understood to be mediated, as historical productions.[11] By representing not just the narrator but the social world he observes equally as "sites of mediation," *The Sacred Fount* comes to resemble the camera obscura as ideological machine.

The linguistic consequences of a model which mediates visual access in this way are substantial for the novel as a whole. To return to "the poor banished ghost," May Server, in her incarnation in the Orpheus myth, we can see this connection drawn out when the narrator tells us, "to mention

[11] As W. J. T. Mitchell has shown, the viability of the camera obscura as a metaphor for ideology has been contested; the definition I offer here is based on Mitchell's interpretation. See Mitchell 1986, 174–78.

her had been to get rid of her" (James 1953, 246). Substituting speech for sight in this formulation of what is solely visual violence in the original tale, the narrator makes an equation that aptly describes the text's operations. In the absence of the knowledge it has as its aim in *The Sacred Fount*, vision can yield only talk—endless accounts of itself which seem to merge with the processes of perception. Because none of the accounts attains the status of truth, retrospectively ordering the excess of meanings produced, the language of vision acquires a surplus value, mimicking the gap between signification and meaning which obtains for visual perception. Language, then, to the extent that it mediates all accounts of vision, becomes the ultimate subjective form by extending the gap between sign and meaning in the visual realm to the linguistic medium in which it's expressed.[12] The narrator conveys something to this effect in his final interview with Grace Brissenden: "It could *not* but be exciting to talk, as we talked, on the basis of those suppressed processes and unavowed references which made the meaning of our meeting so different from its form. We knew ourselves—what moved me, that is, is that she knew me—to mean, at every point, immensely more than I said or that she answered" (272). Sight, and its "excitements," could easily be substituted for speech in this formulation, which closely resembles the narrator's account of perception assisted by the imagination that he offered early on. In this same vein, Grace Brissenden's accusations leveled against the narrator in their final interview—"You see too much" and "You talk too much" (261, 262)—wind up as virtual equivalents. We can see the process of indeterminacy overtake the purely linguistic figure, "the sacred fount," by observing the series of meanings which accumulate around it: As a metaphor for "life force," for the visual imagination, for sexuality, and, through its etymological link with *font*, for language, *The Sacred Fount* produces and circulates meanings, rather than designating a privileged origin.

It's important to situate the varieties of visual subjection James engages and the linguistic indeterminacy and excess it yields within the specifically modernist set of anxieties and practices that inform the interior gaze. The interior gaze, to recall, is a form of disavowal of the subjective character of gaze and image which relocates visual truths to an "interior"—literal or conceptual—where they can be recovered only by a properly expert vision. The interior gaze thus preserves, within the epistemological positions variously occupied by narrators and characters in modernist texts, a positivist fantasy of the availability of visual truths by strategically conceding their difficulty of access. If *The Sacred Fount* should be regarded as a

[12] John Carlos Rowe makes a similar although differently derived point; for Rowe, the indeterminacy of language reflects the difficulties of the artist trying to write himself into being in a language whose meaning is dependent on ambiguous social codes. See Rowe 1982.

kind of metanarrative of modernist authorship and novelistic construction, that is because its understanding of what constitutes authorship and the novel everywhere betrays its imbrication in a cultural formation that privileges difficulty, expertise, and specialization. Jonathan Freedman has convincingly located James as a foundational figure among "a new caste of professionals who designated themselves as experts in cultural knowledge, and who defined their own role as that of instructing others" in esoteric forms (Freedman 1990, 55). James's self-presentation as the disinterested "man of letters" equipped with a mystified special knowledge underscores the paradoxical union of distance and proximity in this conception (a liminal position oddly mirrored by James's overt repudiation of the marketplace on which he nevertheless depended for an audience).

The Sacred Fount, of course, stages the precarious self-maintenance of that expertise and the limits of disinterestedness in ways that at once call them into question and displace their operations onto a reader, one ideally equipped to decode what the narrator's own manifest investments preclude. The literary culture of expertise of which James is a part, in other words, rests on conditions of mutuality that define the practices of authors and readers against the alleged clarity—not to say transparency—of mass cultural forms. Using *The Sacred Fount* as his example, in fact, Thomas Strychacz notes the ways in which "the narrator-as-critic" contributes to "the formation of a critical reading elite in the twentieth century." Just as the real drama of the novel is the narrator's struggle to accrue social authority though his appropriation of the linguistic and cultural codes of the powerful, Strychacz argues, the reader's job also consists in "negotiat[ing] the boundary between 'private' discourse and public codes," to acquire interpretive mastery over the narrative (Strychacz 1993, 66, 75). Because this negotiation is centrally a perceptual matter in *The Sacred Fount*—the effort to see, in effect, what the narrator sees and to assess it—it comprises an exemplary demonstration of the anxious crafting of an interior gaze which marshals its considerable expertise and prestige against a crisis of belief in the equatability of seeing and knowing. But rather than reward that effort, I suggest, *The Sacred Fount* reveals the gaze's inescapably embodied and subjective character.

The political dimensions of the interior gaze in *The Sacred Fount*—its potential for narcissistic distortion and violence—are addressed both within the confines of the novel and, by analogy to the obligations of authorship in relation to its narrative materials, in the structural innovations of James's later works. In *The Sacred Fount* the narrator's pursuit of possibly compromising investigations without the knowledge or consent of his objects is provisionally declared "wanting in taste" (45) or "none of one's business" (69); as he tells Ford Obert, as a result of his methods, " 'Our hands are not clean' " (212). Such considerations point not to the fact of

mediated vision itself, about which, presumably, nothing can be done, but to its uses and applications in relation to its objects. The problem for James, then, is to find a way to reconcile the claims of "expressional curiosity and expressional decency," as he puts in his *Prefaces* (James 1986, 374), to honor his own moral imperatives about the "treatment" of his subject matter by constraining the observer's potential for instrumental violence—so that he may himself emerge, that is, with clean hands. In his preface to *The Ambassadors,* the work written immediately after *The Sacred Fount,* we can see these considerations at work in James's repudiation, though initially in strictly formal terms, of first person narration as "a form foredoomed to looseness." By being rendered in the third person, James tells us, "Strether, . . . encaged and provided for as 'The Ambassadors' encages and provides, has to keep in view proprieties much stiffer and more salutary than any our straight and credulous gape are likely to bring home to him, has exhibitional conditions to meet, in a word, that forbid the terrible *fluidity* of self-revelation" (James 1986, 371–72). We can see how some of *The Sacred Fount*'s iconography has been reformulated in this conception, where the "crystal cage" which transparently contained its narrator has been refined into a more opaque material; "encaged" and thus protected from our "straight and credulous gape," Strether is represented as better able to perform his obligation to maintain the text's "stiff proprieties" and to escape "the terrible *fluidity* of self-revelation" or exposure. By instituting such proprieties and "exhibitional conditions," the reader rather than the narrator (or the author) has been reconstituted as their potential violator, whose prurient gaze is now exiled to the outside of the text.

This displacement of observational agency is echoed in James's preface to *The Golden Bowl,* but here it is authorship that is singled out as the probable transgressor of the text's proprieties: "I have already betrayed, as an accepted habit," James explains, "my preference for dealing with my subject matter, for 'seeing my story,' through the opportunity and the sensibility of some more or less detached, some not strictly involved, though thoroughly interested and intelligent, witness or reporter, some person who contributes to the case mainly a certain amount of criticism and interpretation of it. . . . Anything, in short, I now reflect, must always have seemed to me better—better for the process and the effect of representation, my irrepressible ideal—than the mere muffled majesty of irresponsible 'authorship' " (James 1986, 376–77). The "muffled majesty of irresponsible 'authorship' " suggests of course the prerogatives of the traditional realist narrator, whose irresponsibility derives, we must suppose, precisely from its invisibility, its "*muffled* majesty." Whether or not he is protecting against the alleged "expressional curiosity" of reader or author in his later works, James not only follows his preference for "some

more or less detached . . . witness or reporter" but, in his final two works, multiplies his narrative centers, arguably to obviate the dominating force inevitable in a single perspective; in so doing, he provides a clear alternative to realist omniscience. In *Wings of the Dove*, the "successive centres" or "represented community of vision" (James 1986, 353, 355) work to disperse and democratize visuality in the novel, furthering "the author's instinct everywhere for the *indirect* presentation of his main image" (359). The absence of such precautions is figured as a species of violence that inevitably recalls *The Sacred Fount*. James explains: "It is as if, for these aspects, the impersonal plate—in other words the poor author's cold affirmation or thin guarantee—had felt itself a figure of attestation at once too gross and too bloodless, likely to affect us as an abuse of privilege when not as an abuse of knowledge" (356). As the painting she specularly confronts gradually replaces Milly Theale as a visible presence in the novel, James secures us from the "abuses" which might range from aestheticizing her dying body to "coldly and bloodlessly" viewing her with detachment; along with the reader, he is reduced to "watching her, as it were, through the successive windows of other people's interest in her" (359), a strategy in which the subjective stakes or "interests" of others are made, often chillingly, clear.

We can begin to see the experiments in form that have led critics to designate the works of late James as modernist as an outcome of his perspectival commitments, those which undermine the conventional status of an omniscient, transcendent model of viewing in favor of openly subjectivized forms. In its most extreme version, in *The Sacred Fount*, the formal consequences of this move aren't structural so much as semiotic, in which the indeterminacy of viewing finds its correlate in the disruption of signification itself, rather than in the multiplication of delimited perspectives that characterizes the later works; to this extent, *The Sacred Fount* seems the most properly modernist of the works of the Major Phase. Equally important, James's meticulous construction of this proto-modernist eye involves a crucial renegotiation of the relations to knowledge and power with which the omniscient and penetrating eyes of realist and detective fiction are normally invested. Successful neither as a sovereign representative of the social order nor as the more humble policing agent, the private eye, James's narrative eye rather is private in the more literal sense of the word, primarily subject *to* internalized laws rather than enforcing them objectively. Such an internalization of social order and power obviates the need for, or arguably, the possibility of, the dramatic restoration of the law which provides conventional closure in detective fiction. Instead, the regulatory outcome of that internalization is most clearly defined in the self-reflexive character of the instrumental violence associated with the narrator's gaze: as James's invocation of the end of the

Orpheus myth instructs us (in which Orpheus is destroyed by feminine forces), the narrator himself is as much a victim of his attempt to expose social transgression as are the objects of his unremitting scrutiny. Moreover, because the internalized social order personified by the narrator's gaze acquires such a subjective character, it can lead only to the spectacle of social chaos narrowly averted in *The Sacred Fount.*

Dilating Nabokov's *The Eye*

So far, I have been focusing on how the discrediting of Cartesian spectatorship and its omniscient claims to knowledge in James intersects with and makes possible dislocations in the signifying functions of language; and I've briefly considered the ways these revised epistemological forms square with the tactics of supervision associated with realist techniques of representation. While a full consideration of "the fantasy of surveillance" upheld by realist narration and the intricacies of its imputed relation to societies that are "increasingly dominated by institutions of discipline, regularization, and supervision" (Seltzer 1984, 52) is beyond the scope of my discussion here, I want to extend some of the questions involved in such a consideration to a single modernist text, one in which the relations of surveillance to the sociopolitical world are center stage and are framed in what might be called a post-Cartesian epistemological universe.[13] In what can be only a provisional analysis of the larger question of the degree to which modernism's many narrative eyes stand in for regulatory social forces, I want to ask how the subjectivized forms of viewing represented in *The Eye* inflect its treatment of surveillance as a narrative and possibly a social tool. Written in Berlin in 1930, eleven years after his family's flight from Bolshevist Russia, Nabokov's *The Eye* chronicles the adventures of its Russian emigré narrator in the Berlin of the mid-1920s.[14] Although Nabokov coyly assures us in his 1965 foreword that he is "indifferent to social problems . . . to community life and to the intrusions of history," and that his books "are blessed by a total lack of social significance" (ii, iii), the text's representation of an expatriate community preoccupied by its possible infiltration by communist agents, no matter how shaped by paranoia, is inescapably historically situated; moreover, as a linguistic artifact alone, the text is inevitably subject to "historical intrusions" of social significance.

[13] For an excellent discussion of the politics and power in and of the realist novel, see Seltzer 1984, 171–95. See also Miller 1988.

[14] The book's original title was *Soglyadatay*; Nabokov tells us that it is "an ancient military term meaning 'spy' or 'watcher,' neither of which extends as flexibly as the Russian word. After toying with 'emissary' and 'gladiator,' I gave up trying to blend sound and sense, and contented myself with matching the 'eye' at the end of a long stalk" (Nabokov 1990, i).

We first meet *The Eye*'s narrator while he is an inexperienced tutor in a household with two young boys. After he is beaten and humiliated by the husband of Matilda, a family friend with whom he's been having an affair, he commits suicide. Following his "death," he inhabits a phantom world produced, he believes, by the undiminished activity of his thought and imagination, which nonetheless resembles the world he has left behind in every particular—a fantasy which suggests how fundamentally he equates disembodiment with visions of freedom and power. This universe is populated by a family of fellow emigrés who live in his apartment building on 5 Peacock Street—Evgenia, her husband, Khrushchov, and her sister Vanya, with whom the narrator is infatuated, as well as a group of their friends who are their constant visitors. Among them is the mysterious Smurov, also in love with Vanya, about whom the narrator becomes more and more curious. The balance of the novel is devoted to the narrator's attempt to discover the true identity of Smurov through a series of probing and secretive investigations of increasingly illicit evidence of others' views of him. The text's eventual disclosure that the narrator is himself Smurov transforms this already phantasmatic detective story into a more self-reflexive exercise, in which the surveillance of another bleeds into the search for self-knowledge and an ongoing quest for an elusive sense of substantiality. Surveillance really takes several forms in the novel, although their edges become indistinct: the atmosphere of paranoid vigilance against possible spies, the narrator's self-conscious observance of his own activities, and his ongoing investigations of Smurov.

The world of illusion that the narrator believes he has imaginatively constructed after his suicide, complete with the "themes" (22) of his recovery and so on that he develops, suggests a parallel with the illusory world of fiction and its construction—in this sense the text, like James's, can be taken as an extended metaphor for authorship. Like Nabokov himself, his narrator situates himself at the periphery of an "invisible world that lives in words" (33), which he comes to consider subject only to his cognitive whims for its laws of operation:

> Hosts and guests at 5 Peacock Street move before me from light to shade, effortlessly, innocently, created merely for my amusement. . . . Whenever I wish, I can accelerate or retard to ridiculous slowness the motions of all these people, or distribute them in different groups, or arrange them in various patterns, lighting them now from below, now from the side. . . . For me, their entire existence has been merely a shimmer on a screen. (89–90)

As it does for the narrator of James's *The Sacred Fount*, Nabokov's narrator's narcissistic fantasy that the world is of his own making, "a shimmer on a screen" of his own projection, initially works to expose the solipsistic

delusion underlying subjective perception. The notion of a world dependent solely on the operations of the individual mind for its substance is repeatedly problematized in the novel, through the often unwelcome intrusion of materials independent of the projecting self, or what conventionally passes for the real. Thus, upon learning that Vanya is engaged to another man, rather than being "at [his] dream's disposal, [his] dream-cornered prey" (29), the narrator tells us: "I grew heavy, surrendered to the law of gravity, donned anew my former flesh, as if indeed all this life around me was not the play of my imagination, but was real" (69). In the same way that the intrusion of Vanya's separate desires breaks up his illusion of mastery, the story that the narrator tells Vanya about his heroic escape from Russia is disrupted by her fiancé Mukhin's observation that the railroad enabling his escape had never been built; the narrator's invented narrative is described as a "marvelous soap bubble" (50), now burst. Yet, just as the intrusions of the real can discredit apparently self-made worlds, they can also legitimize them. While the narrator tells us that he used to tease his employer, the bookseller Weinstock, because he "was convinced that he was being regularly watched by certain persons, to whom he referred, with a mysterious laconism, as 'agents,' " he later reports: "Most remarkable of all was that once . . . a person he knew fairly well, a friendly, easygoing, 'honest-as-God fellow' (Weinstock's expression), really turned out to be a venomous Soviet sneak" (26, 43). The fact that the fictions the characters embrace can be intruded upon by materials external to themselves which change their status suggests a comparable vulnerability for the fictive standing of the novel and its relation to the outside world from which it draws. Such intrusions suggest the bifurcated, permeable nature of fictive forms, whose hermeticism is always crisscrossed by potentially independent external references. By calling attention to these two parallel levels operating in *The Eye*—the synchronic universe within the text, and the diachronic negotiation between the text and the world outside it— Nabokov shows that meanings are historically situated to a degree that exceeds the intentions of individual subjects (including authors), an insight which further underscores how playfully disingenuous are his ahistorical protestations in the foreword.[15]

[15] Much of the small body of criticism on *The Eye* is devoted to still a third register of meaning, tracking the ways in which the novel draws on outside literary sources and allusions. Susan Fromberg Schaeffer first suggested the ways Smurov reenacts events from the story he reads to his "pupils," Chekhov's *The Double-Bass Romance*. D. Barton Johnson notes at least six literary references and places particular emphasis on Dostoevsky's *The Double*, arguing that the cumulative functions of those references aren't primarily thematic so much as the means to signal characters' sociocultural statuses through their reading habits. Julian W. Connolly endorses this latter view and, in a more detailed discussion of *The Eye's* debt to Dostoevsky's *The Double*, indicates that the two works employ comparable means to delineate distinctive concepts of the dissociated self. The forms of literary doubling within and across literary works these critics have documented, I would add, suggestively mimic, albeit in a

The text makes explicit reference to these dual ontological levels in its opening sentence, in which the narrator explains that his emigré experience began "in the early twenties of two spans of time, this century and my foul life" (3); but following this introduction the question of the narrator's situation within the 1920s is temporarily upstaged by a more primary issue. Before it can attempt to correlate the century's history with the narrator's, that is, the text must revert to an anterior question—the problem of ontology. The ontological may claim priority because the very notions of "individual subject" and "subject of history" presuppose a narrative of self/other relations. *The Eye*, living up to its name, pursues ontological issues primarily in a visual register, asking how the seeing self may be distinguished from the perceiving other. But *The Eye* makes the process of distinguishing self from other an elusive affair. The self-reflexive, internally unstable ontology that it proposes intimates that we can do no more than propose a "subject of history" as an arbitrary construction. Although *The Eye* repeatedly evokes the historical by investigating the nature of the subject's relation to a world outside itself, it finally defines that relation as unknowable because it is so mediated by self-created and self-serving fictions. The narrator of *The Eye*, then, by obsessively trying to situate a man who turns out to be himself, unquestionably participates in the "fantasy of surveillance" said to characterize the realist narrator's position; but his failure to do so derails the easy equatability between his own panoptic powers and those of the "institutions of discipline, regularization, and supervision" narrative authority is thought to represent in realism. By offering such a fractured and provisional model of the subject and depicting the world that the subject inhabits as its arbitrary extension, *The Eye* unsettles the distinctions of self and world, masculine and feminine, upon which the ideal and disembodied eye normally depends. It thus fundamentally challenges any neat equation of the male subject's narrative authority with disciplinary structures, save in the ways those structures have already been trained upon the self as an object of discipline, where they are internalized and oriented toward self-scrutiny and supervision.

Prior to the narrator's suicide, the seeing subject and perceiving object are represented as at least tentatively distinct. But just as the narrator, plagued by self-consciousness, complains that "even in sleep I did not cease to watch over myself" (7), his description of his young students, or "his pupils" standing by, "one on my right, the other on my left, imper-

formal register, the ambiguities of ontology in the novel. In a later essay, Connolly also addresses many of the ways self/other relations are complicated in the text, in a reading that usefully informs my own, despite our different conclusions about the visual principles which underpin these relations. See Schaeffer 1972, 5–30; Johnson 1985a, 393–404; Connolly 1990, 129–39; 1992. For a general overview of issues and criticism of *The Eye*, see Johnson 1985a, 328–50.

turbably watching me" (10) allows their object gaze to be transformed into an image of self-scrutiny, by playing on the dual meaning of "pupils." After the narrator's "death," subject/object relations shift in the novel, as he comes to view himself and his personal history with a comparable degree of detachment. "Ever since the shot—that shot which, in my opinion, had been fatal—I had observed myself with curiosity instead of sympathy, and my painful past—before the shot—was now foreign to me" (27). Following the shot, too, the narrator begins to pursue his interest in Smurov, who "made a rather favorable impression on me those first evenings" (33), but who, based on his "air of mystery," he also comes to suspect is a spy (43). As the narrator accumulates more and more "images" of Smurov, he resolves to try to identify the "true Smurov," to engage, despite the difficulties, in the "classification of Smurovian masks" (54).

> I could already count three versions of Smurov, while the original remained unknown. This occurs in scientific classification. Long ago, Linnaeus described a common species of butterfly, adding the laconic note "*in pratis West-manniae.*" Time passes, and in the laudable pursuit of accuracy, new investigators name the various southern and Alpine races of this common species, so that soon there is not a spot left in Europe where one finds the nominal race and not a local subspecies. Where is the type, the model, the original? Then, at last, a grave entomologist discusses in a detailed paper the whole complex of named races and accepts as the representative of the typical one the almost 200-year-old, faded Scandinavian specimen collected by Linnaeus; and this identification sets everything right. (53–54)

The problem with this "scientific" approach, as the narrator describes it, is its fundamentally arbitrary designation of the original, amidst the proliferation of copies—a problem conventionally associated with "the age of mechanical reproduction" and its technologies, not the regular operations of the natural world. This portrayal only underscores how profoundly unavailable the "original" has always been in Nabokov's view, and how much it is the production of the human desire buried within analytical systems. An expert gaze may well be trained upon the object to find the elusive prize of authenticity, then, but the novel makes clear that it is actually a production of the eye of the beholder and underwritten by social credentials, rather than inhering as a property of the object. Even if one could arrive at a first cause, a "primary Smurov," the text suggests furthermore, our comprehension of it would be hampered by its mediated character. About the image of Smurov which Marianna, a friend of Khrushchov's, holds, the narrator tells us: "To define this image accurately, however, I would have had to be familiar with Marianna's entire life, with all the secondary associations that came alive inside her when she looked at Smurov—other reminiscences, other chance impressions and all those

lighting effects that vary from soul to soul" (55). The narrator's employment of the phrase "lighting effects" here, as we saw earlier when he referred to the existence of the other characters as "merely a shimmer on a screen" whose movements could be lit "now from below, now from the side" (89–90), evokes the iconography of film. Such iconography leads a double life, at once depicting subjects as the isolated sources of imagery—projectors, in effect—and the screens upon which others are projected into being. That each subject appears to light an independent production obviously does nothing to erase the social character of the imagery it illuminates (the narrator can slow or accelerate images, to recall, but he never claims to create them, fundamentally). The trouble for truth caused by the partial and subjective status of any single image-stream must compete with the arguably thornier prospect of a subject comprised by a potentially infinite number of layered image-transparencies, all copies without originals. For this reason, the *surveillance* of Smurov bleeds (to employ the term cinematically) into the *spectacle* of Smurov, conceived in Debord's sense as "a social relation . . . mediated by images" (Debord 1983, para. 5).

As the images the narrator accumulates of Smurov multiply—making of him a brutal officer to Marianna, a shy and inexperienced youth to Evgenia, a bridegroom to Uncle Pasha, a spy to Weinstock, a "sexual lefty" and kleptomaniac to Roman Bogdanovich, an absurd poet to Vanya—the possibility of designating a "true" Smurov seems as suspect an exercise in classification as Linnaeus's. What remains interesting about this particular accumulation of images, however, is the spectrum of gender positions within masculinity to which they allude—from the hypermasculinized military officer to the implicitly feminized homosexual. This spectrum suggests that the positions normally occupied oppositionally by masculine and feminine bodies within the conventions of the interior gaze's deployment have likewise been condensed into a single "Smurovian" template. *The Eye* thus displaces to the interior of its concept of self the conventional gendered division of transparent subject and embodied object. But the consequence of this displacement is not a centripetally unified fusion of images, but a centrifugally scattered self. Nabokov makes this clear at the end of the novel when, after the conflation of the narrator's identity with Smurov's, Smurov admits to the futility and the irrelevance of trying to construct a unified, or even a privileged, version of himself. Following his encounter with Kashmarin, the assailant who provoked his suicide at the beginning of the novel, he tells us:

> Kashmarin had borne away yet another image of Smurov. Does it make any difference which? For I do not exist: there exist but the thousands of mirrors which reflect me. With every acquaintance I make, the population of phan-

toms resembling me increases. Those two boys, those pupils of mine, will grow old, and some image or other of me will live within them like a tenacious parasite. And then will come the day when the last person who remembers me will die. A fetus in reverse, my image, too, will dwindle and die within that last witness of the crime I committed by the mere fact of living. (103)

The narrator's contention that there is no self apart from others' images of it insists on the dependency of those partial fragments on an external world to exist at all at the same time that it foregrounds their vulnerability to change. Such a contingent model of the self suggests that, to whatever degree the narrator's world is of his own making, it has to compete with those constructed by others; and, while those worlds may be no more definitive than his own, for that very reason they cumulatively pose the same problem of designating authenticity as do the multiplying images of Smurov. Whether in regard to the images of the self or of the historical "real world," that is, authentic originals are in short supply.

Such an atomized vision of simultaneous and arbitrary worlds finds its correlate in the equally arbitrary model of history that the narrator promotes. Repudiating that "wholesale trade in epochs and masses" better known as the science of history in Marxist parlance, he declares: "It is silly to seek a basic law, even sillier to find it. . . . Everything is fluid, everything depends on chance, and all in vain were the efforts of that crabbed bourgeois in Victorian checkered trousers, author of *Das Kapital,* the fruit of insomnia and migraine" (27–28). In place of the behavioral predictability promised by such explanatory "laws" of history, *The Eye* seems to propose a more ethereal, chaotic model, epitomized by Weinstock's séances, in which Lenin puts in appearances alongside less celebrated ghosts, and Caesar, Mohammed, and Pushkin send messages along with "a dead cousin of Weinstock's" (38–39). This metaphysical logic informs more worldly encounters as well. The narrator explains, for example: "Once, in the downstairs hall, I happened to hold the door for [Khrushchov], and his mispronounced German 'thank you' (*danke*) rhymed exactly with the locative case of the Russian word for 'bank'—where, by the way, he worked" (29–30). Meaning, such an encounter suggests, while based on the arbitrary and coincidental, is no less reliable for its patently subjective origins. The kinds of truths such encounters yield, however, are so idiosyncratic that they can't extend beyond their particular contexts; instead, they dissolve, like Lenin's ghost, into the text's insubstantial atmosphere. If we view the séance as an alternative "historical model," we can infer that the external world, defined as just an unstable extension of the subjectivized self, includes both contexts that the narrative began with—"the early twenties of two spans of time, this century and my foul life." In the hall of mirrors that constitutes *The Eye,* it would appear, there is nothing

outside the reflections of self and other to qualify as an independent social world.

The narrator begins, following his suicide, to contemplate a world seen as an extension of his own thought, but he is unable to locate himself within it. In his attempt, however, he comes to occupy two opposed visual positions; in Lacanian terms, he embodies the "constitutive splitting" which characterizes the antinomy between the eye and the gaze. By offering us this fractured model of the subject at the same time as defining the contexts which that subject inhabits as arbitrary extensions of it, *The Eye* reframes the way we must conceive of the subject's relation to the historical arrangements which might be though to constitute it. It's not that *The Eye* won't acknowledge that the subject is situated in a world outside itself, but rather that it defines the process of designating a privileged version of it as an inexact science, as unknowable. The operations of the narrator's supervisory eye, then, are confined to trying to discover the subject of "institutions of discipline, regularization, and supervision" rather than furthering their aims, as a source of power themselves. Perhaps this far more modest project stands behind Nabokov's claim that his books are "blessed by a total lack of social significance." At the end of *The Eye* the narrator tells us: "I have realized that the only happiness in this world is to observe, to spy, to watch, to scrutinize oneself and others, to be nothing but a big, slightly vitreous, somewhat bloodshot, unblinking eye" (103). Unlike the pristine, idealized "mind's eye" of the detached Cartesian subject that invisibly surveys the conceptual theater of the self, this openly embodied eye, veins and all, inversely conjures an "eye's mind"—a subordinate mind, of and by the flesh, that insists on its subjective roots, and their potentially far-reaching perceptual consequences.

Two Mirrors Facing

Freud, Blanchot, and the Logic of Invisibility

Ideology and Oedipus

The tragedy of the Theban king Oedipus, whose discovery that he has killed his father and married his mother forms the basis for Freud's understanding of unconscious desires in the Oedipal complex, could just as easily be read as a tale about the operations of ideology. I take ideology, following Louis Althusser, to be those unconscious or invisible beliefs and assumptions which at once structure representations and mask contradictions in the service of an illusory wholeness or coherence. Fredric Jameson comments on the relationship between ideology and cultural texts or artifacts: "Ideology is not something which informs or invests symbolic production; rather the aesthetic act is itself ideological, and the production of aesthetic or narrative form is to be seen as ideological in its own right, with the function of inventing imaginary or formal 'solutions' to unresolvable social contradictions." The marker of ideology in the text, for Jameson, is the presence of "a purely formal resolution" of "real social contradictions, insurmountable in their own terms" (1981, 79). The difference between *Oedipus the King*'s relationship to ideology and that of the sort of cultural texts Jameson is describing—what makes the play "about" ideology more than just "of" it—is its self-consciousness about its own operations: Sophocles makes the interplay between belief and the interpretive process the primary subject of his tragedy, and the play's formal "resolution" of its contradictions calls attention to its own instability.[1]

[1] See Sophocles 1942. Although Robert Graves (1955, 12) cites twelve sources for aspects of the Oedipus story in addition to Sophocles, Apollodorus is the only competing source for

We can see such a marker of ideology in *Oedipus the King* through Sophocles' paradoxical equation of blindness with sight, the figure which tentatively resolves the play's contradictory appeals to self-determination and Fate, hubris and piety—the proffered explanations for Oedipus's destruction. Sophocles' strategy, to reveal the truth of Oedipus's identity at the play's beginning, makes the real drama one of revelation and, more importantly, of interpretation. Sophocles' tools are tautology and contradiction, as Oedipus's attempts to piece together the narrative of his life reveal that all of his efforts to evade his fate have issued only in its fulfillment. Oedipus's belief in the piety of impiety—realized in his determination to evade a fate he finds morally repugnant—blinds him to such an abundance of evidence that it stretches credulity. Oedipus, always an accomplished misreader, becomes still more so, rejecting the testimony of the oracles, trusted messengers, and of Teiresias, the blind seer, just as he misconstrues physical evidence—the telltale marks on his ankles, the features of his mother and wife, of his children. But Sophocles doesn't allow Oedipus to see the ideology of self-determination for what it is; the moment at which it is discredited is identical with Oedipus's self-blinding. Mediated so literally, Oedipus's limited or blind insight appears to be the only safe or convincing position, if Teiresias is any indication, from which ideology can be viewed. Blind-sightedness, then, itself paradoxical, is the text's "formal resolution" of its contradictions and paradoxes.

But this is not, of course, what Freud sees in the tale. Freud doesn't read ideology when he looks at the Oedipus story; he reads ideologically. But Freud retains, I would argue, the visual emphasis which figures so prominently in Sophocles, and indeed in much other classical mythology. Freud is not alone, either in turning to classical mythology to ground a developmental narrative or in choosing a story in which sight becomes the privileged transmitter of narrative materials. Freud's interest in Oedipus is paralleled, arguably, by Blanchot's interest in Orpheus, as it is articulated in his essay "The Gaze of Orpheus" (Blanchot 1981). Freud finds in the Oedipus myth a model of male and female psychic development; Blanchot finds in the Orpheus story an account of artistic development. In reading one against the other, I hope to expose more than their common impulse to remythologize classical materials and to borrow, thereby, a measure of their poetic resonance. By unraveling some of the shared strands which link these two works, my aim is to look both backward and forward historically: to uncover the vestiges of a narrative constellation involving vision, gender, and embodiment that proved so powerful for literary modernism, as well as a revisionary narrative from "a past to come"

the part of the tale which addresses the accumulation of evidence for the crime, and Sophocles' version is the better known.

which strives to rework the positional violence of its predecessor.[2] My purpose here is not to interpret Blanchot psychoanalytically but to track the ways Freud's master narrative both insinuates itself into Blanchot's and in some sense exhausts itself there. I am reading "The Gaze of Orpheus," then, as a compressed metanarrative of changing visual subcultures, the traces of which comprise not a resolution of social contradictions, to follow Jameson's thinking, so much as a suspension of them. The horrific consequences associated with sight are, I would argue, reimagined in Freud and Blanchot, in an ideological collusion between vision, symbolic activity, and female exclusion that tells its own story of the modernist effort to imagine male symbolic efficacy and its erosion.

The 1950s marked a transitional moment in Blanchot's thinking, a moment when he had distanced himself from the extensive political and literary influence of Jean-Paul Sartre and had turned from the writing of novels to the récit—a change accompanied by a shift from third- to first-person narrative (see Holland 1995, 103–9). Appearing in *L'Espace littéraire* in 1955, "The Gaze of Orpheus" arguably is Blanchot's most significant aesthetic statement from that period. The essay remains residually tied to a modernist past but also contains, as I hope to show, some of the significant themes and commitments Blanchot explores in later, decisively postmodernist works. Like many of his modernist contemporaries, Blanchot began his publishing career as an experimental novelist in the 1930s, and briefly evinced sympathy with fascist politics (a sympathy understood by at least one critic as an antirationalist impulse consistent with Blanchot's "romantic" sensibilities; see Bruns 1997, xiv–xvi). He was thoroughly familiar with Freud—a familiarity traceable in repeated references throughout his essays, from an early mention in "Sade's Reason" (1947) to the more extensive discussion of Freud and Lacan in *The Infinite Conversation* (1969), and beyond (Blanchot 1993, 230 ff.)—and actively engaged with the ideas of Sartre. Blanchot enthusiastically reviewed Sartre's *Nausea* in 1938, praising its experimental form as well as its further introduction of Husserl's and Heidegger's ideas to France. He published regularly in Sartre's journal, *Les Temps Modernes*, in the 1940s (see Holland 1995, 33–34). From the perspective of the 1950s onward, however, Blanchot's own experiments with form and his changing philosophical allegiances appear more legible through the lens of his friendship with Georges Bataille, whom he met in 1940, than through the filter of Freud or Sartre. Such transformations have led other critics to characterize his work as clearly postmodernist, in Lyotard's sense that postmodernist works betray an "incredulity toward metanarratives."[3]

[2] The phrase is Blanchot's; see Blanchot 1982, 17.
[3] For a fuller discussion, see Gregg 1994, 173–200.

THE EYE IN THE TEXT

In the sections that follow, I hope to expose these several conceptual undercurrents or traces, assessing their relative weight in Blanchot's thinking as I measure their distance from James's Orphic metanarrative from the turn of the century.[4] I begin by revisiting Freud's developmental narratives, where I follow the pivotal role vision plays in the distribution of male symbolic agency and transparency compared with female exclusion and embodiment. I use this classic articulation of a modernist visual paradigm to read Blanchot's "The Gaze of Orpheus," exploring its parallel formulations of vision, gender, and embodiment. But Blanchot's essay is not simply a reprisal of this dominant narrative, a point I wish to make by way of Ovid and Merleau-Ponty. By excavating the potential moments of intersubjectivity in these latter writers, I aim to expose the "other" or dialectical mirror of the dominant Freudian story, and to identify its own muted presence in Blanchot. But each of these models, I will finally suggest, along with the notion of subjectivity which they ironically share, is vitiated by Blanchot's ascendant impulse: to show the ways in which all subjects are superseded by language, rendering them disappearing shadows compared with its superior and ubiquitous presence. "The Gaze of Orpheus" thus serves as an exemplary transitional text, epitomizing—as it departs from—modernist visual paradigms.

Freud and the Logic of Lack

Stephen Heath has argued, in his attempt to de-essentialize the meaning of sexual difference as it is conceived in psychoanalysis, that "the vision, any vision, is constructed, not given; appealing to its certainty, psychoanalysis can only repeat the ideological impasse of the natural, the mythical representation of things" (Heath 1978, 55). Heath's understanding of vision as the means by which sexual difference becomes myth in psychoanalytic thinking is indebted, as is my own, in part to Luce Irigaray's critique of Freud's "specular logic" (Irigaray 1985), where visibility of the male sex organ becomes the basis for the perception of female difference as absence or lack, and for woman's position outside of representation. I would like briefly to revisit the particulars of Freud's male and female developmental narratives, as well as Lacan's later rearticulations of them, in order to identify what Heath and Irigaray, among others, are seeing in them. By

[4] Although I employ the term "trace" in this essay in a broad, discursive sense, it is worth recalling its more specialized significance for Levinas, for whom it signals an abstract register of the other: "if the signifyingness of a trace is not immediately transformed into the straightforwardness which still marks signs, which reveal the signified absent and bring it into immanence, it is because a trace signifies beyond being. . . . Through a trace the irreversible past takes on the profile of a 'He.' " See Levinas 1986, 356.

undertaking a review of what is by now a familiar critique of Freud and La-
can, I mean only to establish a framework from which the ideological un-
derpinnings of Blanchot's text can be thrown into relief. In attending to
both implicit and explicit visual currents in Freud, I hope better to articu-
late what is at stake in Blanchot's alignment with Orpheus's look.

As Freud represents it in "The Passing of the Oedipus Complex"
(1924), the little boy's look at the female genitals instigates the series of
psychic events that will lead to the resolution of his Oedipal complex, by
making real the possibility of castration his female caretakers had threat-
ened but which he initially had disregarded (Freud 1959, 270–71). The
threat of castration, made visually plausible by the female body, or more
precisely by its "lack," is the signal factor which sets in motion the series of
repressions by which, according to Freud, "the object-cathexes are given
up and replaced by identification. The authority of the father or the par-
ents is introjected into the ego and there forms the kernel of the super-
ego" (273). This subsequent formation of the super-ego depends upon
the boy's identification with paternal authority and thus assures his suc-
cessful passage into mature masculinity. Rather than responding to the
threatened loss of their organ, girls, Freud explains, accept castration "as
an established fact, an operation already performed"; with nothing to
lose, as it were, girls lack "a powerful motive towards forming the super-
ego and breaking up the infantile genital organization" (274). Freud clar-
ifies girls' relation to the Oedipal conflict and castration most clearly in
his later essay "Femininity" (1933): "What happens with girls is almost the
opposite [of boys]. The castration complex prepares for the Oedipus
complex instead of destroying it; the girl is driven out of her attachment
to her mother through the influence of her envy for the penis and she en-
ters the Oedipus situation as into a haven of refuge. . . . Girls remain in it
for an indeterminate length of time. They demolish it late and, even so,
incompletely" (Freud 1965, 88). Instead of successfully differentiating
and progressing through later developmental stages, Freud tells us, girls
never sever their pre-Oedipal attachment to the mother and suffer from
an intractable regressivity.

Freud's account of the more certain development of the male super-
ego forms the basis for Lacan's assertion of the male's privileged access to
the Law of the Father, the phallus as transcendental signifier, and thus to
the Symbolic—the order of language—itself. For Lacan, symbolization
begins for males and females equally in the mirror stage, when the mirror
image constructs the subject outside of itself through the production of
the "I"; the subject is both constituted through language, therefore, and
split by it (Lacan 1977). This primary division is followed by those of the
castration complex in which the phallus presides over sexual identifica-
tion. The terms of phallic power are denaturalized in Lacan, for whom

sexuality is inseparable from the symbolic order, as Jacqueline Rose, among others, has noted: "The phallus can only take up its place by indicating the precariousness of any identity assumed by the subject on the basis of its token. . . . [The phallus] signals to the subject that 'having' only functions at the price of a loss and 'being' as an effect of division" (Rose 1982, 40). Despite the fraudulent status of the phallus for all, males maintain the illusion of possessing it. Woman's greater exclusion from this legacy of symbolic mastery and phallic power bears precisely on her one remaining, vitally important function—to assure man of his possession of a phallus (the tool he will use to write with, according to one venerable feminist reading of the literary tradition) (Gubar 1980)[5] and his symbolic efficacy. Man's gaze at what is absent in woman, then, has the function of assuring the visibility and viability of his own organ. As Laura Mulvey memorably argued, "An idea of woman stands as linchpin to the system: it is her lack that produces the phallus as a symbolic presence. . . . Woman, then, stands in patriarchal culture as a signifier for the male other . . . still tied to her place as bearer of meaning, not maker of meaning" (Mulvey 1975, 412–13).

Male symbolic activity, then, takes place over and through woman's body—*over* the surmounted desire for the mother, the relinquishment of whom has been achieved *through* the castration threat posed by her "missing" organ. Unable to resolve her own Oedipal conflict because she is "already castrated," the girl has at best uneven access to the symbolic activity represented by the phallus; even allowing for her periodic entry in and disruptions of the symbolic, her descent back into the prelinguistic and undifferentiated depths of the Imaginary seems to be her ultimate "destiny," in Mulvey's words, as "bearer not maker of meaning." It is in and from Lacan's work that so many theories of woman's language have been derived against this male model, each based on an acceptance of some version of the idea of woman's incomplete super-ego formation and her failure, therefore, to gain secure and equal entry into the symbolic. In Lacan still more than in Freud, woman retains a powerful affiliation with the shadowy, undifferentiated realm of the Imaginary, the state existing prior to the symbolic structuring associated with ego-formation in the mirror stage, and with her pre-Oedipal tie to her mother. Jacqueline Rose exposes the implications of this association:

> What this means is that femininity is assigned to a point of origin prior to the mark of symbolic difference and the law. The privileged relationship of women to that origin gives them access to an archaic form of expressivity out-

[5] In this article, Gubar documents the recurring rhetorical motifs of pen/penis and woman's body/blank page that structure accounts of the creative process in a selection of nineteenth- and twentieth-century Western literary texts.

side the circuit of linguistic exchange. . . . It is therefore a refusal of division which gives the woman access to a different strata of language, where words and things are not differentiated, and the real of the maternal body threatens or holds off woman's access to prohibition and the law. (Rose 1982, 54–55)

In compensation for woman's lack, Lacan identifies "jouissance" as the inarticulable something "extra" that characterizes female expressivity (Lacan 1982).

It is worth calling attention again to the primacy of the visual in this tale of male and female development. Both boys' and girls' castration complexes in Freud's narrative proceed from a traumatic visual encounter with the genitals of the opposite sex, encounters which are understood to be inevitable not only in terms of the sheer visibility of difference but in terms of their readily inferable meaning. Freud reluctantly credits this hermeneutic feat in little girls: "The castration complex of girls is also started by the sight of the genitals of the other sex. They at once notice the difference and, it must be admitted, its significance too" (Freud 1965, 84). If girls are supposed to "notice at once," their cognizance of the meaning of difference needs be "admitted" as more exceptional than commonplace. Indeed, this seems to be the only place in the developmental narratives where girls' interpretive or symbolic efficacy is clearly asserted, perhaps because those narratives work so hard finally to erase that possibility. Because vision becomes the privileged mechanism for the transmission of ideology in Freud, girls must have, if only temporarily, equal access to it. But the little girl's discernment of the meaning of the phallus "at a glance" is an isolated moment of symbolic acuity, in which she borrows the male gaze only to view through it her own exclusion. Freud seems to offer us both a male and female gaze, then; but in fact, the girl sees only what the boy sees—the superiority of the phallus—and so she turns out to be just what Freud said she was: a little man.[6]

In his 1919 essay "The Uncanny," where Freud theorizes about the gaze directly, its construction as a phallic activity is made still more explicit. Explaining the common dread of injury to the eyes as a veiled fear of castration, Freud returns to the Oedipus myth as a inverse demonstration of that truth: "In blinding himself, Oedipus, that mythical law-breaker, was simply carrying out a mitigated form of the punishment of castration . . . [There is] a substitutive relation between the eye and the male member" (Freud 1958, 137–38). Toril Moi elaborates Freud's position: "The gaze enacts the voyeur's desire for sadistic power, in which the object of the gaze is cast as its passive, masochistic, feminine victim" (Moi 1985, 134, 180). The connection between the gaze and the phallus, then, has two

[6] Freud 1965, 78. The full sentence reads, "We are now obliged to recognize that the little girl is a little man."

consequences in Freud and Lacan, in which the sighting of difference first leads to the boy's entry into the symbolic, from whence it functions as a tool of erotic domination. The violence of the (male) gaze is forged on several levels: when it is trained on woman's body, it "castrates" or blinds her; and this physical violence presages psychical violence when, consequently, it excludes her from symbolic activity and constructs her as the object of visual/phallic appropriation. But to speak of such a gaze as male is deceptive if it implies, therefore, an alternative—man is the inevitable subject, woman the object, of the gaze in Freud.

For their enormous explanatory ambitions seemingly outside any consideration of historical and cultural particularity, along with their compulsive iteration over five decades at least,[7] Freud's developmental stories have earned the title of metanarratives—a term of postmodernist disapprobation meant to signal their overweening and ideological status. I would add that they comprise a particularly *modernist* metanarrative, discernible through the character of the gaze they wield. This implicitly masculine gaze at once remains aloof, measuring difference at a distance and calling it embodiment, and it penetrates its object in an eroticized excavation of hidden truths that suggests the operations of the interior gaze. This gaze, as I will elaborate in what follows, has both a scopic and a haptic character, though the latter remains uneasily subordinated to its dominant fantasy of subjective transparency.

Tracing the Aesthetics of Visual Violence

Just as Freud's narrative rests upon backward glances—to the Oedipus story and the female genitals—Blanchot looks back to and with Orpheus to a Eurydice who disappears. There are numerous fundamental differences of course between the two—Freud, to begin with, sees himself as a scientist, exposing a stage of psychic development under the bright lights of reason; Blanchot casts himself as an artist, exploring the conditions for creative expression and authenticity through his embrace of a form of darkness. But for the moment I want to dwell on several points of convergence between these two narratives, each of which begins with the gaze and concludes with the word, and which appear to tell similar stories about the ways vision codes male and female access to cultural materials. The two seem, moreover, to occupy analogous spatial or topographical territories: the realms of the symbolic and the upper world, of the imaginary and the underworld, apparently are governed by shared principles.

[7] I include not only Freud's repeated reworkings of these materials in the 1920s and 1930s but also later rearticulations of their premises from Lacan to Nancy Chodorow.

To undertake this sort of reading is, of course, to risk a reductionism which it is my principal hope to evade. What I mean to accomplish by dwelling on these parallels is the exposure of a discernible subtext or historical trace that persists within Blanchot's project—a project which, in a commitment to paradox rivaled perhaps only by Sophocles, appears more intent upon the *exposure* of complexity than its resolution. One measure of that intention may be taken in the essay's very aspiration to *write over*—in the sense both of beginning again and of obscuring—a master narrative of the gendering of vision that culminates in Freud, the roots of which stretch back to classical and Cartesian sources and suggest the intractable power that narrative has had over the Western literary imagination. Blanchot seems to acknowledge the presence of these layers of signification within "The Gaze of Orpheus" when he notes that "as we look at the most certain masterpiece, whose beginning dazzles us with its brilliance and decisiveness, we find that we are also faced with something which is fading away, a work that has suddenly become invisible again, is no longer there, and has never been there. This sudden eclipse is the distant memory of Orpheus' gaze, it is a nostalgic return to the uncertainty of origin" (Blanchot 1981, 103). Just as Blanchot invites us to capture the fleeting moment of Orpheus's gaze that at once sees and cannot see its object, I hope to illuminate the essay's own ideological vanishing point in its "nostalgic return to the uncertainty of origin"—to bring into visibility this dimension of his thought in the very process of its "fading away" from legibility. Among the things I hope to bring to light is the problem of femininity.

My method consists in teasing apart the strands of what Michael Newman (1996, 158) has called Blanchot's "duplicity of vision," a vision which weds (as it moves beyond) materials which are conceptually, if not actually, discrete, and from which I want to isolate two visual trajectories important to my reading: a scopic model linked with distance, discrete subject/object positions, and a project of visual appropriation that looks back to, among others, Freud and Jean-Paul Sartre; and a haptic model which imagines a tactility of vision approximating touch and is associated with proximity, intersubjective relations, and a project of visual engagement and mutuality that reflects back on Ovid as it looks forward to Merleau-Ponty. I separate these strands here, the better to see their ideological roots and possibilities of intersection, as well as their position relative to the more overt currents of Blanchot's thought.[8]

[8] It's interesting to compare Blanchot with Bataille on the relations between scopic and haptic visuality, given Bataille's later influence on Blanchot's ideas. In the final scenes of Bataille's *Story of the Eye* (originally published as *L'histoire de l'oeil* in 1928), we can follow their intersecting courses in the career of protagonist Simone's eye fetish, an exemplar of which she secures from the corpse of a murdered priest, and which she inserts in her vagina. The

Of the many versions of the Orpheus myth that have been passed down since antiquity, virtually all agree on the following elements of the tale:[9] Orpheus, the celebrated singer who enchants even wild beasts with his music, falls in love with Eurydice. Eurydice dies of a snakebite on their wedding day and Orpheus, heartbroken, uses his talents as a singer to charm his way to the forbidden underworld to plead to have Eurydice brought back to life. It is a testimony to the power of Orpheus's art that the gods agree to restore Eurydice to the upper world; their only condition is that as Orpheus guides her, he must refrain from looking back at her. When Orpheus looks, against prohibition, Ovid tells us, "she was gone, in a moment. / Was it he, or she, reaching out arms and trying / To hold or to be held, and clasping nothing / But empty air?" (Ovid 1955, 113).[10] Orpheus loses her for the second and final time.

Although in Ovid the tale does not end there, this is the part of the story on which Blanchot dwells most deeply. He begins after Eurydice's death with Orpheus's descent; Orpheus's art is rendered as the tool of a kind of equivocal seduction, not of the gods but of the night and of Eurydice. The essay opens:

> When Orpheus descends to Eurydice, art is the power that causes the night to open. Because of the power of art, the night welcomes him; it becomes the welcoming intimacy, the understanding and harmony of the first night. But Orpheus has gone down to Eurydice: for him, Eurydice is the limit of what art can attain; concealed behind a name and covered by a veil, she is the profoundly dark point towards which art, desire, death, and the night all seem to lead. She is the instant in which the essence of the night approaches as the *other* night. (Blanchot 1981, 99)

Orpheus's art is from the beginning gendered and sexualized; it "causes the night to open," to greet him with "welcoming intimacy" in "the understanding and harmony of the first night." But Orpheus rejects the night's easy virtue, its openness and receptivity, to seek a different lover, a modestly bridal Eurydice who conceals with the vestiges of an identity ("a

eye—a literal agent of the male gaze, however disembodied—penetrates Simone like a penis at the same time as it covers over her "lack." By internalizing and incorporating the eye, Simone makes it fully her own; securing the gaze of the other as a twofold source of gratification—as the scopic gaze which confers subjectivity, and the erotic, haptic object which brings sexual pleasure—in an image of complete erotic autonomy. See Bataille 1987.

[9] Robert Graves (1955, 113) lists fifteen sources for the Orpheus myth in addition to Ovid's. There is far less consensus about the second part of the story dealing with Orpheus's death; only a few of the versions resolve the tale along the same lines as Ovid.

[10] I don't wish to suggest that Ovid was necessarily Blanchot's source, but only that Ovid's materials—included and excluded—were a widely available and obvious resource. I take Ovid to be one of the more fully imagined versions of the Orpheus myth, the richness of which is useful for my purposes here and later in this essay.

name") and a material presence ("a veil") her "essence," the "profoundly dark point" which defines her. Yet hers is perhaps an ungraspable essence from several points of view—Orpheus's, Blanchot's, the reader's—encompassing in an undifferentiated mass ("art, desire, death, and the night") ends and means, inside and outside, Eurydice and Orpheus, in a moment of transformation: "the instant in which the essence of the night approaches as the *other* night." The primal, boundless terms of Eurydice's essence recall those associated with the mother in the imaginary prior to dyadic divisions, the state which forms the topographical correlate to Blanchot's underworld of shades. Understood as "the limit" of artistic attainment, Eurydice seems to represent a moment of slippage between two states of being—the night and "the *other* night," symbolic and imaginary, presence and absence, subject and object.

Blanchot explores the link for Orpheus between artistic attainment and the attainment of Eurydice, or "the dark point": "Yet Orpheus' work does not consist of securing this 'point' by descending into the depths. His *work* is to bring it back into the daylight and in the daylight give it form, figure and reality. Orpheus can do anything except look this 'point' in the face, look at the center of the night in the night. . . . The depth does not surrender itself face to face; it only reveals itself by concealing itself in the work" (99). The necessity for Orpheus to conduct his "work" in the daylight rather than in the depths establishes the incompatibility of the underworld with symbolic activity. Although the precise threat to the work posed by the depths is nowhere explicitly stated, it's possible to see how the feminized realm of shades, of the dead, and the primal, undifferentiated darkness with which it is associated, might threaten a loss of boundaries between seer and seen, where one could be swallowed up by the center of the night and darkness, held in death's long embrace. These dangers arguably both underlie and overshadow Blanchot's explanation for abjuring a mutual look. Blanchot's account of the indirection required to secure "the depth" makes the avoidance of a face-to-face encounter a question of what is to be gained (the depth "reveals itself by concealing itself"), not lost.[11]

It's important, moreover, to see that Orpheus is rescuing only himself from these dangers, not Eurydice. Rhetorically and conceptually, *Eurydice* is already lost, her dissolution occurring prior to Orpheus's backward gaze, having been imbricated instead in the very terms of her restoration

[11] The iconography of light and dark is itself a rich and overdetermined interpretive field I have space to touch on only briefly here. Woman's association with "the dark continent" in Freud is both racialized and eroticized, coding blackness and the "primitive" along with the dark space of concealed lack. It also has psychic resonances, representing the irrational counterpart of the bright light of reason. Cumulatively, these resonances code a more fundamental division between whiteness-as-transparency and darkness-as-embodiment—a topic I take up in a more sustained way in Chapter 5 with Ellison's *Invisible Man*.

as the "dark point." Eurydice has been turned into a kind of embodiment of artistic raw material that awaits the transformative powers of Orpheus's art—or as Blanchot prefers to call it, his "work"—to restore her to light. Once Orpheus has brought the "point" up to daylight, presumably stripping it of Eurydice's name and veil, he is now free, indeed beholden, to supply it with what she only doubtfully possessed in the first place—"form, figure and reality." But will Orpheus confer "form, figure and reality" on the "dark point" or will he liberate, make manifest, its "essence"? It is the compelling nature of this "point," that propels Orpheus upward, in fact, and not his work: "Orpheus forgets the work he has to accomplish, and he has to forget it, because the ultimate requirement of his impulse is not that there should be a work, but that someone should stand and face this 'point' and grasp its essence where this essence appears, where it is essential and essentially appearance: in the heart of the night" (99).

Blanchot's odd maneuver, which suddenly distances Orpheus from his compulsion to look—an indiscriminate *someone* "should stand and face this 'point' and grasp its essence"—depersonalizes the encounter as it stresses its archetypal ambitions. The look is represented as a visual holdup, a pugilistic and erotic conquest where "essence" is the prize to be "grasped." The compulsion is powerful enough that "the work" must be forgotten (though we will find that the betrayal of the work for Eurydice and the betrayal of Eurydice for the work amounts to the same thing). What Orpheus wants to see, to grasp, is an essence which is "essentially appearance," an inside which is an outside, a depth which is finally a surface—contradictions evocative, I would suggest, of the mystery of her sex. Not only does the object of Orpheus's gaze appear to be a functional paradox; his look itself has a paradoxical character. For what Orpheus's scrutiny exposes is, precisely, disappearance; by at once seeing and achieving Eurydice's formlessness, Orpheus both confers and liberates "form, figure and reality" on and from the "dark point." Eurydice, or her trace as the "dark point," is again represented as a threshold structure, oscillating between what can already be seen on the surface and its meaning or "essence"; and this is the paradox of her sex. As we will see, Blanchot makes these developments the circumlocutionary but indispensable stages on which the work's fulfillment depends. The work begins when Orpheus brings the "dark point" to daylight and gives it form, falls prey to the destructive impulse to see its essence and thus forgets the constructive requirements of the work, and paradoxically finds, in the wake of that destruction, something that critically enables the work. Blanchot now romances the moment of transgression embodied by the look as the privileged route to artistic authenticity, his prior warning that depth "doesn't surrender itself face to face" fading to the background.

The significant terms of this aesthetic program are set forth more fully

when Blanchot arrives at the moment of Orpheus's gaze and its consequences:

> Orpheus' destiny is not to submit to that law—and it is certainly true that by turning around to look at Eurydice, Orpheus ruins the work, the work immediately falls apart, and Eurydice returns to the shadows; *under his gaze, the essence of the night turns out to be inessential.* He thus betrays the work, and Eurydice and the night. But if he did not turn around to look at Eurydice, he would still be betraying, being disloyal to, the boundless and imprudent force of his impulse, which does not demand Eurydice in her diurnal truth and her everyday charm, but in her nocturnal darkness, in her distance, her body closed, her face sealed, which wants to see her not when she is visible, but when she is invisible, and not as the intimacy of a familiar life, but as the strangeness of that which excludes all intimacy; it does not want to make her live, but to have the fullness of death living in her. (100, emphasis mine)

To what is the essence of the night inessential? one might ask. Does the essence of the night, Eurydice, "turn out" to be inessential because of what Orpheus sees, or fails to see? Blanchot frames the possibilities here oppositionally—those sights which would satisfy "the boundless and imprudent force of [Orpheus's] impulse," and those that would betray it. However, what Orpheus wants to see, what will satisfy his impulse, seems either to presuppose Eurydice's intactness, making her unavailable to or prior to his gaze ("her nocturnal darkness, in her distance, her body closed, her face sealed") or her absence after he has seen her, where the attempt to make Eurydice's essence visible entails killing her off ("when she is invisible," "the strangeness of that which excludes all intimacy," "the fullness of death living in her"). The precise moment of the gaze itself seems unrepresentable, perhaps because Orpheus's sight of Eurydice's essence and its "disappearance" are identical. What Orpheus's gaze fatally reveals, at the same time as it asserts its symbolic power, is Eurydice's "penetrability"—unable to deflect or return the gaze, she is effectively blind, "castrated,"—and it is this revelation that renders her "inessential." To put it somewhat differently: if Eurydice, the "dark point" at the threshold between the upper and lower worlds, sustained a limited representational stature prior to the look, Orpheus's gaze eclipses that power, and comes to represent it in her absence. Eurydice's function is to reveal, by disappearing, that there's nothing to see, and thus to authorize Orpheus's usurpation of her symbolic territory and potential in "the work."

While Blanchot frames Orpheus's gaze as a resistance to the law which has prohibited his look, it may by now be clear that his gaze simultaneously aligns itself with a different version of the law—that Law of the Father and his symbolic authority which Freud's little boy identified with when he renounced his desire for his mother. The critical insight Or-

pheus seems to gain when he turns and lifts Eurydice's metaphorical veil compares with the "fact" of her castration—and while that revelation is "essential," the continued positioning of woman's body at the threshold between two worlds "turns out to be inessential," in fact impossible. Once seen for what she is (or rather isn't), Eurydice inevitably slips back to the lower world, where she will melt into the undifferentiated darkness, outside representation.

The Oedipal stakes of Blanchot's narrative, and its indebtedness to a model which associates woman with inarticulate darkness and man with symbolic sovereignty, become still clearer in a later passage, where Orpheus's desire is provisionally singled out as his error: "Orpheus' mistake, then, would seem to lie in the desire which leads him to see Eurydice and to possess her, while he is destined only to sing about her. . . . Eurydice represents nothing more than that magical dependence which makes him into a shade when he is not singing. . . . [O]nly in the song does Orpheus have power over Eurydice, but in the song Eurydice is also already lost and Orpheus himself is the scattered Orpheus" (101). Just as the little boy in Freud must relinquish his mother as his love object, Orpheus must relinquish his desire for Eurydice in order to assure his entry into the symbolic, where "he is destined only to sing about her." Again like the mother presiding over the imaginary prior to the divisions of the mirror stage, Eurydice "represents nothing more than that magical dependence" which is associated with the undifferentiated mother-child bond. Orpheus derives his power over Eurydice through his superior symbolic efficacy in the song, but the cost of his passage into the symbolic is the loss of the imaginary dyad ("Eurydice is also already lost"), and the reassertion of the fragmentary self which stands behind the wholeness of the ego ideal formulated in the mirror stage—"the scattered Orpheus."[12]

Blanchot undertakes his aesthetic rehabilitation of the gaze by linking it with inspiration, thereby reimagining its costs as veiled assets. He explains: "To look at Eurydice without concern for the song, in the impatience and imprudence of a desire which forgets the law—this is *inspiration*" (101). Orpheus's gaze is worth the cost to the work and to Eurydice, Blanchot suggests, because through its inspired means he is able to move on to the next stage of artistic development in which "the work can go beyond itself, unite with its origin and establish itself in impossibility" (102).

[12] The "scattered Orpheus" can be read as the condition we find him in prior to and outside of the projection of imaginary wholeness constructed in the mirror stage; and it may also be understood as a reference to Orpheus's own death at the hands of angry maenads, a reading I develop in the next section. Lacan writes: "The mirror stage is a drama whose internal thrust is precipitated from insufficiency to anticipation—and which manufactures for the subject, caught up in the lure of spatial identification, the succession of phantasies that extends from a fragmented body-image to a form of its totality" (Lacan 1977, 4).

Blanchot characterizes inspiration's costs as merely superficial, covering over a priceless depth:

> All we can sense of inspiration is its failure, all we can recognize of it is its misguided violence. But if inspiration means that Orpheus fails and Eurydice is lost twice over . . . it also turns Orpheus towards that failure and that insignificance and coerces him, by an irresistible impulse, as though giving up failure were much more serious than giving up success, as though what we call the insignificant, the inessential, the mistaken, could reveal itself . . . as the source of all authenticity. (102)

Despite its syntactical convolutions, what is astonishing here is the conceptual ease with which this passage moves from the "misguided violence" of the gaze to its potential status as "the source of all authenticity," an ease made possible, I would argue, only by its elision of the body which underpins its celebration of failure and loss. Blanchot represents Eurydice's annihilation as a loss sustained only by Orpheus, and only measurable in terms of his artistic project. We can't see her loss from any point of view but Orpheus's (not to say Blanchot's) because Eurydice's point of view has been foreclosed even before she disappears. Blanchot's violent blotting out of Eurydice's perspective curiously mirrors the violence of Orpheus's gaze, which requires her destruction in order to discover a higher order of "authenticity."

The route Blanchot traces leading to this higher order follows a kind of boomerang effect, in which Orpheus's flight away from the work leads inexorably back to its place of origins: "Orpheus' gaze is Orpheus' ultimate gift to the work, a gift in which he rejects the work, in which he sacrifices it by moving towards its origin in the boundless impulse of desire, and in which he unknowingly still moves towards the work, towards the origin of the work" (102–3). Orpheus is borne along by "the boundless impulse of desire"—the desire to see and know, to possess Eurydice more than to restore her to light. The linkage between vision and phallic power, the "substitutive relation between the eye and the male member" that Freud posited, is recapitulated in Blanchot where the gaze, like the phallus, defines the point of origin of symbolic activity, that threshold between worlds—imaginary and symbolic, lower and upper—where Eurydice functions as a placeholder until those realms are tentatively divided. Orpheus both discovers and institutes the terms of division through his gaze; relationally, through his split from Eurydice and his "magical dependency" on her, and topographically, as they respectively take up their assigned places in the pre-Oedipal/symbolic hierarchy. At the same time, his gaze recovers the work's "origins" in the depths, and wrestles them back up to the light.

93

For Blanchot, the gaze becomes a transcendent vehicle for Orpheus and the work, in which:

> Orpheus' gaze is the extreme moment of freedom, the moment in which he frees himself of himself and—what is more important—frees the work of his concern, frees the sacred contained in the work, *gives* the sacred to itself. . . . So everything is at stake in the decision of the gaze. In this decision, the origin is approached by the force of the gaze, which sets free the essence of the night, removes concern, interrupts the incessant by revealing it: a moment of desire, unconcern, *authority*. (104, emphasis mine)

The gaze and "the sacred" are likewise liberated from their material bases in this description, where they seem to flutter up and regard us from a great Olympian height. What underpins their exalted status, however, is that moment "of desire, unconcern, authority"—a list whose final term betrays the relations of power which form the basis of this liberation. This moment of authority represents the most extreme moment of paradox, in which antitheses collapse into the release of the sacred, yet it also exposes the violence which enables that conception. What Blanchot means by "set[ting] free the essence of the night," we should recall, is the discovery of Eurydice as "inessential," a discovery that is simultaneous with her destruction. Blanchot's freedom is thus authorized over and through Eurydice's dead body. As in Freud, where the image of the castrated woman functions to assure man of his symbolic mastery, Eurydice's shade seems to underpin Blanchot's final contention that "the act of writing begins with Orpheus' gaze" (104).

It is possible to read Blanchot's depiction of Orpheus's gaze—this form of inspired recklessness aimed to put a purchase on art—simply as a more artful inscription of the Freudian master text, insofar as its celebratory character romanticizes female exclusion, rather than bemoaning it as the inevitable, if lamentable, consequence of her lack. To see the text in this way, to emphasize its gendered disposition of embodiment and transparency through the agency of the gaze, in other words, is to position it in a modernist line of succession that includes not only Freud, but also Jean-Paul Sartre. Sartre's key chapter, "The Look," in *Being and Nothingness* (the publication of which, in 1943, is poised between Freud's developmental narratives of the 1920s and 1930s and Blanchot's "The Gaze of Orpheus" of 1955) serves as another influential articulation of the ways the eroticized gaze produces gendered subjects and objects. The congruence of the terms that the gaze/look—*le regard*—is couched in is startling when we compare Blanchot's rhetoric with Sartre's, particularly given Sartre's far more rigid conception of subject/object relations: "The difference of principle between the Other-as-object and the Other-as-sub-

ject," Sartre contends, "stems solely from this fact: that the Other-as-subject can in no way be known nor even conceived as such" (1956, 389–90). Suggesting that to know—that is, to see—the Other is necessarily to transform the Other into an object, Sartre stresses the destructive power of that translation.

Sartre's choice of metaphors reveals the spatial hierarchy on which his conception of visual relations depends. The presence of the Other effects the self as if "the world has a kind of drain hole in the middle of its being and that it is perpetually flowing off through this hole" (1956, 343). The "drain hole" in the middle of the world through which the self's perspective seeps appears to be governed by the same sort of vertical axis as we saw in Freud and Blanchot—where subjects peer perilously over the rim and objects are washed down the drain. But there is more than hierarchical terrain to recognize here. Subject/object relations, furthermore, are gendered in Sartre (and beyond the ways that the iconography of dangerous holes would suggest) through the medium of the gaze. In this remarkable passage Sartre shifts metaphors, collapsing seeing, knowing, and sexual violation in a contiguous series where seeing subjects are by definition male:

> The idea of discovery, of revelation, includes an idea of appropriative enjoyment. What is seen is possessed; to see is to *deflower*. If we examine the comparisons ordinarily used to express the relation between the knower and the known, we see that many of them are represented as being a kind of *violation by sight*. The unknown object is given as immaculate, as virgin, comparable to a *whiteness*. It has not yet "delivered up" its secret; man has not yet "snatched" its secret away from it." (Sartre 1956, 738)[13]

The "appropriative enjoyment" Sartre describes here—scopophilia—is rendered in terms that inevitably recall "the substitutive relation between the eye and the male member" that Freud described and inscribed in his own work and that we see implemented in Blanchot's equation of the gaze with desire and inspiration. Sartre's appeal to "comparisons ordinarily used" to establish the truth of his position that "to see is to deflower," seems a tacit acknowledgment of the broad ideological basis that the equation of seeing with man's sexual violation of woman acquired in the modernist period. Sartre's rhetoric of sight as seduction also returns us to the beginnings of Blanchot's essay, where the description of the power of Orpheus's art has phallic as well as visionary resonance, causing "the night to open" and to offer "the welcoming intimacy, the understanding and harmony of the first night." Blanchot's depiction of Eurydice as a fantasy of the intact bride, "concealed behind a name and covered by a veil,"

[13] I reencountered this passage from Sartre in Tania Modleski's provocative reading (1988, 63) of the figure of the virginal woman in Hitchcock's film *Notorious*.

whom Orpheus hopes to "stand and face" to "grasp its essence," exposes these terms still more powerfully. Sartre's view of this "violation by sight" also returns us to the scene of castration in Freud, where to see a woman's genitals is to penetrate her mystery, to "snatch," as Sartre puts it, the secret of her castration and its meaning away from her. More nakedly than Blanchot, Sartre assembles the components of the logic of female exclusion predicated on the impossibility of intersubjective relations. We can see the collusion of the gaze in the project of gendering the opposition of subject/object insistently as male/female, where male visual and phallic pleasure is inversely related to female blindness and violation. That this ideology of visual domination is translated into the imagery of sexual conquest both metaphorizes an oppressive relation and threatens to naturalize it. But Blanchot's Orpheus story cannot be said to end here.

Reading Invisibility

When Blanchot looks back to the Orpheus story, part of it threatens to disappear. "The Gaze of Orpheus," that is, touches only allusively on Orpheus's fate following his final loss of Eurydice. Yet those allusions, however brief, form a repository of materials from which to reconstruct the *other* Orpheus story—a story in which hierarchical divisions cede to parity, in which scopic relations yield to haptic, and where intersubjectivity emerges as imagined possibility. In order to bring those materials more readily into focus, I want to begin by recalling Ovid's version of this portion of the story, not because it is more definitive than others, but because the terms of its resolution speak in interesting ways to Blanchot's emphasis.[14] Ovid's conclusion allows us to see that scopic and haptic visual relations are dialectically linked and distinctively gendered—much the way we observed the (female) body to resurface in Descartes in terms that indicated its repressed prevalence. That linkage is also discernible in Blanchot despite (as I will show in the next section) the essay's effort to fore-

[14] There is a kind of symmetry in using Ovid to expose a subtext in Blanchot, since Blanchot himself employs such a technique in his rereading of Ovid's version of the Narcissus myth. As Michael Newman notes, Blanchot suggests in *The Writing of the Disaster* that Ovid's Narcissus "does not recognize *himself*, but rather falls in love with the *image*" (Newman 1996, 153). Blanchot writes: "What he sees is the invisible in the visible—in the picture the undepicted, the unstable unknown of a representation without presence, which reflects no model. . . . It is madness he sees, and death. (But for us, us who name Narcissus, and establish him as the doubled Same—as containing, that is to say, unknowingly, and knowing full well, the Other within the same, death in life. . . .)" He continues: "These are the words of Ovid on Narcissus that should be retained: '*He perishes by his eyes*' (by seeing himself as a god—which recalls: Whoever sees God dies). And these, too: '*Unhappy, because you were not the other, because you were the other*' " (Blanchot 1986, 134–35). Narcissus's problem reflects suggestively on the complex self/other relations of Orpheus and Eurydice and, like "The Gaze of Orpheus," seems to anticipate what Blanchot calls the relation of the third kind—a relation which stresses the irreducibility of difference (which I discuss in more detail later).

close those modernist possibilities in favor of a postdialectical, extrasubjective visual regime.

In Ovid, the story doesn't end with Orpheus's gaze and loss. His gaze is followed by his grief: tears, seven days of fasting, three years of celibacy. Ovid ends this first section with a set piece, in which Orpheus plays mournfully for an audience of trees. He returns to this same scene in a later chapter, "The Death of Orpheus," which begins:

> So with his singing Orpheus drew the trees,
> The beasts, the stones, to follow, when, behold!
> The mad Ciconian women, fleeces flung
> Across their maddened breasts, caught sight of him
> From a near hill-top, as he joined his song
> To the lyre's music. One of them, her tresses
> Streaming in the light air, cried out: "Look there!
> There is our despiser!" and she flung a spear
> Straight at the singing mouth, but the leafy wand
> Made only a mark and did no harm. Another
> Let fly a stone, which, even as it flew,
> Was conquered by the sweet harmonious music,
> Fell at his feet, as if to ask for pardon.
> But still the warfare raged, there was no limit,
> Mad fury reigned, and even so, all weapons
> Would have been softened by the singer's music,
> But there was other orchestration: flutes
> Shrilling, and trumpets braying loud, and drums,
> Beating of breasts, and howling, so the lyre
> Was overcome, and then at last the stones
> Reddened with blood, the blood of the singer
>
> .
>
> The Maenads stole the show. (Ovid 1955, 259–60)

Ovid opens his chapter by exhorting the reader to "behold" this introduction of the female gaze and the occasion for competing symbolic agency it initiates. The impulse of the mad Ciconian women,[15] who understand "at a glance" the self-evident meaning of Orpheus's artistry in relation to their own ("Look there! There is our despiser!"), is to produce a kind of dominance via castration, or perhaps, through an inversion of the genital topography, to recast their symbolic efforts as penetration. They aim their "leafy wand[s]," after all, "straight at the singing mouth"; still, the mouth remains the source of Orpheus's power to charm and deflect the

[15] That the worshippers of Bacchus—"Ciconian women," maenads, bacchants—should be represented as mad and as women is wholly conventional in the classical literature, as Euripides' *The Bacchae*, among other works, demonstrates. Bacchic revelry is typically understood as a devotional frenzy to which women are particularly prone, and in which worshippers temporarily enjoy superhuman strength and powers.

women's weapons, and their triumph is mainly due to their ability to shout him down. Whereas at first Orpheus's art is equal to their assault, he is overcome by that "other orchestration: flutes / Shrilling, and trumpets braying loud, and drums, / Beating of breasts, and howling." While the "other orchestration" seems truly Other—equating the maenads' music with a harsh, bestial physicality ("braying," "beating of breasts," "howling"), forms of expression that register perhaps in the presymbolic range[16]—the triumphant maenads still "steal the show" from Orpheus's now "softened" music.

In the scene of grieving which follows Orpheus's destruction, however, Ovid links his depictions of the mourners with the images of female violence and their struggle for symbolic supremacy that we have just seen:

> The birds wept for him, and the throng of beasts,
> The flinty rocks, the trees which came so often
> To hear his song, all mourned. The trees, it seemed,
> Shook down their leaves, as if they might be women
> Tearing their hair. (Ovid 1955, 260)

The tearing of hair here both echoes and contradicts the beating of breasts we saw earlier. Here female violence is turned against the women's own bodies and, implicitly, against their symbolic ascent. The metaphoric association of women and trees, and by association with the chapter's opening, of woman as audience for rather than competitor against Orpheus's song, is subsequently literalized by the story's appeal to justice at the close:

> But Bacchus
> Demanded punishment for so much evil.
> Mourning his singer's loss, he bound those women,
> All those who saw the murder, in a forest,
> Twisted their feet into roots, and thrust them deep
> Into unyielding earth . . .
>
>
> . . . their breasts
> Were oak, and oak their shoulders, and their arms
> You might well call long branches and be truthful. (261)

Seeing the murder is isolated as the primary form of "evil" here, a fact which makes a larger kind of sense, given that catching sight of Orpheus is equated metonymically with killing him. With its depiction of the

[16] To this extent, their cries recall accounts, such as Kristeva's, that link feminine language to archaic forms of expressivity.

women's metamorphosis, the story roots them more firmly in a receptive position as a new audience of trees, not singers. Just as in Freud, where the little girl's gaze is indistinguishable from the male gaze that she borrows to view her own exclusion, the gendering of the gaze of Ovid's maenads is equivocal. The observing gods reassert a visual and spatial order in which the maenads, reconfigured as audience, can view their exclusion from the song. The form of law Bacchus represents, then, restores the gender relations that characterized the upper world, ensuring that Orpheus's song, even in death, prevails.

But the lower world sustains its own, competing model of justice in the tale. There, Ovid imagines a relation between male and female, Orpheus and Eurydice, that I take to be closer to intersubjectivity:

> And Orpheus' ghost fled under the earth, and knew
> The places he had known before, and, haunting
> The fields of the blessed, found Eurydice
> And took her in his arms, and now together
> And side by side they wander, or Orpheus follows
> Or goes ahead, and may, with perfect safety,
> Look back for his Eurydice. (261)

The parity instituted between Orpheus and Eurydice here in the underworld may have been forged out of violence—they are both dead, after all—but that parity seems to have been achieved without further outcry, and clearly without the violence that characterized the maenads' attempt to achieve symbolic dominance by piercing Orpheus with spears and howls. Ovid depicts both a perfect equality and fluidity: "side by side they wander, or Orpheus follows / Or goes ahead"—and vision has lost its affiliation with destruction. Of course there are questions to pose with regard to this utopian vision, founded in the fields of the blessed: does the location of this scene in the underworld undercut its intersubjective achievement by associating it with the primal regressivity that we have seen to characterize the depths? Given the potential affiliation of the underworld with the feminine, does the source of equality between Orpheus and Eurydice derive solely from his having taken up there the feminine position? Moreover, in Ovid, no mention is made of the continuance of the song; is the cost to Orpheus for achieving his desire the end of his art?

Ovid's ending arguably restores the other half, not only of the Orpheus story, but of the visual discourse that governs its beginning: from a gaze which presides over conventionally gendered subject/object *divisions*, that is, emerges an initial inversion of gender positioning through the maenads' momentary symbolic ascent, and finally an imagination of a mutual gaze between Orpheus and Eurydice, drained of its violence and

divisiveness. This gaze "in perfect safety" bridges the distance between two subjects and becomes the medium through which Orpheus may envelope Eurydice in an embrace seemingly modeled on arms that hold. This intersubjective, fleshly, haptic gaze stands in dialectical opposition to the scopic gaze of Orpheus that is intent upon the disavowal of embodiment to secure its own transparency. In much the same way, I would suggest, the work of Sartre's contemporary, Maurice Merleau-Ponty, theorizes an embodied gaze built on the rejection of a clear subject/object dualism that stands in dialectical opposition to Sartre, and which furthermore provides a useful vantage point from which to grasp Blanchot's postdialectical visual strategies.

In "The Intertwining—the Chiasm" Merleau-Ponty challenges the assumption of the bifurcation of subject and object, understanding the seer as at once a thing among things and what sees or touches them. "He who sees cannot possess the visible unless he is possessed by it, unless he *is of it*" (Merleau-Ponty 1968, 134–35). Merleau-Ponty understands sight, like touch, to reside foremost in the body, so that the act of seeing produces a "double belongingness" to the order of subject and object, distance and proximity, at once. The relation of the seer to the visible is like "two mirrors facing one another where two indefinite series of images set in one another arise which belong really to neither of the two surfaces, since each is only the rejoinder of the other, and which therefore form a couple, a couple more real than either of them" (139). We can find traces of this more haptic visual model in "The Gaze of Orpheus" in Blanchot's revelation that "Orpheus has actually been turned towards Eurydice all along: he saw her when she was invisible and he *touched her intact absence as a shade*, in that veiled presence which did not conceal her absence, which was the presence of her infinite absence" (Blanchot 1981, 100, emphasis mine); and we can see further evidence of intersubjective parity in the repeated parallels Blanchot draws between Orpheus and Eurydice's losses and deaths—parallels to which I will shortly return. Just as does Sartre, Merleau-Ponty couches his characterization of the gaze in the rhetoric of romantic union, but Merleau-Ponty's version remains not just ungendered but reconfigured, where the "couple," although "more real than either [the seer or the seen]," is joined in a kind of amalgam independent of its twin points of origin. This relatively desexualized notion of joining through the gaze is both intensified and shifted slightly when it involves two seers, where other eyes are comprehended as the means of making the self more fully visible:

What is proper to the visible is, we said, to be the surface of an inexhaustible depth: this is what makes it able to be open to visions other than our own. In being realized, they therefore bring out the limits of our factual vision, they

betray the solipsist illusion that consists in thinking that every going beyond is a surpassing accomplished by oneself. For the first time . . . [transitively] I appear to myself completely turned inside out under my own eyes. (Merleau-Ponty 1968, 143)

The "solipsist illusion" that Merleau-Ponty draws attention to here aptly names Freud's perceptual bias which enabled him to imagine as universal a particular male·valuation of the meaning of woman's body, just as Merleau-Ponty's contention that not "every going beyond is a surpassing accomplished by oneself" opens up a space through which to reconsider the intimacy with which the gaze has been linked to subjective agency.

The alternative form of seeing that Merleau-Ponty conceptualizes, whereby we can be "open to visions other than our own," is neither feminized, nor claimed as instrumental to the violent inception of knowledge or art. Rather, Merleau-Ponty equates "inexhaustible depth" with an ever-broadening plurality where the binary codes such associations depend upon collapse under the weight of truly multiple determinacy. The inversion made possible by these other visions, in which "I appear to myself completely turned inside out under my own eyes," so far from tortured, should be understood instead as a vast multiplication of surfaces, exposing new and greater depths in the realm of the visible. Merleau-Ponty indeed turns inside out the exclusionary logic of the subject/object dualism, not through reversal but through a kind of opening out and expansion of the two terms to the degree where their identities as well as the structures which order and divide them are lost in a larger plurality. When Merleau-Ponty expresses the impact of other visions as a state where "I appear to myself completely turned inside out under my own eyes," perhaps he is voicing what Eurydice or Orpheus might say (if only they could speak) as they contemplate each other in Ovid's underworld.

Eyeing the Negative

Merleau-Ponty's haptic utopianism is useful in delineating what is at once a clear alternative to scopic relations but also its structural mirror; rather than interrogating subjectivity itself as a suspect category, it preserves at its core a notion of subjectivity that it attempts democratically to extend to all seers-as-subjects. To this extent, Merleau-Ponty may be said to remain within a dominant scopic regime of modernism, despite his revisionary impulses. The scopic and haptic aspects of that regime, I have tried to show, are linked together as ideological dominant and its Other; the two remain dialectically engaged in Blanchot's essay, but only, as I will demonstrate below, as undercurrents or traces. When we shift our focus

from those undercurrents to the more overt movements of meaning in Blanchot, we find that the essay seeks to move *beyond* those dialectical possibilities toward a conception of the gaze detached from its basis in the subject-as-agent, however compromised and delimited that subject might be by its own veiled embodiment. In so doing, "The Gaze of Orpheus" steps away from modernist visual paradigms that depend on a subject-gaze—even one governed by mutuality—and toward an evacuated notion of the subject, for whom the gaze appears to be a symbolic apparatus it doesn't generate and wield so much as borrow. To follow the essay's own charged iconography: as Orpheus steps from the illuminating daylight into the obscurity of darkness, it becomes difficult to discern his outlines reliably or to determine whether we are regarding a subject at all, and not its shaded vestige.

The currents that gain enough momentum in "The Gaze of Orpheus" to pull beyond its scopic subtext are those that lead to spaces of profound indeterminacy—profound in that they resist recuperation into *any* stable location. As Gerald L. Bruns argues about Blanchot's *The Space of Literature* generally (from which "The Gaze of Orpheus" is drawn), the work of art in Blanchot is "external to all categories"—a space comprised of "neither an inside nor an outside but . . . rather outside the many-sided categories and dimensions of in and out. In this region nothing can be counted or measured. It is outside time but not eternal; it is a space but it cannot be placed" (Bruns 1997, 57–58). With regard to "The Gaze of Orpheus" itself, Michael Newman suggests that in Blanchot's recasting of the myth, "Eurydice comes to figure the 'object' that is between the subject and that alterity, identified by Blanchot with the 'other night,' which exceeds dialectic" (Newman 1996, 160). John Gregg supports this postdialectical assessment in his observation of the ways such apparent oppositions in the essay as law and transgression, apparition and disappearance, unification and dispersion, patience and impatience, the night and the other night, should be understood not as simple, logical oppositions, but rather as "a surplus of negativity" that exceeds those terms (Gregg 1994, 52–53). The experiences which escape such oppositions describe the limits of where language can go, as Steven Shaviro contends: "Such experiences are irreducible to the cultural norms of narration and conceptualization: incompatible with the social or Symbolic realm of representation no less than with that fictional (grammatical) center, or semblance of identity, which is the self or ego" (Shaviro 1990, 113). These readings, I would concur, convincingly render the force of Blanchot's dominant impulse to resist stable categorical oppositions, particularly those of subject and object, but in stressing this they remain unable to register or speak to the ways in which questions of gender and embodiment crucially inflect this work.

But before I examine that limitation more closely, I want briefly to explore the contours of Blanchot's indeterminate method in "The Gaze of Orpheus," so that its difference from both the scopic and haptic modes is fully apparent. These moments of indeterminacy surface throughout the essay (often in the same passages that yield alternate readings), achieving a kind of incandescence in Blanchot's elaboration of the moment of Orpheus gaze: "If he had not looked at her, he would not have drawn her to him, and no doubt she is not there, but he himself is absent in this glance, he is no less dead than she was, not dead with the tranquil death of the world, the kind of death which is repose, silence and ending, but with that other death which is endless death, proof of the absence of ending" (Blanchot 1981, 100). The passage carefully crafts its axes of difference (Orpheus has "drawn her to him" and yet "she is not there"), but also of sameness amidst difference ("he is no less dead than she was" and yet "with that other death") in ways that resist easy movements from antithesis to synthesis. Orpheus's absence, which rivals Eurydice's, and his comparable death intimate the redressing of the gestures of appropriation I considered earlier in favor of a parity that anticipates Merleau-Ponty—but these equivalences fail to establish themselves deeply enough to resist their own undoing. We can observe a similar construction of indeterminacy in a passage I read earlier in the context of scopic relations: "Orpheus' mistake, then, would seem to lie in the desire which leads him to see Eurydice and to possess her, while he is destined only to sing about her. . . . Eurydice represents nothing more than that magical dependence which makes him into a shade when he is not singing. . . . [O]nly in the song does Orpheus have power over Eurydice, but in the song Eurydice is also already lost and Orpheus himself is the scattered Orpheus" (101). While at first Blanchot stresses Orpheus's appropriation of Eurydice, initially eroticized as possession and then abstracted as song, the passage pauses in contemplation of their equivalence when it proposes Orpheus, too, as shade. But the passage's final gesture overturns as it destabilizes each of these, positioning two incompatible ontologies (Orpheus's power, and his own scattered loss) in the aesthetic beyond of the song. When we ask, how can he be at once singing and scattered? we can only respond: in the space of impossibility. Initial pairings of disparity and equivalence, then, quickly fall to cascades of loss and negation in "The Gaze of Orpheus":

> His inspired and forbidden gaze dooms Orpheus to lose everything—not only himself, not only the gravity of the day, but also the essence of the night: this much is certain, inevitable. Inspiration means the ruin of Orpheus and the certainty of his ruin, and it does not promise the success of the work as compensation, anymore than in the work it affirms Orpheus' ideal triumph

or Eurydice's survival. . . . The work is everything to Orpheus, everything except that desired gaze in which the work is lost, so that it is also only in this gaze that the work can go beyond itself, unite with its origin and establish itself in impossibility." (102)

The relations between self and other I have been tracing—the scopic model culminating here in Freud and Sartre; its rejoinder, in the haptic model of Merleau-Ponty; and finally the "going beyond" which Blanchot employs to overtly supersede that dialectical pairing—these cumulatively foreshadow a comparable triad of relations Blanchot explicitly articulates more than a decade after "The Gaze of Orpheus" in *The Infinite Conversation* (published originally as *Entretien infini* in 1969). In a discussion much indebted to Levinas's *Totality and Infinity*, Blanchot presents an apparent dialogue in which voices (whose number and identity, signified only by dashes, remain ambiguous) struggle to delineate the nature of relations between self and other. Two dialectical possibilities—the violent incorporation of the other and the union or ecstatic fusion with the other, reprise the lingering strands of such materials from "The Gaze of Orpheus"—so much so, in fact, that Blanchot recalls the myth specifically to exemplify the relation of the first type:

> —Let us once again recall Orpheus and Eurydice. Eurydice is the strangeness of the extreme distance that is *autrui* at the moment of face-to-face confrontation; and when Orpheus looks back, ceasing to speak in order to see, his gaze reveals itself to be the violence that brings death, the dreadful blow.

> —The second kind of relation would be, it seems to me, the following: unity is always not only demanded, but immediately attained. In a dialectical relation . . . the Self and Other lose themselves in one another: there is ecstasy, fusion, fruition. (Blanchot 1993, 60, 66)

The relation of the third kind—graphically signaled by italics in the text—brings these voices into contact, if not communion, in terms that recall the postdialectical negations of the 1955 essay:

> *I listen to these two voices, being neither close to the one than the other. . . . In this relation . . . the one is never comprehended by the other, does not form with him an ensemble, a duality, or a possible unity; the one is foreign to the other, without this strangeness of privileging either one of them. We call this relation neutral . . . a relation without a relation.* (72–73)

The parallels of these three relational possibilities—the self's incorporation of the other, the ecstatic fusion of self and other, and the "*relation without a relation*"—that subsist between the earlier and later texts indicate

the continuity of Blanchot's thinking from the 1950s on. At the same time, they suggest that it is only in 1969, and with the crystallizing influence of Levinas, that Blanchot is able fully to articulate the assumptions and parameters that I argue remained embedded and implicit in the earlier work.

The Gaze That Writes

In "The Gaze of Orpheus," it is out of the third kind of self/other relation that Blanchot strives to craft his genealogy of writing:

> The act of writing begins with Orpheus' gaze, and that gaze is the impulse of desire which shatters the song's destiny and concern, and in that inspired and unconcerned decision reaches the origin, consecrates the song. But Orpheus already needed the power of art in order to descend to that instant. This means: one can only write if one arrives at the instant towards which one can only move through space opened up by the movement of writing. In order to write one must already be writing. (Blanchot 1981, 104).

The conditions for writing are those of impossibility—of a tautology ("In order to write one must already be writing") instigated by the gaze as an instrument of transgressive license, whose origin exceeds its subject's volition. A comparison of this Orphic gaze with the counterpart employed by James's narrator in *The Sacred Fount* is instructive: what is a crisis of *embodiment* in James amounts to a crisis of *absence* in Blanchot. In James, that is to say, the gaze exposes only the visual indeterminacy born of the inescapably embodied eye of its subject-seer. The epistemological doubt which the revelation of the subjective gaze ushers in leads to a rejuvenation of language as a compensatory resource, for language promises to cover over the representational abyss left gaping by the partiality of the subject's limited vision.

In Blanchot, by contrast, Orpheus's gaze sets up the conditions for the evacuation of the subject position altogether. Just as Eurydice does, finally, Orpheus borrows a subject-gaze from which to view his own exclusion from the song, but that gaze is not reducible to a single seeing subject so much as it marks an (impossible) position. The relationship of that position to embodiment, like everything else about it, is ultimately elusive, and it collapses under the weight of its cumulative contradictions into the "space" of "impossibility." Orpheus's gaze presides over a sequence of losses—the day, the essence of the night, the work, Eurydice—that culminates in the loss of himself; in so doing, the gaze, like its other symbolic counterpart, language, reveals itself as an "agent" far more viable than the

subjects who borrow it in the hope of sustaining the illusion of their independent agency. As it does in James, then, language rushes in to fill the gap evacuated by the gaze, but the gap marks not an ambiguous space of knowing but, rather, an indefinable place of transgression. In an illuminating essay, Michel Foucault clarifies the relative distribution of agency between language and the subject in Blanchot:

> And the subject that speaks is less the responsible agent of a discourse (what holds it, what uses it to assert and judge, what sometimes represents itself in it by means of a grammatical form designed to have that effect) than a non-existence in whose emptiness the unending outpouring of language uninterruptedly continues. . . . Speech about speech leads us, by way of literature as well as perhaps by other paths, to the outside in which the speaking subject disappears. (Foucault 1987, 11, 13)

The subject serves as more of a ventriloquist of words than their place of origin in this conception, whose very status *as* subject is better understood as a position in language than as a depth or interior. In this way, language makes of *everyone* a Eurydice, destined to disappear.

As the latter observation may suggest, the consequences of this negative or disappearing conception of subjectivity for an understanding of the *gendered* gaze are significant. Much as Lacan's insight that *no one* really has the phallus despite male attempts to represent it confers some degree of equivalence on male and female positions, Blanchot's depiction of the loss of Orpheus *and* Eurydice through the agency of the gaze seems to render their distinctive gender positions finally moot. And just as Lyotard's insight that metanarratives have exhausted their utility seems to render their explanatory power harmless, Blanchot's eclipse of the Freudian metanarrative appears to make Freud's understanding of the gendered gaze obsolete. The conviction that we are all "just" positions in language offers a necessarily deracinated understanding of subjects and bodies which creates new challenges for thinking through questions of gender and representation. That problem has occasioned searching inquiries into the relative gains and losses of postmodern perspectives that seem to honor particularity and difference but do so at the cost both of viable means for systemic critique—in whose name can such critiques be conducted?—and of a viable subject imbued with sufficient agency to pursue the strategies of redress which might emerge from those critiques.[17] My own view, as this chapter demonstrates, is that we need to continue to think carefully about the ways gender differences, among others, are in-

[17] For fuller discussions of the encounter between a postmodern critique of metanarratives and feminist concerns of political organization and agency, see, for example, Nicholson 1990.

scribed in language; but however one tries to negotiate these impasses, it should be noted that they gesture well beyond the range of modernist preoccupations.

An approach to language that evacuates the subject in this way necessarily rejects modernist strategies of self-referentiality. Language, as Foucault observes (1987, 11–12), moves outward in a movement of dispersion that discloses the illusion of its subjective origins, rather than folding back upon itself in a play of interior reference whose resolution consists in self-recognition (such as we witnessed in Nabokov's *The Eye*). Orpheus's gaze with which the act of writing begins for Blanchot, then, by definition exceeds the parameters of the interior gaze, since there is neither a concealed truth available for vision to disclose, nor a viable subject whose expertise might recover it. Thus we may explain the borderline unreadability and incoherence of Blanchot's text, overtaken by linguistic forces seemingly beyond its control. Blanchot's shift from the third to the first person, along with his abandonment of the self-enclosed form of the novel altogether in the 1950s, together can be read as concessions to the foreclosure of access to such a gaze, and his turn to the récit arguably emerges as the new formal consequence of his acknowledgment of this "case of the disappearing subject" which I've been tracking. The blurring of literary and philosophical registers in Blanchot's later work may be taken as a measure of the revised terms in which the project of self-reflection must be cast, and an indication of the diminished horizons of visibility over which it presides. The function of the law in Blanchot also stands in marked contrast to its purpose in the modernist narrative worlds of James and Nabokov. The apparition of the law meant to regulate the gaze in "The Gaze of Orpheus" issues neither in the restoration of social order nor in the veiled spectacle of the subject's interiorization of its edicts, but rather, in the brief revelation of its role as the vanishing center of the language that speaks us. Revisited from such a vantage point, the crisis of embodiment staged in James's *The Sacred Fount* some half a century earlier seems almost quaint in all it dared to hope to see, and how much of self it managed to preserve.

Part II

THE BODY VISIBLE IN THE LENS OF AMERICAN SOCIAL SCIENCE

From "Spyglass" to "Horizon"

Tracking the Anthropological Gaze in Zora Neale Hurston

The "spy-glass of Anthropology," Zora Neale Hurston's telling meta-phor for her anthropological training under Franz Boas during her Barnard years, is perhaps the most quoted and least interrogated image in a body of work remarkable for its rich figuration. Used in Hurston's introduction to her first published ethnography, *Mules and Men,* the image is most obviously meant to signal the enabling distancing of perspective and self-regard which that scientific apparatus afforded her in her efforts to record the African-American folklore of her southern childhood.

> From the earliest rocking of my cradle, I had known about the capers Brer Rabbit is apt to cut and what the Squinch Owl says from the house top. But it was fitting me like a tight chemise. I couldn't see it for wearing it. It was only when I was off in college, away from my native surroundings, that I could see myself like somebody else and stand off and look at my garment. Then I had to have the spy-glass of Anthropology to look through at that. (Hurston 1990a, 1)

The "tight chemise" is a revealing trope in which to drape those familiar cultural stories. Hurston chooses an unambiguously female garment which both reveals the form and conceals the surface of the black body beneath, through a form of mediation. It's the chemise's decisive mediating function which Barbara Johnson emphasizes when she remarks that "inside the chemise is the other side of the chemise: the side on which the observer can read the nature of his or her own desire to see" (Johnson 1987, 182). But the chemise is not, I think, so easily separable from the body that's wearing it, which at least competes with it and may become

the chief, if unspeakable, object of visual interest in the scene. Hurston is clearly playing on the to-be-looked-at-ness of the female body in all of its erotically charged materiality here; what the phrase "I couldn't see it for wearing it" sets us up for is striptease—to see the chemise clearly, the logic of the phrase suggests, she'll have to take it off. Heading off this scandalous possibility is another visual feint, in which an objectifying rhetoric of *self*-reflection ("see[ing] myself like somebody else") is pressed into the service of seeing *the garment*, neatly displacing Hurston's body and making cultural stories the real object of the gaze. By the time she's peering with proper detachment through the spyglass, that objective instrument of science, Hurston has managed to dodge the problem of embodiment altogether—her own and that of the stories—which she confronts us with at the start. Given the problematic nature of that embodiment, in which the black female body must stand as both maker and interpreter of cultural meanings against more prevalent significations—the primitive, sexual excess—Hurston's strategy shouldn't surprise.[1] But the body remains as afterimage, reminding us of the personified nature of cultural materials and of the gendered, voyeuristic and objectifying underpinnings of the spyglass as an investigative instrument. The spyglass evokes not just the penetrating male gaze of science but the imperial white gaze of colonialism, both of which inform the ambiguous history of anthropology and its consolidation as a discipline in the 1920s and 1930s.[2] One might ask, To what varieties of striptease, in the form of identity positions, would the black female viewer be subject when aspiring to organize her world through that lens?

This chapter tracks the patterns of such divestitures and reappropriations of identity positions, and the problems of embodiment each foregrounds, to demonstrate the path through which Hurston carves out the visionary territory to which she may lay claim in her work. The story I wish to tell highlights two crucial and conflicting aspects of Hurston's most publicly claimed identities—those of social scientist and novelist—which she occupied by turns over the course of her career; and it dwells on the challenges that each of these identities posed for Hurston in the context of discourses about African-American cultural development and attainment in circulation in the 1920s and 1930s—discourses inseparable from conceptions of the primitive which predate and define the terms in which

[1] For a history of the ways the black female body was viewed as a site of atavistic sexual difference and excess, see Gilman 1985.

[2] For an account of anthropology's roots in imperialism, and charges of its indifference to the exploitation of subject peoples, its use of knowledge to benefit whites, and its complicity as an instrument of white rule, see Willis 1969 and Caulfield 1969. In light of this institutional context, what critics beginning with Richard Wright have seen as Hurston's neglect of the issue of the exploitation of blacks by whites can perhaps be understood as a discipline-wide subordination of issues of exploitation to culture; see Caulfield 1969, 184–85.

such cultural notions were broadly conceived.[3] Hurston's 1937 novel, *Their Eyes Were Watching God,* positioned as it is chronologically between her two ethnographies, *Mules and Men* (1935) and *Tell My Horse* (1938), and written during Hurston's fieldwork in Jamaica, powerfully encodes the intersection of these identities and discourses; it thus provides a multilayered "testimony" about African-American cultural forms, both in itself as a species of the African-American novel and through the conflicting discursive trajectories it contains and works precariously to resolve. I frame my reading of *Their Eyes* between what I argue are the two most prominent of those discourses for Hurston, one of which takes its bearings from the name of science and the other from art.

I begin, as the initial image of the spyglass may suggest, with Boasian anthropology, whose participant-observer method, theory of cultural relativism, and critique of the comparative method of anthropology cumulatively reframe primitivist discourse in ways that are at once enabling and disabling for Hurston. Boasian theory, that is, provides a fully realized conceptual basis from which to revalue African-American expressive forms, but it accomplishes this through a problematically objectifying distance from its selected objects of study; moreover, it retains a concept of the primitive still tainted by its derivation from evolutionary biology, however much it was reformed by Boas, thereby reinscribing the very forms of cultural hierarchy it elsewhere works to discredit. Using this framework, I read *Their Eyes* as Hurston's attempt to revise anthropological method in ways that initially privilege active participation in and celebration of African-American folk culture; however, Janie Crawford's transformation from folk heroine to visionary at the conclusion of the novel, I argue, demonstrates how Hurston's revision moves beyond a critique of anthropological methods and toward an idealist model of individual transcendence. I conclude, then, by tracing the roots of that model to a second, historically anterior, and perhaps unanticipated discursive source, Emersonian Romanticism, through which I delineate the specifically transcendentalist terms in which Janie's transformation from folk heroine to visionary artist is effected. Like Boasian anthropology, Emersonian theory figuratively gives and takes away its cultural capital with the same paternalistic hand, as it situates its notion of the primitive within a paradigm of cultural development and aesthetic currency. Emerson's celebration of the poetic, picturesque language of "children and savages" provides an alternative and aesthetically particular discourse through which Hurston can reclaim African-American linguistic practices. But her attempt to refashion the dimensions of Universal Being and transcendence associated

[3] For further discussion of Hurston's intricate racial identifications and disidentifications, particularly later in her career, see Posnock 1998, 208–15.

with cultural and artistic maturity into a viable visionary consciousness for her folk heroine, Janie, obscures the specific history of black embodiment which prefigures and, for Emerson, disqualifies her from those achievements. We may see the appeal of Emerson's disembodied seer through which Hurston elevates Janie at the end of the novel, therefore, as an imaginary, if not outright false, resolution of the real social contradictions Hurston inhabited, a "solution" which paradoxically suggests the intractable nature of black embodiment as an ontological problem for her. Yet, without contradiction, we may equally understand Hurston to be adapting Emersonian paradigms to suit her own needs: through her appropriation of them, Hurston arguably exposes Emerson's blindness to the situated nature of embodiment and complicates his account of "primitive" artistry, at the same time that she reclaims that portion of the American literary inheritance that he theorizes and personifies.

Through a Spyglass Darkly: The Participant-Observer of Boasian Anthropology

Unlike Boas's other famous female students, such as Margaret Mead and Ruth Benedict, whose foreign, exotic fieldwork experiences conformed with disciplinary prestige and expectation, Hurston is unique for pursuing fieldwork not merely in the southern United States but in her own hometown—the first incorporated black township, Eatonville, Florida.[4] Even in her second ethnography, *Tell My Horse* (1938), in which she investigates Voodoo practices on the foreign soil of Jamaica and Haiti, Hurston apparently views those populations as sharing some of the same West African cultural influences as African Americans, a perspective which may explain both her interest in those countries and her willingness to break with anthropological convention by considering two distinct nations together. The spyglass passage, then, is important for what it reveals about Hurston's equivocal position as both subject and potential object of the anthropological gaze as she pursued her research into African-American folklore and African-influenced religious and cultural practices. Hurston's facile placement and displacement of her material body in the opening sentences of *Mules and Men* operates both as a condensed illustration of anthropology's participant-observer method and as a send-up of its detached and neutral pretensions by exposing the ways in which the bodies on either side of the lens are "material" to the insights it's credited with producing.[5] I want to consider the principal features of

[4] Melville Herskovits later joined this company, but I am concerned here with the problematic positioning of the black and female gaze.

[5] Hurston's research on an indigenous subculture that some observers experienced as "deviant" arguably places her project closer to sociology than social anthropology in key ways,

that method here, particularly its complex relations to notions of the primitive, the better to grasp the equivocal rewards anthropology offered Hurston in the early part of her career.

The participant-observer method, the conventions of which, according to James Clifford, had won international acceptance by the mid-1930s, combines general theory with empirical research, cultural analysis with ethnographic description, in a practice through which the personal experience of the ethnographer is framed and filtered through scientific method.[6] Particularly for Boas, the participant-observer method was meant to produce a wealth of empirical ethnographic data from which theory could only tentatively be derived, and never at the data's expense. There were, of course, numerous unacknowledged limitations to the method. The fieldworker, mythically and presumptively white and male,[7] must set aside his own cultural biases and assumptions in order to see from a monolithically conceived "native point of view"; the fruits of this perspectival reorientation could then be translated culturally, linguistically, and generically into the newly standard ethnographic document, the monograph—purified by science beyond the subjectivist distortions of the diary, the travelogue, and other degraded narrativizing procedures. A recurrent feature of the monograph, often born of the necessity for efficiency in the face of limited fieldwork time, was the selection of a single individual or institution to represent larger cultural truths; this synecdochical logic clearly exerts a homogenizing force against cultural variety, conflict, and difference. Even bracketing such translations, as a chorus of post-Geertzian anthropologists have made clear, the dirty little secret of the participant-observer method is its masking or denial of the complexity of the intersubjective encounter between fieldworker and native, and its inevitable power relations, by seriously proposing what Hurston only burlesques: that cultural assumptions and biases can be taken on and off at will, like clothing. Boas himself, arguably anthropology's most enlightened and methodologically scrupulous early twentieth-century practitioner, makes the tain of this objectivist mirror readily visible in an early, rapturous account of cosmography in which the cosmographer "holds to the phenomenon which is the object of his study . . . and lovingly tries to

and it makes her version of the participant-observer method appear more mainstream. The naturalist method pioneered by the Chicago school of sociology in the 1920s and 1930s, for example, placed less emphasis on objective study and greater stress on the interaction between the observer and the observed. But Hurston clearly allied herself with Boasian methods, as her request that he write the foreword to *Mules and Men* suggests. See Roberts 1975.

[6] For a full discussion of the history of the participant-observer method in anthropology, see Clifford 1983.

[7] Marianna Torgovnick offers a compelling analogy for the gendering of civilized/savage relations in anthropology, comparing the mythic model of the Odysseus/Polyphemus relationship, in Homer's *Odyssey*, with the male anthropologist/native Other; see also Sontag 1996.

penetrate into its secrets until every feature is plain and clear. This occupation with the object of his affection affords him a delight not inferior to that which the physicist enjoys" (Boas 1940, 645; quoted in Krupat 1990, 139). The translation of data into text evidently could be stimulating, not to say perilous.

The Boasian professional fieldworker was further distinguishable from his predecessors—the amateur, the tourist, the missionary, the untrained observer—by his attitude of cultural relativism. With his theory of cultural relativism, Boas maintained the equality of different cultural formations while detaching them categorically from race, thus countering an overtly racist evolutionary discourse that positioned blacks as atavistic precursors to white civilization. Cultural relativism was thus a blow to the thinking that arranged racial development hierarchically and unchangeably, and to the very idea of "primitive" culture altogether, whether expressed in the respectable, scholarly form of Freud's *Totem and Taboo* (1913) with its evolutionist vision of the ways the rituals and prohibitions of "primitive peoples" are reconfigured as "complexes" in modern, civilized man, or in the openly racist and jingoistic form of Lothrop Stoddard's *The Rising Tide of Color* (1921) with its conception of successive waves of "savage" colored races swamping white civilized strongholds.[8] In a cultural moment in which Darwinian and Lamarckian evolutionary theories were vying for adherents (Kuper 1988, 129),[9] Boas was conducting anthropometric studies—he had Hurston measuring heads on Harlem streets in 1926 (Hemenway 1977, 88)—which he used to prove that the categories of race and culture were not coextensive, and therefore that racial characteristics have no essential or genetic basis.[10]

Beyond its anomalously progressive racial politics (it would take until World War II for cultural relativism to gain wide acceptance as a theory), what's so striking about Boasian anthropology is its retention of an almost positivist insistence on the untainted, unmediated scientific gaze as a tool for producing reliable knowledge. Relative to its contemporaries in the hard sciences, for example, which had to contend with the relativization of observational postures previously conceived of as neutral in such theories as Heisenberg's Uncertainty Principle, Boasian anthropology kept faith with a doctrine of observable truths made possible by proper fieldwork methodology. In her autobiography (Hurston 1991, 127), Hurston herself celebrates Boas's "genius for pure objectivity" and his passionate

[8] See Freud's account (1950, 140–51), for example, of the transmutations encompassed in the literal killing of the primal father by "savages" compared with the psychically contained Oedipus complex; see also Stoddard 1921.

[9] Kuper stresses the influence of German debates about Darwin versus Lamarck on Boas's thinking.

[10] Another Boas student, Otto Klineberg, whom Hurston assisted informally in the 1930s, published *Characteristics of the American Negro* in 1944, which set forth the same conclusions.

allegiance to facts over theory. If we are tempted to view Boas himself as a kind of throwback in the evolution of twentieth-century science, however, Arnold Krupat complicates this portrait. While Boasian anthropology seems to resist what has been characterized as the epistemological crisis of 1885–1915 and its shift toward relativity, it doesn't ignore so much as selectively implement relativist discourse:

> Boas and his students seemed to find the new relativity not the foreclosure but the promise of objectivity, scienticity, and realism. Relativism, for Boas, was understood primarily to mean cultural relativism, and a stance of cultural relativism (which was not taken as implying a general epistemological relativism) as enabling a satiric method by which to expose the abundant undocumented generalizations indulged in by practitioners of "the comparative method of anthropology." (Krupat 1990, 134, 137)

Exposure to cultural difference then, for Boas, would have a relativizing impact that would yield a defamiliarized, objective view of culture without impugning the scientific purity of the anthropological gaze itself. However, Boas's insistence that individual cultures be studied on the basis of their distinctiveness and particularity didn't insulate him from producing distorting cross-cultural analogies, any more than his adherence to the participant-observer method prevented him from compromising "pure" observation with subjective perspectives. The primary vehicle for such distortions, I am arguing, is Boas's retention of the cultural category of the primitive, the institutional origins of which were inevitably linked to an evolutionary model of cultural and racial development, and which were arguably methodologically imbricated in the objectifying gaze of anthropology's participant-observer practice and its structurally implicit hierarchies as well.

While Boas could argue that the difference between primitive and civilized was more apparent than real in his 1911 work, *The Mind of Primitive Man*, he nevertheless supplies a wealth of criteria which uphold the distinction. Primitives, he argues, don't properly differentiate between the human and animal, adhering instead to idiosyncratic, irrational classification systems that arise from unconscious processes; they reify attributes as objects and engage in anthropomorphism; and they are the captives of traditional ideas unamenable to advancing civilization through conscious betterment. One hesitates to find a folk literature in any culture that wouldn't match all but the last of these criteria; and, of course, what constitutes advancing civilization is a highly subjective judgment. Moreover, the rationality of mythic systems has been defended by later anthropologists such as Claude Lévi-Strauss, who has argued that the logic of mythical thought "is as rigorous as that of modern science, and the difference lies, not in the quality of the intellectual process, but in the nature of the

things to which it is applied" (Lévi-Strauss 1963, 230). Boas understood such distinctions to be scientifically derived, and offered them by way of disputing the popular, and implicitly racist, characterization of the primitive as unable to inhibit impulses, and as having neither the powers of attention, the originality of thought, nor the ability to reason that civilized man enjoys. He concludes that the transition from primitive to civilized is marked by the "lessening of the number of emotional associations, and an improvement of the traditional material that enters into our habitual mental operations" (Boas 1931, 250)—a definition which endorses the twin virtues of scientific rationality and progress that are the hallmarks of Enlightenment thought, and subject, therefore, to a by now familiar critique of the mechanisms of power and repression which underwrite it.

By dwelling on Boas's engagement with the category of the primitive here, I by no means intend to identify him as an especially pernicious voice in the history of primitivist discourse. Indeed, even an avowedly progressive thinker like Marianna Torgovnick makes a case for the ongoing utility of the concept, and the futility of substituting more "value-free" terms (Torgovnick 1990, 20–21). Adam Kuper notes the remarkable persistence of the concept *despite* such contributions as Boas's, and its rapid dissemination beyond the preserves of social anthropology to infuse "the political and historical consciousness of several generations" (Kuper 1988, 14): Torgovnick explains the immense attraction of the concept to be its chameleon-like, dialectical ability to represent the Other for the cultural imaginary in positive *and* negative terms, as Edenic social palliative or "barbarian at the gate" as the cultural moment warrants. Michael North makes a similar observation about the attractions that racial masquerading and the appropriation of black dialect held for white modernist writers, demonstrating the latitude it afforded them "to play at self-fashioning" through rebellion against linguistic and cultural standardization, at the same time underscoring the conceptual slide between primitivism and blackness in the discourse (North 1994, 11).

The grip of evolutionary thinking on the concept of the primitive and its overdetermined spectrum of racialization is evident in a diversity of cultural documents, from white Bloomsbury critic Roger Fry's celebration of the superior freedom of expression and formal aesthetic success of the "savage" in an 1920 essay on Negro sculpture;[11] to the assurance Alain Locke found it necessary to offer his readers in his 1925 anthology of the Harlem Renaissance, *The New Negro*, namely, not to expect represented in its pages "the mind of a savage" but rather individuals who have achieved "cultural adolescence and the approach to maturity"; to William Stanley Braithwaite's ridicule of the formula of "atavistic race-heredity" as the re-

[11] For an extended discussion of Fry's "primitivist aesthetics," see Torgovnick 1990, chap. 4.

current plot of fictional depictions of Negroes by whites, in the same volume (Locke 1992, xxvi, 35). (As late as 1950, in one of her last essays, Hurston would herself renew this complaint against "the folklore of reversion to type" [Hurston 1995, 953]). In this cultural climate, little wonder that the only way Boas-trained anthropologists could find to implement cultural relativism's presumption of cultural equality and difference with regard to African Americans, according to John Szwed, was to view them as lacking any culture at all, as the victims of cultural stripping accomplished through a legacy of slavery which left them with only a deplorable cultural deficit.[12] A glance at the contents page of *Folk Beliefs of the Southern Negro* (1926) by Niles Newbell Pucket, Hurston's leading contemporary in the field, reveals the sedimentation of concepts of the primitive in a formal ethnographic context, in which a version of the Boasian notion of traditional ideas sits side by side with popular notions of uninhibited impulses—among the topics Puckett addresses are "Laziness, Humor, and Sexuality," "Mutilated English," "Fewer Restrictions upon Self-Gratification," and "Fossilized Customs."

Trained by Boas in anthropological theory and methods, partaking in the literary milieu of the Harlem Renaissance and debates about its modernist qualifications, exposed to popular discourses of the primitive, and immersed in African-American folk culture by personal history and profession, Hurston was situated in a conflictual vortex of hierarchical discourses involving race, artistry, and cultural attainment. Boas's participant-observer method, his theories of cultural relativism and of the independence of racial and cultural variables, and his critique of the comparative method of anthropology all clearly helped Hurston gain sufficient purchase on African-American folk materials to revalue them as complex cultural forms worthy of study and record. At the same time, Boas's theories posed peculiar problems for this African-American woman. First, the participant imagined by the participant-observer method was clearly a guest, not a member, of the community he documented, and possessed a world of tacitly superior cultural differences—including a talent for objectivity—to temporarily suspend; not so, Hurston. Second, the expected translation of oral materials into written texts, whether into the monograph of anthropological science or into the novel of Western literature, could only be a vexed one, the division of oral from written expression being inseparable from its historical use as a litmus test to police the boundaries of primitive and civilized.[13] Arguably, to commit folklore to paper in

[12] As Szwed points out, Melville Herskovits was an exception to this trend, but his perspective was largely ignored at the time.

[13] James Clifford (1986, 112–13) describes the allegorical dimension of the transformation of experience and oral expression into text, and its collusion with an "allegory of salvage" casting the lone ethnographer as the anguished custodian of a fragile, disappearing

any form was to participate in a hierarchy of cultural representation. Hurston's dilemma, staged for the length of her career, was to choose between the hierarchy of science and "objective" knowledge mandated by the conventions of the monograph, and the hierarchy of individuated high culture epitomized by the novel, over and against "lower" collective expressive forms.[14] To collect, record, and otherwise make use of the folklore of her childhood, then, involved Hurston's anxious positioning as both an interloper in the world of anthropology and as an insider willing to sell out African-American arts—a dilemma exacerbated by the fact that her wealthy, white patron, Mrs. Charlotte Mason, retained legal ownership of her scholarship during the collecting trips that led to *Mules and Men*.[15]

Given these pressures, Hurston's preference for rehearsing folk songs, for example, until she learned them by heart, or undergoing Voodoo initiations that involved her in extended fasts and body marking to learn its mysteries, can appear to be ways of "proving on the flesh" knowledge which had the potential to be reproving once made text.[16] Hurston's sporadic sponsorship of folk-oriented theatrical and musical events likewise suggests the attractions that embodiment held for her over that of pure textualization. Deborah Gordon explains the much observed absence of interpretation and analysis in Hurston's ethnographies as the result of Hurston's methodological division between *two* mentors—Mrs. Mason, who herself in her work with Native Americans used a more documentary style of fieldwork collecting which excluded larger cultural references, and Boas (Gordon 1990, 160–61). But it seems possible that Hurston was simply resistant to what amounted to a self-reflexive interpretive enterprise mandated by Boasian methods, and actively preferred to let her subjects speak for themselves. Compared with her white modernist peers— Faulkner, for instance, or West, Nabokov, and Woolf—who presume a subjectively governed visual world and self-consciously explore its conse-

culture. Interestingly, Hurston herself is not exempt from such allegorizing impulses, sometimes depicting African-American folklore as an endangered form requiring immediate transcription, while elsewhere suggesting that, far from dying out, it is a vital, and evolving art (Hurston 1990a, 180).

[14] As Hurston's biographer, Robert Hemenway, encapsulates the conflict, Hurston "had known both written and oral traditions, had participated in American civilization at the levels of both 'high' and 'low' culture, and her commitment to folklore as a field of study was an inchoate challenge to the cultural imperialism that could declare those vertical judgments. . . . Yet even the sophisticated social science of anthropology was part of 'high' culture, a discipline whose methods suggested periodic sorties among primitive folk followed by a return to the Heights for analysis and evaluation" (Hemenway 1977, 100). I'm suggesting that the novelistic form was an equally vexed avenue of expression for Hurston.

[15] For a discussion of the intricacies of the Mason-Hurston relationship, see Hemenway 1977, chap. 5.

[16] For accounts of Hurston's music collecting and of her initiation into Voodoo rites, see *Mules and Men* (Hurston 1990b).

quences, Hurston was initially drawn to a more stable, confident model of visuality in Boas, which lent her preoccupations the prestige and validation of science; but her radicalizations of that model, at least in the early part of her career, produce effects that come to resemble those of her white literary contemporaries. It's noteworthy that in her long career, Hurston wrote only one entirely *interpretive* ethnographic piece—her "Characteristics of Negro Expression" of 1934—and in it, Hurston makes use of primitivist discourse herself.

"Characteristics of Negro Expression" is a curious document for many reasons, not least because it combines something like aesthetic theory with an essentialist compendium of racial "features," some of which, like Hurston's speculation on the relationship between Negro lip form and dialect, literally link the black body with types of expressivity. What makes "Characteristics of Negro Expression" a difficult and perhaps undecidable text are the ways in which it attempts simultaneously to deploy and rehabilitate the category of the primitive and its corollary, the imitative, as artistic resources. The essay opens by developing an analogy between the evolution of language as a medium of exchange and monetary systems: "Language," Hurston tells us, "is like money." Hurston offers three equations of presumed ascending complexity between the two terms: she links "primitive" descriptive language with the bartering of goods in comparably "primitive communities"; highly developed languages, replete with "words for detached ideas," correspond to the "legal tender" of a money system based on abstract equivalence; and "cheque words, like 'ideation' and 'pleonastic,' " which take abstraction to the next stage, Hurston associates with a specifically literary language, exemplified by the Milton of *Paradise Lost*. She concludes that "the white man thinks in a written language and the Negro thinks in hieroglyphics" (Hurston 1990a, 175). Now, this analogy lends itself most obviously to a progressive narrative in which Negro hieroglyphics, however affectively colorful and rich, are manifestly backward, indeed "primitive," compared with the elevated language of literature—represented, ironically enough, by personification.[17]

But this hierarchical ordering is less innocent and straightforward, I would suggest, than it first appears, shaped as it inevitably is by larger discourses about monetary and aesthetic currency in circulation during the 1920s and 1930s. When "Characteristics of Negro Expression" was published in 1934, five years into the Great Depression, the appeal of abstract monetary systems over barter was arguably no longer self-evident. As Melchior Palyi points out in a book about the collapsing gold standard, "more than one half of the 30,000 banks operating in 1921 had closed by the

[17] This theory of linguistic "development" is hardly original with Hurston, being a commonplace of Romantic thought from Emerson to Shelley. I say more about Hurston's debt to Romanticism at the end of the chapter.

end of 1933, more than 8,000 between December 1930 and June 1933, *wiping out $14 billion of deposits* in those two and a half years" (Palyi 1972, 217). Indeed, it's on the grounds of its abstracted detachment from concrete standards of value that Ezra Pound would condemn the apparently autonomous power of money in the practice of usury, first in "Hugh Selwyn Mauberley" (1919–20) and later in the Usury Cantos and in his 1935 polemic *Jefferson and/or Mussolini.* The new aesthetic "currency" of simplified language use that Pound developed with H.D. in the early teens as the Imagiste movement could be construed as merely a poetic correlative to Pound's insistence on the integrity of concrete objects and the dangers of abstraction in the monetary sphere. Imagism advocated "direct treatment of the thing" and to "go in fear of abstractions," while privileging the Image famously defined as the presentation of "an intellectual and emotional complex in an instant of time" (Flint 1913, 198–200; Pound 1913, 200–206). Pound's later preoccupation with the Chinese ideogram in the *Cantos,* understood (following Fenollosa) as a "thought-picture," and H.D.'s poetic hieroglyphs and palimpsests, all more closely resemble Hurston's hieroglyphic in spirit than Milton.[18] Moreover, the hieroglyphic itself is a richly suggestive figure, evoking complexity, poetic condensation, and cultural and historical depth through its allusion to Egyptian civilization.

Although no one, to my knowledge, has identified Hurston as a devotee of Imagism, such a discourse on the image, complete with its rhetorical repudiation of the literary habits of the past, was certainly available to her and to the Harlem Renaissance milieu of which she was a part. Yet I would hesitate to maintain that Hurston's endorsement of the hieroglyphic as the quintessence of Negro expression is all an elaborate ruse meant to deconstruct hierarchical categories at the moment they are invoked by capitalizing on its high-culture cachet and the suspicion now attached to abstract monetary systems—that sort of reclamation strategy seems more convoluted than it's worth. With all the attention Hurston has received restoring her place as an advocate of African-American cultural traditions, it's important not to idealize her contributions at the expense of understanding the historical constraints under which she wrote.[19] I would

[18] The conceptual resemblance works, of course, both ways. As Pound's use of the Chinese ideogram indicates, there is plenty of room for an analysis of white modernist Orientalist and primitivist appropriation here, as well as black modernist assimilation of "high-culture" aesthetic standards.

[19] Michael North offers such a deconstructive reading of a "primitivist" moment in an earlier Hurston essay, "How It Feels to Be Colored Me," in which he interprets Hurston's employment of jungle imagery as a purely strategic opportunity for her to undercut its cultural meanings. Such a reading, I would argue, suppresses Hurston's complex attachments to such imagery, which lead to competing rather than consistent motives and effects and help explain her choice to borrow it. See North 1994, 178–79.

suggest, however, that such countercurrents operate in the passage to complicate and potentially revalue the status of the "primitive" and its aesthetic currency, against "the stark, trimmed phrases of the Occident" (Hurston 1990a, 178) which make up the alleged standard. That they remain countercurrents is made clear by Hurston's very reliance on the sort of cultural evolutionary theory Boas worked to discredit, a theory that sought to distinguish "primitive" from "highly developed" languages in the first place.

The same kinds of contradictory valuations are at work in Hurston's discussion of originality and imitation. At first redefining imitation as fundamental to the artistic process, Hurston stresses Negroes' facility for adapting white cultural forms for their own use, thereby stressing their innate artistic resourcefulness; she then points out that Negro interpretations of whites' musical instruments have been *re*interpreted by whites themselves, transitively shifting the imitative burden to whites, while draining it of its primitivist connotations: "Thus," she determines, "has arisen a new art in the civilized world, and thus has our so-called civilization come." But ultimately, Hurston restricts the black imitation of white culture to a self-despising middle class, who "apes" as she puts it "all the mediocrities of the white brother," in a phrase that both strips imitation of its artistic endowment and reinscribes its primitive associations, but for the new reason of its repudiation of a now authentic black culture (Hurston 1990a, 181–82).[20] What emerges in Hurston's treatment of the concepts of the "primitive" and "imitation" in "Characteristics of Negro Expression" is an overt concession to perceived white standards of aesthetic value, contradicted by a covert endorsement of black practices as the crude but infinitely more vital form of cultural expression. Like "the truly cultured Negro" and the "Negro 'farthest down' " whom she celebrates in the essay, Hurston means to "like her own things best"; she only lacks an agreed-upon, sanctioned aesthetic standard through which to validate her preferences. What remains in suspension to the end of the essay is whether Hurston is arguing that Negro people and Negro arts really *are* primitive but nonetheless powerful and compelling, or that beneath the face of the so-called primitive lies an unlooked-for, alternative standard of civilization and aesthetic accomplishment.

Hurston's reliance on racial, cultural, and aesthetic hierarchies, here and elsewhere, is as striking as its overall instability in her thought. Reading across her ethnographies and autobiography, numerous contradictory statements implicating those hierarchies emerge which arguably tes-

[20] That Hurston felt it necessary to confront the charge of black imitation of white culture seems especially ironic given Michael North's argument about the pervasive mimicry of black dialect by white writers in the dialect literature produced from the 1880s on. See North 1994, 21–22.

tify as much to Hurston's internal conflicts and divisions as to her elusive, editorially shaped and constrained position as a speaking subject.[21] For the purposes of this argument, I'm primarily interested in the ways Hurston locates herself as a participant and observer in these works, because of what these locations reveal about her relationship to hierarchical positioning. As many readers of her ethnographies have noted, Hurston breaks with the conventions of the monograph in ways that anticipate postmodern methods and assumptions, by foregrounding her membership and participation in the communities she's studying and parading the often intrusive means by which she managed to collect materials.[22] Beyond this crucial issue of her placement, Hurston's statements about her methods and materials reveal an inconsistent relationship to them. In *Mules and Men*, for example, one of Hurston's opening moves consists in reassuring the reader that her return to her hometown of Eatonville isn't motivated by her desire "for the home folks [to] make admiration over me because I had been up North to college and come back with a diploma and a Chevrolet" (Hurston 1990b, 2); Hurston revisits this scene in her autobiography, *Dust Tracks on a Road*, with quite a different eye, conceding that "I did not have the right approach. The glamor [*sic*] of Barnard College was still upon me" (1991, 127), interfering, as she explains, with her ability to represent herself as one of the folk and to collect materials easily. Whereas in *Mules and Men*, Hurston makes solemn pronouncements about the efficacy of hoodoo rites and expresses her sorrow at the necessity of refusing a "two-headed doctor's" offer to remain as his partner, both of which would indicate her belief in hoodoo practices (1990b, 211, 205), Hurston adopts the decidedly detached, secular perspective of a scientific observer in *Dust Tracks on a Road*, explaining that "feeling a weakness in the face of great forces, men seek an alliance with omnipotence to bolster up their feeling of weakness, even though the omnipotence they rely on is a creature of their own minds" (1991, 201). In *Tell My Horse*, Hurston excoriates Haitians as liars and thieves in one breath, and ends her chapters in apparent cultural solidarity with the exclamation "Ah Bo Bo!" in the next (1990c, 101).

In every case, Hurston uneasily vacillates between speaking as and for the given group, as insider and outsider, participant and observer, divi-

[21] *Mules and Men* went through a series of drafts and revisions before its ultimate publication; and the editorial interventions into *Dust Tracks on a Road* substantially excised Hurston's sharp political criticisms of U.S. foreign policy, of Anglo-Saxons' superiority complex, and more, transforming it into a nearly pandering, unreliable text. For detailed accounts of the publication histories of Hurston's texts, see Hemenway 1977; to my knowledge, the most detailed account of editorial intervention into *Dust Tracks on a Road* is by Claudine Reynaud (1992).

[22] For detailed readings of Hurston's ethnographies, see, for example: Hernández 1995; Wall 1995a; Dolby-Stahl 1992; Sánchez-Eppler 1992; Boxwell 1992.

sions which are inevitably laced with implicit standards of cultural value. Significantly, the most memorable images from the two ethnographies are those that enact a predatory or ventriloquizing relationship to cultural materials. Hurston closes *Mules and Men* with the story of Sis Cat, who's tricked out of dinner by a lecture on table manners delivered by her main course, a rat, and learns to eat first and wash later; Hurston concludes: "I'm sitting here like Sis Cat, washing my face and usin' my manners" (1990b, 246), having dined, we must imagine, on a banquet of folktales and songs, the proverbial rat in the analogy. Hurston's allusion to her "manners" here, I should add, invites us to reconsider her consumption of those materials as mediated by conventions which mask, perhaps, the essential violence of the encounter. Hurston's second ethnography, *Tell My Horse*, gets its name from the Haitian god Guedé's habit of "mounting" human visitants or "horses" through whom or to whom he speaks, frequently in a spirit of social criticism; Guedé instructs his listeners to "tell my horse" a message which, in Hurston's view, should be understood as a selective opportunity for the masses to criticize their social betters in an otherwise rigid class structure. Hurston represents this practice of borrowing an authoritative voice to express otherwise inarticulable truths about social hierarchy as an enabling rather than violent relation, and clearly, it held for her sufficient resonance and power to motivate her selection of it as the book's title (1990c, 219–21); arguably, the two halves of the relation together epitomize Hurston own position relative to black culture, as the borrower and representative of an anthropological authority used alternatively to maintain and dispute high and low cultural divisions.

The Road to Horizon: The Turn from Boas in *Their Eyes Were Watching God*

It's in the light of Hurston's hierarchical preoccupations and their origins in the anthropological gaze of the participant-observer method that I want to reread *Their Eyes Were Watching God*. While much has been written about the centrality of voice in the novel, little attention has been paid to its visual registers, a striking neglect in a text featuring "eyes" and "watching" in its title, and which ends with the word "see" signaling a new, visionary consciousness for its protagonist. That *Their Eyes* is concerned with hierarchy has been more frequently noted, an observation based on its apparently celebratory depiction of the rural life of the African-American folk. My own reading is most indebted to those of Hazel Carby, Henry Louis Gates, Jr., and Sharon Davie, each of whom foregrounds Hurston's struggle with hierarchical structures, although coming to quite different

conclusions about their larger significances. For Carby, the substance of the novel is rooted in hierarchy, so that "critics are incorrect to think that Hurston reconciled 'high' and 'low' forms of cultural production"; instead, "Hurston could not entirely escape the intellectual practice that she so despised, a practice that reinterpreted and redefined a folk consciousness in its own elitist terms" (Carby 1990, 75–76). Through readings particularly of its folk materials, Davie describes Hurston's "explosion of societal, narrative and linguistic hierarchies in *Their Eyes*," arguing that the novel "not only inverts the terms of accepted hierarchies (black over white, female over male) but—more significantly—allows readers to question, if only for a moment, the hierarchical mode itself" (Davie 1993, 447). To be sure, many materials work to complicate and destabilize hierarchy in the novel, but Davie's case for its inversion, I would argue, is more utopian than the case warrants. For instance, while Davie characterizes Gates's powerful reading of Hurston's formal innovations in *Their Eyes* as "upsetting a linguistic hierarchy" (448), Gates himself describes Hurston's "speakerly text"—one in which free indirect discourse mediates between dialect and standard speech in the novel—as merely "resolv[ing] the implicit tension" between them (Gates 1988, 192). This is an important difference, and one which points to the contradictory character of *Their Eyes*.

What I hope to suggest, through a reading of the visual metaphors of cultural hierarchy in *Their Eyes* and Janie's positioning within them, are the ways in which the novel engages with antihierarchical fantasy despite its larger constitution through hierarchical structures. Through such structures, vertical, hierarchical forms intersect with horizontal, democratizing figures in uneasy coexistence, thereby spatializing Janie's equivocal posture at the center and margins of the folk community, as well as her evolution from object of the gaze to visionary figure. Such intersecting structures point also to Hurston's unstable position as cultural participant and observer, and as the producer and collector of oral stories who ultimately reifies them in print. Through its resolution of these myriad instabilities and conflicts, the novel can be read as a repudiation of the rationalized "language of visuality" of the anthropological gaze and a retreat from the problems of objectification and embodiment its empirical methods pose, in favor of a Romantic idealism that reestablishes Hurston's artistic project on new, seemingly universalist foundations. The American representative of that Romantic idealism is Ralph Waldo Emerson, whose notions of subjective transparency and poetic language help us to comprehend Janie's transformations at the end of *Their Eyes*.

I want to begin with Janie's retrospective narrative that occupies the body of the novel, because it introduces a set of hierarchical problems that the materials within the frame device are designed to resolve. The

largest formal, organizational and figurative structures the novel employs are hierarchical; and Janie is persistently presented in hierarchical terms as well. Again, formally, as Gates describes it in his argument about free indirect discourse, the novel negotiates a discursive path between dialect and standard English. Organizationally, it's unavoidable that the division of Janie's life into relational stages be interpreted hierarchically, since Janie provides such a commentary herself when she repudiates Nanny's high chair and community custom to live her own way (Hurston 1990d, 108). Whether we chart the novel's progress through Janie's acquisition of a voice, through her discovery of a genuine romantic love represented by the pear tree, as the ascension of racial authenticity over a false, white bourgeois ethos, or as the emergence of democratic over autocratic forms of social organization, the novel inescapably charts a descent from, or an ascent to, an identifiable ranking of values, at least until the complicating reversals of the hurricane and its aftermath.[23] Excluding its frame, the novel can also be read as a triumph of participation over observation, by tracking Janie's descent from Nanny's "high chair," associated with white women's privilege, detached observation and abstract contemplation, to the democratized space of the muck, where land and water, male and female, dark and light skins meet and commingle, and where Janie shares in work and storytelling against the expectations, raised by the combination of her money, light skin and femininity, of her "class[ing] off" (135). From Janie's initial positioning in the novel at her grandmother's front gate, "gaz[ing] up and down the road" and "waiting for the world to be made" (11), to her ultimate self-identification as a "delegate to de big 'ssociation of life" (6), Janie's development and increasing freedom is marked by the broadening range of her participation in activities initially cordoned off by racial, gender and class hierarchies.

The novel's two central images, the horizon and the pear tree, likewise seem designed to foreground issues of hierarchy. The horizon, as the place where "ships carrying wishes" sail in the novel's opening (1), remains a transcendental image of freedom and possibility in the text—"the biggest thing God ever made" (85)—which defines the outer limits of vision literally, and figuratively suggests it through the homonym "her-eyes-on." The horizon's axis suggests a leveling democratic force, a spatialized equilibrium, for the novel. But the horizon is frequently cut across by the vertical figure of the road or highway which promises to lead to it and its possibilities, but points to the obstacles of hierarchy instead. Hurston employs the road this way in her adaptation of the Exodus story to narrate Nanny's flight from slavery to freedom, when she describes her intent to

[23] While I invoke some of the most readily available readings of the novel's trajectories here, I do not provide an exhaustive list, nor do I dispute the many factors that complicate such trajectories' unidirectionality.

"throw up a highway through de wilderness" for her daughter, but "got lost" (15), en route, one imagines, to the horizon as promised land. Horizons and roads, it seems, may work at cross-purposes in the text.[24] The pear tree, a visionary figure of self-discovery and eroticism in the novel, also spatializes the intersection of horizontal and vertical forces through its network of branches and roots. Hurston employs it as a tree of life, with "dawn and doom . . . in the branches" (8), and as a genealogical tree, when Nanny describes "colored folks as branches without roots" (15). In both images, vertical and horizontal axes are in conflict, with life threatened by doom, and the branches of the present cut off from their past. Hurston also uses the tree to isolate Nanny from the branches' horizontal promise, describing her head as "the standing roots of some old tree . . . torn away by storm" (12), a Medusan image both vertical and inverted, the very image of destructive hierarchy to which she'll be linked elsewhere in the novel, particularly through the vertical iconography of the "high chair." As figures constituted through visual condensation, the horizon and the pear tree can be understood as a species of hieroglyphic which encapsulates the larger crosscurrents in the text, and recalls the "primitive" hieroglyphics Hurston linked with black expressivity in "Characteristics of Negro Expression." Ultimately, I will argue, they forge a link between the strictly visual and a visionary epistemology in the novel.

The intersection and obstruction of horizontal with vertical structures also tells a larger story of Janie's positioning within her marriages and communities in *Their Eyes*. The novel is endlessly engaged with reshuffling Janie's social status and its nominal causes, suggesting the significance of that instability as a key to her social relations. Because it is framed through a heterosexual romance plot, the hierarchical structure most overtly foregrounded is that of gender, with the couple functioning as a primary space of power; but the structure is inseparable from the inflections of race and class as they are defined by the community. By making the freewheeling, gambling, box-picking folk hero Tea Cake the culmination of Janie's romantic career, Hurston would seem to be positioning Janie to evolve into a corresponding folk heroine. But her inability to sustain that posture reveals Hurston's own ambivalent relationship to the folk, as its sometime member and chronicler, and exposes her treatment of the folk as far more critical than the idealized love relationship at first indicates. Hurston's two apparent aims in *Their Eyes*—to make a heroine of Janie and to celebrate the folk—run parallel only briefly because the two projects fundamentally conflict. Following the hurricane's exposure of the folk ideal as predicated on egalitarian fantasy, Hurston's efforts to

[24] The image of the horizon is clearly a resonant one for Hurston, and she returns to it when praising a favorite teacher as "a pilgrim to the horizon" (Hurston 1991, 107).

produce Janie as a folk heroine collapse in a sequence of irreconcilable divisions: poor versus middle class, black versus mulatto, male versus female, collective versus individual, and finally, embodied folk versus disembodied visionary.

Although Janie is the bastard child of a mother who has been raped by a white man and turned to drink, and ends her story in a pair of dirty overalls, Janie is a folk heroine who won't stay folk. True, her early life with her grandmother living in "de white folk's back-yard" leads schoolchildren to regard her as low, but the whites' hand-me-downs she wears make her seem too high (9). After her first marriage, her husband Logan Killicks says much the same thing, noting that she was "born in a carriage 'thout no top to it" but still thinks she's "white folks" (29). In some sense, this is quite literally true, as Janie's childhood misrecognition of herself in a group photograph would indicate: the "truth" that the objective, technological medium produces—that she's "colored" (9)—is not one she recognizes; indeed, it seems to instigate an alienated sense of identity or even its loss, as one of the white children's remarks makes clear: " 'Dat's you, Alphabet, don't you know yo' ownself?' "[25] Among other things, the moment underscores the enormity of what the objective camera eye (or any other objective apparatus) can't see, just as the name "Alphabet," standing in for the many names Janie is sometimes called, conveys the scope of what language can't say, in its abstracted attempts to name the self. And the moment draws attention to Janie's belief that she occupies a recognizably "white" position as universal subject which the discovery of being "colored" destabilizes. The continuity of Killicks's observation that Janie thinks she's "white folks" is worth noticing in the novel—when Janie returns to the community in the frame narrative which marks the end of her story, a neighbor sums her up: "She sits high, but she looks low" (3).

The novel equivocates about how she got up there. As a black woman, at least as her grandmother tells it, Janie occupies the very bottom of the social order, as "mule uh de world" (14), and is therefore obliged to try to raise her status through the traditional means of marriage and property. Nanny attests to how Janie's marriage to Logan Killicks secures her respectability ("everybody got tuh tip dey hat tuh you and call you Mis' Killicks" [22]), one which is substantially enhanced by his much touted organ and sixty acres. Hurston works to distance Janie from Nanny's materialism by depicting Janie's indifference to Killicks's land, but other details suggest her immersion in her grandmother's standard of values. Unlike at the end of the novel when, on the muck, Janie seems to interpret her husband's invitation to share the spheres of work and domestic-

[25] Barbara Johnson similarly reads Hurston's discovery of her blackness in the Jacksonville section of her autobiography (Hurston 1991, 68) as a loss of identity; see Johnson 1987, 175.

ity as an opportunity for gender and class parity, she greets Killicks's intention to buy her a mule of her own to plow with as a violation of her newly won status; when Killicks asks her to help in the fields, she counters, "Youse in yo' place and Ah'm in mine" (30). Her decision to leave Killicks for the prosperous Joe Starks seems attributable, in part, to Joe's vision of a future in which she rocks on the front porch and eats "p'taters dat other folks plant just special for you" (28), restored to her perch on the high chair of which Killicks deprived her. At the moment of her departure from her marriage and property, even en route to more of the same, the status Janie could be said to derive from her husband would seem to be moot; it's clear, however, that she continues to be perceived in elevated terms, confronting us with an underlying standard of value which the text, perhaps unconsciously, endorses.

That the first men Janie and Joe encounter in Eatonville instantly recognize Janie's high status suggests that her appearance is decisive, since Joe hasn't yet had the opportunity to prove himself as an economic and political force, and the men aren't awed enough by marital sanctity to prevent their trying to steal another man's wife. Still, they recognize the futility of the job, as Lee Coker explains to Hicks about Janie: "There's some women dat jus' ain't for you tuh broach. You can't git *her* wid no fish sandwich" (37). Separate from her share in her husbands' property, Janie's value is made legible in the text through her "heavy," "plentiful" long hair, a marker not merely of female eroticism but of her mixed racial heritage as well (26, 28). It's this asset that Joe attempts to bank through Janie's enforced restriction from community life, save in an ornamental capacity as the "bell cow" (39); the hair, Janie's chief currency, must be tied up in the store to keep other men from "spending" it and diminishing its value. Joe's possession of Janie and her physical assets means control of their circulation, and predictably issues in Janie's exclusion from the public sphere—from speech making and porch "lying sessions" to the dragging out of Matt Bonner's mule and games of checkers. In the marriage to Joe, in short, Janie doesn't acquire so much as herself becomes property, the value of which is legible only through an imposed hierarchy of racial characteristics. Janie is thus highly valued and totally devalued, as the prized object in her conventional marriage. Her association with Joe strengthens the linkage between materialism and whiteness which contributes to Janie's value in this section of the novel. Joe's habits and preferences are identified as white, from the imperious "I god" which punctuates his speech to the plantation-style "big house" surrounded by "servants quarters" that Joe builds, and his style of compulsion which reminds townspeople of slavery days (44–45).

The position of observer to which Janie is restricted then, in this section

of the novel at least, couldn't be less associated with a masterful gaze save in an entirely self-reflexive way as contemplation, since Janie is herself her only possible object. Only white women, Janie argues, have a natural occupation in the high chair, presumably because their elevated cultural position enables them to be subjects of the sovereign view it affords them (107). Hurston stresses Janie's formal compliance but internal resistance to her objectification and subordination by multiplying images of her self-division. Janie develops "an inside and outside now and suddenly she knew how not to mix them" (68); a "shadow of herself" has come to "prostrat[e] itself before Jody, while all the time she herself sat under a shady tree" (73). Such images of Janie's "inside" are clearly meant to suggest Janie's development of an alternative, self-generated standard of value, but they also curiously interiorize the subject/object relations now disrupted with her husband. As Janie acquires a form of autonomy through these mechanisms, she initiates a reversal of subject/object relations, significantly, through the subjective prerogative of the gaze, by objectifying and feminizing Joe's aging body through the apparently fatal pronouncement: "When you pull down yo' britches, you look lak de change uh life" (75).[26] When Joe seems uncomprehending of the insult, Hurston signals the conflation of visual and verbal registers with Walter's phrase, " 'You heard her, you ain't blind' " (75);[27] Janie follows up her objectifying image of Joe with a speech explicitly condemning his autocratic rule (82). However, these various signs of Janie's emerging subjectivity—her expanding interiority, and her brandishing of the gaze and voice, may lead us to forget that Janie has also internalized herself as object. After Joe's death, in a scene clearly intended to affirm Janie's new status as a subject, she appropriately turns to the mirror in a moment of self-reflection: "The young girl was gone, but a handsome woman had taken her place. She tore off the kerchief from her head and let down her plentiful hair. The weight, the length, the glory was there. She took careful stock of herself, then combed her hair and tied it back up again" (83). As Janie takes stock or inventory of her material assets here in order to claim ownership of them, "tying them up" herself, her primary standard of value in her own eyes as well as others seems unchanged—the "glory" of her hair remains a signifier of her elevated place in a racial hierarchy, for the moment eclipsing the economic status derived from her husband that she now enjoys in a class hierarchy.

Interestingly, it's in the Joe Starks section of the novel, presided over by precisely the sort of self-despising middle-class black whom Hurston con-

[26] See also Washington 1988, 241.
[27] I am indebted to Gates's reading of this moment as an instance of synesthesia; see Gates 1988, 202.

demns in "Characteristics of Negro Expression,"[28] that folk materials make their presence most keenly felt. The section features mule stories, the self-contained buzzard fable, seemingly gratuitous depictions of courting rituals among dispensable characters and a caution/nurture debate, and culminates in Joe's dark hints about Janie's involvement with voodoo rites. While the materials are more or less subsumed within the fabric of the larger fiction, their presence and content raise larger questions about their functions in the text. To the extent that the mule is explicitly identified with the labor of black women and is implicitly identified with black folktales through the numerous stories it inspires, it can be understood as a rough symbol of the larger folk community; Davie (1993, 449) stresses the influence of the eighteenth-century derived discourse of black animality on the mule's meaning as well. Joe's perch atop the distended belly of the dead mule which he's formerly freed "like Lincoln," and over which he's delivering a mock funeral oration, literally dramatizes his position above the lowly folk, through an iconic and parodic enactment of the chain of being. Joe leads with a eulogy of the town's "most distinguished citizen," and Sam Watson preaches a sermon articulating for the first time the novel's fantasy of hierarchical inversion through a vision of mule-heaven, in which "mule-angels would have people to ride on" (57). But if we're tempted to take that vision seriously, we should remember that Hurston frames the scene by assessing its value for consolidating Joe's status, making him "more solid than building the schoolhouse had done" (57). When the world is really turned upside-down in the novel, I will argue, it only reveals hierarchy. Just as Janie does, the folk materials in the Joe Starks section serve both as yardsticks against which to measure Joe's greater power and prestige and, through their native interest and complexity, as indicators of possible alternative standards, standards which *Their Eyes* works to elevate through the world of the muck. It's in the Tea Cake section, particularly on the muck, that Janie's identification with the folk becomes most intimate, although the association is unstable and temporary; ultimately, Janie's positioning relative to the folk will be virtually indistinguishable from Joe's.

The hierarchical positioning of the Tea Cake section is complicated initially by its connection with the visionary, specifically, with Janie's vision under the pear tree and the spiritual transcendence with which it's associated. As Gates (1988, 191) notes, Tea Cake's full name, Vergible Woods, or veritable woods, identifies him as the incarnation of the pear tree's promise. Their affiliation thus elevates them: Tea Cake is named "a glance

[28] Like the middle-class Negroes of Hurston's essay, Joe too appears to distance himself from the black entertainment he privately enjoys; for instance, he refuses to participate in the porch "lying sessions," but he laughs "his big heh, heh laugh" at them just the same (Hurston 1990d, 51).

from god" (102); Janie has the "keys to de kingdom" (104). But the spiritual elevation in this section is counterbalanced by the physical movement southward, and mediated by a material and social leveling between Janie, Tea Cake, and the agricultural workers whom they join on the muck, all of which spatially and conceptually averages into a kind of social mean. In this section, the now well-off Janie blames her former "classing off" on Joe (107), and the novel dives headlong into a fantasy of a posthierarchical world, in which the social strata Janie classed off from in Eatonville—the storytelling, gambling, dwellers in the present—here emerge as the ubiquitous standard. Differences of age, gender, class, and race are here dismissed as purely conventional: youth is redefined as a state of mind; Janie is invited to partake and becomes adept at male-defined activities like checkers, fishing, hunting, and storytelling; after Tea Cake's impromptu feast, she tells him she'll kill him dead if he "classes her off" from a good time again; she turns her back on her money to take her place in the fields, thereby quelling concerns "that she thought herself too good to work like the rest of the women" (127); and she discovers the beauty of Bahaman drumming despite the scorn with which others regard it (133). After a season on the heterogeneous muck, Janie can answer the "color struck" Mrs. Turner's denunciation of dark-skinned Negroes and her support for a separate light-skinned class with color-blind indifference, maintaining that the mixing of such racial "classes" "don't worry me atall" (136). Instead, Mrs. Turner's "groveling submission" to the idol of the material white body and its approximations is presented as a contemptible parody of true visionary consciousness (138). Janie's new, "classless" identity is strengthened through her alliance with Tea Cake. Compared with Joe Starks's official and autocratic hold over the black community, Tea Cake's undisputed leadership on the muck is never formalized but is instead based on democratic affections and shared activities. Even the jealous blows Tea Cake delivers to Janie to prove his "possession" are preceded and matched by those with which she favors him when she drives off the persistent Nunkie. The muck, then, emerges as a truly utopian, antihierarchical space in which Janie comes into her own as a folk heroine.

But the hurricane exposes the myriad fractures in the fantasy of what turns out to be an antediluvian world. The first and deepest of these fractures is racial, initiated by Tea Cake's low rating of the Seminole's warnings of hurricane danger; by invoking instead the reliability and knowledge of the white bossman, Tea Cake reminds us that the muck is ultimately owned and governed by whites, bracketing and undermining his own democratic province. Significantly, the scene of hierarchical reversal accomplished through this "act of God" is prefaced by a visionary moment, suggesting that faith in a redemptive *material* sphere was after

all misplaced: "The time was past for asking the whites folks what to look for through that door. Six eyes were questioning *God*. . . . They seemed to be staring at the dark, but their eyes were watching God" (151). As wind and water give "life to lots of things that folks think of as dead" and "death to so much that had been living" (151–52), the hurricane instigates a full-scale return of repressed hierarchical relations in the novel: compared with the moving images of interspecies harmony Hurston offers, with disaster inspiring snakes and wild animals to a temporary hilltop truce, she shows a bleaker picture of human segregation, in which "white people had preempted that point of elevation" (156) that offers safety. Tea Cake is not only coerced by whites into burying the dead but also, as he glibly observes, helping God enforce the Jim Crow law through segregated burial and the provision of coffins for white corpses alone (163). The rabid dog's bite that Tea Cake sustains transforms him from a loving partner into a virtual animal himself, reversing the trend in the muck section of humanizing and elevating the folk. Janie, of course, is forced to kill the animal Tea Cake has become and, with it, her dream of gender equality made flesh; this paves the way for the further exposure of gender divisions at the trial, where white women provide Janie with the sympathy so conspicuously lacking in the response of the black men. The men conclude, revealingly enough, upon her acquittal: " 'Aw you know dem white mens wuzn't gointuh do nothin' tuh no woman dat look lak her' " (179). The final return of the repressed, then, is our confrontation with the species of value that has always fundamentally distinguished Janie from the folk— her mulatto features and the social status they both signify and allow.

While *Their Eyes*, I am arguing, is thus unable to sustain an unwaveringly level gaze at the folk beyond temporary fantasy, it makes one further attempt to subvert hierarchical relations through its strategy of Janie's embodiment. As we saw in Hurston's placement and displacement of her body in relation to the "spy-glass of anthropology" and its objectifying lens early on, and as we later observed about her evasion of the potential distortions endemic to textualization through her preference for cultural enactment, embodiment and its power served as a recurrent and important resource for Hurston. Although embodiment, too, risks the perils of objectification, those perils may be obviated by the body's potential to reassert itself as an experiential subject. Yet another way to track Janie's development in the novel, then, is by observing the ways in which she attempts such a reassertion against the objectifying impulses of other characters, who typically deprive Janie of her coherence as a subject through a fragmenting and synecdochical gaze. From Nanny's reproach against Janie turning her body into a "spit cup" (19) to Joe's fetishization of her hair and criticism of her "hanging rump" (74), to Tea Cake's loving regard for Janie's lips and eyes (99), up through the attention paid by

the occupants of the Eatonville porch to her "pugnacious breasts" and "firm buttocks" (2), the community of the novel sees Janie consistently in parts. But Janie resists this fragmentary vision through her resolute attempts to reassert her bodily integrity. She responds to Joe's criticism of her rump, for example, by insisting, " 'Stop mixin' up mah doings wid mah looks" (71), and concludes, as we've seen, by returning the same kind of objectifying gaze when she says, "When you pull down yo' britches, you look lak de change uh life." Her first act after Joe's funeral is to burn the head rags that signified Joe's definition of her as property and his ownership of her in parts, and to let down her hair (85). When Tea Cake literally jeopardizes her bodily integrity when he threatens her with his gun, she kills him and takes his "seeds"—meant for planting, but arguably a synecdoche for his body as well—with her. Janie responds to the anatomizing vision of the porch by redefining it as "Mouth-Almighty" (5).

But just as the evasion of hierarchy in *Their Eyes* proves only temporarily sustainable, Janie's resistance to the objectifying gaze through bodily reassertion doesn't turn out to be especially long-lasting and effective either. The final moment of its efficacy comes in what Carby has called the "gauntlet" scene, in which Janie's progress down the street upon her return to Eatonville is marked by a veritable tribunal of witnesses on the porch, who at first "couldn't talk for lookin' " at Janie (2). But "the porch" shortly finds its voice, its initial verbal reticence yielding to its articulation of the hierarchical standards that were momentarily submerged on the muck: "why don't she stay in her class?" they want to know, while the women hope that "she might fall to their level some day." Their language is also represented as a weapon—their questions are "burning statements" and their laughs are "killing tools" (2). Carby reads Janie's refusal to narrate her story publicly through "the directly told and shared oral tale" as exemplifying the division and antagonism between Janie as a species of intellectual and the porch as folk (1990, 82–84). I would agree that the novel draws attention to Janie's superior positioning here relative to the folk, as I've been suggesting that it has done really all along; but I would argue that Janie's refusal to speak, taken together with the violent terms in which the porch's willingness to speculatively (and falsely) interpret is rendered, suggests the novel's indictment and gradual withdrawal from textualization altogether, just as Janie's refusal to pause before the porch's gaze and her sequestration inside her house indicate her retreat from embodiment as a method of resistance. Granted, Janie tells her story to Pheoby and tries to include an interpretive apparatus along with it to guarantee proper "understandin' " (7), but she declines the job of conveying it to the community herself, instead retreating further into the privacy of the house and her "visions," and delegating the job of translation to her friend. It's at this point that Janie openly criticizes language as a

substitute for experience when she argues that "talkin' don't amount tuh uh hill uh beans when yuh can't do nothin' else," and concludes with her most explicit endorsement yet of empiricism as the key to knowledge: "you got tuh *go* there tuh *know* there" (183).

But the place to which Janie embarks after expressing this bold epistemology is not out into the world in search of an empirical horizon, but up a flight of stairs carrying, like Diogenes, a lamp "like a spark of sun-stuff washing her face in fire," which spatially and symbolically constitutes her as the ultimate visionary subject, ascendant over the degraded material world below and lit up with visionary power. (Pheoby anticipated this visionary transformation and rebirth when she described how Janie looked once having gained her own backyard: "You looks like youse yo' own daughter" [4]). Of course, Janie's ascent is pedestalled upon materiality—she owns those stairs, after all—but reminders of that fact are nowhere in evidence. Janie, furthermore, seems to divide from her own materiality in this scene, particularly as a black body, when "her shadow behind fell black and headlong down the stairs" (183); as she gains the top of the stairs, blackness drops to the bottom, so that she achieves both elevation and in a sense transparency. Janie is thus disembodied and dematerialized at the end of the novel, a state which allows her to transcend the difficulties and limitations of the material body altogether. She is now free—free to enjoy the "pictures of love and light against the wall," incarnating Tea Cake (184), and further, I'm suggesting, she is free from the problems of hierarchy and embodiment that have dogged her footsteps as an aspiring, empirically constituted seer throughout her journey. That freedom has been purchased, however, through the very hierarchical divisions her new status as visionary conceals: Janie cuts loose not only from her blackness but also from the voluntary poverty and association with black collectivity, part of her heterosexual "contract" with Tea Cake, in favor of a new identity as a single, middle-class individual.

Significantly, to describe Janie's visionary dominion Hurston employs imagery that recalls and selectively modifies the Boasian anthropological project. *Their Eyes* ends: "She pulled in her horizon like a great fish-net. Pulled it from around the waist of the world and draped it over her shoulder. So much of life in its meshes! She called in her soul to come and see" (184). The horizon, revealed here as an unequivocally visionary figure, is at once fashioned into a tool of collection, sifting and selecting the materials of life to be brought in for meditation and analysis, and reclaimed in the service of defining the self as world. The first set of meanings suggests a revision of the participant-observer method through the mechanism of the second set: in other words, Janie will assuredly reconsider observed materials through a secondary stage of interpretation, but here, her interpretive lens seems specifically introspective and subjective rather than em-

pirical and objective. By reimagining the materials of Janie's life as a store of resources reserved for the uses of the sovereign self, Hurston thus uniquely yokes anthropological method to an idealist project by draining it of its empiricist assumptions.

Emerson and the Language of "Primitive" Artistry

It's tempting to view Janie's turn away from empirical observation, experience, and the material body upon which they depend in favor of a dematerialized visionary posture as her—and Hurston's—precipitous flight from the African-American folk she so equivocally represents in *Their Eyes*. But I want to suggest that this visionary turn is not only a turning away, through which, as Carby critiques it, the "discourse of the folk . . . is irrevocably displaced in the figuration of a discourse of individualized autonomy existing only for the pleasure of the self" (1990, 88). Through the visionary, I would argue, Hurston is also turning back, to a Romantic discourse of language and self that enables her to redefine the "primitive" language of the folk as constitutive of a specifically artistic practice, one whose conceptual rewards apparently exceed the bounds of individual pleasure. Hurston's first flirtation with such a discourse goes back to "Characteristics of Negro Expression," in which she reproduces in her theory of the evolution of languages a symbolic paradigm popular in nineteenth-century Romanticism, sometimes referred to as the superseded theory of language (Baym et al. 1994, 1002 n. 3). Like a variety of eighteenth- and nineteenth-century figures, from Vico and Shelley to Herder,[29] Ralph Waldo Emerson took up the question of the origins of language by sentimentalizing the "primitive," equating the language of "savages" with a poetic purity, affective power, and an unmediated linkage

[29] A dominant model of historiography in Europe in the eighteenth and early nineteenth centuries conceived an elaborate analogy between the development of civilizations and the life cycles of man. An early and highly influential articulator of this idea is Giambattista Vico, for whom all nations pass cyclically through childhood to maturity, with each stage of their development being marked by a corresponding linguistic stage. Thus, poetry is portrayed as the definitive genre of primitive civilizations, tragic drama as the genre of young adulthood, and nonfiction prose as the genre of civilizations in full maturity. Vico's model is cyclic, positing a return; the late eighteenth century adopted the model and altered it to reflect a linear pattern of growth. The notion of correspondences between linguistic, individual, and national growth was popular among German intellectuals such as Herder and Niebuhr; it was an assumption that gave rise to the discipline of philology. Among British poets of the late eighteenth and early nineteenth centuries, the belief that cultures in an early stage of growth spoke a more metaphorically vibrant language was a source of some dismay; it forms the basis upon which Thomas Love Peacock and Percy Bysshe Shelley carried out their famous (and partly ironic) debate upon the history and modern viability of poetry. Blake, Carlyle, and Macaulay all explored, modified, and felt the influence of Vico's "developmental" historical/linguistic paradigm. See Steiner 1975, 75–80; Said 1975; and Roberts 1983, 63ff.

to nature, the return to which would revivify the linguistic resources of the modern poet. I'm interested here in the version of this paradigm articulated by Emerson in his 1836 essay "Nature" for its uncannily numerous correspondences with Hurston's conceptual language—beginning with the origins of poetic language in "Characteristics of Negro Expression," extending to the rhetorics of Universal Being and transcendence present in *Their Eyes,* and culminating in the novel's use of "thought pictures," particularly through its central figure, the horizon. If, individually, the points of intersection between Hurston's and Emerson's concepts and language appear merely suggestive, cumulatively they point irresistibly in a direction of discursive confluence. While it's impossible to know for certain whether or how widely Hurston actually read in Emerson, juxtaposing the two writers exposes a dimension of a discourse on primitivism and artistic authenticity indisputably present in her work, whose historical sources otherwise are hidden from view. The constellation of primitivism, artistic authenticity, and individual possibility and transcendence epitomized by Emersonian thought, I'm suggesting, was culturally and discursively available to Hurston, perhaps uniquely so as a student of anthropological discourses on the primitive. Hurston would not have been the first modernist writer to engage with such discourses equipped with only a limited awareness of their historical roots.[30]

There are, to be sure, ironies implicit in turning to Emerson to isolate one of Hurston's discursive resources. As readers attentive to Emerson's racial politics have noted, his notions of individual potential and transcendence did not extend to those of African origins, despite his eventual sympathy with abolitionism and his sporadically progressive racial views. As Cornel West has demonstrated through a reading of Emerson's journals and essays, Emerson evinced an early belief in a racial "scale of being" and its sometime corollary, racial obsolescence theory (which predicted the eventual extinction, like the dodo, of the "lesser" races), which persisted even into the late, canonical essay "Fate" (West 1989, 37). Moreover, Emerson's conceptual program for self-expansion can equally be understood as a blueprint for a far more material program of imperialist expansion and conquest.[31] Such views, needless to say, would seem to make Emerson complicit with race "scientists" and other precursors of American anthropology's roots in racial determinism, and hardly an antidote to them. But to ignore Hurston's potential involvement with Emersonian discourse on such grounds is to presume her incapacity to occupy conflicting discursive locations on race, a presumption which even a cur-

[30] For two convincing, book-length arguments on white modernists' seemingly unconscious deployments of nineteenth-century discourses of the primitive, see, for example, Torgovnick 1990; and North 1994.

[31] For additional accounts of Emerson and race, see also Lee 1992; and Nicoloff 1961.

sory reading of "Characteristics of Negro Expression" or *Tell My Horse,* to take only the most obvious examples, would dispute.

Just as Boasian anthropology offered Hurston a scientific discourse and method through which to reclaim the category of the primitive through a cultural relativism presuming equal complexity across cultural and racial differences, Emersonian Romanticism, as I'll elaborate below, offers a theory and method of reclaiming the primitive as well; and arguably, for a writer like Hurston, the Emersonian narrative of artistic authenticity may ultimately have held more resonance than Boas's cultural authenticity, since her commitments tended toward literature more consistently than toward social science. Interestingly, Emerson himself is often viewed as writing against an objectifying view of nature he ascribed to natural science, thus anticipating up to a point the difficulties Hurston would experience in relation to Boasian positivism.[32] Although I do not claim that Hurston so self-consciously traded one looming white male figure for another as the basis for her own intellectual architecture, I am suggesting that Emersonian concepts function—however schematically in Hurston's piecemeal appropriation of them—as a temporary palliative to the problems that self-reflexivity and racial embodiment posed through her adoption of Boasian anthropological perspectives. Her appropriation of such concepts should not be construed, however, as obviating the real conflicts which the adoption of Emersonian notions of artistry would pose for Hurston as a black woman, but only as an imaginary solution to the myriad social contradictions she inhabited. As much as do Boas's anthropological methods, Emerson's primitivist aesthetics also depend on the suppression or transcendence of the body, although the body imagined to be capable of decorporeally merging with the All was neither female nor black. Nevertheless, through its linkage to Universal Being, disembodiment achieves a positive valence in Emerson that necessarily overshadows its merely instrumental value in Boas as a means to objectivity; the disembodied seer at the basis of Emersonian thought, then, offered Hurston substantial payoffs in the form of artistic valorization and spiritual communion which together are the primary sources of that seer's appeal.

With such qualifications in mind, I turn to Emerson's version of the superseding theory of language as he articulates it in his 1836 essay "Nature":

> Every word which is used to express a moral or intellectual fact, if traced to its root, is found to be borrowed from some material appearance. . . . We say the *heart* to express emotion, the *head* to denote thought; and *thought* and *emotion* are, in their turn, words borrowed from sensible things, and now appropri-

[32] See Whicher 1953 on Emerson's critique of natural science.

ated to spiritual nature. Most of the process by which this transformation is made, is hidden from us in the remote time when language was framed; but the same tendency may be daily observed in children. Children and savages use only nouns or names of things, which they continually convert into verbs, and apply to analogous mental acts. . . . As we go back in history, language becomes more picturesque, until its infancy, when it is all poetry. (Emerson 1992, 13–14)

Emerson's formulation prefigures Hurston's in surprising detail, describing the language of "children and savages" in the same terms in which she theorizes Negro hieroglyphics as tied to "sensible things" or objects; in "Characteristics of Negro Expression" she even has a linguistic category entitled "Verbal Nouns" (Hurston 1990a, 177). Emerson's linguistic hierarchy, moreover, makes explicit what remains a suggestive implication in Hurston—that "primitive" language is the language of poetry, conceived of as high art. Such a sublimation of "primitive" technique is doubly useful to Hurston, as it helps to frame Janie's thought pictures of Tea Cake— the "pictures of love and light against the wall" through which he's made manifest in the novel's final images—specifically as forms of artistic expression, at the same time that it serves broadly to stamp Hurston's figural language in the novel with the seal of artistic prestige and purity.

Both Hurston and Emerson, furthermore, make use of an analogy between language and money to establish for their preferred linguistic practices a stable grounding in verifiable values, encompassed by the intimate linking of word and thing. For Emerson, corrupt language consists in language which has lost its "gold standard" of value in the world of objects and thus, the guarantee of its linkage with "natural facts": "When simplicity of character and the sovereignty of ideas is broken up by the prevalence of secondary desires . . . new imagery ceases to be created, and old words are perverted to stand for things which are not; a paper currency is employed when there is no bullion in the vaults" (Emerson 1992, 15–16). One can read here Emerson's simultaneous anxiety to ground subjective and linguistic purity in the objective and stable value of bullion, and thereby to preserve its simplicity from the "perversions" of desire and abstraction; the poet's goal, as Emerson puts it later, should be to "pierce this rotten diction and fasten words again to visible things; so that picturesque language is . . . a commanding certificate" (16), a fully underwritten currency. This conception of a "picturesque language" with its guaranteed value finds its parallel in Hurston's celebration of barter in "primitive communities"; picturesque language likewise functions to secure an inherent linguistic value and meaning, ultimately expressed by the yoking together of word and thing in the condensed proximity of the hieroglyphic. We can observe numerous reworkings of this linguistic ge-

nealogy and standard of values in *Their Eyes*, in which Hurston's hiero-
glyphics, or "thought pictures" as they're called, serve as intermediary
terms between the superseding theory of language and a transcendental
model of visuality. Not only the culminating images of Janie's vision of
Tea Cake but also the earlier images of the horizon and pear tree can
be understood as exemplars of the "picturesque" language of hierogly-
phics Hurston first described in "Characteristics of Negro Expression";
only they're developed beyond the crude "crayon enlargements of life"
(Hurston 1990d, 48) that characterized the folk expressions of "thought
pictures" (personified by the porch "lying sessions") to a greater degree of
refinement, which is measurable through their pronounced disembodi-
ment. If words are signs of natural facts in Emerson, natural facts are
themselves the symbols of particular spiritual phenomena (Emerson
1992, 13), and the trajectory of thought pictures in *Their Eyes* seems to
participate in this means of authenticating artistry through the merger of
the particular into the universal.

While the horizon and pear tree still derive part of their meaning from
their presence in the phenomenal world of objects, Tea Cake has been
liberated from that world as ghost or spirit. This privileging of demateri-
alization is consistent with another dimension of Emersonian thought
which likewise imagines visionary possibility in a disembodied form.
Thought pictures "evolve" in the text apace with Janie's development in—
and out of—her material body, such that the physicality of the pear tree
matches Janie's sexually awakening body, while her ephemeral projec-
tions of Tea Cake mirror Janie's own incipient dematerialization. Such an
evolution echoes the path charted for Emerson's poet; to recall the most
famous lines of "Nature": "Standing on the bare ground,—my head
bathed by the blithe air, and uplifted into infinite space,—all mean ego-
tism vanishes. I become a transparent eye-ball. I am nothing. I see all. The
currents of the Universal Being circulate through me; I am part and par-
ticle of God" (Emerson 1992, 6). As Janie ascends the staircase at the end
of *Their Eyes* and divides from her black "shadow," she comes to approxi-
mate the uplifted "transparent eyeball" and its universal purview; she
thereby recovers the position of universal subject lost when the objectify-
ing visual medium of the photograph taught her she was "colored" in the
white folks' backyard. She thus recalls Emerson's rhetoric of Universal Be-
ing in "Nature," part of a larger argument about the essential oneness of
the natural world; as he puts it more directly later in the essay: "A leaf, a
drop, a crystal, a moment of time is related to the whole, and partakes of
the perfection of the whole. Each particle is a microcosm, and faithfully
renders the likeness of the world" (22). Hurston echoes this conception
in *Their Eyes*, at first negatively, when Janie is described as too uneducated
to know that she is "the world and the heavens boiled down to a drop";

and later positively when, in the closing image, Janie takes the horizon from "the waist of the world" and drapes it over her own shoulders (Hurston 1990d, 72, 184).

The image of the horizon itself is a recurring figure of visionary possibility in Emerson; as he puts it, in a phrase which draws the several parts of his theory together: "There is a property in the horizon which no man has but he whose eye can integrate all the parts, that is, the poet" (Emerson 1992, 5). The visionary artist who can claim that property, then, is an individual rather than a collective force, one whose heightened powers of vision at once win him title to the horizon and must elevate him above the sights of the folk whose origins he may nonetheless claim. At the close of *Their Eyes*, Janie closely corresponds to this Emersonian vision of the poetic seer: she, too, has laid claim to her "property in the horizon," both in the visionary and material sense, however under-acknowledged the latter may be in the novel; she likewise owns the "eye [which] can integrate all the parts" since she herself now personifies Universal Being with its vision of interconnectedness; and finally she, and by extension Hurston, takes on the mantel of the poet, having distilled a "savage" picture language into the medium of art.

Yet, as is perhaps fitting in Hurston's chosen medium of artistic expression, the novel, Janie's "transcendent" position appears to be mitigated by its social and interpersonal construction; it is framed and circumscribed, that is, both by the very material encumbrances which have made it possible and by the persistently hierarchical love relation that at once forms its motive and its chief substance of expression. That Janie can't fully achieve the status of Emerson's poet—"*he* whose eye can integrate all the parts" (emphasis mine)—is furthermore suggested by her apparent confinement to her house, emblematic of the curtailed and feminized private and domestic sphere. Such a narrow, hemmed in version of her "property in the horizon" may remind us of the distinction Hurston's narrator draws in the novel's opening lines, when she suggests that, unlike men, women must restrict themselves to surveying exclusively imaginative horizons (1). Furthermore, Janie's "shadow," as the metaphor of blackness of which she attempts to divest herself in the final scene, is arguably not so easy to dispense with; certainly Emerson would have regarded it as an inescapably atavistic impediment. If we take the metaphor seriously, moreover, shadows are among those nagging consequences of embodiment from which we proverbially can never escape. Far from completely autonomous, then, Janie's transcendence more closely resembles what might be called an embedded individualism, or what Christopher Newfield has described as the conflict between the subject's constitution through external structures and its potential for autonomy—a pressing contradiction explored in Emerson's negotiations of the poet's imitative

and inventive obligations, but which takes on added urgency in relation to the black woman artist who has worked to define herself, elsewhere, within that rubric.[33]

To the extent that she succeeds in burying the immediate historical and cultural consequences of Janie's materiality under a transcendentalist mantel, Hurston's manipulation of Emersonian tropes may be taken as a measure of her own ambivalence about representing and celebrating African-American culture. Yet, her identification with that mantel is desta-bilized by her and Emerson's divergent relations to the term that joins their projects—namely, the primitive. Whereas Emerson understands the primitive nostalgically as a model and a means to preserve a language the purity of which will secure for his poet a transcendental merger, Hurston's relation to the term is at once less instrumental, more personal, and firmly anchored in the more immediate problem of reconceptualiz-ing and reclaiming the artistic expression of the black community. These material interests so manifestly represented by African-American bodies and community, including her own, bring to the surface a second irony entailed by Hurston's use of Emersonian tropes: that is, beyond the fact that she functions by definition as a trespasser in Emersonian territory, her presence there works to expose the idealist limitations of a theory so blind to the situated nature of embodiment. Precisely because Janie can recast herself in the mold of Emersonian seer, in other words, Hurston is able to demonstrate the ways in which the transcendentalist ethos is an expression of cultural isolation and privilege, since the very availability of that identity is predicated upon Janie's physical and psychic detachment from her community, and through a financial independence that has been purchased through the exploitation of its labor.

Just as Hurston's construction of Janie as visionary operates reflexively as both an adoption and adaptation of Emersonian terms, her stylistic practices also refer to and revise Emerson's notions of poetic language. Hurston complicates Emerson's account of "primitive" artistry by assimi-lating the picturesque language of "children and savages" into the "high-culture" linguistic container of the novel; she thus historically telescopes, in Emerson's terms, the linguistic practices of early and advanced stages of cultural development into a hybridized simultaneity, effectively over-turning them as discrete forms of evidence for an evolutionary model of culture. As a consequence of the new contexts in which these several Emersonian paradigms are pressed into service and the revisionary effects they entail, then, Hurston may be seen not simply as a writer retreating

[33] Newfield explores the relative values of invention and imitation in Emerson's vision of the poet in terms which clearly have resonance for Hurston's anxieties about black artistry, as they are expressed, for instance, in "Characteristics of Negro Expression"; see Newfield 1996, 43ff.

from the consequences of black embodiment but equally as one advancing to reclaim some lost territory. She does so by actively appropriating a discourse whose spoils include a means of reorienting black female subjectivity at the center of aesthetic and visionary possibility, as well as within the dominant trajectory of American literary history described and presided over by Emerson. Yet, we risk obscuring the underlying conflict between these alternatives if we overlook the ways in which the universality proffered by Emerson's poetic genealogy necessarily elides the specificity and materiality of the body, Hurston's revisionary efforts notwithstanding. Through Janie's transformation, then, Hurston accomplishes a reorientation of the visual economy, the outcome of which is equally distant from the objective and objectifying empirical observation of the orthodox anthropological gaze, and from the subjective revisions of that gaze Hurston made use of when she foregrounded herself as a material participant in her ethnographies. Unlike her white male modernist peers, who were content to explore the varieties and limits of subjective visuality left over from the collapse of objective forms, Hurston turns to a visionary model through which she attempts to redefine and revalue her art.

In a 1943 interview with the *New York World Telegram*, Hurston maintained: "I don't see life through the eyes of a Negro, but those of a person" (Hemenway 1977, 289). In the wake of her repositioning, through her character Janie, from spokeswoman of the folk to transcendent seer that she tentatively accomplished six years before in *Their Eyes*, Hurston's self-description needs to be understood as more than either a grand ahistorical evasion or the expression of a political conservatism widely seen as typical of her later years. Instead, we need to comprehend it as the outcome of a philosophical trade-off—the casting off of a black, female body whose cultural meanings she could not control, even through the optical apparatus of science, in exchange for an artistic vision poised on the brink of a universal transparency, however much that alleged transparency was actually underpinned by a white male body, fixed but concealed like a watermark beneath its surface. Perhaps Hurston grasped the terms of that trade-off when, in her autobiography, she recalls her affection for Odin, the hero of a Norse tale known from her childhood, who plucked out one eye in exchange for knowledge (Hurston 1991, 39). In its suggestion at once of pathologized embodiment, Cartesian monocularity, and Emerson's singular "transparent eyeball," the image anticipates in complex and disturbing ways the one-eyed seer in Ellison's *Invisible Man*. Still more so than Hurston, I will suggest, Ellison insists upon the violence inscribed at the foundations of all three alternatives.

One-Eyed Jacks and Three-Eyed Monsters

Visualizing Embodiment in Ralph Ellison's *Invisible Man*

Pausing midway in his 1964 autobiographical essay, "Hidden Name and Complex Fate," in order to meditate on his artistic origins, Ralph W. Ellison describes two puzzling possessions dating from childhood, the significance and functions of which initially were opaque to him: the first, a large photographic lens discovered in a back alley; and the second, his own name—a name previously claimed by Ralph Waldo Emerson. About the mysterious lens, he explains:

> I could pretend that it was a telescope, the barrel of a cannon, or the third eye of a monster—*I* being the monster—but I could do nothing at all about its proper function of making images, nothing to make it yield its secret. Still, I could not discard it. . . . I could no more deal with my name—I shall never really master it—than I could find creative use for my lens. (Ellison 1995, 196–97)

The augural dimensions of the tale, and particularly, the apparition of the lens itself, are most likely contrived, given Ellison's career-long penchant for optical imagery.[1] Yet we can perhaps find a clue to the tenacious grip the image held over Ellison's imagination—strong enough for him to inscribe it as a foundational form of self-mythmaking—in a 1955 interview, where Ellison derides naturalists as those who, unlike himself, "stick to case histories and sociology and are willing to compete with the camera and the tape recorder" (222). We can understand the photographic lens,

[1] Indeed, Ellison worked as a freelance photographer during a portion of the composition of *Invisible Man*.

then—the image-making tool of documentary realism and an instrument of empiricism—as a representative of American social science which, "since its inception," as Ellison observes elsewhere, "has been closely bound up with American Negro destiny" (329). By analogy with the telescope and cannon, the photographic lens can be understood to suggest a measure of the aspiring visual mastery and the attendant violence which Ellison associated with early-twentieth-century American sociology, particularly with regard to race. To read the lens in this way is to comprehend the "complex fate" heralded in the essay's title as a critique of the far more simple fate that American sociology normally reserved for African Americans, through a reductively determinist perspective blind to African-American cultural contribution, which Ellison assailed throughout his career. With "complex fate," Ellison signals his faith in the powers of the sovereign individual to overcome those material constraints American sociology found collectively decisive for blacks, as well as his belief in individuals' ultimate capacity to measure rather than be measured by the instruments of science.[2] Ellison thus plays on the conventional slippage between the "I" and the eye here by linking his "lens" with a question of self-knowledge and self-possession.

By invoking the photographic lens simultaneously with the "hidden name" of Emerson, Ellison conjoins a symbol of empirical science with the Romantic idealism of Emersonian thought. He accomplishes this both analogically, as lens and name, eye and I, are equated as secrets to be disclosed; and iconographically, through the vision of the three-eyed monster, an emblem of African-American subjectivity and a playful but telling variant of DuBois's well-known dualistic formulation of black identity as double-consciousness. Cobbling together the monocular and the binocular, the image plays on the multiple resonances of both: the isolated third eye evokes at once Emerson's monocular image of the poet/seer—the "transparent eyeball" imagined in "Nature"—as an instrument of material transcendence, and the abstracted, monocular gaze of science, one equally committed to disembodiment through its aspiration to neutral detachment and objectivity. The third eye is also yoked to a more orthodox pair of eyes, attached, as it were, to solid evidence of vision's embodiment, which the notion of monstrosity as physical deformity serves to underscore. The mechanical third eye, moreover, sutures a deterministic idea of a mechanical man onto an otherwise unpredictable, organic body. Cumulatively, the third eye can be seen as a figure representing the synthesis of blacks' "complex double vision" (Ellison 1995,

[2] See, for example, Everett C. Hughes's *The Sociological Eye*, in which he suggests that "among the methods I would recommend is the intensive, penetrating look" (1984, ix). Hughes was a student of the Chicago school and of the virtual father of race sociology, Robert E. Park.

178), as Ellison calls it, providing not only the perception of depth contingent upon the assimilation of dual perspectives but also the successful performance of synthesis as the crucial intellectual operation of dialectical thought. Compared with DuBoisian double-consciousness, which derives its force from the conflicts it describes between national and racial identity, Ellison's racialized three-eyed monster functions more explicitly as a discursive hieroglyphic, in which the triangulated tensions of race "science" and transcendentalism, embodiment and disembodiment, determinism and individual agency, are more readily legible.

The possibility that Ellison holds out of claiming possession of his historically burdened name, and of discovering the lens's "proper function of making images," promises a method of resolving the conflicting discursive traditions each personifies into a subjective model more "integrated" than might be predicted either by the three-eyed monster itself or the anathematized social relations it presumably would inspire. Such a model, furthermore, would have specific aesthetic and political consequences, measurable in the negotiations within each of those spheres undertaken at length in Ellison's 1952 monument to visual metaphor, *Invisible Man*: aesthetically, such a resolution allows him to combine the mimetic powers of the photographic lens, those often associated with the literary practices of realism and naturalism, as well as the specifically Marxist-inspired aesthetic of social realism, with the visionary compass of Emerson's poet, who transmutes all of the natural world, to paraphrase "Nature," into a metaphor for the human mind (Emerson 1992, 17). As Eric Sundquist has observed about the stylistic commitments of *Invisible Man*, "although Ellison shares with a number of novelists of the 1930s and 1940s an interest in photographic realism, he infused documentary fiction with a heightened sense that the writer's distortion of, and improvisation on, the observed world could bring out more effectively the moral and psychological density of its internal meaning" (Sundquist 1995, 16). (Ellison, whose work is normally assimilated to the rubric of modernist practice, doesn't himself dispute naturalism's enhanced capacity to represent social truths; he only complains that it becomes a "dull instrument" when trained upon black subjects [Ellison 1995, 83]).[3] Politically, the marriage of social science with Romanticism allows Ellison to document existing social conditions in ways that mirror those methods favored by American sociology and mandated by Marxist literary theorists, without relinquishing individual narratives of development and transcendence and, better still, without being wedded to any *particular* narrative of such change. Un-

[3] Among the several ironies here must be counted Dorothy Ross's observation that the ahistorical and technocratic features of American social science, particularly from the 1890s through the 1920s, were more characteristic of modernism than naturalism or realism (Ross 1994, 171 ff.).

like Richard Wright's protagonist in *Native Son*, Bigger Thomas, whom Ellison critiques as the product of a cripplingly narrow sociological vision in which "Wright could imagine Bigger, but Bigger could not possibly imagine Richard Wright" (Ellison 1995, 162), Ellison retains a belief in subjective transcendence informed by Emersonian thought that equally maintains a foothold in the representational world of social conditions.

Most crucially, Ellison accomplishes a rapprochement between these documentary and visionary perspectives in *Invisible Man* through his manipulation of the trope of invisibility. Through this metaphor, he dramatizes the evolution of perceptions of the racialized body from a definable set of subject/object relations in which the black protagonist (or invisible object) arguably functions as the necessary obverse of the three-eyed subject anatomized in "Hidden Name and Complex Fate." To appreciate the magnitude of Ellison's revision of the metaphor of invisibility, one need only recall that James Weldon Johnson employed the concept in his 1912 *Autobiography of an Ex-Coloured Man* to describe racial passing. Whereas passing depends on the illegibility and instability of racial signs, Ellison's invisibility insists upon the emphatic determinacy of the black body, insofar as it unleashes a predictable constellation of social effects. "I am an invisible man," Ellison's protagonist explains in the prologue,

> simply because people refuse to see me. Like the bodiless heads you see sometimes in circus sideshows, it is as though I have been surrounded by mirrors of hard, distorting glass. . . . That invisibility to which I refer occurs because of a peculiar disposition of the eyes of those with whom I come in contact. A matter of the construction of their *inner* eyes, those eyes with which they look through their physical eyes upon reality. (1952, 3)

Conceived as a process of white projection-as-erasure, instigated by the sight of the black body and culminating in a burlesqued form of embodiment (via the distorted, "bodiless heads"), Ellison's conception of invisibility can be grasped at once as problem and solution, since it finally displaces the corporeal barrier to transcendence which was responsible for producing it in the first place; invisibility is, in short, the cure to its own disease. The brilliance of the figure arguably is itself an intervention into the debate which the novel takes up thematically about the interplay between subjective agency and its determination through larger social forces. What I want to suggest here is that Ellison's notion of invisibility takes its bearings, not from the isolated basis of individual invention that Ellison espoused, but from a range of discourses largely contemporary with the novel that theorize subject/object relations through the metaphorics of embodiment—discourses, furthermore, which are dependent upon the visual as the mechanism through which embodiment and its

attendant ontologies are perceived. In this sense, Ellison should be taken as a characteristic modernist, not only for his manifest stake in a myth of the isolated man of genius, but also for his eclectic assimilation of intellectual resources, many European in origin, that make up the fabric of his work.

In what follows, I hope to suggest some of the relationships between the several discourses which most influenced Ellison's development of invisibility as a racial construct, one that has been variously contrived to sustain the dispersals, displacements, repressions, and erasures of the corporeal and its signs. I begin by considering American sociology's deterministic conception of the consequences of the black body's visibility, and the roots of this conception in another discourse exploring the visible economies of the body: comparative anatomy. Ellison's rejection of that sociological view is made possible, I argue, with the help of three other discourses he was centrally engaged with throughout the 1940s—folklore, Emersonianism, and Sartrean existentialism—each of which theorizes a far less problematic agency for the subject. However, the solutions each offers, because not explicitly adapted to the peculiar exigencies of race— indeed, because in each case covertly inimical to them—complicates Ellison's attempts to adapt them to his purposes, as does their imbrication in the metaphorics of gender. Folklore, to begin with, provides the evidence to dispute the accusation of cultural impoverishment leveled by social science, because it demonstrates the vitality of African-American culture and its inventive capacity to resist racist constructions; it's also easily assimilable, however, to prevailing ideas of cultural development that rank it below more individuated or "advanced" forms, and is thus susceptible to a sociological gaze that would reduce it to an expression of cultural adolescence. Emerson not only provides a blueprint for the poet's valuing and transforming of folk materials in terms resonant for Ellison, but he also supplies a vision of self-determination and agency that likely appealed to a writer eager to challenge race sociology's deterministic account of subject formation—a subject conceived, moreover, in a specifically disembodied form through his conception of the "transparent eyeball"; however, Emerson's commitment to racial hierarchy and the rhetoric of conquest he employs to describe his program of self-expansion together compromise the efficacy of his more palatable views and expose the continuity between Emerson's beliefs and later sociological conceptions of racial difference. Finally, much like Emerson, Sartrean existentialism offers a theory which affirms the human capacity to comprehend and shape its own history through a doctrine of self-created meanings that also challenges sociology's racial determinism, as well as providing a specifically visual account of subject/object relations sensitive to the operations of power governing visual exchanges. However, the account of subject/

object relations on which Sartre's conception of subjectivity depends, as Frantz Fanon's critique makes clear, is unable to accommodate the ways in which the historical conditions producing racial constructions complicate that relation. Seen in the context of these discourses, Ellison's selection of invisibility as his governing metaphor begins to appear as overdetermined as it is inevitable, and as vexed.

"High Visibility" and Invisibility: Bodies, Culture, and the Sociological Gaze

That Ellison's *Collected Essays* overflow with scathing references to sociological theory is easily comprehensible in light of the substance of the sociological record which I examine briefly below, yet the abundance of criticism is, surprisingly, unusual among Ellison's African-American intellectual contemporaries. Ellison takes up, nearly always to dispute, sociological positions in more than a dozen different essays over a roughly twenty-five year period. His engagement with sociological discourse, particularly in the years just prior to and during the composition of *Invisible Man*, was especially intense, and persisted long after its publication.[4] Ellison's antipathy to sociological discourse and its underlying assumptions about the limits of individual agency and the absence of a viable African-American culture, I would suggest, is the single most important context for understanding five interrelated dimensions of *Invisible Man*: its preference for modernist over naturalist aesthetics; its relationship to folklore; its limited endorsement, despite Ellison's evident knowledge of his racist views, of Emersonian theory; its elaboration of invisibility as its central metaphor; and its misogyny. Numerous critics have noted the significance, individually, of each of these facets of the novel; however, their full significance I would suggest cannot be grasped in isolation. It's their complex interrelations I hope to sketch here, in which sociological assumptions about black people and black culture pose the problem which Elli-

[4] There is abundant evidence for Ellison's engagement with these three discourses in essays and interviews beginning in the 1940s; see, for example, "Introduction to *Shadow and Act*"; "Twentieth-Century Fiction and the Black Mask of Humanity"; "The World and the Jug"; "Hidden Name and Complex Fate"; "The Art of Fiction"; "Working Notes for *Invisible Man*"; "What These Children Are Like"; and "A Very Stern Discipline" (Ellison 1995). Ellison began work on *Invisible Man* in 1945, and his extended debate with Irving Howe over the viability of sociological categories, for instance, was conducted in print in 1963–64, in which he describes Howe as "not the first writer given to sociological categories who has had unconscious value judgments slip into his 'analytical' or 'scientific' descriptions" (175–76). Richard Wright's engagement with sociological theory and Sartrean existentialism, I should add, was similarly intense, and it may be that his explicitly sociological agenda at once distanced him from literary modernism and made the space of exemplary black modernist available to Ellison.

son exerts immense intellectual resourcefulness attempting to resolve.[5] At least in one respect, however, Ellison follows the lead of sociology, simply by privileging the mechanisms and metaphorics of sight as a means of defining individuals and communities. Although he implicitly critiques the pretense of an empirically based and analytically "pure" sociological gaze—including its belief in the primacy and determinacy of visible difference—Ellison nevertheless retains vestiges of such paradigms in his own optically charged language.

The '20s, '30s, and '40s witnessed recurrent collaborations between social scientists and literary figures on publications concerned with African-American culture, which juxtaposed literary and sociological pieces devoted to anatomizing social conditions, documenting and reworking folk materials, and offering strategies for social reform. From 1938 to 1942, Ellison himself worked for the Federal Writers Project, where he was assigned to the "living lore unit" collecting African-American folklore. Despite his later hostility to sociological perspectives on African-Americans, he wrote reviews and essays addressing a variety of sociological positions throughout the forties. What American sociology had to offer the writers who embraced its message was the most persuasive analysis available of the social conditions responsible for black life aside from Marxism, which lacked a fully developed race consciousness; and because that analysis increasingly fell outside the framework of biological science with its evolutionary hierarchy of racial types, it could be seized upon as a blueprint for change. The sociologist Charles S. Johnson and the poet Countee Cullen edited the journal *Opportunity: A Journal of Negro Life* from 1923 to 1928, and in 1927 they issued the anthology *Ebony and Topaz*, whose contents span their respective disciplines. Richard Wright wrote the introduction to Horace Cayton and St. Clair Drake's *Black Metropolis* (1945), the first full-scale sociological study of black urban community. The "New Negro," so-called and commemorated in Alain Locke's landmark 1925 anthology, invoked that designation to celebrate both the artistic flowering associated with the Harlem Renaissance and an advancing stage of black cultural development more or less indiscriminately, in terms resonant with sociology's evolutionary model of culture.

There is evidence, too, that the perspectives of sociology and Marxism were not experienced as necessarily antithetical, despite the view of sociological historians who tend to understand its racial politics as an outgrowth of liberalism. Numerous black intellectuals involved in the collaborations between sociology and literature also became Communist Party members during its peak of popularity with African Americans in the

[5] Jerry Gafio Watts and John Wright are notable exceptions to this trend, but while both provide a more complex map of Ellison's developing thought, they exclude a full reading of its ramifications for the novel. See Watts 1994; Wright 1980, 142–99.

1930s, an era in which it served as an important source of intellectual community, political possibility, and publishing opportunities for many African-American writers.[6] In 1942, Ellison edited *The Negro Quarterly* with communist cause célèbre Angelo Herndon; the journal published, among others, Sterling Brown, Richard Wright, and the sociologist E. Franklin Frazier. Two of Johnson's important sociological studies, *Shadow of the Plantation* (1934) and *Growing Up in the Black Belt* (1941), show the (unacknowledged) influence of Marx through their analysis of conflicting agrarian and industrial interests.[7] The active participation of many prominent African-American writers in the Communist Party—Richard Wright, Claude McKay, Langston Hughes, for instance, to name the most obvious—is well known, and the aesthetic commitments of a writer such as Wright tend to blur the empirical pretensions of naturalism with the politically programmatic aims of social realism in ways which expose their underlying affinities. But, almost from the beginning of his career, and despite the strong early influence of Wright on his writing, Ellison set his own course. Although Ellison initially forged a relationship with the Communist Party, publishing his first essays in communist journals, he was never a party member, and he severed his connection with the party entirely in the 1940s because of its alleged racial opportunism.

In order to appreciate the scope of Ellison's debt to and revision of sociological concepts, I want briefly to review some key moments in the development of American sociological ideas about race dating from the turn of the century. Like American anthropology, American sociology began to consolidate as a discipline only in the 1920s and 1930s from its origins in the 1880s and 1890s as the new "science of society," but sociology maintained its belief in evolutionary theory, with its naturalist assertions about the differences in racial bodies, much longer. Sociology clung to the conviction of black biological inferiority, complete with the confidence that such unfitness would lead to blacks' gradual extinction, long after such views were discredited by evolutionary biology and by its partner in social science, anthropology. Consequently, reform-minded sociologists of the Progressive Era tended to ignore the race question overall be-

[6] From 1929 to 1930, black Communist Party membership increased from 200 to 1300, climbing to 10,000 in 1935; and the Communist Party's role throughout the 1930s—from the Scottsboro case and the 1935 Harlem riot to its efforts to form a sharecropper's union in Alabama and the Angelo Herndon trial (Herndon faced execution in the early 1930s for his Communist Party activities)—all enhanced the party's prestige and strengthened its claim to be an ally of black Americans. For more detailed accounts of the relationship between the Communist Party and black communities, see Foner and Shapiro 1991, xi–xxix; Naison 1983; Record 1951. For an account of the political development of black and white writers on the left see Aaron 1992; Kostelanetz 1991; Ostendorf 1982; Panichas 1971; Cruse 1967.

[7] For a more detailed account of Johnson's methods and motives, see Robbins 1974, 56–84. Robbins speculates that Johnson's failure to acknowledge Marxist influence may have been an aspect of professional prudence for which Johnson was well known.

cause of the consensus that the conditions of white supremacy and black inferiority were not susceptible to reform. At roughly the same time that the anthropologist Franz Boas was privileging the unpredictability of favorable circumstances over fixed racial qualities as the key to advancing civilization, and was proposing that differences across racial groups were no more significant on average than those within them (in *The Mind of Primitive Man*, which first appeared in 1911), sociologists were parlaying notions of genetic inheritance into rigid accounts of racial typology. Charles Horton Cooley, for instance, could object to the existence of racial castes in 1909 on moral but not on intellectual grounds, since they appeared to him structurally inevitable; his contemporary, W. I. Thomas, even as he acknowledged the dearth of evidence to support differences in brain structure between the races, offered a biologically based theory of racial temperament that remained influential until the 1930s. Even prejudice could be inherited; it was, according to Thomas, an instinctive feeling of solidarity necessary to group preservation.[8] Such Lamarckian accounts of the ways habitual behavior led to the production of heritable instincts functioned as a proximate alternative to a determinism based on natural forces, despite the hope those accounts implicitly extended that such behavior, being merely habitual, could be changed. Between the political success of the Eugenics movement between 1910 and 1930, with its quest to prevent the degradation of the nation's racial stock through contamination by the unfit, and the widespread agreement that disparate racial performances on the newly invented IQ test constituted scientific proof of hierarchical racial differences, racist discourse anchored in bodily difference regained the ground it had lost to genetic discoveries and enabled sociologists, among others, to preserve their own prejudices intact. Such views flourished despite the contention of many social scientists, such as the anthropologist Melville Herskovits, that a majority of blacks—80 percent by his estimate—were, in any case, of mixed racial heritage.[9]

Early twentieth-century sociology, then, followed more closely the barometer of white intolerance than the empirical discoveries of biological science, despite its invocation of evolutionary principles to justify its conclusions. Unlike Marxism, which held that race and ethnicity would become increasingly irrelevant as modernization progressed, sociology had more respect for the power of racial attitudes—both white racism and a presumed black docility—that frequently blinded it to the material exigencies affecting race relations. Yet the vision of entirely self-governing

[8] See Cooley 1909; Thomas 1904. Also, see McKee 1993 for a discussion of first generation American sociologists.

[9] Although, to be sure, much ink was spilled in the effort to determine the precise physical, moral and temperamental characteristics of such "mongrels"; see McKee 1993, 84–86.

natural law imagined by evolutionary theory did fall out of favor at the turn of the century, according to James B. McKee (1993, 40), for the reason that the evolutionary model, like its economic counterpart, unregulated capitalism, was by definition unresponsive to strategies of social intervention that could lead to calculated change. The emerging success of the theory of the independence of culture proposed by Boas, which rejected the Social Darwinist account of natural struggle, led to a philosophical trade-off in which the greater credence lent to the possibility of cultural change was purchased at the expense of a viable theory of conflict through which it presumably would be fueled, in a vision of reform as reassuring to those whites who wished to regulate its speed and direction as it was unrealistic. American sociologists replaced their faith in a racial hierarchy anchored in biology with an equally strong conviction of black *cultural* inferiority, rooted in the retooled evolutionary distinction between modern and traditional societies, with blacks occupying the cultural position of "premodern" near-primitives from which they might only gradually evolve.[10] This revised set of assumptions led to what Thomas Pettigrew (1980) has identified as American sociology's three most tenacious analytic biases with regard to African Americans—its reliance on static descriptions of black culture, which overlooked dynamic cultural processes; its pathologization of black culture and its alleged deficits; and its emphasis on individual rather than institutional prejudice which worked to disarm systemic critiques.[11]

[10] For further discussions of evolutionary models of culture and their impact on perceptions of blacks, see Stepan and Gilman 1991, 72–103.

[11] Compared with their white peers, black sociologists were more comprehending of black nationalism and race pride, more cognizant of class and generational differences among blacks, more sensitive to the impact of black urban migration in the 1930s and its complication of black folk culture as a category, and more critical of the notion of fixed racial castes which would yield to change only gradually, but the impact of their work on white sociologists was selective and uneven. Most early work by black sociologists was undertaken between 1935 and 1945; of this next generation, most prominently, Charles S. Johnson and E. Franklin Frazier (both students of Robert Park) were nonetheless constrained by the intellectual and political framework outlined by white theorists such as Park, who ignored ideas and conclusions which fell outside their own narrow parameters. Frazier's career is instructive for the modesty of its challenges to the received ideas which dominated the field: in a public debate with Melville Herskovits, Frazier rejected the possibility of African origins for African-American cultural practices at the largest structural levels, while still defending the idea of a partly autonomous black culture due to its relative isolation from whites; however, Frazier is also associated with the view of black culture as a "faithful but inferior copy," which had selectively retained archaic forms of *white* culture. Because Frazier's *Negro Family in the United States* (1939) made use of the current sociological orthodoxies about black communities—that they had been subjected to "cultural stripping" through slavery, and suffered from social disorganization and matriarchy, it has been read as pathologizing the black poor and later identified as the precursor to the much criticized 1968 Moynihan Report. Ellison himself later suggested that white American sociologists were responsible for using Frazier's theories partially against blacks (Ellison 1995, 377–78).

But while Frazier was analyzing the *process* of black cultural development, however limited

Robyn Wiegman has provided a compelling cultural history of the evolving relations between ideas of racial essence and the black body as a ground of visibility, arguing that the equation of race with visible difference was consolidated and stabilized only in the nineteenth century from a much earlier emphasis on geographical origins (Wiegman 1995, 27–30). Wiegman describes the shift in attention within race science from the surface of the body to its depths or interior in the nineteenth century as "a simultaneous strengthening of the corporeal as the bearer of race's meaning *and* a deepening of that meaning as ultimately lodged beyond the assessing gaze of the unaided eye" (23). Such a shift enabled the consolidation of specialized disciplines trained in a putatively objective empirical gaze such as physiognomy, phrenology, and craniology, which were devoted, through techniques of comparative anatomy, to identifying racial differences. The consolidation of these disciplines led, too, to a concomitant decorporealization of an investigative gaze increasingly imagined as neutral and detached (though perhaps to a lesser extent for the hard sciences, ironically, than for social sciences such as sociology and anthropology, which were bent on perfecting such practices as the participant-observer method). On the basis of similarities in skull and brain size, craniologists famously forged a "visible" link between women and the "lower races," leading to an understanding of those races as corresponding to a "female" type.

This perceived relationship between blacks and women persisted well into the twentieth century, and we can find a version of it in the views of the most influential race theorist of the Chicago school of sociology, the white sociologist Robert E. Park. Park worked as an assistant to Booker T. Washington at the Tuskegee Institute (which Ellison later attended) and came to the University of Chicago in 1913, where he became its most influential race theorist and the mentor of several generations of black sociologists. Although Park clearly occupied a place in sociology's liberal wing, he could nonetheless write in 1921, in the important textbook he

by the conceptual vocabulary available to him, white sociologists were busy demonstrating why such development was neither possible nor, indeed, especially desirable. Neglecting the vast black migration to the urban North, sociologists like W. Lloyd Warner and John Dollard concentrated on blacks in the South, arguing that they constituted a caste rather than a class or folk—a distinction Warner used to explain the long-term intractability of black subordination. Dollard went still further in his hugely influential *Caste and Class* (1937), in which he used psychoanalysis to show how blacks derived limited benefits from their caste position. Dollard stressed the functionality of caste for blacks by painting a psychic portrait of both freedom from repression and economic security which lent new prestige and material basis to the popular image of the happy, childlike black, languishing indolently in an unchanging cultural substratum. In spite of the limited objections voiced by Chicago school partisans, as well as those of Park, Johnson, and Frazier and two highly critical responses published by the black sociologist Oliver Cox (Cox noted that in America "caste" was a mark not of status but conquest), the caste concept persisted though the 1940s.

edited with Ernest W. Burgess, *Introduction to the Science of Sociology*, that "the Negro is, by natural disposition, neither an intellectual nor an idealist, like the Jew; nor a brooding introspective, like the East Indian; nor a pioneer and frontiersman, like the Anglo-Saxon. He is primarily an artist, loving life for its own sake. His métier is expression rather than action. He is, so to speak, the lady among the races" (Burgess and Park 1921, 136). Ellison refers to this "humiliating" view of Park's, which he apparently was exposed to in school, twice in print.[12] Although Park recasts the analogy in terms of racial temperament, it's important to recall its origins in the physical and specifically visual analogies identified by comparative anatomy. Park also articulated a second position Ellison refers to repeatedly in his essays, which likewise hearkens back to the visual determinacy of the body. In a 1926 essay, "Behind Our Masks," Park argued that "race prejudice is a function of visibility. The races of high visibility . . . are the natural and inevitable objects of race prejudice" (Park 1950, 247). In a 1979 essay, Ellison retrospectively derides for its determinism the "then popular sociological formulation which held that black Americans saw dark days because of their 'high visibility,' " though curiously, he never disputes the presumption that some races are more "visible" than others. He rephrases this sentiment in his 1981 extended introduction to *Invisible Man* (Ellison 1995, 351, 478). Park's views and Ellison's response to them equally suggest the close affinity between ideas of embodiment, femininity, and determinism, as well as their collectively negative consequences for ideas of black citizenship; as Wiegman observes, the insistence on black corporeality—on the feminized black body functioning as *the* body for culture—served to disqualify African Americans (and women generally) from a universal subject position imagined by Enlightenment political theory as unmarked and disembodied (Wiegman 1995, 49–50). If race prejudice *were* a function of black visibility, Ellison concludes, "there was no God-given or man-made ritual through which blacks could achieve social redemption. In this dark light 'high visibility' and 'in-visibility' were, in effect, one and the same" (Ellison 1995, 351); in other words, to have a body marked as such would be equivalent to being relegated to utter sociopolitical oblivion.

It's in this context of the history of American sociological discourses on race and its proximity to key Marxist assumptions that we need to understand Ellison's review of Gunnar Myrdal's *An American Dilemma* (1944),

[12] Ellison first refers to this passage in his 1944 review of Gunnar Myrdal's *An American Dilemma*, and again in his introduction to his first collection of essays, *Shadow and Act*, in 1964; see Ellison 1995, 57, 330. Daniel Kim has contributed a perceptive analysis of the ways Ellison reworks Park's charge in *Invisible Man*, where Ellison offers a (homophobic) critique of white men's feminization of black men as a symptom of whites' repressed homoeroticism, through which structures of racial discrimination are enacted; see Kim 1997, 309–28.

which contains the single most developed articulation of Ellison's complex response to sociological principles. Commissioned by the Carnegie Foundation, Myrdal was a Swede selected for his presumed objectivity about the American race problem, and his voluminous study both summarizes and challenges prevailing views, while stressing the impact of values over social structures as constitutive of social formations.[13] Its most distinctive contribution is the way in which it yokes a sociological conception of race to a vision of national identity, arguing that race poses a moral problem because prejudice violates the Enlightenment ideals epitomized by the American creed.[14] Ellison's review is a powerful demonstration of just how conversant he was with the history of American sociology's racial discourse at this early stage of his career, in which he traces sociology's growth from its roots in antebellum "pseudoscientific literature," with its goal of promoting slavery, to its development after the 1870s, from which its claims to objectivity and neutrality date—claims that were compromised, he suggests, from the beginning: "Here was a science whose role, beneath its illusionary non-concern with values, was to reconcile the practical morality of American capitalism with the ideal morality of the American creed" (Ellison 1995, 330). Noting the connection between the Tuskegee Institute and the Chicago school, particularly the influence of Park on its founder, Booker T. Washington, Ellison doles out praise and blame in roughly equal measure, acknowledging the benefits of Park's research at the same time that he charges the black scholars Park trained with timidity and identifies them as the victims of a "bourgeois science" (331). It's also here that Ellison quotes Park's assessment of the Negro as "the lady among the races" and takes vengeance on him in the most bluntly reciprocal terms, by feminizing him: "Park's descriptive metaphor is so pregnant with mixed motives as to birth a thousand compromises and indecisions" (332).[15]

Ellison reserves similarly equivocal judgment for Myrdal himself, crediting him with having divested sociological literature of its racist mythology through the *proper* use of science, but identifying the book's deepest motive as "*the blueprint for a more effective exploitation of the South's natural, industrial and human resources*" (1995, 337). Ellison admires Myrdal's tech-

[13] W. E. B. DuBois, easily America's best-known black sociologist, was passed up for this position because of his presumed "lack of objectivity."

[14] Interestingly, Ellison adopts a comparable position at the close of *Invisible Man*.

[15] Ellison regularly reverses racial tropes in this way: in "Twentieth-Century Fiction and the Mask of Humanity," he describes the process through which "like a primitive tribesman dancing himself into the group frenzy necessary for battle, the white American prepares himself emotionally to perform a social role" (Ellison 1995, 84)—that of the fictional production of the Negro in conformity to self-serving cultural myths; he likewise disparages sociology-oriented critics' "primitive modes of analysis" in his rejoinder to Irving Howe in "The World and the Jug" (Ellison 1995, 155).

nique of disarming potential frictions between different social groups by invoking their shared stake in the American Creed, but deplores his denial of class struggle, which enables him to "avoid admitting that actually there exist *two* American moralities, kept in balance by social science" (338), presumably by legitimizing the concept of racial groups and its linkage with stages of cultural development. Most significantly, Ellison takes issue with what he sees as Myrdal's too limited construction of blacks' response to white racism, one which characterizes Negro culture and personality merely as the by-products of social pathology. In a much cited refutation, Ellison asks: "But can a people . . . live and develop for over three hundred years simply by *reacting*? Are American Negroes simply the creation of white men, or have they at least helped to create themselves out of what they found around them? Men have made a way of life in caves and upon cliffs; why cannot Negroes have made a life upon the horns of the white man's dilemma?" (339). In a rhetorical reversal similar to his feminization of Park, Ellison makes the case for the black *rejection* of (a horned and cuckolded) white culture; regarding blacks' perception of white culture, he observes that "there is nothing like distance to create objectivity" (340). He thus arrogates the most cherished of social science's advertised tools—detachment and objectivity—to blacks, while redefining them as products not of training but survival (though not survival merely; the improvisational resourcefulness of that survival through a responsive culture is key to Ellison's understanding here).[16]

Folkloric Embodiment and Emersonian Transparency

If American sociology's flattening determinism—its simultaneous conviction of the pronounced visibility of black bodies and the static invisibility or pathologization of black culture—is the recurrent villain of Ellison's *Collected Essays*, one of the rare heroes is Constance Rourke, whom Ellison singles out for praise on three separate occasions in the collection.[17] A

[16] The irony here is that Myrdal himself, as Stepan and Gilman note, "stressed that black intellectual resistance to the dogma of Negro racial inferiority had a significant impact on the black community itself. This counterformulation of the issue of race emerged as a fundamental belief of all black communities, he said, allowing them to refuse to accommodate themselves to white beliefs" (Stepan and Gilman 1991, 103). Ellison is correct, then, to assert black's relative independence from white judgments of racial essence, though here (and elsewhere) he mischaracterizes the views of his opponent to dramatize his own. For a detailed discussion of the development of Ellison's complex understanding of cultural pluralism and the myriad appropriations, borrowings, and influences on which it's based, see Posnock 1998, 186–208.

[17] References to Rourke can be found in Ellison's essays, "Change the Joke and Slip the Yoke" (1958); "Blues People" (1964); and "Indivisible Man" (1970). Although these essays

folklorist, cultural critic, and child of the Progressive Era, Rourke's advocacy of the generative powers of folk traditions incarnates her nearly as sociology's antipode. There are numerous grounds for her appeal to Ellison. First, Rourke disputed the popular representation of Americans as "stripped European[s] . . . without a Moses to guide them," as critic Lewis Mumford put it in 1926, taking as her project the delineation of a "native" American tradition that would contradict the prevailing belief in American cultural impoverishment (Mumford 1926, 43–44). No doubt her impassioned rescue of Americans broadly from a legacy of cultural displacement had resonance for Ellison with regard to African Americans. Second, Rourke included black folk culture in her inventory of "native" American (rather than strictly African) traditions, placing the black minstrel on an equal footing with the white folk figures, the Yankee and the backwoodsman.[18] Such an understanding of the cross-cultural fertilization of American traditions allowed her to see the intertwining of black and white elements in, for example, white minstrelsy (Rourke 1931, 76–79). Transplanted Africans and transplanted Europeans, Ellison and Rourke each insist, had developed new, complex cultural forms, which offered riches to American writers ready to make use of them. Such an integrationist perspective on folk cultural contributions countered the tendency—found, for example, in Rourke's contemporary Van Wyck Brooks—to see Americans as plagued by individualist impulses that put social cohesion at risk. Perhaps most significantly, Rourke's views also critique the evolutionary model of cultural development that designated (implicitly white) Americans as cultural adolescents relative to Europeans (much as African Americans were viewed as cultural adolescents compared with European Americans), in favor of a historical particularism that recognized unique patterns of development and influence. In *The Roots of American Culture*, Rourke disputes two prevalent theories of cultural transmission: first, the static and developmentally invariable "transit theory of civilization," which maintained that the seeds of a mature culture must be cultivated in the wilderness in order gradually to take root, and, second, the concept of cultural "lag" (Ellison's first published essay is titled "Creative and Cultural Lag"),[19] which posited an essentially diminished and imitative relation between an aspiring and established culture (Rourke 1942, 45–47). Rejecting both theories, she proposed the more dynamic concept of "syncopation"—the term itself a nod to the African-American cultural innovation, jazz—which conceived of American cul-

were published after *Invisible Man*, he discusses Rourke's ideas in conjunction with the novel, indicating his early acquaintance with them (Ellison 1995, 103–12).

[18] These three figures collectively comprised Rourke's "comic trio"; see Rourke 1931.

[19] The context is a brief review of Waters Edward Turpin's first novel, *These Low Grounds*; see Ellison 1937, 90–91.

tural elements jumping toward and away from European models in fluid and unpredictable ways.[20]

Ellison's essential agreement with Rourke's views is made clear in a 1958 debate with Stanley Edgar Hyman, published as "Change the Joke and Slip the Yoke," in which Ellison attempts to complicate the notion of African Americans' privileged relationship to folk traditions, in particular, by questioning the origins and meaning of blackface performances. Challenging Hyman's genealogy of these performers, Ellison argues:

> Although the figure in blackface looks suspiciously homegrown, Western and Calvinist to me, Hyman identifies it as being related to an archetypal trickster figure originating in Africa. Without arguing the point I shall say only that if it *is* a trickster, its adjustment to the contours of "white" symbolic needs is far more intriguing than its alleged origins, for it tells us something of the operation of American values as modulated by literature and folklore. (Ellison 1995, 105–6)

Ellison is concerned here with the specifically American incarnation of the trickster figure as a collaboration between black and white cultural interactions. While he takes for granted the existence of a black cultural heritage and its value, he refuses to see it in isolation, instead using it as a cultural Rorschach test to diagnose *white* cultural pathology. This transformation of the trickster from an active subject, as a figure of inventiveness and subversion, to a manipulable object personifying white projection and anxiety, also suggests the limitation of folklore as a reliable alternative to white racism.

Ellison concludes the essay by insisting on the modernist roots of his own attraction to folklore, an assertion from which we may discern both Ellison's resistance to racial essentialism and the undercurrent of high-culture elitism that distinguishes him from Rourke overall.[21] "I use folklore in my work," he explains, "not because I am a Negro, but because writers like Eliot and Joyce made me conscious of the literary value of my folk inheritance" (Ellison 1995, 112). Whereas Rourke distances herself from equating literary art with culture, going so far as to propose the possibility that, Emerson notwithstanding, "after all the American genius is not literary" (Rourke 1942, 56), Ellison would no doubt have been unwilling to cede a territory so large, so overdetermined as the historical proof of blacks' capacities for reason and civilization, and one in which he was so personally invested as a literary artist himself. Moreover, whereas

[20] The term "syncopation" appears in Rourke's manuscripts, cited in Rubin 1980, 66–67, 204 n. 17.

[21] Though this is not entirely true; Rourke herself betrayed a latent conformity to European standards by attempting to reclaim symbolism, primitivism, surrealism, and dadaism as primarily American movements; see Rubin 1980, 96–98.

Rourke felt that the accomplishments of the folk superseded those of isolated masterpieces, and supported democratic principles better than the luxury items of the rich, Ellison understood folk materials primarily as another resource from which to produce such masterpieces, the superiority of which was self-evident. He thus effectively shifted the developmental burden from race and nation onto class by discriminating an intellectual elite from its less "evolved" cohort.[22] Finally, while the scope of Rourke's democratic vision insured her inclusion of regional, Native-American and African-American contributions in her genealogies of American cultural traditions, Ellison, as Jerry Watts notes, ignores non-Western cultural traditions to an extent which "preclude[s] the development of an Afro-American critique of Western cultural hegemony and the cultural objectification of non-white others" (Watts 1994, 62).

Yet, if the folk can be said to have a mainly instrumental value for Ellison in his ambition to engage with Western literary traditions, it still retains the capacity to counter the far blunter instruments of social science. Folklore can be regarded as a key intermediary term for Ellison because it provides both the cultural evidence to dispute the accusation of cultural impoverishment leveled by social science and the raw materials from which to construct "higher" modernist forms as transcendent art. With its complex portrait of animal relations, moreover, folklore may be seen to offer an alternative to the vision of embodiment inherited by race sociology. Whereas in evolutionary biology and its conceptual predecessor, the Chain of Being, animals are ranked hierarchically from the most humbly corporeal to the most transcendent, in folkloric traditions animal qualities and relations confound such hierarchies; they may personify and exaggerate isolated human traits and, through their interactions, portray alternative models of social organization. But folklore remains a double-edged sword: if it demonstrates the vitality and complexity of African-American culture and its inventive capacity to resist racist constructions, it is also easily assimilated to prevailing ideas of cultural development that rank it below more individuated cultural expressions. No matter what degree of substantive challenge folklore is able to pose to ideologies of racial hierarchy, therefore, it is still structurally locked in an idiom contaminated by the discourse of evolutionary biology and culture. Moreover, the transformation of folkloric materials across cultures may alter them beyond recognition, making of them mirrors of rather than alternatives to prevalent racial politics and inequities, a process illustrated by Ellison's debate with Hyman about the transformation of African materials in American blackface performances. As Lawrence W. Levine has shown,

[22] For a useful discussion of Ellison's difficulty in adapting folk forms to the needs of the self-conscious artist, see Kent 1974, 169–70.

African-American folktales don't exclusively function as narratives of wish fulfillment for slave or postslavery communities. Although some tales, to be sure, depict tricksters who cleverly outwit Master and symbolically redress social injustice, others serve quite different purposes. Such tales may represent the perpetual war between the world's creatures in ways that should properly be regarded as (relatively) realistic accounts of survival in a hostile environment, not as fantasy. Furthermore, by depicting tricksters alternatively and unpredictably as strong *and* weak, these folktales may also convey a sense of the world's fundamental irrationality, and consequent human helplessness. Folktales, Levine argues, may well propose an alternative world view, then, but not one that should be naively seen as liberatory (1993, 60–77). Robert Stepto's observation of the affinities between Hurston and Ellison as writers of narratives "of both ascent and immersion" should, by these lights, be extended to include an even more basic commonality—their shared ambivalence about folklore as a viable basis on which to ground modern African-American identity (Stepto 1987, 361).

We can see that ambivalence played out vividly in Ellison's 1944 story "Flying Home," in which an old man, identified as a "peasant," tells a tale about a black angel thrown out of heaven for flying too recklessly; the story mirrors and condenses, in folktale form, the main narrative in which Todd, a black pilot, is grounded from flying air force missions because of his race. The two stories' correspondences are numerous; both sustain undercurrents of criticism about white power structures, celebrate black aeronautical skill, and culminate in crash landings in the state of Alabama. Such compatibilities would seem to suggest that differences in genre are superficial compared with their shared substance. But Todd misinterprets such commonalities as a satiric diminution of his own plight, and recalls his disaffection for old men "with childish eyes" such as the one who tells the folktale, who "did not understand his accomplishments" (Ellison 1996, 151–52). When the old man asks Todd why he likes to fly "way up there in the air," the younger man thinks to himself, "because it makes me less like you" (151, 153) —an observation whose affective power persists despite the "current of communication" (172) the two men establish at the close of the story. However integrated, finally, are the "peasant" and more educated narrative strata in "Flying Home," the emotional impact of the story relies on Todd's perception of folk materials as a threat to his identity and success.[23]

Ellison's preoccupation with a literary sphere that is conceived in narrowly Western and hierarchical terms, and that relegates folklore to the

[23] For more detailed readings of "Flying Home," see Ostendorf 1976, 185–99; Trimmer 1972, 175–82.

status of source materials for the conscious artist, not only constitutes his primary difference from Rourke but also points to still deeper historical roots traceable to his debt to Emerson. In "Nature," as we saw in the last chapter, Emerson provides an esteemed place for folk language and culture in his genealogy of poetic language, but only by positioning the picture language of "children and savages" as the precursors of the more evolved language of the American poet, who might thereby tap into an essential source of cultural vitality. Although Emerson celebrates the "familiar [and] the low" and "our Negroes and Indians" as appropriate poetic subjects (Emerson 1992, 57, 304), they remain but useful indigenous raw materials, incapable of self-representation on a par with those who might more worthily transform them. Of course, Emerson was also a key source for Rourke, prefiguring her views on the viability of a distinctive American culture when he argues that "We have listened too long to the courtly muses of Europe" (59); but there is no mistaking the literary emphasis of his conception of national culture for which the poet was to be the exemplary founder.

Emerson not only provides a blueprint for the valuing and transforming of folk materials in terms resonant for Ellison, but he also supplies a vision of self-determination and agency that likely appealed to a writer eager to challenge race sociology's deterministic account of subject formation. In "Transcendentalist," Emerson offers an extended defense of idealism, stressing the primacy of consciousness over the senses and "the power of Thought and Will" over material exigencies, and concluding that the "Mind is the only reality" (81, 83). With as much conviction as Emerson, Ellison might have authored the assertion "You think me the child of my circumstances: I make my circumstances" (83); the theme is developed still further in "Self-Reliance." Emerson also dismisses a narrowly empirical model of perception, in language that anticipates sociological methods; he insists that imaginatively assisted vision supersedes a more clinical gaze in its discovery of interior truths. The poet, he writes, "turns the world to glass, and shows us all things in their right series and procession. For through that better perception he stands one step nearer to things. . . . He uses forms according to the life, and not according to the form. This is true science" (296). Emerson's privileging of the conscious subject equipped with both visionary capacities and the empirical vision which complements it achieves its fullest articulation, of course, in the "transparent eyeball" of "Nature." With the transparent eyeball, it's not only the world but also the self which "turns to glass," in a model of disembodied subjectivity which achieves merger with the "All" of nature. To again recall the most famous lines of "Nature": "Standing on the bare ground,—my head bathed by the blithe air, and uplifted into infinite space,—all mean egotism vanishes. I become a transparent eye-ball. I am

nothing. I see all. The currents of the Universal Being circulate through me; I am part and particle of God" (6). The metonymic transposition of the "transparent eyeball" for a figure of the visionary subject provides an image which readily conforms to Ellison's description of the distorted, "bodiless heads" of his original definition of invisibility, with the difference that Emerson's enlarged heads, or, at least, the eyeballs that stand in for them, have been wrenched from the relational contexts that initially gave them birth. Even the eye's intersection with nature does not support conventional subject/object relations because its expanding purview erases the very distinction between self and world. Emerson's conception of the poet-seer depends, then, both on disembodiment and on social isolation—criteria which, as I will explore at greater length later on, have important implications for the gendering of the paradigm. For our immediate purposes, however, we can see how Emerson's project is actuated by a visual and visionary collaboration which differs from Ellison's invisibility chiefly in its withdrawal from human relations; and Emerson's views also complement and extend Rourke's by carving out a conceptual space in which free, self-creating subjects may subsume the materials of folk culture into a true national art.

Yet, as enabling as these dimensions of Emerson would appear to be for a writer of Ellison's sensibilities, Emerson's commitment to racial determinism and his explicit exclusion of those of African descent from his vision of individual development would seem to jeopardize, if not disqualify, their efficacy. As late as the canonical essay, "Fate" (1860), Emerson meditates on the "odious lessons" of a racially conceived biological determinism which, however admittedly unwelcome, appear literally to be ingrained: "Who likes to have a dapper phrenologist," he inquires rhetorically, "pronouncing on his fortunes? Who likes to believe that he has hidden in his skull, spine and pelvis, all the vices of a Saxon or Celtic race, which will be sure to pull him down . . . into a selfish, huckstering, servile, dodging animal?" (Baym 1994, 1115). Through readings of Emerson's journals and essays, Cornel West and Kun Jong Lee each have demonstrated the presence in Emerson's work of the majority of proslavery arguments of his historical moment, from polygenesis, biological determinism, and survival of the fittest to the belief in a racial "scale of being" and its sometime corollary, racial obsolescence theory (which predicted the eventual extinction, like the dodo, of the "lesser" races).[24] As Lee has argued at length, these views must be regarded as more than merely reflective of the racism of his contemporaries; they should be regarded, rather, as integral to a philosophical program committed to classifying degrees of human potential (Lee 1992, 335). Such views effectively extinguish the

[24] See Lee 1992, 331–44; West 1989, 28–34.

liberatory potential of Emerson's idealism; they also prefigure views later adopted by American race science. Moreover, the conceptual program for self-expansion that Emerson outlines for his poet can equally be understood as a blueprint for a far more material program of imperialist expansion and conquest; such a program is anticipated, for instance, in the language of subordination with which Emerson describes his poet as the "true land-lord" in a world of "tenants and boarders" whose possession of the land is necessarily imperfect (Emerson 1992, 306).[25] If we juxtapose these two broad tendencies in Emerson's thought—his rehabilitation of the folk and his belief in individual agency, on the one hand, and his commitment to racial hierarchy and expansionist ideals of the self, on the other—we can see that internal to Emersonian thought, installed in its very heart, lies the whole scope of Ellison's defining intellectual conflicts entire. Emerson, in other words, prefigures the key problems that race sociology will inherit at the same time that he offers the means of resolving them, only these opposed tendencies remain unintegrated within the body of Emerson's work itself.

Critics such as Leonard Deutsch and Eleanor Lyons have tended to discount *Invisible Man*'s critical representations of Emerson's theories, arguing that they show Ellison's depiction of the ways Emerson's ideas have been perverted historically, and not their endemic limits. Deutsch (1972, 159–60) insists that Ellison maintained an "abiding affection" for Emerson, while Lyons (1989) maintains that *Invisible Man* unfolds the fulfillment of Emersonian ideals. Critics such as William Nichols and Earl Rovit, on the other hand, have been more cognizant of the undercurrent of critique in the text, reading it respectively as satirizing Emerson's idealism and exposing it as rhetorical nonsense; but these perspectives, I would argue, overlook the depth of Ellison's engagement with an intellectual legacy too complex to be so easily dismissed. My own reading is most indebted to the more balanced assessment of Lee, who notes that Ellison's simultaneous identification with and rejection of key figures and elements of the American tradition should be comprehended through his commitment to both "preserve and destroy" or, as the Invisible Man puts it in the prologue, to "condemn and affirm, say no and say yes" (Ellison 1952, 579).[26] Such alert revisionism may be regarded as the most consistent impulse in his work, defining his relationships not only to Emerson but also to the folk, as well as to such literary predecessors as Hawthorne and James, and to the political ideals of American pluralism broadly. The novel spatializes such a dichotomous relation to Emerson from the beginning when, in the prologue, it presents the Invisible Man inhabiting a

[25] For additional accounts of Emerson and race, see also Lee 1996, 421–40; Nicoloff 1961.
[26] See Deutsch 1972, 159–60; Lyons 1989, 93–106; Nichols 1970, 70–75; Rovit 1960, 34–42; Lee 1992.

"section of the basement that was shut off and forgotten during the nineteenth century" in a "building rented strictly to whites" (6). If we regard the building as the edifice of Emersonian thought that for Ellison defined the nineteenth century,[27] the building affords shelter, to be sure, but only covertly, and in strictly stratified form. The Invisible Man may live in the house of Emerson, that is, only under duress, and by tapping outside currency for his own clandestine use; such revisionism remains circumscribed by the structural constraints under which it operates. The light that makes the basement habitable, furthermore, recapitulates the Invisible Man's equivocal relation to Emerson, since it serves both as a metaphor of illumination that evokes the formless operations of mind and as the mechanism which, in Emerson's terms, literally exposes the Invisible Man's disqualifying embodiment.

Transparent Eyeballs Made Flesh: Black and White Emersonians

Invisible Man is a novel of self-discovery which aims to situate the self simultaneously within two defining collectivities—race and nation—each of which is governed by particular expectations of eligible embodiment. Basic to Ellison's project in the novel is to foreground how for African Americans the qualifications for the two collectivities fundamentally conflict, at the same time as to show the dangers of collective identity broadly for the political and existential freedom of the individual subject. In the first half of the novel, Ellison pursues this theme though the Invisible Man's repeated encounters with Emersonian figures. As we've seen, Emerson's views intersect complexly with issues of race and nation: on the one hand, Emerson espouses inclusive ideas of national culture that incorporate the folkloric resources of many cultural traditions; on the other hand, Emerson evolved the highly exclusive conception of a poetic representative of national culture whose idealized disembodiment is predicated upon his "transparent" whiteness. Through the persistent juxtaposition of folk materials with Emersonian figures, Ellison foregrounds the conflict between these twin legacies, legacies which he presents, furthermore, in racially stratified form. The Invisible Man, that is, encounters a world divided into white and black Emersonians, who between them personify these disparate elements of Emerson's thought. Overt white Emersonians—Norton, Mr. Broadnax, Emersons Jr. and Sr.—display the proprietary self-expansionism and racial determinism which together comprise the least democratic aspects of Emerson's heritage, and without

[27] Ellison's employment of Mumford's term "Golden Day," which positions Emerson as the fountainhead of nineteenth-century literary and intellectual culture, strengthens this association.

which their status as disembodied seers would seemingly be jeopardized. In other words, it is critical to white Emersonians' achievement of cultural transparency (a term which I follow Homi Bhabha in equating with the successful naturalization of a discourse of power) that blackness represents the materiality and embodiment their gaze produces, and over which finally they may claim dominion.[28] Covert black Emersonians—Trueblood, Wheatstraw, the Golden Day's vet—display the self-determination and agency associated with the Emersonian ideal of self-reliance, and identify with folklore in nonhierarchical ways, either by skillfully employing folkloric materials themselves as Emersonian poets (Trueblood, Wheatstraw) or through the acknowledgment of its centrality as a resource (the vet). While black Emersonians best personify the more democratic of Emerson's ideals, they simultaneously expose their limitations by demonstrating the ways in which the historical situatedness of their embodiment as *African* Americans prevents their being recognized as viable representatives of national culture. This failure of recognition is enacted not just individually but discursively, as the alternative discourses and social orders proffered by black folklore invariably fall to the white hegemonic discourses of evolutionary biology and its kin. Such a failure of recognition occurs not only through the agency of white Emersonians but also through the race scientists, from the factory hospital doctors to the historical "scientists" of the Marxist Brotherhood, who inherit and extend these hierarchical racial views.

This discursive struggle is enacted through bodily relations: specifically, through visual encounters intent on dividing embodiment and the political agency with which it is associated along gendered and racial lines. In the novel, a hegemonic, monocular white gaze, linked with race science and extrapolated virtually into a cosmic principle through its association with heavenly bodies, hovers ubiquitously over the text: the moon, for instance, is likened to "a white man's bloodshot eye" (Ellison 1952, 110), which governs the relations producing black invisibility as if by natural law. The failure of white Emersonians to recognize their black counterparts (or, conversely, their persistent misrecognition of them as dangerous primitives) is but one indication of the white gaze's power; the failure of black subjects to produce a sustainable subject gaze is yet another. I want to begin by examining the paradigmatic white gaze and its effects in the first half of the novel, along with the range of black spectatorial positions

[28] See Bhabha 1994, 109 ff. Ellison's invisibility should be distinguished rhetorically from Bhabha's transparency, and perhaps conforms more closely to Bhabha's concept of "*negative transparency*." As Bhabha defines it, "negative transparency" is the obverse of the naturalized discourses of power, and must be "processed into visibility through the technologies of reversal, enlargement, lighting, editing, projection, not a source but a re-source of light. Such a bringing to light is a question of the provision of visibility as a capacity, a strategy, an agency" (110).

that comprise possible responses to it—from simple complicity or absorption into the subject/object relations that signify white dominance to attempts to reimagine or, indeed, to reconfigure the black body through the counter-discourse of folklore in order to resignify its possibilities. These sections of the novel ask us to assess the viability of an *embodied* black seer, of a fleshly rather than transparent eyeball, the materiality of which may be comprehended as a resource able to resist the association, made powerfully by Emerson, with a cultural stage destined to be overcome.

Daniel Kim has described the foundational character of the specular relations sustained between white and black men in the initial Battle Royal episode in the novel, in which a complex constellation of identification and scopophilia structures the white male gaze as it designates the black male body as "a kind of human scrim" whose utility is "to give vicarious expression to desires that are ordinarily repressed" (Kim 1997, 314). White Emersonians take up this mantle of periodically eroticized instrumentalism, likewise using looking relations to delegate embodiment or to experience it vicariously. Mr. Norton, the "trustee of consciousness"—Emerson's phrase—and college benefactor whom the Invisible Man chauffeurs early in the novel, is the first character to make explicit mention of Emerson and to be identified, albeit critically, with Emersonian concepts. About his unqualified belief in the vision of the Founder of the college, Norton avers (in terms whose conflation suggest both identification and desire) "that sometimes I don't know whether it was his vision or mine" (Ellison 1952, 39). We can recognize in incipient form here an affinity between Norton's ideas and Emerson's concerning the extension of "[one's] being, [one's] dominion" through others (Emerson 1992, 50), an appropriative logic whose manifest destiny unfolds with the novel's own development. As the Invisible Man drives, he seems unconsciously to intuit the proprietary nature of the principle Norton has introduced by displacing it onto a recollected series of photographs documenting the college's early history:

> Faded and yellowed pictures of the school's early days . . . flashed across the screen of my mind, coming fitfully and fragmentarily to life—photographs of men and women in wagons drawn by mule teams and oxen, dressed in black, dusty clothing, people who seemed almost without individuality, a black mob that seemed to be waiting, looking with blank faces, and among them the inevitable collection of white men and women in smiles, clear of features. (Ellison 1952, 39)

That the pictures "flashed across the screen of [his] mind" and came to life suggests their decisive inscription upon the Invisible Man's consciousness as he reviews this photographic record, and it indicates that the

"screens" of mind and body are alike vulnerable to white projection. The "clear" features of the whites evoke the privileged cultural transparency they enjoy which is unavailable to the "blank" faces of the blacks who, instead, seem to await their designated content, and whose "dusty clothing" signals the degraded embodiment which would warrant that form of cultural inscription. The waiting "black mob," furthermore, seem reduced to a homogenous group identity which recollects the folk, but one that is disturbingly drained of animation next to the expressive individuality of the whites. They can only be the collective objects of a gaze which the whites are each smilingly and uniquely able to return to the viewer. These dynamics are recapitulated when Norton and the Invisible Man's eyes meet "through the glass" of the car's rearview mirror, in a scene which recalls the Invisible Man's initial description of invisibility as "mirrors of hard, distorting glass." As Norton refers to Emerson's importance to black people, and to his own destiny through his "first-hand organizing of human life" (42), the Invisible Man and Norton's eyes "met for an instant in the glass, then I lowered mine to the blazing white line that divided the highway" (44)—a dividing line that suggests a kind of visual Jim Crow law, with the symbolic authority of the "white line" dividing and governing its black object.[29]

The distorting mirror through which subject and object status is distributed in the text is further represented through two subsequent pairings—those of Norton and Trueblood and of their respective daughters—each of which dramatizes the characteristic forms of embodiment which accompany subject and object positions. As has been frequently noted, both Norton's and Trueblood's relations to their daughters are eroticized (although Norton's is nearly suppressed), the former as an icon of white female purity, and the latter as a personification of incestuous contamination. The embodiment of Norton's daughter was tentative even in life, as we see when Norton compares her with the ethereal "liquid light of the moon" (42)—a heavenly body which itself refers to the white gaze—and it dissipates entirely in her death, the spiritual state into which she gently "fades." The embodiment of Trueblood's daughter, by contrast, is everywhere multiplied, in itself through her pregnant body, by its reflection in her mother's pregnancy, and ultimately, through the very convicting evidence of her blackness itself that she shares with her transgressive father. Norton's daughter, finally, is apotheosized by her father into an aesthetic

[29] The Invisible Man's object status relative to Norton is, of course, only epitomized in visual relations which express its broader prevalence, as Norton makes clear in his intent to construct a "living memorial" to his daughter: "Through you and your fellow students I become, let us say, three hundred teachers, seven hundred trained mechanics, eight hundred skilled farmers, and so on." Norton's appropriation of black college students as his collective "fate" is made possible, then, by his blindness to them as individuals, as the Invisible Man reminds us when he silently objects, "But you don't even know my name" (Ellison 1952, 45).

object, an image, her oval portrait framed in a delicately wrought brooch; Trueblood's daughter, by contrast, is imaginatively transformed by her father from "a little ole pigtail gal" into "a whore" (59). The distinction between disembodied whiteness and embodied blackness is completed by the conclusion of the episode through the expanding contrast between the two fathers; as Trueblood winds up his narrative, Norton's face "drained of color. With his bright eyes burning into Trueblood's black face, he looked ghostly" (68)—an image which stresses both the opposition of the two men and Norton's "burning" gaze as its cause. Norton seemingly acknowledges the interdependency of the exchange and the ontological debt it creates, since the gain in disembodied subjectivity is all on his side, with his gift to Trueblood of the hundred-dollar bill—one which exceeds in amount but not intent the other presents whites have showered on Trueblood for narrating his trueblooded "primitivism" so persuasively.

The paradox of that skillful telling, which inscribes Trueblood in a discourse of artistry, emerges most dramatically during Trueblood's narration of the dream sequence. Here he describes his quest to find Mr. Broadnax, who lives at the top of "the highest hill in the world," in search of promised "fatmeat" (57). Mr. Broadnax is most likely a satiric portrait of Emerson's American scholar, whom Emerson cautions in that essay to be "broad-in-acts" because action is a crucial personal resource and source of power. But Emerson's advocacy of action is couched in a rhetoric of conquest that recalls Norton's earlier proprietary claims: "So much only of life as I know by experience, so much of the wilderness have I vanquished and planted, or so far have I extended my being, my dominion" (50). Trueblood's attempt to reach Mr. Broadnax and his "prize" is complicated by a seemingly unbridgeable distance, suggesting the exclusion of blacks from Emerson's program or, at least, their relegation to its "back door" and the diminished status it represents. "The more I climbed," he tells Norton, "the farther away Mr. Broadnax's house seemed to git. But finally I do reach there. And I'm so tired and restless to git to the man, I goes through the front door! I knows it's wrong, but I can't help it" (57). Trueblood is initially trapped by the embrace of a spectral white woman who quickly dematerializes: "That woman just seemed to sink outta sight," he reports, breaking up into "a flock of little white geese" that "disappear"; in her place, apparently, is a black woman, whose relations with Trueblood are sufficiently embodied to inspire the now present Mr. Broadnax to pronounce, " 'They just nigguhs, leave 'em do it' " (58). But Trueblood fears this female body, too, explaining "I got a feelin' somethin' is wrong. I git aloose from the woman now and I'm runnin' for the clock," retreating to the clock's interior. But the clock seems to function still more as an image of engulfing femininity than of temporality (though it may connote historical entrapment as well), with

its "hot and dark tunnel" presaged by "crinkly stuff like steel wool on the facing" (58). Trueblood becomes trapped in this cultural machinery, which we learn resembles the power plant at the college—a machine equally committed, presumably, to churning out pliable, feminized black men. The proverbial light Trueblood finds at the end of this tunnel turns out to offer not escape but, rather, his definitive inscription in these overdetermined, asymmetrical relations which are again expressed visually—through a dominant white subject gaze which "burst like a great big electric light in my eyes" and, in a final acknowledgment of the pain of the embodiment it produces, "scalded me all over" (59). Trueblood's efforts to be "broad-in-acts," then, only inscribe him the more intractably as (sexualized) object, reminding us of the basis of this Emersonian ideal in race and class privilege.

That the white woman initially is the sexual aggressor in Trueblood's dream is consistent with Ellison's efforts throughout the novel to shift the burden of embodiment to white women, from the naked woman with the flag tattoo who dances for the boxers at the Battle Royal to the lascivious Sybil who begs the Invisible Man for rape. Such an effort is explicable, of course, as a critique and revision of the historical use of a mythic white female purity to construct ideologically and persecute physically hypersexualized black men. But the strategy is of limited success, since each of these scenes ultimately reorients its focus to black male bodies, cast either in the role of pugilists, as in the Battle Royal, or in the role of sexual transgressors as incestuous fathers and rapists, through the mechanisms of white machinations and projection. Ellison seems to postulate both the need to reembody white women and the enormity of such a revisionist project by repeatedly staging their disappearance: the stripper at the Battle Royal is carried off by white men; Trueblood's seductress evaporates, leaving Trueblood caught, as it were, with his pants down; and Sybil retreats into the night, only to be confused with a row of storefront mannequins symbolically strung up by Ras the Destroyer, who turn out merely to be false bodies. Arguably, Ellison is wasting his powder on small game with this displacement, given the imbrication of women widely within discourses of embodiment, and the more challenging task of dismantling subject/object relations between white and black men in the novel.

That challenge is well illustrated by way of a second possible Emersonian source for Mr. Broadnax, one more explicitly racial in its views, which resonates with another aspect of the scene. In "Self-Reliance," Emerson develops a series of contrasts between the "thinking American" and the "naked New Zealander" to demonstrate that "the white man has lost his aboriginal strength." To exemplify this, he suggests: "Strike the savage with a broad-axe and in a day or two the flesh shall unite and heal as if you struck the blow into soft pitch, and the same blow shall send the white to

his grave" (Emerson 1992, 151). Here Emerson would seem to be retooling his argument about the linguistic vitality of "savages" presented in "Nature" to encompass physical qualities. The temptation to see the "aboriginal strength" of the New Zealander as the victor in this bizarre test of vigor is of course mitigated by its isolation from the powers of mind highlighted by the "thinking" American, which constitute Emerson's subjective ideal. But for that very reason the passage can be seen to prefigure the moment Trueblood narrates when his wife, Kate, does in fact strike him with a broad axe, leaving the raw, moist wound the Invisible Man remarks on initially and which conspicuously attracts insects throughout the section. Seen through this lens, Trueblood's healing wound draws attention to his resilience and, together with the limited mental capacities it implies, signifies his "savagery." Ellison seems to parody Emerson's savage/civilized binary and its reliance upon degrees of bodily endurance when he recasts it in a theological register: Norton demands of Trueblood, " 'You have looked upon chaos and are not destroyed!' 'No suh! I feels all right' " (Ellison 1952, 51). The comedy of the scene is further reinforced by Trueblood's winking self-consciousness about its import, which is later signaled by the exchange of gazes between himself and the Invisible Man: "Trueblood seemed to smile at me behind his eyes as he looked from the white man to me and continued" (61). The parity of the black men's intersubjective gaze only highlights the subversive mimicry of Trueblood's performances for Norton, the outcome of which is both complicit with and disruptive of the authority of the white gaze, to which Trueblood's continuing residence and remuneration together testify.[30]

Such subversion evolves still more complexly in the substance of the narrative, where Trueblood makes manifest the numerous parallels between Mr. Norton and Mr. Broadnax. Both figures are paragons of white privilege, behind whose promises of philanthropy—be it fatmeat or college endowments—lie racist preconceptions; each stands transfixed before Trueblood's tabooed sexual relations, and winds up justifying his voyeuristic regard with the rationale "They just nigguhs, leave 'em do it"; finally, each produces his own subjective domain by maintaining Trueblood, permanently, at its periphery as savage. Trueblood's dream narrative in effect holds a mirror up to Norton in which he can view his own racial territorialism, while Trueblood himself stands to one side, enjoying the spectacle of the white man's failed self-recognition. Such a canny rela-

[30] To this extent, Trueblood seems to exemplify the process of hybridity which, as Bhabha has described it, serves both as a sign of colonial power and its reversal: hybridity is "the revaluation of the assumption of colonial identity through the repetition of discriminatory identity effects"; and through its deformations, it "unsettles the mimetic or narcissistic demands [of the subject gaze] but reimplicates its identifications in strategies of subversion that turn the gaze of the discriminated back upon the eye of power" (Bhabha 1994, 112).

tion to what at first seems his own self-convicting narrative mirror crystallizes the highly equivocal nature of this character. Trueblood's name may evoke ideas of racial essence suggestive of evolutionary biology and race sociology in one discursive tradition, but it may equally signify his inscription in a more positive cultural trajectory, as Houston Baker has argued in identifying him with a folkloric tradition of phallic tricksters.[31] The incompatibility of these traditions, implied by Trueblood's and Norton's ongoing inability to understand each other, doesn't preclude their mutual presence. Like the "high, plaintively animal sounds" (47) that the Invisible Man tells us best characterize Trueblood's singing, Trueblood's name and storytelling cut both ways, as the proof at once of cultural attainment and its impossibility. Yet, if Trueblood's dream seems to hold up a subversive and self-reflexive mirror to Norton, his triumph appears to be solitary and compromised by the material conditions which circumscribe it. That is, while Trueblood successfully sells the folk cultural forms he crafts for money, he also sells them out, since they go at the considerable cost of reinforcing ideas of black primitivism. If, as several critics have contended, Trueblood's statement, "I ain't nobody but myself" (66) should be construed as his successful reappropriation of an Emersonian ethos of self-determination and self-acceptance, the larger perceptual world he inhabits shows up its solipsistic limits. He's still defined, in other words, by how the white subject sees him, with the irony that, as Lee observes, "the *true* Emersonian poets, because of their race, are not recognized as such by the Emersonian figure [Norton] and are despised and rejected by the community" (Lee 1992, 338).

The place the Invisible Man takes Norton to recover from his strained first encounter with a black Emersonian is, significantly, another revised Emersonian space. Ellison named the Golden Day for Lewis Mumford's Luddite homage to the American Renaissance of the same title (Mumford 1926), which celebrates the years 1830–60 as the flowering of an individualist ethos ushered in by the period's "morning star," Emerson. Mumford's vision of tragic decline that Emerson's "Golden Day" was to suffer at the hands of the industrialism and materialism of the Guilded Age represents an interpretation of the postbellum years likely to be treated skeptically by those who viewed the emancipation of the slaves as more than a historical footnote. The name of the Golden Day itself, then, connotes racial unconsciousness as well as Emersonian ideals, and Ellison's Golden Day explores the disparate meanings Emersonian individualism might have for white and black subjects through a series of dialectical inversions, which might be said to bring the Golden Day into eclipse.[32]

[31] See Baker 1984, 184.

[32] This is initially signaled by the Invisible Man taking Norton's car down the wrong side of the road en route to the bar, in order to avoid the "crazy" veterans headed there for their

The initial structural inversions that frame the episode are triggered into activity by the temporary demise of Supercargo, the nature of whose authority is indicated by his name's resemblance to super-ego and who, like Norton, remains unconscious for most of the episode. Although Supercargo is black, both men are associated with white power, and their joint decommission ushers in a hiatus of racial norms and liberation of repressed elements, measurable in the veterans' reversal or dismantling of various systems of racial hierarchy and embodiment.

Much like Hurston, in her representation of the muck, Ellison also crafts a space animated by antihierarchical fantasy—here fueled by folkloric imagery and discourse—which proves unsustainable in a wider social context. Norton, who is at first identified as General Pershing, Thomas Jefferson, John D. Rockefeller, and the Messiah, is shortly declared merely to be suffering from a "case of hysteria" (Ellison 1952, 79); the designation feminizes him and, from this point, Norton slides precipitously down the proverbial Chain of Being, demoted from his status at its pinnacle as "the Creator" to a position somewhere well below the human, as a composite, sexualized creature with "monkey glands and billy goat balls" as Edna describes him. She concludes, in an image that tellingly conflates the animal and sexual with the imperial, thereby inverting the equation of natural superiority with conquest, "They want to have the whole world" (88). Meanwhile, another patient, who identifies himself as "a student of history," offers a global vision of black ascendancy which supplants evolutionary models of racial difference and historical change with a far less predictable mechanism: " 'The world moves in a circle like a roulette wheel. In the beginning, black is on top, in the middle, white holds the odds, but soon Ethiopia shall stretch forth her noble wings! Then place your money on the black' " (81). Norton's illness itself aids in embodying him as material object, with his slumped form requiring some dexterity on the part of the Invisible Man and others to cart about. Over time, Norton also accumulates two minor flesh wounds, the descriptions of which indicate the ways his growing materiality undercuts his standing as a universal subject: the "five pale red lines" which "bloomed on the white cheek, glowing like fire beneath translucent stone" (79) record the imprint of the black hand which finds him flesh, thereby depriving him of his perfect "translucence." Upon his departure, Norton's head scrapes on

weekly visit. Inversion is further signaled through the genealogy of the space itself, having been used as a church, bank, restaurant, and "fancy" gambling house, presumably of service mainly to whites, and later, as a jailhouse, and in its current incarnation as a raucous bar and whorehouse with a black clientele. The changes chart a trajectory from respectably white to transgressively black space that local whites work to maintain despite the school's efforts to sanitize it; their intervention seems to echo the white support of Trueblood, support apparently calculated to maintain the sort of racial dichotomies that sustain white power.

the "screen of the door," which leaves a "raw place showing on his fore-head" (97). That the mark is produced by a screen suggests the violence of interracial projection and invites comparison with Trueblood's wound. Redesignating the white body as marked is the Golden Day's parting shot in the battle over racial embodiment. Through these means, Ellison has revised the meaning of "Golden Day" to signify the period when oppressive race relations are overturned. The provisionality of such a development is signaled, however, by Norton's momentary regaining of consciousness, which instigates a brief return of conventionally racialized subject/object relations and produces discomfiture in the patients. The incident reinforces the ways racial divisions are affected by the white gaze: in response to it "some were hostile, some cringing, some horrified; some, who when among themselves were most violent, now appeared as submissive as children" (81).

The section ends with Norton's encounter with another black Emersonian when he becomes the object of examination and diagnosis by the black vet, a former physician, who fixes Norton with his own assessing, scientific gaze. (The Invisible Man responds nervously to this reversal: "Men like us," he notes, "did not look at a man like Mr. Norton in that manner" [90].) In a thinly veiled critique of the Emersonian legacy to which Norton lays claim, the vet immediately interrogates Norton about his "destiny," ridiculing his "achievement" for its appropriative reduction of individuals like the Invisible Man to "marks on a scorecard" (95). As the vet exposes Norton's instrumentalism and the Invisible Man's blind complicity with it, he emerges as the heir to the more appealing aspects of Emerson's Golden Day, expressed in his commitment to unvarnished truths and nonconformity. Like the earlier black Emersonian, Trueblood, the vet is also associated with a self-conscious knowledge of folk culture, telling Norton that he'd once forgotten such things "as most peasants and folk peoples almost always know through experience, though seldom through conscious thought" (91); the vet's identification of folk wisdom as the basis for more developed cultural forms further links him to Emerson. But also like Trueblood, the vet's emergence as the truer or, at least, the better Emersonian figure doesn't insulate him from the whims of white power any more than his varied forms of medical knowledge and skill do. The Golden Day may be a zone of chaotic possibility but it's finally a circumscribed one, bracketed off from the actualities of the race relations which surround and define it; the section culminates in the vet's deportation. Yet, even as the vet becomes a living illustration of the effects of white power, he shores up his Emersonian credentials with his advice to the Invisible Man about the value of self-reliance: "Be you own father," he says (156).

The fantasy-space of racial reversals encompassed by the Golden Day is

both circumscribed and extended by the next incidence of the collaboration between Emersonian and folkloric materials in the novel, which juxtaposes the Invisible Man's encounter with the cartman Peter Wheatstraw and his subsequent visit to Emerson's office. Wheatstraw's connection to Emersonian materials is reinforced by the Invisible Man's insight that he resembles the vet from the Golden Day, and he emerges as another black Emersonian who uses folk materials to counter the imperial aspirations of Emerson's legacy. Like Trueblood, Wheatstraw marshals the resources of folklore to resist exclusionary racial hierarchies and thus aims to carve out a space for his own individual artistry. Wheatstraw sings a blues song (made famous by Jimmy Rushing)[33] which potentially reshuffles and dismantles evolutionary hierarchies and binaries, even as it inevitably alludes to them.

> "She's got feet like a monkey
> Legs like a frog—Lawd, Lawd!
> But when she starts to loving me
> I holler Whoooo, God-dog!
> Cause I loves my baabay,
> Better than I do myself." (173)

The anatomization of the lover's body through animal parts clearly flirts with the discourses of comparative anatomy and race science even as it playfully revises them; the lover here resembles several different animals (later, Wheatstraw changes the second line to "Legs, Legs like a maaad / Bulldog" [177]), and while the method of the song is vertical, since it travels up the woman's body beginning with the feet, it would be a mistake to regard the change from monkey to frog or dog as a developmental trajectory. The singer's enthusiastic "Whoooo," uttered in the act of love figuratively inscribes him within an animal discourse as well, while the palindrome, "God-dog," by placing a mirror between the two terms, suggests their basic equivalence and thereby disrupts any vertical understanding of their relation. The sheer diversity of animal types in the song, as in folklore broadly, as Robin Calland (1996) argues, undoes a simple animal/human binary, with the implication that there are as many ways to be human as there are to be animal. Such diversity poses an implicit challenge to rigid hierarchical ordering ranging from the Chain of Being to more recent "scientific" taxonomies by creating relationships too mercurial to be accommodated within them; "a wolf may be born with fangs and legs seemingly built for the victorious hunt," Calland notes, "but if the cottontail rabbit can find a way to outfox the wolf, s/he is superior" (1996, 7–9). But it would be equally short-sighted to view the comparison of the

[33] See Marvin 1996, 594.

black female body with the monkey as less than fully imbricated in a discourse capable of imagining, as English anatomist Edward Long did in 1788, that the commonalities between the black female and the ape were sufficient to warrant their interbreeding (cited in Wiegman 1995, 57). To make use of such imagery is, of necessity I would argue, an effort to reclaim it by revising its conventional cultural meanings. The difference between Wheatstraw's conclusion ("I loves my baabay/Better than I do myself") and the Invisible Man's ("how could even *he* love her if she were as repulsive as the song described?" [177]) is a confirmation of the ongoing power of the conventional, hegemonic view of such a body as grotesque. Nevertheless, Wheatstraw's enthusiastic performance of the song displays its deconstructive potential in relation to those meanings, even while it remains permanently vulnerable to them.

That the Invisible Man has yet to discover the resources of folklore as a means of alternative self-definition is made clear throughout the section, from his incomprehension of Wheatstraw's initial question, "Is you got the *dog?*" (173) to the Invisible Man's conclusion that "*they're* a hell of a people," excluding himself from the category and pondering whether he feels "pride or disgust" (177, emphasis mine) at Wheatstraw's verbal virtuosity. Compared with Wheatstraw, whose complex and intimate relationship to the animal world is reprised through the language used to describe his own body, including a head that snaps "like an angry rooster's" and tilts to one side "like a bear," as well as torn clothes explained by the "bear that got holt to me" (173–76), the Invisible Man definitely does not "got the dog." And whereas Wheatstraw exemplifies the ways old ideas can be modified to new uses, converting damaging racial ideologies into celebratory blues songs, just as he intends to transform stacks of obsolete blueprints into paper houses, the Invisible Man prefers simply to "stick to the plan" (175). Wheatstraw's resourcefulness and ingenuity is of a particular, bricolaged variety, drawing from multiple cultural sources the heterogeneity of which serves to detach them categorically from race and thus, to de-essentialize them. Ellison borrowed Wheatstraw's name from the blues singer William Bunch—also known as Peetie Wheatstraw, the Devil's son-in-law—but the character of the musician/conjurer at the crossroads has also, according to Thomas Marvin (1996, 587–89), West African roots in the legend of Legba. This mixture of African, American, and also European sources holds true in Wheatstraw's characteristic smattering of cultural allusions (not to mention in Ellison's own literary practices) that we see in his bravura autobiographical spiel. He claims several identities in sequence: "I'maseventhsonofaseventhsonbawnwithacawloverbotheyesandraisedonblackcatboneshighjohntheconquerorandgreasygreens" —a list all of whose elements derive from African-American hoodoo tradition (Marvin 1996, 592)—and continues, " 'My name's Blue and I'm

coming at you with a pitchfork. Fe Fi Fo Fum. Who wants to shoot the Devil one" (Ellison 1952, 176). Here, Wheatstraw riffs on his blues affiliations and brandishes a pitchfork worthy of the "Devil's son-in-law," and mixes these American- and African-derived traditions with European ones. "Fe Fi Fo Fum" is the chant of the giant in the English tale "Jack and the Bean-Stalk," a nursery story which itself resembles myths found among North American Indians and native tribes of South Africa; Wheatstraw replaces "I smell the blood of an Englishman" with "Who wants to shoot the Devil one," blending disparate traditions together.[34] The Wheatstraw segment thus illustrates Rourke's and Ellison's arguments about the dynamic interactions of multicultural sources in the American hybrid, at the same time that it supports Berndt Ostendorf's contention that Ellison uses mythic codes, such as those involved in accounts of origins, to explore historical particularity rather than universality.[35]

The Invisible Man's encounter with Wheatstraw and the folkloric heritage he represents, perhaps because it operates as an intersubjective engagement relatively insulated from the white gaze ("relatively" because the Invisible Man himself projects an internalized version of that gaze), seems to function as a symbolic inoculation against the "disease" of Emersonian instrumentalism; for, when he next encounters it directly in Emerson's home territory, the resources of the folk seem for the first time to surface and rally against its assault. By the end of this section, we find him humming a folk tune himself, and contemplating independent action. His transformation is expedited, once again, by the resources of reversal in which Ellison augments the colonial dimensions of white specularity with homoeroticism, in a now familiar strategy to feminize and thus reembody the white male subject. Ellison makes Emerson's office an importing firm, the interior of which gives new meaning to the decorating style, "neocolonial." Evidence of the appropriative expansion of Emerson's "being and dominion," as he puts it in "The American Scholar," is everywhere, with special emphasis placed on the southern hemisphere. Decorated in "tropical colors," and featuring an aviary of tropical birds remarkable for the "savage beating" of their wings, the office is presided over by the younger Emerson, initially identified simply as a blond man, sporting a "tropical weave suit." In case we don't get the point, on the office wall hangs a huge map, underneath which stand specimen jars filled with representative natural resources which correspond to individual countries. Just as Norton displayed his blindness to the integrity of individuals, the younger Emerson declares that he knows " 'many things about [the Invisible Man]—not you personally, but fellows like you. . . . I

[34] The beanstalk is said to be derived from the ash tree Yggdrasil, the world tree of northern mythology; see Drabble 1985, 501.
[35] Bloom 1986, 186.

know the conditions under which you live' " (187–88). Cumulatively, these details point to another critique of the proprietary dimensions of Emerson.

That the Invisible Man never has an audience with Emerson senior suggests both the remoteness of the past to the conditions of the present and, perhaps, an acknowledgment of the betrayed promise of some Emersonian ideals as well. But the copy of Freud's *Totem and Taboo* that lies on the table and which conveys a cultural evolutionist vision, may shed further light on the relation between the elder and younger Emersons in ways more consistent with critique than nostalgia. Freud's text purports to describe the ways the rituals and prohibitions of "primitive peoples" are reconfigured as "complexes" in modern, civilized man by tracing the origins of the psychically contained Oedipus complex to the literal killing of the primal father by ancestral "savages." The presence of Freud's text immediately functions as a simple marker of the continuity between the historical and fictional Emersons' biases and a social scientific discourse whose cultural hierarchies are implicitly racist. More obliquely, Freud's text provides ironic commentary on young Emerson's clearly vexed relation to his own father; still recovering from "a difficult session with [his] analyst," the manifestly neurotic younger Emerson feels silenced by the elder man, and refers to himself as "still his [father's] prisoner" (185, 187, 192). Ellison works to overturn the savage/civilized binary presented in Freud not only by stressing the degree of conflict between father and son, the psychic violence of which rivals the physical, but also by linking psychic trauma with diminished masculinity. The younger Emerson is coded as homosexual, from his conspicuous attention to the Invisible Man's build and his "elegant gesture[s] of self-disgust" to his references to Club Calamus[36] and his self-designation as an "unspeakable" (183, 185, 188). The portrayal of the white male gaze as erotically charged in itself foregrounds its embodiment, a point which Ellison reinforces with Emerson's invitation to employ the Invisible Man as his body servant. Ellison's portrayal is frankly homophobic, playing on ideas of male homosexuality as the outcome of unresolved Oedipal dramas and equating it with feminization and decadence. Ellison uses young Emerson's homosexuality, then, to show degeneracy, both *from* father to son generationally (a movement echoed by the son's subordination to his father) and *between* father and son intrapsychically; through these means, Ellison attempts to deconstruct, if not reverse, the Freudian categories that cast psychic complexes as somehow superior versions of cultural paradigms.

It is folklore, rather, that emerges as the superior cultural form, as is suggested by the Invisible Man's singing of a folk song, "Oh well they

[36] The broader reference is to Whitman's homoerotic Calamus poems.

picked poor Robin clean" (193), that he picks up from a man on the bus headed back to Harlem, and which helps him express his feelings of betrayal; the song triggers early memories and the words come back. But, significantly, the Invisible Man renders his use of folkloric materials self-conscious, both by trying to grasp their history and meaning—"who was Robin and for what had he been hurt and humiliated" (194)—and by translating the oral song into a (mentally) written medium and his own idiom.

> "My dear Mr. Emerson," I said. "The Robin bearing this letter is a former student. Please hope him to death, and keep him running. Your most humble and obedient servant, A. H. Bledsoe. . . ."
> . . . "Dear Bled, have met Robin and shaved tail. Signed, Emerson." (194)

This return to and reinvention of his folk past serves, ironically, as the means by which the Invisible Man first successfully pursues the Emersonian ideal of self-reliance, as he "use[s] Emerson's name without his permission" (196) and for his own ends.

Detaching the Sociological Gaze

The racialized dimensions of the Emersonian legacy are taken up, in the middle episodes of the novel, by what Ellison perceived to be its historical successors: race science and Marxism. Just as the Invisible Man's covert tenancy in the nineteenth-century building of the prologue spatializes his relation to Emerson, his traversal of the vertical strata of the Liberty Paint factory maps the base/superstructure model of economic relations conceived by Marx. Literally working in the basement of the factory to produce the base of the paint, the Invisible Man's tenure in Lucius Brockway's basement conforms to a Marxist view of the exploitation of (black) labor within existing relations of production, from which arises the forms of social consciousness which justify and perpetuate them—as Lucius Brockway personifies with his risky and undercompensated expertise, his resistance to union organizing, and with his slogan "If It's Optic White, It's the Right White" (217). Ellison thus concedes a measured endorsement of such views, even as he will expose the limits of their scientific pretensions and their latent racism in his later treatment of the Brotherhood. This perceived complicity of Marxism with race science is first depicted in the factory hospital episode, where we find race science harbored quite literally, to extend the metaphoric configuration of the paint factory a bit further, within the "House of Marxism." As he did in his several confrontations between white and black Emersonians, here Elli-

son places folkloric materials in a critical engagement with discourses of racial hierarchy and, once again, these counter-discourses prove momentarily able to destabilize entrenched, racialized distributions of embodiment; but they are of limited long-term efficacy in redrawing the boundaries of visual power.

The factory hospital episode is rich in resonances, reprising, as if through the layering of transparencies, a series of symbolic contexts: literally, the scene depicts an electroshock treatment; but it also suggests a museum display, with the Invisible Man exhibited in a "glass and nickel box" (Ellison 1952, 233); and it evokes a mechanical birth—complete with breast-feeding, bathing, and a cut umbilicus (238, 244), as well as a racialized Frankenstein episode, implying the construction (as opposed to the distillation) of the Invisible Man's identity.[37] From the specifically male agency involved in this rebirthing process we could infer Ellison's critique of whites' construction of the black Other as an "unnatural" process; but equally, given Ellison's excision of the maternal Mary Rambo from her prominent role in an earlier draft of the episode, in conjunction with the male- and machine-birth imagery that permeates the scene, the factory hospital episode may suggest a fantasy of autogenesis—an effort to evade the most problematic and inescapable evidence of embodiment epitomized by the attachment to the maternal body.[38] This latter view is more consistent with the compulsively repeated scenes of self-birthing we find at the conclusion of nearly every episode throughout the novel, which typically either exclude the feminine (as in the vet's advice to "Be your own *father*" upon leaving the College [156, emphasis mine]) or are openly matriphobic (as demonstrated in the Invisible Man's abrupt parting from Mary as he takes the name given him by the *Brother*hood, and his rejection of her protection prior to his assumption of his final, invisible identity).[39] In the drama of dis- and rememberment staged in the factory hospital episode, of the unraveling and knitting together of mind and body, folklore once again plays a key if highly ambiguous role, as it inter-

[37] Elizabeth Young has shown the ways in which white racial anxieties were transcribed into the Frankenstein films of the 1930s, in which the monster's delinquency, criminality, inferiority, and subhumanity converge in a frightening reinscription of black stereotypes; the monster's primitive appearance and grotesque embodiment make him a symbolic cousin, Young argues, of another demonized monster, King Kong, whose coding of the myth of the Black rapist is expressed in his abduction of the helpless Fay Wray. Ellison is clearly reworking such imagery here, from his reanimation of the Invisible Man in a laboratory through electrical current to his inclusion of a doctor's recommendation of castration as an appropriate "therapy" (1952, 236–37). See Young 1991, 423–26. With its temporal disturbances, sexualization of the black man and equation of the white gaze with black embodiment, the episode also recalls the imagery of Trueblood's dream.

[38] See Ellison 1963.

[39] For further consideration of women and gender in the novel, see Spillers 1989, 127–49; Tate 1987, 163–72; Rohrberger 1989, 124–32.

sects most prominently with the discourse of race science and the white medical gaze which is its vehicle.

The episode opens by revisiting the imagery of the white gaze—multiplied here by a doctor's headlamp, "a bright third eye"—and its links with the racialized forms of embodiment that were introduced in the Trueblood episode. The monstrosity of the description of the three-eyed doctor, which as a consequence may destabilize conventionally racialized subject/object relations, sounds the note of tentative reversal that will pervade the section as it works toward the redistribution of embodiment (such monster imagery, too, interestingly anticipates Ellison's self-description as the three-eyed monster from "Hidden Name and Complex Fate"). Initially, the Invisible Man, swaddled in new white overalls, is involved with processing a whole array of bodily sensations—itching skin, bitter tastes, and trembling fingers—while he is fixed by a medical gaze completely disembodied through a kind of synesthesia: the doctor is merely "a thin voice with a mirror on the end of it" (231). The mirror once again recalls the mechanisms of white projection that produce invisibility, as does the recurrent imagery of visual distortion in this section, expressed through the thick-lensed eyeglasses worn by most of the doctors. The constitutive nature of the white medical gaze for the Invisible Man, who is "under observation," is made clear by the fact that "the bright eye [was] still burning into mine, although the man was gone" (231).

> "My head—that burning eye . . ." I said.
> "Eye?"
> "Inside," I said. (232)

The Invisible Man's enactment of this internalized white gaze is responsible for much of the ambiguity of the chapter, since it throws into question whose perspective—hegemonic or resistant—he subsequently expresses and the degree to which they can be distinguished, given the ways they may be blurred by the mechanism of internalization itself: "I twisted on my back, fighting something I couldn't see," the Invisible Man reports. "Then after a while my vision cleared" (233)—it's uncertain from such a description who won the contest, particularly because such transparency has elsewhere been linked with the naturalization of power.

It's while "fighting against the stabbing pulses of the machine" that the Invisible Man has a pastoral vision, complete with green hedges, a shaded lawn, and a uniformed military band playing "The Holy City," that seems to evoke his rural Southern past; yet these images are rapidly overwhelmed by the presence of "fine white gnats, filling my eyes, boiling so quickly that the dark trumpeter breathed them in and expelled them through the bell of his golden horn, a live white cloud" (234). The divi-

sions between real and hallucinatory, self and other, break down in this imagery as microscopically as do the divisions between black and white: the Invisible Man seems to project himself into the "dark trumpeter"; the white gnats are taken directly into the black body, presumably mixing with its substance. This racially and ontologically liminal depiction, which parodies the cultural interactionism personified by Peter Wheatstraw, foregrounds the Invisible Man's vulnerability to white influence even over past memories, and forms the equivocal setting for the folkloric reverie he drops into next:

> Oh, doctor, I thought drowsily, did you ever wade in a brook before break-fast? Ever chew on sugar cane? You know, doc, the same fall day I first saw the hounds chasing black men in stripes and chains my grandmother sat with me and sang with twinkling eyes:
>
> > "Godamighty made a monkey
> > Godamighty made a whale
> > And godamighty made a 'gator
> > With hickeys all over his tail." (234)

Like the Invisible Man's initial vision, the setting for this reverie is pastoral, just as its bucolic simplicity is ruptured by the introduction of a menacing if unnamed whiteness in the form of those who most likely lead the chasing hounds. But unlike the first vision, this one turns next to a folk song, which provides critical commentary on the display of white power the Invisible Man is witnessing. Like Peter Wheatstraw's song, the song the Invisible Man's grandmother sings implicitly challenges evolutionary hierarchies by presenting monkey, whale, and alligator as unique examples of God's creation, in no particular order. Such a democracy of life forms stands in stark contrast to "the hounds chasing black men in stripes and chains" that occasions the song, as the grandmother's ironically "twinkling eyes" confirm, since such a state of affairs represents a perversion of even the most basic of taxonomies in which humans would rank higher than animals. "Godamighty," however, as Calland notes, seems immune to even that simple binary in this folk construction, which seems to privilege instead the sheer inventive variety of God's creation; the perversion, therefore, is of human and white, and not divine, origin (Calland 1996, 12).

But as the episode continues, the redemptive role of folkloric materials is undermined by the mechanical and coercive terms of its production. When the Invisible Man is unable to answer the questions his doctors pose, "WHAT IS YOUR NAME?" and "WHAT IS YOUR MOTHER'S NAME?" (Ellison 1952, 239–40), which address him as an individual, they turn to ques-

tions which rely instead on his collective, racial identity. That he is able to respond in some fashion to the questions about Buckeye and Brer Rabbit, however, need only be taken to confirm the power of the doctors' "scientific" discourse to produce their object of inquiry within expected parameters, and to reward him for not exceeding them. It was the doctors, after all, who destroyed the Invisible Man's ability to recall his name in the first place, through the operations of their machine. The Invisible Man seems to acknowledge this new genealogy with his confused response to the doctors' questions: "Mother? But the scream came from the machine. A machine my mother?" (240). The doctors discuss such "primitive instances" as the Invisible Man's, which they imagine have been "developing some three hundred years" (236–37), in the rhetoric of evolutionary biology, a discipline that, far from retreating from the challenge posed by folklore's alternative social orderings, easily subsumes it within its framework as a "primitive" cultural form; thus, when the Invisible Man responds to the names of folk figures with apparent recognition, his doctor, "Old Friendly Face, seemed pleased" at the confirmation of his racial expectations (242), much as the whites did who rewarded Trueblood's performance. Although we might take the Invisible Man's perception that "somehow *I* was Buckeye the Rabbit" (241), then, as a form of resistance, because his identification with that trickster figure provides a subversive alternative to the devastating hierarchies of race science, the scene also underscores folklore's susceptibility to low ranking next to the more "developed" discourse of science. Moreover, the folkloric alternative is only operational at the level of collective identity; it can offer little assistance to the Invisible Man by way of crafting or unearthing a unique subjectivity. In this scene, however, Buckeye the Rabbit is the only identity available to the Invisible Man, and it necessarily contributes to the problem of white blindness to black subjects' distinctiveness and particularity that recurs throughout the novel.

The more successful form of resistance the Invisible Man employs is not narratively based, as folklore is, but visual—being rooted in strategies of the gaze as a vehicle for producing embodiment in the Other. Still encased in his glass box, the Invisible Man nevertheless turns the visual tables on his observers, metaphorically encasing them in a glass box: "Faces hovered above me like inscrutable fish peering myopically through a glass aquarium wall. . . . I could see smut in one doctor's nose; a nurse had two flabby chins. Other faces came up, their mouths working with soundless fury. But we are all human, I thought, wondering what I meant" (239). The Invisible Man not only transforms his doctors into caged animals here (and conspicuously low ones with "finlike fingers") but, by zeroing in on the less appealing aspects of their physicality, gives them the sort of grotesque embodiment which, as Peter Wheatstraw demonstrated, can

normally be redeemed only by love. But his triumph is only temporary. The Invisible Man's inability to recall his name—to produce a viable "I" to back up his eye—leads to "swift shame" (239) and, eventually, the restoration of conventional, racially based subject/object relations. Upon his release from the machine, tellingly, it's the Invisible Man's own mouth that "worked soundlessly" (243), while he returns to being watched and evaluated by "a calm, scientific gaze" (245). We observe a convincing demonstration of the power of that white gaze to construct and regulate identity when the Invisible Man meets with the factory hospital director to be discharged: when the director calls him by name, "I shot to my feet and looked wildly around me . . . but suddenly I saw him looking at me intently, and I stayed down this time" (246). The director follows up this silent demonstration of his predominance with a verbal account of the hierarchical principles which authorize it, those which situate blacks in an arrested stage of cultural development: " 'You aren't ready for the rigors of industry,' " he explains; " 'You mustn't try to go too fast.' . . . '[Y]ou just aren't prepared for work under our industrial conditions. Later, perhaps, but not now' " (246–47).

The director's words anticipate those of the Communist group, the Brotherhood, which is also in the habit of dismissing classes of people as historical atavisms (291), and whose leader, Jack, turns out to be the author of the anonymous note reading, "Do not go too fast" (383). Ellison's representation of the Brotherhood in the novel can be understood, from this perspective, as overdetermined from the start, since its members refer both to themselves as scientists and to the science of history in ways that can only resonate with the biases of social scientists. Ellison's antipathy to Marxism is arguably consistent with his simultaneous rejection of sociological thought, and can be comprehended merely as the obverse of many of his contemporaries' dual affiliation. Both American sociology and Marxism invoke a rhetoric of science to describe predictable stages of historical development—whether through Marx's conception of the transformation from agrarian to industrial society or via Park's race-relations cycle in which competition between races yields by stages to assimilation[40]— whereas Ellison's historical vision is attuned to the fluid and chaotic. And both minimize individual agency and significance compared with the impact and importance of collective experience on subject formation, be it imagined as racial experience that occludes the differences of generation, gender, and class (American sociology), or class experience that covers over the stratifications of gender and race (Marxism). Ellison, by contrast, adheres to the humanist mythos of individualism in which "will and imagination" can develop a subject's potential to transcend circumstance and

[40] See McKee 1993, 109–11.

exceed collective definition (163). To these crude but powerful theoretical parallels could be added the historical congruity of sociology and Marxism's shared paternalism with regard to black social and political advancement, and here again, Ellison is at pains to defend the importance of individual autonomy and initiative against the encroachment of larger political agendas. We can see the conflation of sociology and Marxism, too, in Ellison's critique of the Marxist critic Irving Howe, whom he describes as being "so committed to a sociological vision that he cannot see" the difference between sociopolitical arrangements and culture (163).[41]

A symbolic version of the affinity between the gazes of race sociology and Marxism can be found in the way the novel revisits and modifies the distorting third eye of race science in its iconography of the one-eyed subject, which is consistently associated with the Brotherhood. The Invisible Man introduces the metaphor in his first public address for the Brotherhood, the stadium speech. Ellison signals the connection of this scene with the factory hospital doctors by noting that the Invisible Man feels before the eyes of his audience "the hard, mechanical isolation of the hospital machine"; the bright lights in which he stands, which also recall the light as white gaze in Trueblood's dream, similarly encase him "like a seamless cage of stainless steel" (341). Such imagery, followed by the revelation that the Invisible Man has been blinded by the lights for the duration of his speech, throws into doubt its authenticity as an intersubjective encounter with his audience, despite the Invisible Man's stirring declaration to his listeners that "I feel suddenly that I have become *more human*. . . . With your eyes upon me I feel that I've found my true family! My true people! My true country! I am a new citizen of the country of your vision, a native of your fraternal land" (346). The white gaze of the Brotherhood members who watch critically from behind the podium turns out to be a more decisive gauge of the limits of fraternity, when they condemn the speech as "the antithesis of the scientific approach" and refine their plans to retrain both crowd and speaker (348, 350). However ironically intended are the Invisible Man's nationalist effusions, the novel seems more reliably to endorse his diagnosis in the body of his address that "they've dispossessed us each of one eye from the day we're born. So now we can only see in straight white lines" (343). The image of the one-eyed

[41] The parallels between Marxism and Emersonianism are also worth noting here. As Cornel West has observed, there are several grounds of compatibility: "Like his contemporary (and major twentieth-century competitor) Karl Marx, Emerson is a dyed-in-the-wool romantic thinker who takes seriously the embodiment of ideals within the real, the actualization of principles in the practical—in short, some kind of inseparable link between thought and action, theory and practice. Similar to Marx, Emerson focuses on the pressing concerns unleashed by the American, French and Industrial revolutions: *the scope of human powers and the contingency of human societies*. These concerns are addressed by highlighting the willful self (or selves) up against and overcoming antecedent circumstances" (West 1989, 10).

subject functions most obviously as a comment on the loss of depth perception attendant upon monocularity; we should contrast the "straight white lines" that are alone perceptible with the fanned-out spectrum of lines that indicate visual depth in Renaissance perspective, and which the Invisible Man seems to invoke when he enjoins the crowd to "combine and spread our vision" (344). That the lines are white suggests the hegemonic restrictions exercised by white power on what may be brought into cultural visibility under any circumstances.

The image also functions as a version of grotesque embodiment, inflicted on black subjects through violence "from the day we're born" as the very origin and condition of their subjectivity. Rather than sustain an ontology that is so inherently pathologizing, however, Ellison ultimately shifts it categorically to whites; Ellison literalizes that transference in the image of the one-eyed Brother Jack, who exposes his false eye to demonstrate the nobility of political sacrifice. The Invisible Man narrates:

> I heard his voice but no longer listened. I stared at the glass, seeing how the light shone through, throwing a transparent, precisely fluted shadow against the dark grain of the table, and there on the bottom of the glass lay an eye. A glass eye. A buttermilk white eye distorted by the light rays. An eye staring fixedly at me as from the dark waters of a well. Then I was looking at him standing above me, outlined by a light against the darkened half of the hall. (1952, 474)

Ellison would seem to be parodying presuppositions of white transparency in this passage, as he highlights the inescapable materiality of the isolated eye, "distorted by light rays," compared with the "transparent shadow" it casts, thus reversing the conventional racial positions of subject/object relations produced by the gaze. Although the eye "star[es] fixedly" at the Invisible Man, it has lost along with its transparency its objectifying power, so that the Invisible Man's gaze predominates as he looks up to face Jack, who is described like an eclipse of the sun, "outlined by a light" but no longer its source. Instead, the false eye presides over a moment of demystification of white power. Jack reveals himself to be fatally shortsighted and to be the proponent of an instrumental logic and racial paternalism that recall the white Emersonians in the novel: "We do not shape our policies," he confides, "to the mistaken and infantile notions of the man in the street. Our job is not to *ask* them what they think but to *tell* them" (473). Ellison's use of one-eyed imagery emerges as an ironic rewriting of the Cartesian tradition of disembodied monocularity by critiquing its two most significant descendants—the disinterested, neutral observer of science, and Emerson's mystical idealist as transparent eyeball. The ultimate irony here, as Carolyn Porter has shown, may be

that the two are less distant from each other than they might initially appear. Although Emerson (1992, 36) critiques empirical science as a form of "half-sight" that requires union with its other half, poetic vision, to be complete, "in fact," as Porter observes, "they are already united by the detached perspective upon which each relies; the tyrannizing unity Emerson identifies with scientific vision is made possible by the same detached vantage point . . . which the poet experiences" (Porter 1981, 118). Ellison seems to make a similar point about their fundamental sameness when he sees the figures identified with these disparate visual modes, Jack and Norton and Emerson, "merge into one single white figure" (1952, 508).

Against the tyranny of a one-eyed perspective with its persistent instrumentalism and abiding blindness to individuals, the novel proposes the democratized wholeness of the intact body whose unique experiences are fully integrated into the self. The first signs of this bodily recuperation appear at Tod Clifton's funeral and are presaged, significantly, by folk materials, with a singer who "sang with his whole body" performing music "from the past" (452–53). The Invisible Man follows up this introduction with a speech which aims to detach the meaning of the black body from the white gaze that has defined it: " 'All right, you do the listening in the sun and I'll try to tell you in the sun. . . . His name was Tod Clifton and they shot him down. His name was Clifton and he was tall and some folks thought him handsome. . . . His name was Clifton and his face was black and his hair was thick with tight-rolled curls. . . . He had good eyes and a pair of fast hands, and he had a heart' " (455). The Invisible Man's repetitive framing of this experience "in the sun"—an oppressive source of light and heat throughout the scene—recalls the surveillance of a seemingly inescapable white gaze, one which, not incidentally, produces blackness as a by-product. But the Invisible Man resists the objectifying consequences of its presence through strategies of individuation and embodiment intent upon subjectifying Clifton. As he repeats his name, he details the parts of his body with a loving attention that recalls Peter Wheatstraw's song; he goes on to describe Clifton's blood as it spilled, and the names of his organs touched by the trajectory of bullets (456–58). Ellison follows up this testimonial to particularity by extrapolating it outward, ending the episode by particularizing the entire crowd; the Invisible Man reports: "And as I took one last look I saw not a crowd but the set faces of individual men and women" (459). That this process was precipitated by folk materials suggests that they may hold the potential to rescript notions of black collectivity in ways that preserve individuals as well as traditions.

The novel's ultimate endorsement of individualism immediately follows, with the Invisible Man's final break with the Brotherhood represented as a constructive disillusionment from which emerges his comprehension of his own unique subjectivity:

It was as though I'd suddenly learned to look around corners; images of past humiliations flickered through my head and I saw that they were more than separate experiences. They were me; they defined me. I was my experiences and my experiences were me, and no blind men, no matter how powerful they became, even if they conquered the world, could take that, or change one single itch, taunt, laugh, cry, scar, ache, rage or pain of it. (508)

The new synthesis of visionary and empirical modalities of sight in this passage is noteworthy. Although seemingly an echo of the ways the two are conjoined in the one-eyed Cartesianism earlier critiqued in Ellison's fusion of Jack, Norton, and Emerson, the difference here is that the synthesis has been negotiated through the reassertion of intact embodiment. The Invisible Man can now "look around corners" like a visionary, but he proves the integrity of his experiences by conjoining this new power with the sensations of the body directly, via each individually cherished "itch, taunt, laugh, cry, scar, ache, rage or pain." The Invisible Man emerges from this scene of self-recognition, having anchored a humanist model of subjectivity—one that places a stable, self-conscious, and self-determining subject at the center of a world it claims confidently to know—to a resolutely material, embodied self.

But this iteration of subjective rebirth is not the final one, for all the optimistic self-affirmation it seemingly has purchased through bodily integration. Ellison has worked, in this second part of the novel, to demonstrate the immensity of the task of reclaiming the body that "science"—be it social science or the Brotherhood's Marxist "science of history"—has defined for the Invisible Man, and for the aspiring black subject generally. The Invisible Man attempts to reconfigure that body and its meanings by marshaling strategies of mimicry and reversal, chief among them being the molding of the discursive resources of folklore into instruments more sensitively attuned to measuring individuals than collectivities, and therefore more able to register the horizon of possibility and agency that hovers beyond crude determinisms. The privileged mechanisms of these reversals are visual relations: Ellison aims to link whiteness with the compromised vision and grotesque embodiment epitomized by the imagery of the one-eyed seer, and to reserve intact, normative embodiment for the black subject as the basis for fully individuated subjectivity. But, as the Invisible Man's dream from underground indicates, the white prerogative to produce a feminized, mutilated embodiment supersedes such ambitions; Brother Jack presides over his symbolic enucleation/castration in which he is deprived of his "two bloody blobs," leaving him with his "generations wasting upon the water" (569–70)—a loss that frees him from the overweening delusion of the possibility of racial reversal. The prospect of a simple reversal of subject/object relations that have been

fundamentally constituted through systemic inequities and complex histories of oppression—for reasons that Ellison's engagement with the ideas of Jean-Paul Sartre makes clear—is decidedly bleak.

Black Orpheus as Subject-Lens: Critiquing Sartre's Existential Look

In a letter to Richard Wright written 22 July 1945 (Wright Papers), the year he began work on *Invisible Man*, Ellison describes with evident approval the enormous emphasis French existentialism places on individual responsibility, making clear his belief that, in stressing exclusively the fate of collectivities, the Left had gotten the matter precisely backward. Using a characteristically optical metaphor, Ellison notes that existentialists "view the role of the individual in relation to society so sharply that the leftwing boys . . . seem to have looked at it through the reverse end of a telescope."[42] Compared with such crude collective categories as racial caste, "the folk" (as the term was employed by race sociology), or the racially homogenizing class categories upon which Marxism relies, existentialism's concentration on the individual appealed to Ellison, as Michel Fabre summarizes it, for its stress on the responsibility of the intellectual, its defense of humanist values, and its faith in the relation between truth and freedom (Fabre 1982, 186). Existentialism, too, supplies a theorization of self-determination and agency as fundamental to its philosophical vision as it is to Emerson's, but one less evidently hampered by the racial biases that make Emerson such an equivocal intellectual ancestor for Ellison. Moreover, the existentialism of Jean-Paul Sartre in particular offers a specifically visual account of the construction of subjectivity that rivals Emerson's conception of the transparent eyeball as a precursor of Ellison's invisibility; unlike Emerson's paradigm, however, Sartre's is a specifically relational account, sensitive to the operations of power governing visual exchanges in subject/object relations. As a result, the Sartrean narrative is structurally better able to accommodate an exploration of the relations of race (although, as we'll see, there are limits to the malleability of that structure).

Numerous critics have commented on Ellison's interest in existentialism, typically emphasizing the influence of Malraux and Dostoevsky (and, to a lesser extent, Kierkegaard), all of whom are mentioned in his published writings.[43] Critics have also remarked on the presence of Sartrean

[42] All further mentions of Ellison's correspondence refer to the Wright Papers. See Fabre 1982, 184–85.

[43] See Busby 1991; Dietze 1982; Foster 1970, 46–58; Savery 1989, 65–74. Foster briefly discusses the affinities between Ellison and Frantz Fanon, which I expand on later in this chapter.

themes in the novel, most notably, in the Invisible Man's journey to find freedom by discovering the truth of his identity or, to use Sartrean terms, as a drama of coming to consciousness enacted through a movement from the *en-soi* to the *pour-soi*; but their accounts are primarily impressionistic and offer little to substantiate Ellison's direct engagement with Sartre.[44] There is, however, direct evidence that Ellison read and admired Sartre in Ellison's correspondence with Wright from 1945 to 1953; but with the waning of interest in Sartre from its peak in the 1950s to its current state of neglect in the wake of poststructuralism, the precise nature of Sartre's influence on Ellison's thinking has remained largely unexplored. In the letter to Wright with which I began, written 22 July 1945, Ellison goes on to speak highly of Sartre and quotes extensively from his introductory essay in the inaugural issue of the French journal *Les Temps modernes*.[45] In the quote Ellison selects, Sartre argues for a conception of man as "an absolute" in the sense that "by taking part in the singularity of our era, we ultimately make contact with the eternal." In the same essay, Sartre develops the theme of the human freedom to choose despite the determining limits of the social, restating arguments from *Being and Nothingness*; and he condemns any mode of analysis which "blind to individuals, had eyes only for groups" (Sartre 1988, 262–65). On 18 August 1945, furthermore, Ellison wrote to Wright that he "sent a copy of Horizon containing news of literary developments in France" (Wright Papers). (Ellison was probably referring to the July issue of *Horizon*, which contains essays on Sartre and on political conditions in France, as well as paintings and an essay by André Masson.) The essay on Sartre, by A. J. Ayer, is a detailed assessment of *L'Etre et le Néant* (1943) from the perspective of a logical positivist, the conclusion of which appeared in the August issue; although the review is critical, it would nevertheless have introduced Ellison to Sartre's concepts of negation in being, the *en-soi* and *pour-soi*, and the visually governed relations of self and Other. It seems safe to assume that Ellison was impressed with what he read, and not only because he troubled to mail the issue to Wright in France. In the same letter, he also claims about his own writing that he's "on a station getting its power from the mature ideological dynamos of France," and he expresses his intention to learn French. That he may well have acquired at least a reading knowledge of French is suggested by a letter to Wright three years later, on 1 February 1948, in which he inquires after the French journal *Présence Africaine*, which had not arrived as scheduled; "Be sure that I get Presence Africaine," he reminds Wright. Although *Being and Nothingness* did not ap-

[44] See Bennett and Nichols 1974, 171–75; Glicksberg 1970; Long 1967; Rubin 1969; Watts 1994.

[45] The essay (Sartre 1988) was reprinted in English translation in two different journals in 1945, *Horizon* and *Partisan Review*; see Ungar 1988, 349.

pear in English until 1956, then, it's possible that Ellison gained further acquaintance with the text in French. There is evidence, too, that Ellison's interest in Sartre was much more than a temporary fascination. As late as 21 January 1953, Ellison inquires of Wright, "What on earth has happened to Sarte [sic]? He's acting, from this point of perspective, as cockeyed as he looks. Is there any way that I can keep posted on developments?" Such an assessment demonstrates an ongoing knowledge of its subject.

A number of Sartre's philosophical works were available in English translation during the years Ellison was composing *Invisible Man*: *Anti-Semite and Jew* (1948), *Baudelaire* (1949), *The Emotions* (1948), *Existentialism* (1947), and *Psychology of the Imagination* (1948), in addition to several novels. Of this group, *Existentialism* was among the most widely reviewed in America, and its ideas seem most germane to the thematic preoccupations critics have noted in *Invisible Man*. Written as a defense of existential ethics against the charges of its political apathy, pessimism, isolationism, and relativism,[46] the essay's comparative accessibility is clearly intended to popularize as much as demystify Sartrean concepts. Beginning with the premise that "existence precedes essence" (Sartre 1947, 15)—the defining proposition upon which *Being and Nothingness* also depends—Sartre crafts an account of how individual responsibility and freedom, activated solely by the subject's inner resources, may propel him from "nothing" to "what he wills himself to be" (18). Consistent with his premise of the subject's self-creation, Sartre explicitly rejects the range of conceptual underpinnings from which race sociology, among other disciplines, emerged, dismissing "heredity, the workings of environment, society . . . [and] biological or psychological determinism" as explanations for subject formation. Sartre concludes the essay with a brief discussion of the Other as the indispensable condition of one's existence in a world of "inter-subjectivity" (44–45).

The positions Sartre lays out in *Being and Nothingness* develop and extend the areas of overlap with Ellison's views. Here Sartre unfolds the notions of "negation" and "the dialectical concept of nothingness," which consider being to be at one and the same time its own nothingness; the concept is not only suggestive with regard to Ellison's invisibility, which likewise conceives of being in terms of simultaneous presence and absence, but may also comprise a second source for the dialectical method of the novel as a whole in addition to Marxism. Here, too, Sartre works out his conception of possibility,[47] the notion of radical choice that underpins his idea of the freedom to which we are condemned as indeter-

[46] The charges leveled against Sartre's ideas, incidentally, are not unlike those typical of critiques of *Invisible Man*.

[47] Or "possibles" in Hazel Barnes's translation.

minate beings, as well as the responsibility to exercise it consciously that mitigates "bad faith," or the denial of our freedom. "Possibility" emerges as a key term in *Invisible Man*, first when he's advised by the vet upon his departure for New York that "the world is possibility if only you'll discover it" (Ellison 1952, 156), and later when it forms the basis for the critique of the excessively rigid, "scientific" view of history associated with the Marxist Brotherhood, the inadequacy of which is personified by the protean character of Rinehart, through whose dark glasses the Invisible Man sees "the merging fluidity of forms" (491). Responsibility and freedom also surface as central issues in the novel: when the Invisible Man declares on the final page that "even an Invisible Man has a socially responsible role to play" (581), he echoes Sartre's contention in *Existentialism*, the main repository for his ethics, that "when we say that a man is responsible for himself, we do not only mean that he is responsible for his own individuality, but that he is responsible for all men" (Sartre 1947, 19–20). The epilogue to *Invisible Man* makes use of yet another central Sartrean concept, the absurd, Sartre's term for the intrinsic meaninglessness of man's existence, when the Invisible Man comments that "all life seen from the hole of invisibility is absurd" (Ellison 1952, 579).

Finally, in his well-known chapter of *Being and Nothingness*, "The Look," Sartre's account of the construction of subjectivity through the activity of the Other's gaze mirrors Ellison's own presentation of invisibility as the outcome of an intersubjective encounter. Sartre emphasizes both the violence of the self's objectification through the Other's eyes and its more constructive by-product, self-discovery. For Sartre, the look of the Other instigates a radical redistribution of the visual economy from the self to the Other, in which the ascendancy of the Other's perspectival universe functions as a violent usurpation, experienced by the self as "a permanent flight" and "an internal hemorrhage" of its purview (Sartre 1956, 343, 345). As a consequence of this reorientation, the self is subjected to a virtual annihilation, a reduction to "a pure reference to the Other" (349); the challenge for the self in this exchange is to recover through the operations of "responsibility" a subjective perspective which exceeds the meanings imposed on it by the Other. But the shame produced by the Other's gaze must first be overcome; Sartre characterizes the process: "My original fall is the existence of the Other. Shame . . . is the apprehension of myself as a nature although that very nature escapes me and is unknowable as such" (352). Ellison's conception of invisibility as a process of white projection-as-erasure closely follows Sartre's description of "the look," in that each imagines the Other's gaze as overtaking, and redefining—indeed, nearly eradicating—its object. Each, furthermore, links the Other's gaze with a process of self-discovery, mediated by the shameful recognition of the absence of complete self-knowledge. In the factory hospital episode,

for instance, when confronted by doctors who fix him with their burning "bright eyes" and demand that he identify himself, the Invisible Man responds: "I was overcome with swift shame. I realized that I no longer knew my own name" (Ellison 1952, 239); he later concludes, "When I discover who I am, I'll be free" (243). At the end of the novel, when the Invisible Man reencounters the white philanthropist, Mr. Norton, he asks whether Norton is ashamed by his apparent loss of direction: "Because, Mr. Norton, if you don't know *where* you are, you don't know *who* you are. So you came to me out of shame" (578). Ellison uses Sartrean ideas about self-knowledge in this scene to critique the Emersonian impulse of instrumentalism and self-expansion with which Norton is associated.

As integral as Sartrean concepts are to *Invisible Man*, however, they are also subjected to revision and critique. The application of the Sartrean model of the gaze, in particular, to racially charged contexts necessarily complicates its accounts of visuality and violence. The gender connotations of the gaze alone, as Sartre reveals them in *Being and Nothingness*, would create difficulties for Ellison, concerned as he is to disentangle blackness from its history of feminization in the discourse of social science. Sartre, on the contrary, reveals the violence of the Other's gaze to have a specifically gendered and sexualized character, made manifest in his comparison of the "violation by sight" with the "unveiling" of a feminized nature, and with man's "deflowering" through his gaze the immaculate "virgin" who is his object (Sartre 1956, 738). Such a gaze extrapolated to a racialized context would reinscribe the equation of blackness and femininity Ellison is everywhere at pains to undo. But still more fundamental to a critique are the ways in which the historical construction of racialized subjectivity inflects, and perhaps supersedes, a Sartrean vision of subject/object relations. It's not until his aptly named essay of 1948, "Black Orpheus" (Sartre 1963),[48] the introduction to an anthology of African poetry, that Sartre undertakes a racialization of a gaze, the sexualized character of which is also implicit in the title's evocation of the mythic Orpheus (whose gaze leads to the annihilation of the feminine in the form of his bride, Eurydice).

In "Black Orpheus," Sartre identifies the prerogative of seeing without being seen as a white privilege, at the same time that he imbues the black gaze with a uniquely retributive power. "Today," he claims of the poets he is introducing, "these black men have fixed their gaze upon us and our own gaze is thrown back in our eyes; black torches, in their turn, light the

[48] Sartre also commented specifically on American racial politics after a four-month visit to the United States in 1945 in a brief article, "Retour des Etats Unis: Ce que j'ai appris du problème noir," published in *Le Figaro*, 16 June 1945; see Gordon 1997, 83–89, where the essay is translated as "Return from the United States: What I Learned about the Black Problem."

world and our white heads are only small lanterns balanced in the wind" (Sartre 1963, 7–8). Sartre equips the black Other with a paradoxical yet enhanced visual power here, albeit a power derived from racist stereotypes; the black gaze, he argues, being "savage and free," will render white entrails "visible to the world" (9–10), in an exposure of an otherwise opaque interior with presumably demystifying, if deadly, consequences. But whereas the racialization of the gaze leaves subject/object relations reversed but essentially intact for Sartre, the case couldn't be more different for his near contemporary, Frantz Fanon, who undertakes a critique of Sartre's looking relations in *Black Skin, White Masks*. Fanon's important contribution to existential psychology and response to Sartre was published in France in 1952, the same year that *Invisible Man* appeared in America. Ellison could not, therefore, have read Fanon, yet their arrival at such similar conclusions about the limitations of the Sartrean model when applied to black/white relations makes a comparison fruitful, and suggests that there is a structural basis for their overlapping critiques. Fanon provides an explicit philosophical critique of visual relations in Sartre which, I would argue, Ellison thoroughly anticipates and which he presents in embedded form in *Invisible Man*.[49]

Fanon argues that any ontology for the black and colonized other is rendered impossible for the reason that "the white man is not only The Other but also the master, whether real or imaginary" (Fanon 1967, 138 n. 24). Whereas for Sartre, the relations between self and Other are oppositional but symmetrical, for Fanon, the inequities of institutionalized racism produce systemic asymmetries which, as a consequence, lead to the effective disappearance of the black subject, apparently beyond the possibility of reversal. Fanon persistently renders this ontological "operation" in language that resonates with the racial experiments that are part of the history of evolutionary biology and comparative anatomy, thus mirroring Ellison's technique in *Invisible Man*'s factory hospital episode. Fanon describes blacks' experience of the white gaze as "being dissected by white eyes" which "objectively cut away slices of . . . [his] reality." The only defense against that gaze which the black subject has at his disposal is to strive for "invisibility" against the "unalterable evidence" of his blackness (116–17). It is the inescapable embodiment of blacks, their "overdetermin[ation] from without" (116), which Fanon identifies as the most ineradicable obstacle to the assumption of the "responsibility" that, for Sartre, is the precondition for human freedom. Because he argues that the embodiment of the black subject reduces him to being the bearer of

[49] For further discussion of the affinities between Sartre, Fanon, and Ellison, among others, see Gordon 1997, 69–79. For further analyses of Sartre and Fanon, see Kruks 1996, 122–33; and for a discussion that touches briefly on Fanon and Ellison, see Goldberg 1996, 179–200. See also Reed 1996.

preexisting meanings (134), Fanon's view amounts to a fundamental reversal of the Sartrean dictum "existence precedes essence," provided that "essence" is understood as a historical product. Subjecting himself to his own "objective exam," Fanon experiences the consequences of his self-objectification in terms similar to Sartre's representation of the gaze of the other, as "an excision, a hemorrhage," but here, what is spilling over is his own "black blood" (112), not merely (as in Sartre) his perspectival orientation. Fanon's critique makes clear the ways in which black embodiment complicates and destabilizes any straightforward borrowing of Sartre's existentialist program. Significantly, Fanon employs the term "invisibility" to describe the *material* destructiveness accomplished by a hegemonic white gaze that makes the prospect of black ascendancy as a viewing subject appear exceedingly dim. In Ellison's novel, too, it's the seeming permanence of invisibility, compared with the temporary condition of shame, that negates the Invisible Man's ability to assume what is for Sartre the contingent burden of his freedom—namely, responsibility. As the Invisible Man phrases it in the prologue, echoing Fanon's contention of the impossibility of responsibility for the black subject, "I am one of the most irresponsible beings that ever lived. Irresponsibility is part of my invisibility" (Ellison 1952, 14).[50]

To successfully claim and exercise responsibility would necessitate more than the highly provisional gains the Invisible Man and black Emersonians are able to secure against the defining power of the white gaze. From Trueblood to the vet, from Wheatstraw to the Invisible Man of the factory hospital episode and thereafter, we've seen the ways in which the black subject's strategies to deflect, reconfigure, or return the "master" gaze collapse under the sheer hegemonic weight of their opponents' gazes. Trueblood may hold up a subversive mirror to Mr. Norton's subjectivity, but the deformed image it produces quickly rebounds into the normativity and possibility Trueblood will never achieve; likewise, the vet's exposure of the arbitrary forms of racialized power projected through Norton's gaze fail to protect him from their material effects. Wheatstraw and the Invisible Man each deploy the discursive resources of folklore to craft alternative intersubjective relations, but their scramblings and reversals of taxonomic hierarchies ultimately yield to the more intractable orderings of the gaze of race science. These consistently vanquished outcomes indicate Ellison's acknowledgment of the tenacity of historically

[50] Ellison is not of course the first to make this sort of argument, whose history leads back at least to Frederick Douglass. Douglass argued, in 1855: "The morality of a *free* society can have no application to *slave* society. Slaveholders have made it almost impossible for the slave to commit any crime, known either to the laws of God or to the laws of man. If he steals, he takes his own; if he kills his master, he imitates only the heroes of the revolution. . . . Make a man a slave, and you rob him of moral responsibility"; see Douglass 1969, 194.

constituted, racialized subject/object relations, despite the perception of some of his critics that his humanist faith led him to minimize such constraints. If we're tempted to understand the triumphal synthesis of embodied subjectivity the Invisible Man claims following Clifton's funeral as marking a sea change in such relations, its aftermath, in which the Invisible Man literally goes underground into a social isolation that insulates him from the white gaze and its metaphorical substitutes, suggests otherwise. Among the several forces the Invisible Man would seem to be in retreat from therein may be a confrontation with the limits of a humanist faith in the subject's capacity to overcome all external obstacles.

The Invisible Man's withdrawal beyond the periphery of that white gaze in the epilogue, furthermore, decisively shifts the meaning of the invisibility which was originally produced by it: it is no longer a *relational* modality, but subsides rather into a solipsistic idealism that ironically reprises Emerson's transparent eyeball, a figure for the disembodied, visionary self. As the Invisible Man declares it, from his state of "hibernation": "damn it, there's the mind, the *mind*" (Ellison 1952, 573)—disguising the fact that what put him there, emphatically, is the body. Indeed, Emersonian rhetoric makes a conspicuous comeback at the end of the novel, and it is an appropriately disembodied resurrection, one which enables Ellison to shift his emphasis from a relational to a purely autonomous ontological conception of invisibility. As the Invisible Man puts it: "When one is invisible he finds such problems as good and evil, honesty and dishonesty, of such shifting shapes that he confuses one with the other, depending upon who happens to be looking through him at the time. Well, now I've been trying *to look through myself*" (572, emphasis mine). The epilogue signals the return to Emerson still more overtly through the Invisible Man's encounter with Mr. Norton, who asks directions for how to get to Centre Street; the Invisible Man responds: "take any train; they all go to the Golden D—" (578). "Centre Street" recalls Emerson's extended meditation on spheres in his essay "Circles," where he posits a homology between self and world that recalls the self's merger with the All accomplished by the transparent eyeball: "The eye is the first circle; the horizon which it forms is the second" (Emerson 1992, 252). That all roads lead to the Golden Day suggests the inevitability of Emerson as an ancestral presence and American institution; the Invisible Man's capacity to direct the white philanthropist there indicates that, unlike the other black Emersonians in the novel, he may now claim direct access to it.

The Invisible Man's reconstruction of himself as a version of Emerson's transparent eyeball, then, offers him escape from the violently objectifying and seemingly irreversible visual relations presided over by the white gaze, relations which relegated grotesque embodiment to the black subject, thereby placing the respective Emersonian and Sartrean ideals of

transcendence and freedom out of reach. It's important to note that he escapes through these means not just from any black body but from a particular feminized version of it, whose heightened corporeality enables the production of white male transparency. In the transparent eyeball's fusion of part to whole in which the eye becomes, in effect, an entire body, Emerson imagines a specifically male form of reproduction which, as Richard Hardack has shrewdly noted, makes it possible to exclude the feminine from his visionary program; as Hardack puts it, "eyes are figuratively the reproductive organs of a self-producing male" (Hardack 1996b, 4).[51] The return to Emerson may be regarded, then, as consistent with the novel's overarching gynophobia, only this appeal to masculinization would seem to enjoy more stability and, hence, a greater efficacy than Ellison's prior symbolic efforts. This renewed source of self-fathering may insulate the Invisible Man at once from a contaminated feminine and a relational matrix which together enable him to personify the ideals of disembodied transcendence, but at the personal, and more tellingly, the political cost of his social isolation. Arguably, the Invisible Man's attempt to craft a "socially responsible role" (Ellison 1952, 581) at the end of the novel founders on this paradox. In the epilogue, Ellison works to forge the foundations for an integrated model of the African-American subject that successfully situates the self within the collectivities of race and nation, but that democratic vision is finally solipsistic, not relational—a fatal flaw in an imagination of the body *politic*—and thus evades what we might see as the real challenges to African-American political and cultural agency. In this way, the increasingly autonomous shape invisibility takes at the conclusion of the novel should be regarded as an enabling male fantasy as well as a diagnosis of cultural powerlessness, because it allows Ellison to divide the spoils of embodiment and transcendence along traditional gender lines. Because women regardless of race can be turned into bodies, in other words, black men can be turned out of them.[52]

That such a precariously brokered compromise can only exist in the realm of fantasy, however, is suggested in Ellison's epilogue by the contradictions sustained by the disembodied political rhetoric which hovers at a brief and unsafe distance above its feminized and racialized iconography. The protagonist, self-described as "invisible and without substance, a disembodied voice" (581), attempts to ground an idea of black citizenship on an equally disembodied political pluralism; he thus recommends that we "affirm the principle on which the country was built and not the men"

[51] See also Leverenz 1989, 134–62.

[52] I essentially agree with Laura Doyle's argument about the Invisible Man's desire to erase the evidence of his embodiment, but I ascribe to that impulse a more broadly conceived threat of feminization than is encompassed by the mother figure in isolation. See Doyle 1984.

because we can "only thus find transcendence" (574). Yet he articulates that vision from the confines of a black "hole" which evokes not only insulation from the white gaze, but also, the black female body his autonomous invisibility is meant to escape. Although the Invisible Man promises to "shak[e] off the old skin and . . . leave it here in the hole" (581), that final ritual self-birthing eludes him within the confines of the novel. Instead, the necessity of shedding skins (and dark holes) for the purpose of acquiring political agency reminds us of the persisting conceptual weight of feminized, black corporeality in Ellison's ambitious attempt to reimagine the violence of invisibility anew as a political resource.

Part III

AUDIENCE AND SPECTACLE

Spectacles of Violence, Stages of Art

Walter Benjamin and Virginia Woolf's Dialectic

Dialectical Visions: Walter Benjamin and Virginia Woolf

At the end of his 1936 essay "The Work of Art in the Age of Mechanical Reproduction," Walter Benjamin makes a distinction between the aestheticization of politics under fascism, which inevitably culminates in the aestheticized spectacle of war, and the politicization of art—communism's possible antidote to that spectacle. Benjamin situates this distinction in the context of a perceptual revolution presided over by the new visual technologies of photography and film, among the consequences of which he stresses two: first, the destruction of the aura or ritual value of distinctive objects through reproduction; and second, as a result of the increased availability of these objects, a new stance of critical proximity on the part of an ever widening audience of experts. In particular, film's replacement of the old perceptual model of aesthetic contemplation of unique wholes with the momentary, distracted consumption of fragmented reproductions produces an optics of "shock effects" in spectators that is exploitable to varying political ends. Whereas fascism, Benjamin argues, will mobilize the energies of this new class of spectators by providing them with the artistic "gratifications" of the falsifying outlet of war (falsifying, since it leaves material conditions intact), communism must wage a counterassault by making a resource of the new critical optics engendered by film. Politicizing art will mean making use of demystification, the systematic estrangement of the everyday, toward the goal of social transformation. The precise process through which we get from distracted consumption to demystifying critique in Benjamin remains, however, troublingly oblique.

In addition to the enormous weight given to collective spectatorship as a politically significant activity, Benjamin's opposition of aestheticized politics and politicized art deploys two quite different spectatorial models: the irrational crowd, passively absorbing the propagandistic images of "the theater of war," who "can experience its own destruction as an aesthetic pleasure of the first order" (Benjamin 1969, 242), and the enlightened audience, actively disabusing itself of its illusions through liberatory political theater, who can assess afresh the material preconditions for social and political change. While Benjamin's assumptions about agency remain implicit, they are nonetheless clear: to aestheticize politics is to reduce it to a consumable spectacle and deprive it of what might be considered its natural mandate for action; to politicize art is to recreate spectacle, at least potentially, as an active mechanism for change. Benjamin's terms effectively complicate and reverse conventional images of marauding crowds, on the one hand, and compliant audiences on the other; that he is able to do so suggests the growing definitional fluidity of collectivities newly organized around emerging technological, aesthetic, commercial, and propagandistic forms.

Virginia Woolf's *Between the Acts* (1941) is centrally occupied with some of these new forms. Crisscrossed by the warplanes which surround and make up the fabric of its composition, the novel investigates the crowd as theatrical audience; its distracted consideration of its annual village pageant—part airy entertainment, part history play—raises fundamental questions about whether aesthetic spectacle can further political aims by exposing ideological biases and galvanizing the audience into significant political activity. For Woolf, the audience's capacity to insulate itself from the historical insights the play aims to provide threatens to devolve into violence—the atavistic outcome which shadows all the narrative's relationships. Yet Woolf could ill afford such unqualified pessimism as she composed her final novel—itself an attempt to affirm the political and cultural value of art—in the middle of the London Blitz. Arguably, *Between the Acts* lays still greater stress on the means by which aesthetic spectacle can potentially function as a palliative to violence, when it mystically serves as a conduit to collective, if momentary, apprehension.[1] I read the novel's representation of these interpretive possibilities, contained and reworked within its representation of a village play, through the lens of Walter Benjamin's redemptive optics: his theories of constellation and the dialectical image as the visual means for producing the "flash" of historical insight that can lead to social transformation. Through the juxtaposition of Woolf's and Benjamin's final works, I aim to delineate the contradictory

[1] In countless letters written during the composition of *Between the Acts*, Woolf debated the potential impact of writing on the political arena, of "prod[ding] Hitler] if even with only the end of an old inky pen." See Woolf 1980, letters 3570, 3627, 3633, 3634, 3704.

mechanisms by which aesthetic events can serve a didactic purpose—both for the audience depicted within *Between the Acts* and for its larger audience of readers—without surrendering fully their artistic integrity.

While my argument about Benjamin's and Woolf's many conceptual affinities consists neither in comparative biography nor in accounts of *influence*, direct or otherwise (there is no evidence indicating that either Benjamin or Woolf was familiar with the other's work), biographical materials are not entirely without interest or relevance.[2] Walter Benjamin (1892–1940) and Virginia Woolf (1882–1941) were contemporaries who,

[2] Several critics have attempted to link the ideas and practices of Woolf and Benjamin; their comments, however, are either brief and not intended as a detailed comparison of Benjamin's and Woolf's ideas or are confined to Benjamin's important but necessarily limited essay "The Work of Art in the Age of Mechanical Reproduction" (Benjamin 1969). Jane Marcus is the first to identify important biographical and conceptual connections between the two, emphasizing, for instance, their shared interests in mysticism, Marxism, and the practice of quotation (Marcus 1981). Patricia Joplin likens Woolf's reaction to the rise of fascism with that of the Frankfurt School: neither was much surprised at its development, since each regarded it as the culminating form of the concentration of social power. Joplin, furthermore, perceives a resemblance between Woolf's belief that art should facilitate the reflection upon and exposure of sociopolitical conditions and Benjamin's and Brecht's imperative of "making strange." Joplin also contends that Woolf shares with Benjamin the vision that art which reproduces relations of dominance and submission constitutes the aesthetic counterpart of fascism; Joplin exemplifies the paradigm in the response of the actors to La Trobe in *Between the Acts*: "The actors may laugh, but they also obey" (Joplin 1989, 97–101). Catherine Wiley argues that Woolf's use of theater to upset rather than to mirror reality anticipates Brechtian techniques and, as Benjamin and Brecht each advocate, represents the potential interruption of the audience's fantasy structures in ways that may—as the final mirroring scene in *Between the Acts* suggests—transform them from spectators into actors. By incorporating "high" and "low" populations into the drama, and by resisting formal closure in the parallel contexts of play and novel, Wiley shows, Woolf presents a model of artistic making which resembles Benjamin's *Trauerspiel* artist as he describes that figure in *The Origin of German Tragic Drama* (Benjamin 1977; Wiley 1995, 4–16).

The most sustained comparison of Benjamin's and Woolf's antifascist aesthetics to date is Michael Tratner's, which seeks to establish crucial differences between them despite their shared endorsement of public art (whether in Benjamin's promotion of film in "The Work of Art" or in Woolf's theater) and the mechanism of shock effects through which to transform crowds. Compared with Benjamin, Tratner argues, Woolf manifests both a greater ambivalence toward new technologies and a greater respect for earlier artistic traditions; and her preoccupation with gender inequities underlies her valorization of difference over and against the Marxist vision of its eradication in a classless society. Finally, Tratner contends, Woolf is concerned to purify or enhance artistic aura rather than celebrate, as Benjamin seems to, the new possibilities born of its eradication. Useful as these distinctions are, they may exaggerate Woolf's and Benjamin's differences, particularly at the expense of some of Benjamin's many complexities and contradictions. First of all, even as early as "The Work of Art," Benjamin's attitudes toward new technologies are arguably more equivocal than they are represented as being here: we have only to consider Benjamin's framing of his argument in response to fascist appropriations of new technologies, or his concluding that essay with a rejection of Marinetti's fetishization of the technologies of warfare; and later on Benjamin's enthusiasm for technology becomes still more measured. Second, as I hope to demonstrate in my discussion of dialectical images, Benjamin's concept of difference is too faceted to be encompassed by a Marxist vision of a classless society or, indeed, by any version of Marxism unmitigated by more mystical strains of thought. See Tratner 2000.

Although she mentions Benjamin only briefly and *Between the Acts* not at all, Jane Gold-

for different reasons, experienced themselves as spiritual exiles in their native lands. Born ten years apart, one a German Jew, the other a British critic of patriarchal politics and the wife of a Jew, they committed suicide within six months of each other at a historical juncture in which the outcome of the Second World War was far from clear.[3] Both spent their final years attempting to complete works composed of fragmentary materials whose form and content arguably were conceived as strategic responses to the fascist threat. Benjamin did most of the work on *Das Passagen-werk* (*The Arcades Project*)— his ambitious study of the Paris Arcades, the nineteenth-century forerunner of the department store—between 1937 and 1940; he left the manuscript, save for two long sections, largely incomplete. Woolf wrote *Between the Acts* between 1938 and 1941, leaving the final proofs unrevised. In their final works, Benjamin and Woolf struggle to reconcile two crucial but perhaps insuperably incompatible strains in their thought: a mystical idealism epitomized by their shared belief in a collective unconscious; and a historical materialism expressed by their attempts to document a (largely shared) set of social conditions and their consequences. Just as they yoke together conceptual premises whose assumptions are at odds, Benjamin and Woolf also create formal constructs from materials of disparate origins; this reliance on the quotation, the fragment, and the ruin is a means at once of salvaging overlooked cultural materials and constructing from them new wholes. For each of them, such procedures served as a way to reconceive historical narratives, whether they be narratives of historical progress or of eternal recurrence, wrenching them into new if momentary configurations from which genuine historical knowledge might be glimpsed.

With all the attention given to Walter Benjamin's literary theory, more may still be said of the critical role vision plays in the unfolding of his redemptive aesthetics. To a surprising extent, given his immersion in iconoclastic Marxist concepts such as commodity fetishism, Benjamin offers a theory of redemption based on the transformative potential of the image. Understanding the inspiration for Benjamin's *Das Passagen-werk* helps to situate him in a material and intellectual culture whose preoccupations, too, were overwhelmingly visual. Materially, Benjamin understood the monolithic, glassed-in Arcades, with their elegant, panoramic displays of goods, as consumer temples which offered an unprecedented degree of public access to luxury items at the same time that they obscured the class relations which stood behind their production. The Arcades commemorated representational values—the pleasures of display and looking—while rendering ex-

man's work on Woolf's "politics of the visual" (Goldman 1998) provides an extremely useful context for the innovations of Woolf's final novel in terms resonant for my own argument.

[3] Having fled Germany, Walter Benjamin committed suicide at the French border in September 1940; Virginia Woolf died in Sussex, England, in March 1941.

change relationships relatively invisible in a perpetual celebration of the social progress brought about by the miracle of technological advancement.[4] Intellectually, the Arcades, as a monument to the scopophilic pleasures of consumerism, enabled Benjamin to bring about the convergence of two central anti-visual discourses: psychoanalysis, with its descriptions of projected, displaced, or fetishized desires; and Marxism, with its accounts of commodity fetishism, reification, and ideological coercion.

Through these conflicting mechanisms of obfuscation and disclosure, seduction and resistance, the decaying Arcades provided Benjamin, and by extension, his readers, with a crucial visual opportunity: by providing images of the old amidst the new, the Arcades could be transformed into "dialectical images" which, if properly read, would create a flash of historical insight through which the present, in its relation to the past and future, could be illuminated.[5] The theory of dialectical images that Benjamin originally developed about the Arcades takes on a new urgency and significance in relation to twentieth-century fascism, and particularly the new technologies used to disseminate fascist spectacle. Fascism, too, made use of visual paradigms and tools as a mechanism for creating new historical understandings; as Susan Buck-Morss puts it, "Fascism . . . stag[ed] not only political spectacles but historical events . . . thereby making 'reality' itself theater" (1991, 36). Given this fascist theatricalization of history—another version of the aestheticization of politics that Benjamin deplores in "The Work of Art"—the whole category of theatrical display would seem to be rendered suspect, a fact to which the revolutionary theater of Benjamin's friend Bertolt Brecht provides testimony, since it aims to convert theater into a confrontational and progressive political medium.[6]

In light of the conceptual contortions of a Brecht to reclaim theater from fascism's appropriation and deployment of its conventions, it comes as something of a surprise that the "symbolic text" that is Woolf's equivalent to Benjamin's Arcades is the theater. But Woolf's treatment of theater approximates Benjamin's conception of the politicization of art: much as Benjamin conceives of the critic's use of the Arcades, Woolf conceptualizes theater as the potential visual means through which elements of the past may be reconstellated in the present by an active and critical audience. Woolf's view of theatrical spectacle is strongly informed by her vision of the anonymous wandering minstrel of early English history

[4] The Arcades were also the setting for the birthplace of a new form of spectator: the flaneur, "botonizing on the pavement," strolling about the metropolis and feasting his eyes on the marketplace and on the spectacle of the crowd in the evolving "phantasmagoria."

[5] For detailed discussions of dialectical images and their conceptual antecedents, see Abbas 1989, 43–62; Buck-Morss 1991; Eagleton 1990, 1991; Jennings 1987; McCole 1993; Rolleston 1989; Wolin 1982.

[6] For Benjamin's commentary on the aesthetics of interruption at work in Brecht's epic theater, see Benjamin 1973b.

whom she idealizes in the late essay "Anon" (Woolf 1979). Conceived as the guardian of a shared, unconscious national life, this anonymous wandering minstrel imaginatively serves as Woolf's ancestral basis for the collaborative relationship between artist and mass audience that she depicts in *Between the Acts*. Written as Woolf was completing *Between the Acts*, "Anon" offers its own historical narrative about the changing ability of art both to create and express collective emotion. Following the invention of the printing press, Woolf argues, which both killed and preserved the anonymous voice of the singer by naming him, Anon's universal vision is compromised by outside pressures and influences and can no longer, therefore, express the emotions of all. After 1477, Woolf suggests, "The thing the writer has to say becomes increasingly cumbered. It is only to be discovered in a flash of recognition" (this "flash," it should be noted, is precisely the language Benjamin uses to convey the momentary apprehension of dialectical images in the present) (Woolf 1979, 390; Benjamin 1999, 463 [N3, 1]).[7] Woolf presumes the ability of sixteenth-century theater to assume Anon's legacy because of the huge audiences it drew, freeing the playwright from the confining politics of patronage, while drawing a "nameless vitality . . . from the crowd" (Woolf 1979, 398). Once relieved of responsibility and self-consciousness by anonymity, the playwright could resume the work of collective expression.

The village pageant in *Between the Acts* is clearly modeled on this ideal, though Woolf has complicated and updated it in critical ways. The play itself, to begin with, depicts scenes of English history, enabling the question of the past's impact on the present and future to be posed in several dimensions, overlaying the collective and transhistorical assumptions that stand behind Anon with the evidence of historical particularity. Woolf's depiction of Miss La Trobe, the playwright, also crosses the collectivist pretensions of Anon with individual traits; while she tries to remain invisible to her audience, the reader is privy to enough details of her biography to complicate her status. Whereas Woolf describes the anonymous playwright as he who "flouts truth at the bidding of the audience" so that "the emotion is wasted" (Woolf 1979, 398), La Trobe seems bent on exposing truths, however uninvited, and pressing emotion into the service of political ends—that is, into a new way of understanding the present. Finally, whereas "Anon" manifests a nostalgic longing for the simpler, purer past from which we've degenerated into a divisive individualism, *Between the Acts*, takes a more dialectical approach to issues of collectivity and historical change. As Patricia Joplin puts it, "For the first time in Woolf's career, she seizes hold of the gap, the distance, the interval, and the interrupted

[7] I follow *The Arcades Project*'s translators, Howard Eiland and Kevin McLaughlin, in including the section numbers as well as page numbers from which quotations derive. For the original German, see Benjamin 1972–.

structure not as a terrible defeat of the will to continuity or aesthetic unity. Rather, she elevates the interrupted structure to a positive formal and metaphysical principle" (Joplin 1989, 89). By bringing into productive tension such apparent oppositions as individual versus collective, past versus present, and language versus image, the novel is able to interrogate the betweenness which connects them, and to distill from that process a dynamic understanding of what politically may be a still more crucial division: that which distinguishes actors from spectators. To fully appreciate Woolf's method in what follows, I want to situate it in relation to Walter Benjamin's evolving thought on the ways in which a certain kind of *active* observer may discern, amidst ruins, keener visions.

Walter Benjamin's Optics of Redemption

The roots of the growing prominence of the image in Benjamin's thought can be traced to his evolving conceptions of constellation and allegory, which jointly comprise the central antecedents to his later concept, the dialectical image. The constellation is first defined in the "Epistemo-Critical Prologue" of his 1928 work *Trauerspiel*, translated as *The Origin of German Tragic Drama* (Benjamin 1977), and marks the only place in which Benjamin attempts systematically to lay out his epistemological premises (although, to be sure, they evolve somewhat from this early formulation). The constellation is an expression of a fragmentary, homeostatic relationship between ideas and objects:

> Phenomena do not . . . enter into the realm of ideas whole, in their crude empirical state, adulterated by appearances, but only in their basic elements, redeemed. . . . [P]henomena are not incorporated in ideas. They are not contained in them. Ideas are, rather, their objective, virtual arrangement, their objective interpretation. . . . Ideas are to objects as constellations are to stars. . . . Ideas are timeless constellations, and by virtue of the elements being seen as points in such constellations, phenomena are subdivided and at the same time redeemed. (1977, 329)

Broken down into their "basic elements," objects in this account are re-constellated through ideas which comprise their "objective, virtual arrangement"; correspondingly, ideas verge on embodiment *as* objects, but in an improved, reconfigured form. As such, ideas and objects approach the kind of ideal semiotic unity William Carlos Williams expressed as "no ideas but in things," with the difference that "things" have undergone a transformative reduction in which only their essential parts are spatialized as ideas. The resulting constellation is an arrangement of perceptual objects into ideas, "a kind of cryptic code or riddling rebus to be

deciphered, a drastically abbreviated image of social processes which the discerning eye will persuade it to yield up" (Eagleton 1990, 329).

But ideas and our access to them are not purely or simply immanent in objects; in fact, this act of "persuasion" or cognition by "the discerning eye" is doubly mediated. As Benjamin puts it: "It is not a question of the actualization of images in visual terms; but rather, in philosophical contemplation, the idea is released from the heart of reality as the word" (1977, 37). Requiring both "philosophical contemplation" by a perceiving subject and a translation into language "as the word," Benjamin's early conception of the constellation subordinates the visual significance of constellations as images per se to their sensuous transactions with the mind as (a materially conceived) language. But the relative importance of the visual and the linguistic in the constellation and its constituents, like the monad, fluctuates throughout Benjamin's writings. For instance, in *One Way Street*, published in 1928, the same year as *Trauerspiel*, language is clearly a degraded substitute for image: "Only images in the mind vitalize the will. The mere word, by contrast, at most inflames it, to leave it smoldering, blasted. There is no intact will without exact pictorial imagination" (Benjamin 1979, 75). Even in *Origin*, Benjamin insists upon the communicative scope and immediacy of the idea as image, regardless of the somewhat magical linguistic translations apprehension requires: "The idea is a monad—that means briefly: every idea contains the image of the world. The purpose of the representation of the idea is nothing less than an abbreviated outline of this image of the world" (Benjamin 1977, 48). The urgency Benjamin attaches to the legibility of the constellation, whether in visual or verbal terms, is tied to his sense of its political mission; the idea functions best as a prescriptive critical tool rather than as descriptive, normative phenomenology. For Benjamin, the constellated elements of phenomena are "redeemed"—their truth disclosed—through the privileging of the part over the whole, by a meticulous adherence to the particularity of the component. As Terry Eagleton has observed, the constellation opposes Cartesian epistemology insofar as it aims to liberate rather than to possess phenomena, the better to "preserve its disparate elements in all their irreducible heterogeneity" (1990, 329).[8] Such a resistance to parts ceding their identities to a cannibalizing whole can be understood as a response to the ways in which capital absorbs and homogenizes objects which have been deflected from their use; and, in more human terms, it can also be glossed as an anticipation of the perceived dangers of the group mind encouraged with the emergence of fascism.

The fact that constellations require interpretation or reading, often by transposing from one medium (the image) to another (the word), provides

[8] Richard Wolin (1982, 93) makes the same point.

a structural clue to one reason Benjamin's views on the constellation preface his work on allegory in the *Trauerspiel* study. In its coalescence of intrinsically unrelated components, the constellation has many affinities with the allegorical object. As Benjamin puts it, "allegory is in the realm of thought what ruins are in the realm of things" (quoted in Buck-Morss 1991, 165); arguably, the best reader of the constellation is the allegorist. Like its contemporary form, the commodity, the allegorical signifier operates through the attenuation of "original" or primary meanings jeopardized by the system of substitution and equivalence into which it is conscripted; in allegory, that is, the "real" meaning is always elsewhere, displaced. The arbitrary referential potential of the allegorical signifier becomes a resource available to the allegorist for new interpretive uses, offering itself up for a potentially infinite multiplication of meanings, whose power to estrange becomes a redemptive force. The corpse is the ultimate allegorical object because, as a signifier drained of immanent meaning, it remains endlessly hospitable to possible signifieds. Moreover, the structure of the Baroque allegory Benjamin anatomizes in *Origin* is dialectical, in that its cumulatively contradictory meanings or antitheses are both emblematized and inverted by allegorical reading. As Richard Wolin puts it, "The 'dialectic' of allegory causes all manifest content to be transformed into its opposite. . . . Once the profane material content of *Trauerspiel* is consumed in the fire of critical examination, the truth content as *allegories of redemption* is revealed" (1982, 71).

Benjamin's theory of dialectical images is indebted both to the atomized constructivist epistemology of the constellation and the interpretive polyvalence and dialecticism of allegorical reading, but with a greater emphasis on the concrete, material world of experience as its base. Wolin usefully situates the new theory in relation to the earlier concepts:

> The employment of the theory of Dialectical Images . . . represents an attempt on Benjamin's part to transpose the theory of "ideas" or "monads" of the *Trauerspiel* study from an idealist to a materialist framework. . . . The major difference between the two renditions of the theory is that the later form abjures references to the tradition of Western metaphysics and instead draws its inspiration from concrete aspects of contemporary social life. Nevertheless . . . both attempt to deduce an image of transcendence while remaining wholly *within* the boundaries of the empirical world of experience. The ultimate concern of both approaches is the *redemption* of phenomena from the profane continuum of historical existence and their transformation into images of fulfillment or *now-time*. (Wolin 1982, 125–26)

One explanation for this shift toward a materialist framework, or an emphasis on "the concrete aspects of contemporary social life," can be found in Benjamin's ongoing interest in the new visual technologies, which he credits, in "The Work of Art," with the production of the "profound

changes in apperception" of the contemporary moment (Benjamin 1969, 240). Published in 1936, just prior to his most extensive work on the uncompleted *Passagen-werk* during 1937–40 and the important "Theses on the Philosophy of History" of 1940—the two works in which dialectical images are substantially defined—the essay serves to ground the more ethereal reaches of his early work through its discussion of photography and film and anticipates some key aspects of the dialectical image.[9]

What begins in "The Work of Art" as an apparently nostalgic eulogy for artwork's "aura" of authenticity, destroyed by photographic reproductions and film, transforms through dialectical inversion into a celebration of the ways such reproductions, by mobilizing a newly proximate, distracted gaze, can free objects for new political ends. Again, as the masses relinquish the contemplation of wholes in favor of the consumption of fragments, Benjamin argues, they will be shocked into a new political awareness via an "unconscious optics" (1969, 237) that will break up fascism's aestheticization of politics into the materials that will lead instead to a new politicization of art. The path from fragmentation to dialectical inversion to redemption is a straightforward and overtly visual one in "The Work of Art," consolidating Benjamin's claims with regard to constellation and allegory at the same time as anticipating, through the notion of "unconscious optics," his controversial version of a "collective unconscious," which becomes so important to the realization of the dialectical image. Equally important, we can see in Benjamin's treatment of the concrete historical developments of both fascism and the visual technologies of photography and film an attempt to disarticulate each of these trajectories from a seamless narrative of historical progress; in order to redeem phenomena from "the profane continuum of historical existence," as Wolin describes it, the critic must engage in a process of disruption in which the myth of progress and the new is demystified, exposed.

Benjamin is at his most exegetical in *Origin*, the longest and earliest of his works, and in the late essay "The Work of Art," in a critical career otherwise noteworthy for a highly condensed, fragmentary, aphoristic style. The literary method Benjamin developed in his later work is entirely consistent with the theoretical commitments outlined fully in the dialectical image. Indeed, Benjamin's plan for *The Arcades Project* was to construct it almost entirely from quotation, on the grounds of the sufficiency of the particular fragment to speak uncorrupted by subjective commentary; as he puts it, "Method of this project: literary montage. I needn't *say* anything. Merely show" (1999, 460 [N1a, 8]). The method of juxtaposing fragments is intended to avoid collusion with dominant ideological narrative forms

[9] For a detailed account of the chronology of composition of *Das Passagen-werk* (*The Arcades Project*), see Buck-Morss 1991, 48–55; Tiedemann 1999.

by foregrounding the inconsistencies covered over by conventional narrative continuity. It thereby defers closure, disrupts the complacency of detached contemplation and, in the fresh collisions it enables, offers the possibility of bringing a new political language to birth.[10] Benjamin defines the dialectical image in terms characteristically condensed and oblique:

> It is not that what is past casts its light on what is present, or what is present its light on what is past; rather, image is that wherein what has been comes together in a flash with the now to form a constellation. In other words, image is dialectics at a standstill. . . . Only dialectical images are genuinely historical. (463 [N3, 1])

> Where thinking comes to a standstill in a constellation saturated with tensions—there the dialectical image appears. It is the caesura in the movement of thought. Its positioning is naturally not an arbitrary one. It is to be found, in a word, where the tension between dialectical opposites is greatest. Hence, the object constructed in the materialist presentation of history is itself the dialectical image. The latter is identical with the historical object; it justifies its violent expulsion from the continuum of the historical process. (475 [N10a, 3])

Benjamin's newly materialist conception of the dialectical image, as compared with the idealist emphasis of his constellation and allegory, leads to two further consequences. First, Benjamin is able to conceive of it more explicitly as a medium through which heretofore buried historical content can manifest itself; dialectical images "are genuinely historical" or "identical with the historical object" in the sense that their constellatory structure exposes the ruptures between a past and a present whose relations are arbitrary, rather than fusing elements into a deceptive totality. Whereas myth comes from naturalizing historical change as "progress," dialectical images show us that the technological progress from which such myths proceed is separable from history proper, and does not, of necessity, lead either to historical progress or catastrophe. They achieve this by resuscitating and reconstellating the refuse of history, obsolescent forms or ruins— typically, commodities—whose political force derives precisely from their apparent insignificance. Shocking the observer into a new critical awareness based on the estrangement of the everyday, dialectical images are thus insured against the replication of dominant ideological structures.

Second, Benjamin aims to garner for the dialectical image a broader objective or rationalistic stature, to secure it from the charge, leveled by Theodore Adorno and others, that it remains merely a random expression of subjective intention or reading. That the positioning of dialectical images "is naturally not arbitrary," in other words, is meant to suggest *both*

[10] On quotation as method, see Rolleston 1989, 13–27.

the rational construction of dialectical images—appearing "at the point where the tension between dialectical oppositions is greatest"—and their independence from the individual subject's interpretive capacities ("I needn't *say* anything. Merely show"). Dialectical images come to legibility only at specific times, "in a flash as a constellation"; whether or not they succeed in their revolutionary aim of demystification depends on the exigencies of subjects' capacities to recognize them. Benjamin is clear about the uncertainty of this outcome in his "Theses on the Philosophy of History": "every image of the past that is not recognized by the present as one of its own concerns threatens to disappear irretrievably" (Benjamin 1969, 255). In the frozen moments in which they appear, then, dialectical images function as "ideology's inverted mirror-image" (Eagleton 1990, 334), a visible opportunity for the present to redeem a moment of the past that would otherwise remain obscured and, finally, lost. Dialectical images should not, however, be construed merely as archaeological tools for historical recovery. As Wolin notes, Benjamin's intention "was not to attempt to discover rudiments of archaic life in the modern per se, but rather, to unmask the idea of the modern itself. . . . By characterizing the modern as eternal recurrence, one could therefore show how it coalesces with the idea of mythical repetition, which dominates life in prehistory. Thus, prehistory returns to dominate the modern era under the mythical guise of commodity exchange, in which the self-identical perpetually presents itself as the new" (Wolin 1982, 129).

The subjective, nascent corollary of the dialectical image is the wish or dream image which, because it recasts waking materials in new, defamiliarizing shapes, mimics or anticipates the redemptive procedures of dialectical images; at the same time, the wish image functions as the repository of utopian visions which distinguish the unconscious desires of the collective.[11] As psychological categories, wish or dream images are not yet dialectical images, but they can be drawn into an awakened state by them, an awakening "synonymous with historical knowledge" (Buck-Morss 1991, 115, 261). In "Paris—the Capital of the Nineteenth Century," Benjamin defines them:

> To the form of every new means of production, which to begin with is still dominated by the old (Marx), there correspond images in the collective consciousness in which the new and the old are intermingled. These images are wish-images, and in them the collective seeks not only to transfigure, but also to transcend, the immaturity of the social product and the deficiencies of the social order of production. In these wish-images there also emerges a vigorous aspiration to break with what is outdated—which means, however, with the most recent past. These tendencies turn the image-fantasy, which gains its

[11] The wish or dream image demonstrates the surrealist dimension of Benjamin's thought. For an excellent discussion of the influence of Proust and surrealism on *The Arcades Project*, see Pensky 1996.

initial stimulus from the new, back upon the primal past. In the dream in which every epoch sees in images the epoch that is to succeed it, the latter appears coupled with elements of pre-history—that is to say, of a classless society. The experiences of this society, which have their storeplace in the collective unconscious, interact with the new to give birth to the utopias which leave their traces in a thousand configurations of life, from permanent build ings to ephemeral fashions. (Benjamin 1973a, 159)

In this account, which combines elements equally from Freud and Jung, pre-existing wish-images which mingle the old with the new come into correspondence or legibility with "new means of production" as they appear. Unlike Jungian archetypes, the images in Benjamin's "collective unconscious" are formed from concrete historical experiences, rather than being biologically inherited (Buck-Morss 1991, 278), a process which analogizes, in its picture of a social awakening from collective childhood, collective and individual psychic history. These wish images, activated by the desire to "break . . . from the most recent past," actually transcend "the deficiencies of the social order of production" through recourse to "the primal past" or "pre-history"—Benjamin's own utopian vision of the classless society whose traces remain in "the collective unconscious." To this extent Benjamin's wish images recall Woolf's own recourse to the "primal past" or "pre-history" through the figure of Anon. Just as Benjamin's wish-images only prepare the ground for revolutionary awareness, requiring mediation by concrete material forces to be reconstellated into properly dialectical images, Woolf's Anon must be reconfigured by contemporary material conditions and conflicts into the minstrel's dialectically responsive successor, La Trobe; by using "dream-elements in waking," La Trobe will craft a "textbook example of dialectical thought" through a collaborative vision enabled by, if not reducible to, her efforts (Benjamin 1973a, 176). Benjamin clarifies: "In the dialectical image, what has been within a particular epoch is always, simultaneously, 'what has been from time immemorial.' As such, however, it is manifest, on each occasion, only to a quite specific epoch—namely, the one in which humanity, rubbing its eyes, recognizes just this particular dream image as such. It is at this moment that the historian takes up, with regard to that image, the task of dream interpretation" (1999, 464 [N4, 1]). As Buck-Morss argues about dialectical images and their interpretation: "Such is the logic of historical images, in which collective wish images are negated, surpassed, and at the same time dialectically redeemed. . . . The moment of sublation reveals itself visually, in an instantaneous flash wherein the old is illuminated precisely at the moment of its disappearance" (Buck-Morss 1991, 146).

Benjamin has often been taken to task for inconsistency and mysticism, and particularly, for his selective divergence from Marxist principles (which, by some accounts, form the most important source for his ideas).

Foremost among those critics has been Adorno, Benjamin's sometime collaborator, whose objections can be distilled into three central concerns—concerns that may equally hold for Woolf. First, Adorno thought that Benjamin's theory of dialectical images and their methodological equivalent in *The Arcades Project* invited at once too little and too much subjective intervention: too little, insofar as Benjamin's implicit claims for the sufficiency of juxtaposed, constellated fragments or quotations threaten to eliminate the active, critical role of the interpreter; and too much, to the extent that those isolated fragments proffer no inherent guidelines or limits to the interpretive act, and seem to allow, therefore, for unbridled subjective excess (Eagleton 1990, 332). But this very contradiction exposes the legibility of the dialectical image within a broader modernist cultural fantasy. Adorno's skepticism about the viability of the dialiectical image as a critical method/outcome leads us to discover the degree of its ideological imbrication in the interior gaze, the key features of which it reiterates. If we understand the dialectical image fundamentally as the outcome of a penetrating mode of *seeing* that inevitably constructs as much as discovers its objects as it brings them to visibility, we may conclude that the apprehension of dialectical images is inseparable from (a disavowed) intervention and expertise. That disavowal arguably is facilitated by the supposition of dialectical images' collective and "spontaneous" character as apparitions, despite the far more deliberate interpretive forces that may bring them into being, both in Benjamin and in Woolf.[12] Second, Adorno saw Benjamin's invocation of "the classless society" in his utopian vision of primal history as a betrayal of the dialectical thinking that inspired the plan for *The Arcades Project*. While originally, Benjamin intended to show how the proliferation of commodities, whose false novelty concealed their underlying sameness, instigated a regression to the myth of eternal recurrence or cyclical time, Adorno argues that the utopian representation of prehistory from *The Arcades Project*'s "Paris—the Capital of the Nineteenth Century" erects a competing myth of an unsullied golden age to which we should try to return (Wolin 1982, 174–82). Interestingly, Woolf's final novel echoes Benjamin's alternately critical and nostalgic views of an ancestral past in ways that suggest their dialectical linkages. Third, Adorno objected to Benjamin's emphasis on dreams and his reliance on the notion of a "collective unconscious," since they jointly mask real social conditions and divisions through the interposition of a mythical collective psyche. The lily pool in *Between the Acts* is surely vulnerable to a comparable critique as a mythical, collective space. Cumulatively, then, Adorno finds these inconsistencies to impugn the redemp-

[12] Buck-Morss (1991) is arguably among the most optimistic about the capacity to recuperate Benjamin's ideas along properly dialectical and materialist lines.

tive pretensions of dialectical images, suggesting that, rather than transcending their social origins in a flash of illuminating truth, they merely reflect them (Adorno 1977, 115–16).

Benjamin's conceptual eclecticism, like Woolf's I will suggest, must be understood symptomatically in the context of historical crisis—through the "necessity of a theory of history from which fascism can become visible" (quoted in Buck-Morss 1991, 303). In Eagleton's words: "As fascism comes to power, there is a sense in which Benjamin's whole career becomes a kind of urgent constellating, a cobbling together of whatever unprepossessing scraps and fragments come to hand in the teeth of a history which . . . seems to have subsided into ruins" (1990, 333). Eagleton's description, it's worth noting, could equally be applied to legions of modernist writers struggling with the technological and political realities of their moment; as T. S. Eliot's "Wasteland" has taught us, "shoring fragments against ruins" is a characteristic modernist strategy through which to salvage meaning from decay, however those oppositions are framed. For Benjamin, as for Woolf in her final novel, those oppositions persistently are defined visually, as the dialectical poles of the social spectacle each invested with political meaning—for Benjamin, the Paris Arcades and, for Woolf, village theater. Against the fascist politics they hoped to undermine, Benjamin and Woolf aim to transform the observer's relation to the image from the passive complacency of aesthetic contemplation or commodified desire to a more active, transformative relation. In order to see how the two overlap, I propose to use Benjamin as both a model of formal construction and a method of reading, to wrench quotations from their native contexts and, through the work of constellation, to try to see Woolf and Benjamin dialectically anew.

Between the Acts and the Constellation of Narrative

> For we are not concerned to represent literary works in the context of
> their time but rather to bring to representation that time that has knowl-
> edge of them—that is, our time, in the time of their genesis. Thus
> literature becomes an organ of history. To do so—and not make them
> into another set of materials for history—is the task of literary history.
> —Walter Benjamin, "Literary History and Literary Studies"

> History decays into images, not into stories.
> —Walter Benjamin, *The Arcades Project*

In the musical interval following the end of the village play that the characters of *Between the Acts* attend for roughly half of the novel, Woolf's

narrator describes the unnamed tune that is fitted on the gramophone, and the audience's response:

> Like quicksilver sliding, filings magnetized, the distracted united. The tune began; the first note meant a second; the second a third. Then down beneath a force was born in opposition; then another. On different levels they diverged. On different levels ourselves went forward; flower gathering some on the surface; others descending to wrestle with the meaning; but all comprehending; all enlisted. The whole population of the mind's immeasurable profundity came flocking; from the unprotected, the unskinned; and dawn rose; and azure; from the chaos and cacophony measure; but not the melody of surface sound alone controlled it; but also the warring battle-plumed warriors straining asunder: To part? No. Compelled from the ends of the horizon; recalled from the edge of appalling crevasses; they crashed; solved; united. . . .
>
> Was that voice ourselves? Scraps, orts and fragments, are we, also, that? The voice died away. (Woolf 1941, 189)

By collapsing the audience's experience of unity—"the distracted united"—with the music's assimilation of separate notes into a single tissue of sound, Woolf initially depicts the power of an aesthetic event to overcome divisions and sustain itself through the force of collective vitality. But, much like Benjamin's constellation, Woolf's image of union quickly reveals itself as one born of discord, in which the whole is comprised of independent components—"scraps, orts and fragments"—which preserve their integrity through sustained internal conflicts. Also like Benjamin's constellation, the music yokes together perceptual exteriors ("flower gathering . . . on the surface") and conceptual interiors ("descending to wrestle with the meaning") in a spatialized structure of oppositions. The musical ideas, moreover, resemble Benjamin's monads as abbreviated images of the world in which "the whole population of the mind" is enlisted and spans, in a global reach, to "the ends of the horizon."

Although, like "quicksilver sliding, filings magnetized," parts seem irresistibly drawn together as if by the laws of physics,[13] their coherence seems suspended in a fragile and temporary flux, subject to "force[s] born in opposition," and under siege by "warring battle-plumed warriors straining

[13] Michele Pridmore-Brown (1998) suggests that these dynamics literally should be comprehended in the context of the "new" physics—that is, through the lens of Einstein's work, information theory, and quantum mechanics, which offer new models of (more fluidly) relating parts and wholes. This fascinating perspective may have much to offer to our understanding of the genesis of Benjamin's ideas as well. Pridmore-Brown tracks the relations of parts to wholes mainly through the novel's depiction of sound and listening, or its reformulation of noise into sense; but as my reading of the gramophone music below indicates, these aural relations may be regarded as typical rather than privileged instances of a broad and prevalent mode of apprehension. Given that the audience's seeing and listening practices are represented integrally in the novel, these perceptual layers may productively be regarded together.

asunder"—martial imagery not casually chosen in this novel over which
the specter of wartime violence hovers. Woolf virtually essentializes con-
flict as the basis both for unity—"from the chaos and cacophony mea-
sure"—and for the instability which ensures its inevitable collapse. How-
ever temporary, unity still has a clearly redemptive tenor here, recalling
its parts "from the edge of appalling crevasses" from whence, presumably,
they would otherwise be lost. When the narrator asks about the music,
"Was that voice ourselves?" she raises really two questions: does the musi-
cal "voice," with its internal divisions and harmonies, *mirror* the voices of
the audience as a kind of objective correlative, or does it literally embody
them, however fleeting the moment of self-recognition? Just as she ex-
poses the conflicts which underlie a temporarily forged unity in song,
Woolf sustains the tension between a metaphorical and actual equation of
musical and human voices through to the end of the passage. The mo-
ment of potential recognition of the music as a constellation of human
voices occurs in a flash of dialectical insight destined to fade, in which the
music provides both an image of progress—"ourselves [going] forward"
toward unity—and its dissolution: "The voice died away."

I've read this passage in some depth because, despite the aural rather
than visual terms in which it's cast, it forms the text's most concise ex-
pression of the dialectical and constellatory method it employs through-
out, as well as the relation of that method to a notion of collective human
agency. *Between the Acts* continuously reworks the constellatory image-as-
process both structurally, at nearly every level of the novel's formal con-
struction, and thematically, as an explicit argument about artistic making
and aesthetic perception; as Melba Cuddy-Keane puts it, the novel "em-
ploys fragmentation as a new way of seeing" (1990, 283). Variously de-
scribed as "a tissue of near citations," a "polyphony" of voices, a "structure
of oppositions" or "rhythm of dialectic," and "a palimpsest of 'orts, scraps
and fragments,' "[14] *Between the Acts* combines genres—drama, newspaper
clippings, poetry, and music—as conspicuously and freely as its allusions
to Egyptian, Greek, and Christian mythology and to English literature and
history; it also reworks autobiographical materials from Woolf's past.[15] In-
deed, at ever more microscopic levels of construction, the principle of

[14] See Abel 1989, 127; Laurence 1991, 242, 245, 238; Shattuck 1987, 279. David
McWhirter stresses the novel's discursive and aesthetic variety in a specifically Bakhtinian
register, describing its "polyphony of forms" and "dialogizing" tactics (McWhirter 1993,
803, 807).
[15] A number of Woolf's childhood recollections in "A Sketch of the Past," which she com-
posed simultaneously with *Between the Acts*, appear in the novel: her revelation of a flower's
completeness (Woolf 1976, 71) resurfaces in George's response to a flower (Woolf 1941,
11); the skeleton of the dog found in a swamp (1976, 76) recalls the sheep's thigh bone re-
covered from the lily pond (1941, 44); the detail of lice in fish scales as evidence of freshness
(1976, 102) returns as Lucy Swithin's observation (1941, 29).

juxtaposed elements gives the novel's signature phrase, "orts, scraps and fragments" an epigraphic if not epitaphic weight. The politics of quotation run in two directions, on the one hand producing moments of discord or collision from which the sutures of an otherwise apparently seamless narrative become visible, and on the other hand suggesting, through the ways disparate cultural myths and materials echo one another, the structuralist implication that we're all—despite differences in time and place and identity—telling the same story.

These two trajectories based on the fragment as constellatory unit—of irreducible difference and underlying sameness or, in the characterological terms Woolf also casts them, of separatists (Bart Oliver) and unifiers (Lucy Swithin)—comprise the broad dialectical poles between which the narrative heaves its weight, whether inflected as a matter of historical epochs or individual identities. Unlike a modernist aesthetic of fragmentation based mainly on verisimilitude—the conviction that the discontinuities of modern experience can and should be mimicked through the discontinuities of discursive surfaces—Woolf's use of the fragment problematizes precisely the notion of form as an adequate means of *representing* experience. Instead, Woolf uses the fragment skeptically to comment on, to interrogate, and perhaps to demystify, both our experience of historical difference as a narrative of progress and our experience of historical sameness as a narrative of universality and transcendence. By reconstellating the dialectical oppositions of difference versus sameness against the backdrop in which village theater meets the theater of war, Woolf aims to deconstruct, to "blast . . . out of the continuum of history's course" (as Benjamin puts it) the false polarities which, with luck, may yield a flash of historical insight. In this sense, we can understand the much-interpreted title of the novel not only as a reference to the historical space between the World Wars and to the segmented structure of dramatic action, but as a commitment to the "betweenness" of "dialectic at a standstill" itself. Woolf's description of Miss La Trobe's artistic methods and ambitions arguably provides a window into her own: La Trobe aims to be "not merely a twitcher of individual strings; [but] one who seethes wandering bodies and floating voices in a cauldron, and makes rise up from its amorphous mass a re-created world" (Woolf 1941, 153). To the extent that she aims, like La Trobe, to reconstellate her "wandering bodies and floating voices" into such a world, Woolf's redemptive ambitions can be understood to match Benjamin's—in a process of "thinking in common" as Woolf called it (1929, 58), of which they both, presumably, would have approved, if for different reasons.

Whether in the "amorphous mass" of La Trobe's cauldron or the constitutive notes of the festival music, Woolf's constellatory imagery takes a consistent position on the relationship of parts to the whole. Much like Benjamin's constellation, which, in Eagleton's words, "safeguards particu-

larity but fissures identity" (1990, 330), Woolf's parts always retain a measure of their integrity at the same time that they make themselves available to form newly imagined wholes or "re-created worlds." Benjamin's insistence on the part's particularity has been explained as a dual rejection, on the one hand, of a version of totality consisting in the oppressively hierarchical subordination of parts to the whole and, on the other hand, of a competing view of totality defined by sustained contradictions, an essentializing account of the whole comprised of conflicting parts espoused by Lukács (Eagleton 1990, 330 ff.). The sources for Woolf's rejection of totalizing wholeness appear to be less Marxian than Freudian, considering that she was reading Freud's 1921 essay "Group Psychology and the Analysis of the Ego" (Freud 1955), which reprises and augments Le Bon's classic account of the psychology of the crowd, as she composed *Between the Acts*.[16] The essay hinges on the notion of the obliteration of individual traits in a group mind, governed by a spontaneously formed collective unconscious which has regressed to a barbaric, primitive state. Divested of their particularity, members of the group are characterized by their intolerance to change or difference, obedience to authority, respect for strength, embrace of contradictory ideas, and their propensity for randomly directed violence (Freud 1955, 77–79). For Woolf, the conceptual leap from Freud's recital of the general political dangers of a wholeness purchased at the expense of its parts to the particular political horrors of the mobilized fascist crowd can only have been effortlessly brief in 1939. Woolf's constellatory method, then, can be understood as a politicized alternative to a narrative surface whose seamlessness obscures the disparate materials that have gone into its making—a technique which can be aligned with the subsuming, regressive force of the crowd. Although *Between the Acts* does propose an alternative conception of "group mind," with "the other voice" as it's often referred to, its redemptive possibilities must be situated against this grim alternative, whose effects serve, both within and without, as the defining backdrop of the novel.

The allegorically typological rather than psychologically complete characterizations Woolf chooses for *Between the Acts,* with the built-in discontinuities between image and meaning they sustain, can be understood as a corollary to Woolf's constellatory method, much as allegory functions in Benjamin to show the mobility of meanings that may attach to the allegorical signifier. Described as "the same age as the century" and graced with the epithet "abortive" (Woolf 1941, 19, 15), Isa is the character most prominently allegorized as "the spirit of the age." The other principal

[16] Woolf mentions Freud's essay in her diary entry of Monday, 18 December 1939 (Woolf 1953, 310). Various critics have commented on the relevance of the essay for her novel (though not in relation to Benjamin); see Abel 1989; Cramer 1993; Cuddy-Keane 1990; English 1994; Joplin 1989.

characters are likewise largely presented as allegorical or conceptual positions. Woolf distinguishes Lucy and Bart as oppositional principles—"she belonged to the unifiers; he to the separatists," (118); Mrs. Manresa is "a wild child of nature" (41); Giles is the "sulky hero," introduced by martial music; Lucy is also "Old Flimsy," La Trobe, "bossy"; and William Dodge, reducible to the word "which cannot be spoken in public" (60). La Trobe's play, of course, carries allegorical typecasting to its extreme, with "the Age of Reason hobnobb[ing] with the foreparts of the donkey" (195), and so on. Cumulatively, the allegorical dimensions of the text contribute to the sense that narrative meaning is always elsewhere, reliant on external interpretive frameworks, which would explain why so many critics have been drawn to translate the main characters, with varying degrees of persuasiveness, into their presumed "authentic" identities as historical or mythic figures. Without speculating as to whether it enriches or forecloses the connotative universe of *Between the Acts* to equate La Trobe with Hitler, it may be worthwhile to observe the discursive conditions that make such equations possible.[17] (The characters' epithets, it turns out, too, are not always stable indicators, often serving as markers of contested terrain. Mrs. Manresa, for instance, comes to personify the question of what constitutes the natural more successfully than she represents a clear and recognizable category.)

That the constellation is sustained by internal conflict—as Woolf expressed it in her description of the pageant's music: "warring battle-plumed warriors straining asunder"—creates the expectation of a nearly structural divisiveness which the novel's unfolding narrative doesn't disappoint. That conflict, to be sure, is not merely a neutral, structural feature but one, as Woolf's martial imagery makes clear, that is informed and defined by the war, however indirectly. The first half of *Between the Acts* depicts a series of central interpersonal conflicts: between the young married couple, Isa and Giles Oliver, whose estrangement is complicated by real and imagined infidelities; and between Giles's father, Bart Oliver, and his sister, Lucy Swithin, who engage in a series of small skirmishes in their ongoing battle over the claims of faith and reason. Other, lesser conflicts add to the general atmosphere of hostility and tension: Bart, after frightening his grandson with a newspaper mask (11), retires to dream of himself as "a young man helmeted" (17); Isa reads about a rape in the newspaper which preoccupies her for the balance of the day (20). By and large, the characters are a collection of outcasts and interlopers, none of whom is exempt from whispered assessments of the purity of their bloodlines—or worse. The playwright, Miss La Trobe, one villager notes, "wasn't presumably

[17] For excellent discussions of the grounds for and limits of this perception of La Trobe, see English 1994; Johnston 1987; Joplin 1989.

pure English," and perhaps has Russian blood (57–58); Isa, we're told, is
part Irish (16); Mrs. Manresa may have been born in Tasmania, amidst
vague scandals (39–40); even the Olivers' English pedigree, with only one
of a pair of legitimate ancestors, is not beyond question (7). As homosexu-
als, Miss La Trobe and William Dodge at times are the objects of social cen-
sure and loathing (60, 111), and defined as outcasts (73, 211). One feels
that it is only by luck that Albert, the village idiot, is left unmolested by an
audience made squeamish by his uninhibited antics (86–87). The charac-
ters' preoccupation with questions of national and sexual purity begs com-
parison with Nazism, and serves to measure the psychic distance between
the villagers and their wartime opponents. As the "purest" character, Giles
is also the most intolerant, as we see in his hostility toward William Dodge,
symbolized in the second half of the novel by his traipsing about "with
blood on his boots" (111). Conflict in the novel is consistently conceived
dialectically, as a matter of fidelity and betrayal, faith and reason, purity
and pollution, and so on. Woolf casts the text's most constitutive and orga-
nizing conflicts—between progressive and cyclical history, and between
pastoral and savage nature—also in dialectical terms, the tensions reach-
ing their saturation point in Miss La Trobe's play.

> The belief in progress—in an infinite perfectibility understood as an infi-
> nite ethical task—and the representation of eternal return are comple-
> mentary. They are the indissoluble antinomies in the face of which the
> dialectical conception of historical time must be developed. In this con-
> ception, the idea of eternal return appears precisely as that "shallow ra-
> tionalism" which the belief in progress is accused of being, while faith
> in progress seems no less to belong to the mythic mode of thought than
> does the idea of eternal return.
>
> —Walter Benjamin, *The Arcades Project*

Between the Acts is nothing so much as a meditation on the nature of
time and history. Whether it poses the question most broadly as a matter
of species history or more narrowly with regard to national and individual
history, *Between the Acts* asks perpetually, " 'D'you think people change?
Their clothes, of course. . . . But I meant ourselves' " (Woolf 1941, 121).
In keeping with its constellatory structure, *Between the Acts* juxtaposes a
whole series of interlocking and conflicting temporal frameworks, epito-
mized by the "five seconds in actual time, in mind time ever so much
longer" (9) that it takes Lucy Swithin to distinguish her maid, Grace, in
the present tense from the primeval beasts loosed from the prehistoric
past, which her bedtime reading of the Outline of History has evoked.
Each of the intermediary temporal frameworks in the novel emphasizes
both continuity and disruption. Adhering to the ideal Aristotelean unities

by unfolding the text's action over a single day and location, Woolf none-theless cuts across those contexts with the interposition of the play and its multiple temporal and spatial valences. While the village play has been staged successively for seven years, this year is different, marred by the un-derlying violence epitomized by the newspaper story about rape Isa has read: "only this year . . . she heard: 'The girl screamed and hit him about the face with a hammer' " (22). The narrative of English history the play depicts moves chronologically enough from Chaucer to the present, but it skips parts, and, more importantly, it repeatedly lifts the veil on its illu-sionistic conventions—unmasking, for example, Queen Elizabeth as "Eliza Clark, licensed to sell tobacco" (83)—under which the present time and the "real" can be glimpsed.

What functions structurally as a conflict between continuity and rup-ture in *Between the Acts* is reimagined, in thematic configurations so nu-merous they form the very substance of the narrative, as a dialectic be-tween a model of history as eternal recurrence based on natural cycles—what might be called natural history—and of a mythos of eternal progress based on the unfolding of unique events—what we might call human history. Natural history is associated with a benign view of the nat-ural world in which natural and human cycles harmoniously complement one another. The ideals of eternal improvement upon which human his-tory depends, by contrast, require a more malignant view of nature as a primitive sphere whose submission to human invention constitutes progress. The song of the play's villagers articulates the transcendent per-spective of natural history: "*All passes but we, all changes . . . but we remain forever the same*" (139); an audience member voices faith in eternal progress and perfectibility as the self-evident truth of human history: "change had to come, unless things were perfect; in which case she sup-posed they resisted Time. Heaven was changeless" (174). By presenting these two competing temporal frameworks dialectically, Woolf is able to stage a remarkably complete deconstruction both of history as intrinsi-cally either cyclical or progressive, and of nature in the alternate capaci-ties in which it upholds each conception.

From the beginning of the novel, Woolf locates human history within the widest possible frame. In her Outline of History Lucy reads of a time when England was populated "by elephant-bodied, seal-necked, heaving, surging, slowly writhing, and, she supposed, barking monsters . . . from whom presumably, she thought . . . we descend" (8–9). The delivery boy makes his rounds to those whose names, like his own, can be found in Domesday Book, the Roman census; Figgis's Guidebook still gives an ac-curate account of the local countryside, proving that "1830 was true in 1939," the only difference being that tractors partly have supplanted plows (52). The Olivers, whom we're told have lived in the village "only"

for over a hundred and twenty years, unlike the truly established families (7), inhabit a house marked by changing historical epochs, with its plastered-over chapel turned larder (32), which sings "of what was before time was" (36), and next to a barn which "reminded some people of a Greek temple, others of the middle ages, most people of an age before their own, [and] scarcely anybody of the present moment" (99). The sweeping historical context Woolf contrives seems calculated to represent the human as continuous with the natural order (descended from "barking monsters"), at the same time as it reduces single human generations to inconsequential cogs in the wheels of broader temporal cycles (those recorded, say, in the Domesday Book). The human departure from those natural cycles is also made evident in the novel though the disjunctive presence of technology, well dramatized against the pastoral backdrop of the remote village setting. A discussion of that unglamorous innovation, the cesspool, for example, forms the text's opening gambit, as the promised but undelivered means to bring water to a village subsequently defined as landlocked and parched (3). Planned for the Roman Road, the cesspool would have made the contemporary contribution to a march of human history including "the scars made by the Britons; the Romans; by the Elizabethan manor house; and by the plough, when they ploughed the hill to grow wheat in the Napoleonic wars" (4); the cycles of human history, alternating war with cultivation and culminating in the cesspool, clearly provide a different historical narrative than that of nature, and complicate our means of distinguishing progress from recurrence.

Underscoring the perspectival incompatibility inherent in the difference between human and natural scales, nature in *Between the Acts* frequently is named "the view." By domesticating it in this way, Woolf stresses its to-be-looked-at-ness, its instrumental value in relation to a human observer, thereby containing it as visual spectacle. For Giles, "the view" sums up all the aestheticized irrelevance of which the "old fogies" are guilty, "looking at views, instead of—doing what?" (53), as they allow nature's "long view" to occlude pressing political realities. The difference in perspective between the natural and the human at such moments seems oppressive and decisive—or in Lucy Swithin's words, with her eyes on a more distant horizon, "sad" and "beautiful," since the view will be there "when we're not" (53). Yet as the group collectively experiences it early on, "the view" is also mind-numbing, overwhelming: "How tempting, how very tempting, to let the view triumph; to reflect its ripple; to let their own minds ripple; to let outlines elongate and pitch over—so—with a sudden jerk. . . . The flat fields glared green yellow, blue yellow, red yellow, then blue again. The repetition was senseless, hideous, stupefying" (66–67). Neither a pointless distraction nor a register of the fleetingness of human life, "the view" asserts its own perspective here; no longer domesticated

and contained, its menacing "glare" nearly "triumphs" over the human observers. Woolf's description of the empty barn—empty, that is, of all but mice, insects, dogs, and swallows—again emphasizes the irreconcilability of the human and natural; whereas "all these eyes, expanding and narrowing, some adapted to light, others to darkness, looked from different angles and edges" (100), they escape the vision of Mrs. Sands: "But butterflies she never saw; mice were only black pellets in kitchen drawers; moths she bundled in her hands and put out of the window" (100).

As the character who "belonged to the unifiers" (118), and who is "given to increasing the bounds of the moment by flights into past or future" (9), Lucy Swithin is most identified with natural history. Lucy rejects a linear historical model based on principles of change and fundamental difference: " 'The Victorians,' " she muses, " 'I don't believe . . . that there ever were such people. Only you and me and William dressed differently' " (174–75). Instead, she favors a cyclical model personified by the swallows for whom Bart, quoting Swinburne, names her: "Across Africa, across France they had come to nest here. Year after year they came. Before there was a channel, when the earth . . . was a riot of rhododendrons" (108). Not content with analogizing human and natural cycles, she collapses them in a mystical vision of wholeness which transcends the particularity of its parts. As she puts it to William Dodge, on their house tour: " 'But we have other lives, I think, I hope,' she murmured. 'We live in others, Mr. We live in things' " (70). Because Lucy's process of "one-making" (175) subsumes its fragmentary components rather than suspending them in a sustained and conflicted whole—"If discordant, producing harmony—if not to us, to a gigantic ear attached to a gigantic head" (175)—it can be understood as a virtual parody of constellatory construction. Bart's "separatist" perspective, in this sense, can be seen as a necessary corrective, restoring the conflict her unity belies. "How imperceptive," he observes, "her religion made her! . . . Skimming the surface, she ignored the battle in the mud" (203). Through Bart's critique as well as those of the other characters, Lucy's essentially ahistorical vision emerges as flighty and insubstantial, supported mainly by her weightless, disembodied mind floating "up in the clouds, like an air ball" (116), her eyes fixed on God (23). "Old Flimsy," as she is called, then, remains a nearly comic extreme, the target of a gentle mockery, whose religious faith and enveloping, all-embracing vision the text, overall, is unable to endorse, despite its intrinsic attractions and the extensive attention it receives.

But the novel doesn't discredit Lucy's "one-making" in order easily to embrace an alternative.[18] An early conversation between Isa and Lucy

[18] James English suggests that the novel's pastoral ideal of community (with which I associate Lucy) "circulates so busily and playfully through *Between the Acts* that one cannot hope to assign it a simple positive or negative value" (English 1994, 119).

shows how Isa's initial impulse to create a narrative of progress is quickly complicated and derailed. Lucy describes the prehistoric London sketched in her Outline of History:

> "There were rhododendrons in the Strand; and mammoths in Piccadilly."
> "When we were savages," said Isa.
> Then she remembered; her dentist had told her that savages could perform very skilful operations on the brain. Savages had false teeth, he said. False teeth were invented, she thought he said, in the time of the Pharaohs. (30)

The technological proficiency of the "savages," recast suddenly as brain surgeons and dentists, effectively discredits the whole category, obstructing a neat trajectory from ancient savagery to contemporary civility. Yet, the scene resists replacing a narrative of progress with a narrative of eternal recurrence. The ambiguous terrain Isa occupies in this scene seems to characterize not just Isa individually, but the whole generation she allegorically represents, in marked distinction from their elders. In spite of their differences as unifier and separatist, Lucy and Bart are jointly cordoned off, as the older generation, from a future defined as peculiarly Isa's.

> "Marking time," said old Oliver beneath his breath.
> "Which don't exist for us," Lucy murmured. "We've only the present."
> "Isn't that enough?" William asked himself. Beauty—isn't that enough? But here Isa fidgeted. . . . "No, not for us, who've the future," she seemed to say. The future disturbing our present." (82)

Isa echoes her husband's impatience with aesthetic contemplation here as she silently rebukes William Dodge—though not her elders—for his indulgent interest in the beauty of the present alone, underscoring the political urgency of making time exist for themselves. Isa's equivocation toward the end of the novel, when she is asked to validate Lucy's vision of recurrent historical cycles, can be understood to reflect the difficulties of a whole generation attempting to chart a course between two arguably untenable historical discourses. " 'Did you feel,' [Lucy] asked," about the Reverend Streatfield's speech, " 'what he said: we act different parts but are the same?' 'Yes,' Isa answered. 'No,' she added. It was Yes, No. Yes, yes, yes, the tide rushing out embracing. No, no, no, it contracted" (215). Whether Isa's answer should be condemned as a potentially fatal failure of conviction or celebrated, in Benjaminian fashion, as the dialectical means to historical insight, is a question Woolf's narrative sustains to the end.

Corresponding to the form of the new means of production, which in the beginning is still ruled by the form of the old (Marx), are images in the

collective consciousness in which the old and the new interpenetrate. These images are wish images; in them the collective seeks both to overcome and to transfigure the immaturity of the social product and the inadequacies in the social organization of production. At the same time, what emerges in these wish images is the resolute effort to distance oneself from all that is antiquated—which includes, however, the recent past.

—Walter Benjamin, *The Arcades Project*

Despite those historical factors which isolate Isa's generation, they are clearly also the inheritors of a past. Emblematic of the persistence of the past amidst the present are the two portraits of the male and female ancestors—the one legitimate, the other adopted—who occupy a position of prominence in the Oliver household. As Woolf describes them, the male ancestor in the painting is "a talk producer, that ancestor. But the lady was a picture" (36). The portraits introduce two sets of oppositions that have wider significance in the text: first, they equate masculinity with legitimate, legally binding lines of inheritance, and place femininity outside that circuit of exchange; cut off from or out of, in this propertied sense, history, femininity is associated with an alternate standard of value, a communitarian ethos expressed by Lucy Swithin's rationale of "ownership" of the female portrait—"we claim her because we've known her—O, ever so many years" (68). The difference between the portraits essentially recapitulates the claims of the text's two living "ancestors" upon the Pointz Hall property, Lucy and Bart—he has inherited and owns it, whereas she occupies it based on ties of affection. Second, by associating masculinity with language and femininity with image, the portraits preside over a broader mapping of language and image in the novel and of their linkage with gender. Whereas the male ancestor stands always ready to bark out orders ("'I always feel,' Lucy broke the silence, 'he's saying: "Paint my dog"'" [49]), the lady is reducible to image alone, decorative and silent. The male portrait, then, graphically links the legacies of language and inherited property as male prerogatives, just as the female portrait joins more fluid terms of intergenerational alliances—the claims of proximity, not law—to the image. But if this division suggests a devaluation of image in relation to language as a symbolic medium, *Between the Acts* works to invert those designations. It's the world of conventional male language that is presented as bankrupt in the text, against the superior expressive possibilities and resources both of the image and of a more underground tongue—those subterranean "languages" associated with the feminized, unconscious realm of the lily pool, which, in effect, approach the condition of images.

When Bart Oliver asks the assembled group, about pictures, "'Why, tell me, are we, as a race, so incurious, irresponsive and insensitive . . . to that noble art, whereas, Mrs. Manresa . . . has her Shakespeare by heart?'"

(54), his confidence in the group's superior knowledge of English letters proves misplaced. Lucy interrupts the botched patchwork of Shakespearean soliloquies strung together by Mrs. Manresa, Giles and William Dodge with the assessment: " 'We haven't the words—we haven't the words . . . Behind the eyes; not on the lips; that's all.' " Following Lucy's dismissal of words in favor of a mysterious and presumably superior, imagistic truth "behind the eyes," Bart responds in a philosophical spirit that confirms his own insensitivity to pictures, and reliance on conventional language: " 'Thoughts without words,' her brother mused. 'Can that be?' " (55). The female characters typically accord visual truth a higher order of authenticity than their male counterparts. The scene in which Isa contemplates her emotional response to Haines, the gentleman farmer, concludes: "She returned to her eyes in the looking glass. 'In love,' she must be . . . since the words he said . . . could so attach themselves to a certain spot in her; and thus lie between them like a wire, tingling, tangling, vibrating—she groped, in the depths of the looking glass, for a word to fit the infinitely quick vibrations of the aeroplane propeller that she had seen once at dawn at Croydon" (14–15)—she never finds the word. Isa not only makes her preference for the visual evidence of the looking glass clear, but reconfigures Haines's words imagistically, "attaching" them to her "certain spot" as a physical rather than linguistic line of connection.[19] For Lucy, "Often the delight of the roaming eye seduced her—a sunbeam, a shadow" (204). Inversely, in one of her many poetic reveries in the novel, Isa imagines a landscape whose bleakness is defined by its visual poverty: " 'Where do I wander?' she mused. 'Down what draughty tunnels? Where the eyeless wind blows? And there grows nothing for the eye' " (154). Bart, by contrast, is represented, as he frightens his grandson with his newspaper mask, as a "terrible, peaked eyeless monster" (11–12). Giles blames "old fogies" in general, but especially his Aunt Lucy for "looking at views, instead of—doing what?" (53). That for Giles, the art of looking is tantamount to the betrayal of civilization is made clear by his Promethean vision of spectatorial torment: "This afternoon he wasn't Giles Oliver come to see the villagers act their annual pageant; manacled to a rock he was, and forced passively to behold indescribable horror" (60).[20] In these ways, femininity is loosely affiliated with (the correct perception of) images in the novel.

[19] It's interesting to consider Isa's fantasy of directly incarnated meaning with Patricia Joplin's observation that "when language is used as if there were no gap between sound and meaning, sign and referent," it acquires greater proximity to authoritarianism (Joplin 1989, 89).

[20] For Isa, the visual realm becomes problematic when it moves from the private to the public sphere. William Dodge, whom she earlier greets in the greenhouse as a fellow "conspirator" and as a "seeker after hidden faces" (114), now seems the source of visual violence as part of the play's audience: "She felt Dodge's eye upon her as her lip moved. Always some cold eye crawled over the surface like a winter blue-bottle! She flicked him off" (176).

Against the possibilities of the visual, conventional (masculine) language looks much more like a dead end. In the age of the newspaper which "obliterated the day before" (216), Isa asks herself, "What remedy was there for her at her age . . . in books?" (19). Bart, whose library proudly preserves the material legacy of men's words, surveys his books with a new eye: "A great harvest the mind had reaped; but for all this, compared with his son, he did not care one damn" (116). Once defined as " 'the heart of the house' " (16), the library appears now to be irrelevant, an exhausted sanctuary; Bart admits: "But it was not in books the answer to his question—why, in Lucy's skull, shaped so much like his own, there existed a prayable being" (25). For Giles, trapped at the pageant, an adversarial language literalizes this betrayal: "Words this afternoon ceased to lie flat in the sentence. They rose, became menacing and shook their fists at you" (59–60). The only words apparently exempt from the enormity of language's overall failure are the unconventional, semiconscious words represented most often by Isa's poetic musings, but which include even Giles in their compass.[21] Giles talks to himself as he listens to the pageant music, and produces poetry: " 'I fear I am not in my perfect mind,' Giles muttered to the same tune. Words came to the surface—he remembered 'a stricken deer in whose lean flank the world's harsh scorn has struck its thorn' " (85); Bart mutters quotations from Swinburne; Isa meditates on phrases of her own devising; and for Lucy, inhabiter of a more ethereal realm, an alternate language seems to come naturally, at unexpected moments: " 'The nursery,' said Mrs. Swithin. Words raised themselves and became symbolical. 'The cradle of our race,' she seemed to say" (71). Given that matters of substance are mainly conveyed in this underground tongue, no wonder the narrator repeatedly insists that "it didn't matter what the words were" (94) when the wind blows the words of villagers away in scene after scene of the village play (124).[22]

That Giles's uncharacteristic indulgence in poetic utterance is described as "words [coming] to the surface" is not an idle conceit, but rather, offers a clue to the source of that language in the novel, the lily pool—the lone body of water present in this otherwise driest of worlds.

[21] My position differs from that of Sally Sears (1983, 217–22), who views language in all its forms as tending toward the inauthetication of reality.

[22] If overall, *Between the Acts* represents men as more receptive to language, and women as more receptive to image, the text's two homosexual characters, William Dodge and La Trobe, suggest that these designations are not reducible to notions of bodily essence, but more complexly emerge from gender oppositions and relations in culture. For William Dodge, a lover of pictures, "the beauty of the visible world took his breath away" (82); far from experiencing the play as Giles does, proverbially manacled to a rock, Dodge sees it as "an entrancing spectacle . . . of dappled light and shade" (93). Conversely, La Trobe maintains an almost sacred relation to language, though of the secondary, semiconscious variety—"Words without meaning—wonderful words" (212). But the fact that Woolf is careful to complicate her gender trajectories only underscores their overall significance.

The lily pool, which is perhaps the most complex and resistant image in *Between the Acts*, seems to function as a source of renewal both in this physical sense as a water source and, more ambiguously, in a spiritual sense as a source of unconscious materials. As such, the lily pool is also associated with the processes at the core of artistic creation, and is identified clearly as a feminized space. Woolf describes its genesis. "Water, for hundreds of years, had silted down into the hollow, and lay there four or five feet deep over a black cushion of mud. Under the thick plate of green water, glazed in their self-centred world, fish swam. . . . It was in that deep centre, in that black heart, that the lady had drowned herself" (43–44). The account of the lily pool as a "self-centred world" for fish formed over hundreds of years initially suggests the autonomy and epic cycles of natural history. But the lily pool distance from the human is doubly bridged: first, figuratively, through the use of human, female imagery—the pool's "deep centre" and "black heart"; and second, literally, through the penetration of its surface by the lady drowned, whose never recovered body defines the pool as much as its natural evolution. The lily pool and the dead body are well matched, too, as allegorical signifiers that pose virtually no resistance to multiple interpretive uses.

Particularly for the female characters but not exclusively, the lily pool functions as a wellspring or primal source for the underground dispositions of the human psyche that recalls Benjamin's wish images in the collective unconscious. Isa's poetic musings are linked with the lily pool, sometimes explicitly, as when she reimagines herself, in blank verse, as the woman drowned: " 'That the waters should cover me,' she added, 'of the wishing well' " (103); Isa's longing for water can be understood as the need for the physical and spiritual replenishment of the lily pool, for total immersion into the "deep centre" of nature and its cycles of death and rebirth. Through Lucy's eyes, the lily pool's global (not to say imperial) parameters appear tangibly, as she reads its surface: "Now the jagged leaf at the corner suggested, by its contours, Europe. There were other leaves. She fluttered her eye over the surface, naming leaves India, Africa, America. Islands of security, glossy and thick" (204–5). The lily pool also functions as a metaphor for the world of the mind when, for Giles, " 'Words came to the surface' " and inspire poetry (85); it as readily transforms itself into a shadow world from which characters emerge: "Like a fish rising to a crumb of biscuit, Bartholomew snapped at the paper" (216). Even Mrs. Manresa, whom Woolf elsewhere subjects to rigorous critique, is nonetheless distinguished from the Olivers, Lucy Swithin, and William Dodge as being close to the source the lily pool embodies: "A spring of feeling bubbled up through her mud. They had laid theirs with blocks of marble" (45). But, perhaps most crucially, the lily pool is identified with Miss La Trobe's process of artistic conception, defined as the interpenetration of

watery surfaces and muddy banks, clearly a reworking of the lily pool's im-
agery. Just as for Giles at the play, when La Trobe is left alone as dusk falls,
"something rose to the surface" (210); and later, "Words of one syllable
sank down in the mud. . . . The mud became fertile. Words rose above the
intolerably laden dumb oxen plodding through the mud. Words without
meaning—wonderful words. . . . There was the high ground at midnight;
there was the rock; and two scarcely perceptible figures" (212); the words
and images which rise to the surface of La Trobe's mind, of course, are
those Woolf chooses to have Isa and Giles enact as the closing sequence of
the novel, suggesting their collectively held character.

La Trobe's words—"words without meaning"—still more pointedly de-
part from the male language/female image dualism embodied in the an-
cestral portraits hanging in Pointz Hall. These, again, are words which ap-
proach the condition of images; as such, they effect the sort of dialectical
synthesis achieved by the "other voice," the name Woolf gives to the silent
expressions voiced by the conjoined human and natural forces which are
intermittently evoked by the play. As the audience assembles after the first
interval, Woolf notes: "The inner voice, the other voice was saying: How
can we deny that this brave music, wafted from the bushes, is expressive of
some inner harmony?" (119). Or later, following the brief anthropomor-
phic rain which "poured like all the people in the world weeping": "now
that the shower had fallen, it was the other voice speaking, the voice that
was no one's voice" (180–81). The "other voice" seems also related to the
characters' various interior dialogues in which they exchange a language
of poetry and nursery rhymes:

"This year, last year, next year, never," Isa murmured.
"Tinker, tailor, soldier, sailor," Bartholomew echoed. (217)

The feminized lily pool, then, functions as the site of a collective uncon-
scious from whence the images and voices of the human and natural
realms are ideally if subcutaneously unified. Like wish images in Ben-
jamin, the materials the lily pool embodies don't themselves constitute
new historical understandings, being distinct from the particular material
and historical conditions that could imbue them with such conscious
power; however, as La Trobe's unconscious anticipation of the actual en-
counter between Isa and Giles in the novel's closing scene suggests, the
lily pool's materials can prepare the ground for historical epiphanies by
supplying the medium through which natural and human history can ul-
timately overlap.

But the lily pool's apparent embrace of natural history, with its assump-
tions of complementary human and natural cycles, is counterbalanced by

the alternative portrait of the convergence of the human and natural, notably in Woolf's depiction of Mrs. Manresa. Whereas the intersection of the human and natural is literalized in the depths of the lily pool in the form of the woman drowned, it has a rather more rhetorical existence in the generously proportioned form of Mrs. Manresa, the sexually voracious, uninhibitedly vulgar "wild child of nature" (41), who has been driven to the doors of Pointz Hall with William Dodge "by the very same instinct that caused the sheep and cows to desire propinquity" (37). If Mrs. Manresa is a "primitive," she is an identifiably modern one—a childless, nouveau riche divorcée now married to a Jew, Ralph Manresa, of indeterminate but vaguely scandalous past and national origin, and who seemingly is devoted to the erosion of class distinctions and decorum by both deed and predilection. While all the main characters experience Mrs. Manresa as liberatory, and follow her breaches of etiquette "like leaping dolphins in the wake of an ice-breaking vessel" (41), the balance of their responses to her divide cleanly along gender lines. To the men, she is a virtual fertility goddess incarnate, infusing them with life force and a powerful sense of well-being. For Giles, who exempts her from his criticism of view-watchers, along with his father—"why, he could not say" (54)—she makes him feel "less of an audience, more of an actor" (108); unlike Lucy Swithin, she possesses the specific gravity to "weight Giles to earth" (119). For Bart, this "thorough good sort" (43) and "admirable woman" (202) restores to him his youth. As he watches her cross the lawn "buoyant, abundant," he blesses "the power of the human body to make the earth fruitful" (119); when she leaves at day's end, her absence amounts to "ripp[ing] the rag doll and let[ting] the sawdust stream from his heart" (202).

Isa, however, remains suspicious of her, a feeling confirmed by but preceding Mrs. Manresa's infidelity with her husband. Whereas Mrs. Manresa seems to echo the principles of Lucy Swithin's unifying vision—"For had she not complete faith in flesh and blood? and aren't we all flesh and blood . . . under the skin—men and women too!"—as the passage continues, it becomes clear that any resemblance must be understood parodically. "But she preferred men—obviously. 'Or what are your rings for, and your nails, and that really adorable little straw hat?' said Isabella, addressing Mrs. Manresa silently" (39). Following Mrs. Manresa's successful and culturally scripted romantic conquest of Giles ("Somehow she was the Queen; and he (Giles) was the surly hero" [93]), Isa paints her as a predatory beast: "She could feel the Manresa in his wake" (110). Mrs. Manresa's actions and Isa's characterization of her together produce a version of femininity whose nature consists in the same kind of savage primitivism that underwrites Woolf's portrayal of human history. This style of femininity, too, is nearly identical to the one Woolf explicitly condemns in yet

another brief essay written during the composition of *Between the Acts*, "Thoughts on Peace in an Air Raid," in which she castigates women's complicity in the fascist psychology of domination:

> Let us try to drag up into consciousness the unconscious Hitlerism that holds us down. It is the desire for aggression; the desire to dominate and en-slave. . . . We can see women gazing; painted women; dressed up women; women with crimson lips and crimson fingernails. They are slaves who are try-ing to enslave. If we could free ourselves from slavery we should free men from tyranny. Hitlers are bred by slaves. (Woolf 1942, 245)

The voice from the bushes at the end of the play echoes these words: "*Mrs. E's lipstick and blood-red nails. . . . A tyrant, remember, is half a slave*" (187). Whether or not we are fully convinced by Woolf's analysis of the complicity of conventional gender relations in the production of fascism, Manresa's seductively hypnotic effect on the male characters suggests that, in *Between the Acts* at least, this sort of woman actively colludes in re-lations defined by domination. Just as Woolf implicitly and unfavorably compares conventional language to the "other voice" in the novel, she contrasts the conventional forms of female image production—associated with seduction, narcissism, and domination—with the dialectical poten-tial of "feminine" images linked with the lily pool. Mrs. Manresa is clearly a false goddess, symbol of a meretricious, predatory nature sustained ulti-mately by artifice, as Bart observes at day's end: "But alas, sunset light was unsympathetic to her makeup; plated it looked, not deeply interfused" (202). Whereas the forms of feminine renewal the lily pool offers are available to all, those Mrs. Manresa embodies are suspect, both insofar as they are complicit with systems of domination and because they are de-signed for men alone. Yet, the male characters remain wholly susceptible to her charms. This fact, as well as their relative obliviousness to the re-sources of the lily pool, doesn't bode well for the prospect of a merger of natural and human history in a novel in which the force and permanence of male power is everywhere acknowledged.

> The past can be seized only as an image which flashes up at the instant when it can be recognized and is never seen again. . . . For every image of the past that is not recognized by the present as one of its own con-cerns threatens to disappear irretrievably.
>
> —Walter Benjamin, "Theses on the Philosophy of History"

The ambitions of Miss La Trobe's play are not limited to its grand his-torical theme but also include its reception—two aims not always in sym-

pathy with one another. On the one hand, the satirically inclined parade of human history which makes up the substance of the pageant forces hard questions about whether the rubric of progress offers an adequate vocabulary for measuring human events; on the other hand, the seductive mixture of captivating music, bright costumes, familiar faces, and soothing views transports the audience into a state of receptive well-being, a pervasive feeling of oneness with Man and Beast which seems to inoculate them against more troubling concerns. For all its mishaps—its creaking machinery, forgotten lines, unraveling costumes, botched timing, and capricious weather—the fact that the play is able to produce a sense of cohesion at all is an overwhelming testimony to the power of artistic illusion, but it's not clear that its effects are those Miss La Trobe values most. Like the other constellatory structures in the novel, the audience's wholeness is fragile and temporary, but nonetheless necessary if La Trobe is to impart her vision. But the odds are long: the audience is restive; Mrs. Swithin is late (79); Isa pays more attention to Haines's arrival than to the play (81); words are lost to wind, laughter, applause, distraction. And perhaps, even where La Trobe succeeds she fails by appealing to the audience's most childish impulses, reminding us that the collectivity must *awaken* from wish or dream images if those images are to be "dialectically redeemed": "The actors delayed. Every moment [the audience] slipped the noose; split up into scraps and fragments. 'Music!' she signalled. 'Music!' . . . Miss La Trobe watched them sink down peacefully into the nursery rhyme" (122). Even when characters attempt to engage with the substance of the play, they often remain outside of it. Isa responds to the lost complexities of the Elizabethan drama with a rather more elemental assessment: "There was such a medley of things going on . . . that she could make nothing of it. Did the plot matter? . . . The plot was only there to beget emotion. There were only two emotions: love; and hate. . . . All else was verbiage, repetition" (90–91). Thus archetypally reduced, the play can offer nothing new. As the gramophone churns out the news of the audience's dissolution during the first Interval ("*Dispersed are we*. It moaned: *Dispersed are we*" [96]), La Trobe tries to salvage her slim and doubtful achievement: "still for one moment she held them together—the dispersing company. Hadn't she, for twenty-five minutes, made them see? A vision imparted was relief from agony . . . for one moment . . . one moment. . . . She hadn't made them see. It was a failure, another damned failure! As usual. Her vision escaped her" (98).

At critical junctures, nature works as an apparent collaborator in Miss La Trobe's play, but it may also be complicit in undermining the play's political content. During a scene change of the Restoration comedy: "The view repeated in its own way what the tune was saying . . . how after toil men rest from their labors; how coolness comes; reason prevails; and hav-

ing unharnessed the team from the plough, neighbors dig in cottage gardens and lean over cottage gates. The cows, making a step forward, then standing still, were saying the same thing to perfection. Folded in this triple melody, the audience sat gazing; and beheld gently and approvingly without interrogation" (134). That the audience receives this comfortingly pastoral celebration "without interrogation" perhaps indicates the fragility of this vision of human and natural unity, or at least, its vulnerability to the charge of wishful thinking. But nature plays other roles as well, some of which "continue the emotion" (141) the play seeks to produce, others, rather more comically, work as role models: "Suddenly the cows stopped; lowered their heads, and began browsing. Simultaneously the audience lowered their heads and read their programmes" (141). More poignantly, nature not only continues but contributes emotion to the play. La Trobe's failed experiment to "expose [the audience], as it were, to douche them, with present time reality" (179) is relieved by rain, which literalizes her desire: "Down it poured like all the people in the world weeping. Tears. Tears. Tears. 'O that our human pain could here have ending!' Isa murmured. Looking up she received two great blots of rain full in her face. They trickled down her cheeks as if they were her own tears" (180). Represented as an evocation and mirror of the audience's emotions and La Trobe's desire, nature achieves the primal unity here that it garners only rhetorically elsewhere.

It's with this distracted audience and invasive natural "theater" that the play itself must contend. For Benjamin, we should recall, it's precisely the state of distraction which provides the conditions for an audience's critical reception of aesthetic spectacle; in Woolf, this linkage is less clear. Dispensing quickly with England's earliest history through the time of Chaucer, La Trobe's play concentrates on four periods—the Elizabethan Age, the Age of Reason, the Victorian Age, and "The Present Time—Ourselves," showing an early preference for parodic imitations of each period's literary genres. The strategy provides Woolf with multiple canvases on which to test her idiomatic virtuosity, as well as a body of shared conventions from which to draw. The representation of each period depends on comic juxtaposition and diminishment: the "gigantic" Queen Elizabeth, announcing the achievements of her high office (*"For me Shakespeare sang—"* [84]), loses something of her stature as Albert, the village idiot, "picking and plucking" lasciviously at her skirts, pries into the hiding places of the audience, her de facto subjects: *"I know . . . All your secrets, ladies, / And yours too, gentlemen"* (86). Reason, having announced an end to savagery and the rise of art (123–24), presides loftily over the Restoration comedy, *Where There's a Will There's a Way*, in which conspiracy, greed, betrayal, and hypocrisy play the most prominent parts, and which lends Giles sufficient resolve to head off to the greenhouse with Mrs. Manresa,

"damn the consequences" (149). The nineteenth-century constable, genius of the Victorian period and the self-proclaimed defender of prosperity, respectability, and *"the laws of God and Man,"* is an apologist for *"the price of Empire," "the white man's burden,"* and for force, generally: *"all of 'em,"* he announces, *"Obey the Rule of my truncheon"* (162–63). Unlike the earlier two eras, the constable's paternalism frames the vignette which follows without irony; the 1860 Picnic Party simply embraces his imperialistic values through Eleanor's betrothal to the minister, Edgar, to whom she avows that "a lifetime in the African desert among the heathens would be—Perfect happiness!" (166).

Cumulatively, it's hard to make La Trobe's historical eras add up to a narrative about the progress of anything but male power—power to undermine female sovereignty through its satirical depictions of Queen Elizabeth and Reason; to make contracts and control inheritance rights, in the case of the Restoration comedy; or to embody the male prerogatives of race and empire, in the forms of the Victorian constable and Christian missionary. But La Trobe's representation of the Present makes a departure from even this crude line of continuity, as it substitutes a series of juxtaposed voices and images untethered to identifiable historical narratives and figures. The result is a conceptual salad of possible relationships between past, present, and future which the text rapidly tosses up and discards. In the first of these, those representatives of the cycles of natural history, the swallows—"or martins were they?"—join with the favored organ of human history, the newspaper, to become the incongruous mouthpieces for a vision of liberation and progress through technology. They seem to foretell "what after all the *Times* was saying yesterday. Homes will be built. Each flat with its refrigerator, in the crannied wall. Each of us a free man; plates washed by machinery; not an aeroplane to vex us; all liberated; made whole" (182–83)—a vision which, including the "vexing" presence of the airplane which it insulates against, could not offer a more sunny (if technologically mediated) prognosis of the future. In the second instance, a jazz tune or something "very up to date" conveys youth's propensity for the demolition of the old, thereby suggesting either a process of historical retrogression or, more hopefully, generational cycles of destruction and rebirth: "The young, who can't make, but only break; shiver into splinters the old vision; smash to atoms what was whole" (183).

It is precisely this break with the past personified by destructive youth that seems to reconstellate the parts of the play—its audience as well as spectacle, its wish-images and material forms—into the momentary and liberatory form of the dialectical image. The third movement literalizes such a vision through the mirror-bearing children who appear and trap piecemeal the fleeting images of the audience, and who elicit nearly universal outrage for their pains. The audience protests against both the

technique of mirrored verisimilitude as a means of capturing an image of the present and its fragmentary result: "Here a nose . . . There a skirt . . . Then trousers only . . . Now perhaps a face. . . . Ourselves? But that's cruel. To snap us as we are, before we've had time to assume . . . And only, too, in parts. . . . That's what's so distorting and upsetting and utterly unfair" (184). But the "scraps, orts and fragments" the audience is reduced to don't signify a process of destruction so much as construction, albeit along specifically constellatory lines. Rendered in pieces, they can apparently the more readily assimilate other elements from which to construct new wholes. Just as we saw in the unconscious medium of the lily pool, for a moment, the constellatory theatrical technique La Trobe uses to manifest the Present brings about the same overlapping of human and natural history: "the reticence of nature was undone, and the barriers which should divide Man the Master from the Brute were dissolved" (184). As the full cast "each declaimed some phrase or fragment from their parts" (185), they promiscuously recombine script and songs, chorus and characters, Elizabethans and Victorians, in a tableau in which neither part nor whole can claim definitive precedence. Woolf makes clear the tentative, fragile nature of the constellatory structures the play produces in her description of the final image reflected by mirror-holders when they take up their positions before the audience: "And the audience saw themselves, not whole by any means, but at any rate sitting still" (185), another temporarily forged unity made up of sustained internal divisions.

That the turning of the mirrors on the audience arouses their discomfort, even indignation, is unsurprising, given that it turns the spectatorial tables and exposes their complicity in a spectacle which heretofore had seemed sustained, at a safe distance, by detached aesthetic contemplation. Such exposure, in Benjamin's terms, can be understood to be a stage in the politicization of art: before the audience members are able to recognize themselves in the stages of history, they must recognize the varied parts of themselves and grasp fully their roles as historical actors in the present. Such an ideological inversion, too, literalized by the use of mirrors, makes the reflected audience the text's best candidate for the dialectical image. The audience as a whole, of course, attempts to evade such reciprocal responsibility and knowledge—all, that is, save "the Manresa," whose untroubled face becomes the sole stable image which the multiple mirrors manage to disclose. But arguably, Mrs. Manresa's confident assertion of her image as alternative spectacle signals not her precocious historical knowledge but her utter indifference to it: "facing herself in the glass, [she] used it as a glass; had out her mirror; powdered her nose; and moved one curl, disturbed by the breeze, to its place. 'Magnificent!' cried old Bartholomew. Alone she preserved unashamed her identity, and faced without blinking herself" (186). Bart's celebration of Mrs.

Manresa's narcissistic display as a triumph of identity misses the dangers of total self-referentiality, compared with the pressing need La Trobe's play has persistently urged to rediscover the self in a historical, that is, collective, context. That the text isolates and lingers on this image of Manresa, allied most nearly with the fascist threat, in the midst of refurbishing her "means of seduction" would seem to be an ominous sign.

The reflection of Mrs. Manresa's face is not, however, conclusive, but rather is followed by the anonymous loudspeaker voice from the bushes which proceeds to condemn *"without larding, stuffing or cant"* (187) the vices of the crowd. Systematically, comprehensively, the voice ridicules rich and poor, young and old, calling them liars and thieves, corrupt and faithless; it ends with a challenge: *"Look at ourselves, ladies and gentlemen! Then at the wall; and ask how's this wall, the great wall, which we call, perhaps miscall, civilization, to be built by* (here the mirrors flicked and flashed) *orts, scraps and fragments like ourselves?"* (188). The impulse behind the voice's diatribe is consistent with that of the mirror-bearers (who indeed punctuate it with visual flourishes), as an exercise which at once exposes the flaws in the audience's "nature," and thus, its broader species complicity in historical failures, and which insists on its responsibility with regard to the maintenance of civilization's *"great wall."* As if to make this implicit call to action more plausible for such imperfect beings, the voice relents somewhat and, shifting *"to a loftier strain,"* concedes assorted redeeming human qualities. Asking, *"All you can see of yourselves is scraps, orts and fragments?,"* the voice recommends, *"Well then listen to the gramophone affirming . . . "* (188)—affirming and producing, we can safely conjecture, a moment of temporary union from which the achievement of collective, which is to say, political, ends are possible.

Neither the identity of this critical "voice" nor its preference for anonymity poses any real mystery. Much like the ideal critical posture Benjamin articulated in relation to *The Arcades Project*— "I needn't *say* anything. Merely show"—in which individual fragments were allowed to speak unencumbered by ideologically freighted commentary, Miss La Trobe also prefers to stay out of the way of her materials and, as much as possible, to let the inevitable collisions ensured by her absence speak for themselves. Within the critical intervention in which her presence is most intrusive, she scrupulously avoids the pretense of objective detachment, admitting, *"Take myself now. Do I escape my own reprobation, simulating indignation, in the bush, among the leaves?"* (187). It's in this spirit that we must take La Trobe's invisibility when Reverend Streatfield attempts to commend her efforts at the play's conclusion, as well as the narrator's comment on Streatfield's summing up of its meaning: "O Lord, protect and preserve us from words the defilers, from words the impure! What need have we of words to remind us? Must I be Thomas, you Jane?" (190).

Streatfield's comments are problematic, not only because he's speaking in the impoverished language of male institutions, rather than with "the other voice", whose collective reach transcends the divisions of particular Thomases and Janes, but also because, by imposing a consoling narrative about unity upon the play, he robs its constitutive fragments of their integrity as parts which resist as much as produce wholeness. While Streatfield quite successfully accounts for at least one dimension of the play—its assertion of the soothing correspondences of natural history—he overlooks, much as Lucy Swithin does, the sustained conflicts and tensions of human history. Streatfield sermonizes: " 'we are members one of another. Each is part of the whole. . . . Did I not perceive Mr. Hardcastle here' (he pointed) 'at one time a Viking? . . . We act different parts but are the same. . . . I thought I perceived that nature takes her part. Dare we, I asked myself, limit life to ourselves?' " (192). Compared with the unflinching voice from the loudspeaker wrestling with the "orts, scraps and fragments" it sees, Streatfield's account seems idealized and incomplete, and unlikely to provoke a political response from the audience.

The responses the audience evinces, however, can be construed to be allied either with La Trobe's or Streatfield's viewpoint, or obtusely independent of them both depending on who you listen to. Woolf juxtaposes the audience's reactions to the play with their comments on such weighty matters as crepe-soled shoes to convey the distracted regard they bring to bear; but in spite of the prosaic preoccupations which compete for their attention, audience members ask some pointed questions: "Also, why leave out the Army, as my husband was saying, if it's history? And if one spirit animates the whole, what about the aeroplanes?" (197); "What we need is a centre. Something to bring us all together. . . . Did she mean, so to speak, something hidden, the unconscious as they call it? . . . It's true, there's a sense in which we all, I admit, are savages still. Those women with red nails" (198–99); "The looking-glasses now—did they mean the reflection is the dream; and the tune—was it Bach, Handel, or no one in particular—is the truth? Or was it t'other way about?" (200); "While we're waiting, tell me, did you feel when the shower fell, someone wept for us all?" (200); "To return to the meaning—Are machines the devil, or do they introduce a discord . . ." (201). The audience, much more effectively than Reverend Streatfield, identifies the underlying conflicts within the play which the notion of "one spirit animat[ing] the whole" is clearly inadequate to account for. Acknowledging the need for a center, as well as the airplanes whose "zooms" have "severed" Streatfield's speech as he delivers it (193), the audience casts about for an explanation of the incompatibility of unity and airplanes—is it unconscious human savagery or devilish machines which are to blame? Struggling to distinguish dreams from

truths, the audience can be understood to be on its way to something akin to a historical awakening.[23]

But the inherent instability of constellatory structures means their shelf life is brief, and the play, whatever the disputed terms of its impact may be, begins to fade, following the lead of the gramophone: "The gramophone gurgled *Unity—Dispersity*. It gurgled *Un . . dis . . .* And ceased" (201). Woolf's rendering of the terms of the play's dissolution singularly echoes Benjamin's description of the ways "that which has been and the Now come together in a flash as a constellation" in the dialectical image: "Sitting in the shell of the room [Isa] watched the pageant fade. The flowers flashed as they faded. She watched them flash" (216). As the play recedes from "the sky of the mind" (212) and "drift[s] away to join the other clouds: becoming invisible" (213), we must ask what remains of it after that flash has faded. For Isa Oliver, representative of her generation and guardian of "the future disturbing our present," the pageant's troubling remainder would seem to be a new, more vivid sense of the theatrical contours of her own life, reconceived as a social script, and, consequently, of its potential value as an instructive medium. Isa remonstrates about the tensions with Giles which have tinged the whole day with conflict: " 'The father of my children, whom I love and hate.' Love and hate—how they tore her asunder! Surely it was time someone invented a new plot, or that the author came out from the bushes" (215). Believing herself governed by narrative conventions not of her own design, Isa's implicit desire to be self-authorizing can be understood, in microcosmic form, as the same desire to expose and demystify dominant ideological narratives that motivated La Trobe's play.

Yet Woolf's elemental representation of the drama in which Isa is locked with Giles leaves ambiguous whether those narrative conventions can be thus transformed, either for the actors or, for that matter, for the newly constituted audience in the novel's final scene, the reader. That final scene, we should recall, recasts La Trobe's recent vision of a new play which "rose to the surface," drawn from the black heart of the lily pool—a source which asserts the scene's claim to represent an underground, unconscious truth.

[23] I am essentially in agreement here with Sallie Sears's reading of the desired impact of La Trobe's play: "La Trobe's satire of the rhetoric, values, manners, social priorities, literary forms, politics and world view of successive ages of English history is predicated upon the assumption (so crucial to modernists like Brecht, Artaud, Peter Weiss) that an audience that *sees* deplorable truths, hitherto unconscious, hidden, or denied, will not only deplore but seek to abolish the circumstances that brought them into being. La Trobe's pageant is directed toward the moral and political change of the spectators based upon such an awakening of consciousness" (Sears 1983, 229).

Alone, enmity was bared; also love. Before they slept they must fight; after they fought, they would embrace. From that embrace another life might be born. But first they must fight, as the dog fox fights with the vixen, in the heart of darkness, in the fields of the night. . . . The house had lost its shelter. It was night before roads were made, or houses. It was the night that dwellers in caves had watched from some high place among rocks.

Then the curtain rose. They spoke. (219)

That truth, on the surface, is one of savage primitivism, of naked aggression and conflict, suggesting that the bedrock narrative of human "nature" is one of transcendent barbarism—a position which negatively reworks Lucy Swithin's ahistorical account of the differences between past and present as amounting only to being "dressed differently." But Woolf's reconstitution of the scene in its final line as theater complicates our reading. *Between the Acts* leaves us, the text's most enduring and politically relevant audience, not with this bleak metanarrative of historical sameness, but instead with questions: who has authored the script that Giles and Isa are painfully rehearsing, and can we, the literate spectators of this final aesthetic tableau, through the work of constellation and attentive reading, bring them "out from the bushes" to write a different story?

Modernist Seductions

Materializing Mass Culture in Nathanael West's
The Day of the Locust

It takes some effort to recapture the historical moment, in 1967, when Guy Debord's prophetic analysis of the image culture, *Society of the Spectacle*, could be considered "shocking in its extremism" rather than dispassionately descriptive.[1] In the same way, F. Scott Fitzgerald's assessment of the cast of Nathanael West's 1939, Hollywood-of-the-underclass novel, *The Day of the Locust*, as a group of "vividly drawn grotesques"[2] in hindsight looks extreme. Compared with the self-inventive mastery attained by media stars such as Madonna, West's characters can seem almost as stolidly mainstream and self-identical as Donna Reed. Even the apocalyptic pessimism of the ending of West's novel depicting a Los Angeles in flames at the hands of the disenfranchised masses—in Fitzgerald's words, "the pathological crowd"—could no longer seem an untenable imaginative reach after the Watts riots of 1965, or the bitter social upheaval of the Rodney King riots of 1992. The difficulty, then, in reading West's book, is that we must shake off the blinders of such contemporarily conferred familiarity and remember that before the 1980s the commodifying and disseminating strategies of what I am calling the image culture that Debord and West each describe, and which may be credited with the birth of such "grotesque" persons and events, were still relatively emergent forms.

For a writer such as West, working at what is often considered the end

[1] From the jacket copy of Debord 1990. As Debord himself puts it about the text's initial reception, "I was sometimes accused of having invented [the spectacle] out of thin air, and was always accused of indulging myself to excess in my evaluation of its depth and unity" (3).

[2] Quoted in the jacket copy of West 1962.

of the modernist period, confronting and incorporating Hollywood cul-
ture into his text entailed what would appear to be some categorical liter-
ary problems. That West experienced some of the contradictions of that
rapprochement firsthand is made clear when we consider both his anxi-
eties about the mismarketing of his book as a pulp novel and his decision
to publicize his newly published text through personal appearances at the
Broadway Department Store of Hollywood.[3] If there can ever be such a
thing as consensus about what literary modernism is or was, it can perhaps
best be founded upon its hostility to those very materials West takes as his
subject in *The Day of the Locust*. As Andreas Huyssen put it: "Modernism
constituted itself through a conscious strategy of exclusion, an anxiety of
contamination by its other: an increasingly consuming and engulfing
mass culture" (Huyssen 1986, vii). Yet the success of such a strategy of ex-
clusion, Huyssen suggests, was compromised from the beginning: "Mass
culture," he argues, "has always been the hidden subtext of the modernist
project" (47). If Huyssen is right, that mass culture serves as the latent
content of modernism's manifest bedrock values—the autonomy of the
work of art and the expressive authenticity of the individual artist—then
the kind of confrontation between high and low culture staged in West's
text begins to assume the inevitable contours of a "return of the re-
pressed," more so than an anomalous challenge to our notions of literary
periodization. Beneath such assertions of textual and authorial auton-
omy—or what Lukács complained was modernism's insistence on the
"solitariness of man" (Lukács 1963, 20), its preoccupation with individual
psychopathology cut loose from all sociopolitical moorings—lies an op-
positional discourse of the intimate collaboration between the author, the
literary text, and the social order which constructs them. In fact, both of
these positions—aesthetic autonomy and social construction—are repre-
sented in *The Day of the Locust*, in a stratified form which suggests their
vexed cohabitation.

West's episodic, multicentered novel is loosely organized around the
central intelligence of Tod Hackett, the Yale art school graduate who
moves to Hollywood for work in the film industry, and who pursues
"higher" artistic aims in a series of his own drawings and lithographs, that
he intends to incorporate into his apocalyptic painting, *The Burning of Los
Angeles*. The subject that captivates Tod's art centers on the intertwining
destinies of the two groups he observes in his new setting: the native Hol-
lywood "masqueraders" who, as components in a larger cultural machine
from which they are functionally inseparable, are fairly well adapted to

[3] See Martin 1970, 323–39. In another characteristically modernist contradiction, West
expressed faith that his depiction of Hollywood in *The Day of the Locust* was accurate enough
that it could be illustrated by a photographic study in *Look* or *Life*—a faith that substantially
belies his otherwise exemplary sophistication about images (I'm indebted to Rita Barnard
[1995, 167] for this detail; see Martin 1970, 340).

their world, and the largely Midwestern transplants who, having "slaved and saved" at dispiriting jobs, are drawn to California by the allure of the manufactured illusions which drive them to frustration and, ultimately, to violence. Despite the formal distinctions Tod attempts to make between himself, the natives, and the disillusioned transplants ("the people who stare"), their shared infatuation with the artificial charms of Faye Greener, a talentless aspiring actress, works to expose their common vulnerability to mass cultural seduction. But the ways these characters are differently drawn into the circuit of desire, frustration, and violence, epitomized and supervised by the largely invisible because all-pervasive image industry, are still more crucial. Homer Simpson, the credulous transplant, is destroyed by unfulfillable desires and torn apart by an angry mob; Tod, the artist-observer, suffers a loss of detachment extreme enough to challenge his visionary pretensions, if not his sanity. The resourceful and apparently indestructible native, the actress/whore Faye Greener, remains the lone success story of the novel, whose survival seems predicated on her indissociability from the strategic allures of Hollywood culture as an autonomous object of desire.

West's attempt to acknowledge the new forms of production and consumption embodied by Hollywood's industries is made legible by his depiction of the relations between his two sets of characters. While West foregrounds the differences between the Midwestern transplants, who seem to represent an older socioeconomic order, and the native Angelenos, who appear to be constructed by and continuous with the new image industry, ultimately those differences exist on a continuum in which the transplants are gradually absorbed into the new order through the mechanism of desire. Whereas new transplants like Homer, relatively unified subjects who have stable relationships to linguistic and visual signs and who emerge from a loosely definable historical past, can be understood collectively to represent conservative, humanist assumptions about subjectivity, language, and history, the fractured subjectivity of the masquerading native Angelenos seems indebted to, if not comprised by, the equally fractured models of language and history that Fredric Jameson identifies with the postmodern practice of pastiche. Although Jameson understands pastiche to characterize the literary practice which evolves from "the disappearance of the individual subject, along with its formal consequence, the increasing unavailability of the personal style," *The Day of the Locust* inverts this formula; the novel doesn't stylistically employ so much as thematically represent pastiche as the broad cultural practice which itself creates the conditions for "the disappearance of the individual subject."[4] Jameson describes its features:

[4] Pastiche, however, is also a useful concept for understanding the novel's overall formal construction. Richard Keller Simon offers detailed evidence for understanding *The Day of the Locust* as "a Hollywood movie in novel form" based on its resemblance to a group of films

Pastiche is, like parody, the imitation of a peculiar or unique, idiosyncratic style, the wearing of a linguistic mask, speech in a dead language. But it is a neutral practice of such mimicry, without any of parody's ulterior motives, amputated of the satiric impulse, devoid of laughter and of any conviction that alongside the abnormal tongue you have momentarily borrowed, some healthy linguistic normality still exists. Pastiche is thus blank parody, a statue with blind eyeballs. (1991, 16–17)

"Amputated of the satiric impulse," blinded and turned to stone, pastiche appears in this account as the denatured, not to say castrated, victim of a Medusan encounter with the fact of a lost authenticity, in which language, in this case—though it could as easily be image—seems to have become detached from its signifying function. Pastiche thus takes the leveling equivalence of exchange value one better: if exchange value masks the original meaning of an object, or its use, pastiche here masks the *absence* of that original meaning; indeed, it seems to have no intrinsic relation to any meaning whatever.[5] The detachment of pastiche from the original meanings which constitute it can be understood as a structural key to many of the other central features of postmodern practice, at least as Jameson defines them. I'm relying on Jameson's account, not because I see it as more definitive than others, but because it articulates so precisely the main currents in West's text, a congruence perhaps made explicable by Jameson's and West's shared attempt (despite the separation of their analyses by more than five decades) to situate their work in the changing socioeconomic conditions they each regard pessimistically. In Jameson's version, then, the postmodern foregrounds:

roughly contemporary with it. The chief model for the novel, he argues, is the Frank Capra–Robert Riskin production, *Mr. Deeds Goes to Town* (1936), the story of a naive but good-hearted young man-with-an-inheritance who arrives in the big city and falls for a hard city woman; seeing his unusual financial generosity, people call his sanity into question, and the film ends in a riot. Simon cites eight other possible film influences in addition to *Mr. Deeds*. Although Simon uses the modernist term "collage" to describe West's techniques of incorporation of these film models, characterizing his method as "intricate parody" because he deflates or inverts aspects of their plots and characters, these practices may be more consistent with the affectless quotation of pastiche—particularly given the unattributed nature of West's sources, which make judgments about the tone and character of his alterations, or indeed even the cognizance of their (relatively generic) presence, difficult to gauge. Stephanie Sarver makes a suggestive if less sweeping case for the influence of James Whales's *Frankenstein* film (1931) on West's depiction of Homer, citing Homer's awkwardly mechanical, dissociative embodiment which West abruptly animates at intervals. But more so than Homer, I would suggest, the novel itself is best comprehended as the product of overtly sutured parts, from its filmic and novelistic sources to its cinematic techniques (the jump cut, the close-up, the panorama) to its sudden, episodic shifts in point of view, which cumulatively create a cultural composite along postmodernist lines. See Simon 1993, 513–34; Sarver 1996, 217–22.

[5] I am indebted here to Jean Baudrillard's account of the successive phases of the image; see Baudrillard 1988a, 170.

a new depthlessness . . . in a whole new culture of the image or the simu-
lacrum; a consequent weakening of historicity, both in our relationship to
public History and in the new forms of our private temporality, whose "schiz-
ophrenic" structure (following Lacan) will determine new types of syntax or
syntagmatic relationships in the more temporal arts; . . . [and] the deep con-
stitutive relationships of all this to a whole new technology. (1991, 6)

These interrelated models of pastiche construction—involving new forms
of subjectivity, of images, history, and of language, as well as their linkage
with the new technologies of the image industry—define the world that
the natives inhabit, and to which the transplants come to adapt with vary-
ing levels of success. Because it is the dominant but not exclusive model,
West is able to foreground the conflict between the image culture and
that older order the transplants represent.

We can see this conflict at work in Tod's ambiguous positioning be-
tween them. On the one hand, as a transplanted observer himself, Tod is
linked with "the people who stare" and their insatiable appetites for a vi-
sual stimulus which comes to be associated with consumerism. On the
other hand, Tod's status as an image producer associates him with the
self-productions of the native Angelenos and challenges his distinctness
from the larger image industry. But Tod's unique position as an artist en-
ables him to foreground a still more fundamental conflict in the novel,
between the postmodern character of the dominant image culture and
the central assumptions of aesthetic modernism.[6] West attempts to arro-
gate for his artist-observer a stance of satiric detachment from the observ-
able world from which uncontaminated aesthetic artifacts—Tod's paint-
ings—will cooperatively issue; the assumptions of aesthetic autonomy and
visionary independence which uphold such a stance implicitly invoke a
modernist frame. Yet Tod's ability to embody that detachment credibly is
increasingly thrown into question, particularly through his seduction by
Faye, the quintessential representative of mass culture. Tod's desire to
represent without reproducing the materials of the image culture—to
maintain a distinction between his own production of aesthetic images
and mass culture's proliferation of commercial images—dictates the ne-
cessity for him to find strategies with which to contain it. Tod pursues
these, first, by distancing himself from his subjects, the mass consumers of
those images, who are consistently identified as grotesques; Tod's sympa-
thetic portrayal of the ways the masses are betrayed by the created desires
and false promises of the image culture, it's worth noting, is always medi-

[6] Given the range of positions within the contested terrain of modernism itself, some of
these same features could no doubt be understood to be expressive of its own internal ten-
sions; but I am persuaded by the arguments which suggest that cumulatively they represent
a sea change.

ated by his insistence on their mercenary vulgarity. But as the instability of the borders between high and low becomes apparent or, to put it differently, as the text develops the troubling analogy between aesthetic and commodity production, West transforms the high/low cultural divide into explicitly gendered territory, so that high art's fall into mass culture is represented as an inevitable process of seduction. Tod's desire for Faye, which contaminates his objective posture and thus his art, is thereby naturalized, and threatens to obscure its commodified roots.[7] The frustration of Tod's desire violently to possess and break through the feminized, autonomous images of mass culture, I will argue, suggests a diminished role for the modernist observer: confronted by a world of images which is apparently governed by its own laws and resists incorporation by a dominating gaze, Tod's failure to create a master image which stands outside the image culture indicates the foreclosure of "outside" as a viable cultural location.[8]

Tod's aspiration to transform the materials of Hollywood and "the people who stare" into high art propels his search for relevant artistic models. The fact that he begins by rejecting the early-twentieth-century American realist and "romantic" painters Winslow Homer and Thomas Ryder in favor of the nineteenth-century Spanish and French satiric painters Goya and Daumier suggests both the dearth of appropriate contemporary and indigenous models and his perhaps naive belief in the adequacy of the more distant past to illuminate the present. But the desig-

[7] Susan Edmunds's argument that the novel is best understood as a *competition* between Tod and Faye as representatives of two cultural matrices—one male, middle-class, and highly educated, the other female, lower-class, and uneducated—is consistent with my own reading of the novel's struggle between modernist and postmodernist modes of aesthetic organization. For Edmunds (1998), Faye personifies a transitional form of femininity between two historical dominants, the Victorian bourgeois ideal of true womanhood and the modern, mass cultural ideal of the body beautiful; she is an ambiguous, border-crossing figure who disrupts hierarchies of gender, taste, and purity in the novel.

[8] My own reading here is informed by Mathew Roberts's thoughtful discussion of the important parallels and still more significant differences that subsist between West's and Adorno's understandings of mass-mediated desire. West's representation of the "dream factory's" mechanisms of control, Roberts suggests, closely echoes Adorno's diagnosis of mass culture's endless creation of necessarily unfulfillable desires, but it departs from Adorno's faith in the modernist artist's capacity to resist commodification: where Adorno sees a modernist apotheosis that escapes mass-mediated desire, West confronts the impasse in which high art remains complexly mired in it. And where Adorno sees no obstacle to the dream factory's ongoing production of such desire, West seems to find in the factory's by-product—frustrated desire—the possibility for its (violent) interruption. In Roberts's view (1996, 61–90), however, these are not fatal departures so much as more dialectically conceived conditions of aesthetic possibility. Unlike Adorno's modernist artist, West's artist, Tod, adopts a posture of "critique through complicity" with mass-mediated desire, purchasing his critical insight, as it were, precisely *through* his identification with the masses via his seduction by mass-marketed spectacle. West, as a consequence, must be situated beyond Adorno's modernist aesthetics in a location which, I would argue, heralds postmodernist commitments, Roberts's attempt to defer this conclusion notwithstanding.

nation of satire as the governing sensibility of Tod's project quickly proves to be misleading, if we understand satire to be an ironic antagonism that is comic rather than tragic in tone. In fact, Tod secures that comic, antagonistic distance in name only, as we see almost immediately in his description of the stylistic excesses of Hollywood architecture, the "Mexican ranch houses, Samoan huts, Mediterranean villas, Egyptian and Japanese temples, Swiss chalets, Tudor cottages, and every combination of these styles" that he sees. "[The] houses," Tod tells us, "were comic, but he didn't laugh. . . . It is hard to laugh at the need for beauty and romance, no matter how tasteless, even horrible, the results of that are. But it is easy to sigh. Few things are sadder than the truly monstrous" (West 1962, 61). Tod's posture here is undoubtedly critical, but the sympathy which underlies his criticism suggests his identification with the "need for beauty and romance" rather than his ridicule of it. Tod's problem, as a would-be satirist, is to identify the norm against which the folly he isolates can be measured. But in view of the pastiche of architectural styles he describes, defined precisely by their neutralization of the normative meanings conferred by the native contexts from which they've been drawn, Tod can only chronicle the aberrant shapes the observable world takes in the hope that their subversive meaning is somehow intrinsically available.

Tod's search for an authentic artistic past in which to situate his own endeavors stands in stark contrast to the ways historical materials function in the rest of the book. Whereas Tod's indebtedness to artistic models conforms to a conventional modernist posture, that archaeological labor of unearthing and making present the past that T. S. Eliot called "the historical sense" (1965, 62), elsewhere in the novel history, too, seems reduced to the random recyclable referents of Jameson's pastiche. *The Day of the Locust* opens, for instance, with the English infantry and French grenadiers storming past Tod's office to the battle cry of "Stage Nine— you bastards" (West 1962, 59). In one of the more hilarious epic scenes in the text, Napoleon's army comes to grief at Waterloo when a collapsing set injures the soldiers. "It was the classic mistake, Tod realized, the same one Napoleon had made." But this time, Tod points out, "the same mistake had a different outcome. Waterloo instead of being the end of the Grand Army, resulted in a draw. Neither side won, and it would have to be fought over again the next day" (134). The result of this casual redrawing of the historical map is that the authentic historical past and contemporary Hollywood fiction become functional equivalents; since the battle will be fought over again the next day, we are promised a potentially infinite number of Waterloos, the primacy of which will be designated by unpredictable contingencies. The distinctiveness of past and present collapse, then, as catastrophically as the set of Mont St. Jean; the cumulative effect is not just a flattening of historical time and agency, of course, but

its trivialization. In such a referential maelstrom, it should be clear, Tod's invocation of artistic antecedents begins to look naively out of date.

These two models of historical construction—the circulation of signs drained of their original meanings versus an authentic, stable depth—correspond to the two central models of subject formation offered in the novel. West characterizes the native "masqueraders" in terms nearly identical to those in which Tod casts Hollywood architecture, as traffickers in arbitrary signs: "The fat lady in the yachting cap was going shopping, not boating; the man in the Norfolk jacket and Tyrolean hat was returning, not from a mountain, but an insurance office" (60). The transplanted Midwesterners' clothing, by contrast, "somber and badly cut, [and] brought from mail-order houses," straightforwardly signifies the functional aesthetics of modest means. Whereas the active masquerading natives "moved rapidly, darting into stores and cocktail bars," the transplants, who "loitered on the corners or stood with their backs to the shop windows and stared at everyone who passed" (60) signify both their resistance to consumption ("their backs [against] shop windows") and their passive participation in it as spectators. Once again, Tod himself is ambiguously situated; his "large sprawling body, his slow blue eyes and sloppy grin made him seem completely without talent," the narrator tells us, "almost doltish in fact"; but "despite his appearance, he was really a very complicated young man with a whole set of personalities, one inside the other like a nest of Chinese boxes" (60). West locates Tod somewhere between the depth-model of selfhood suggested by the unified coherence of the transplants and their resistance to commodifying self-invention, and the misleading, shifting signification of the natives' multiplying surfaces of self. However, while the gap between the visible signs of Tod's "doltishness" and his inner complexity evokes a conventional distinction between essence and appearance, the ambiguous image of the nested boxes also destabilizes this model by spatially reiterating the question of which, among this "whole set of personalities," may be assigned priority. Fittingly, then, Tod documents the fully reciprocal relations of these two groups in an early lithograph, *The Dancers*, in which Faye, Harry Greener, and a truculent dwarf, Abe Kusich, dance before a rapt audience of "the people who stare." According to Tod, "It was their stare that drove Abe and the others to spin crazily and leap into the air with twisted backs like hooked trout" (62). If the natives' need for an audience is matched by the transplants' need for diversion, however, the relationship remains asymmetrical; as assimilated members of Hollywood's image culture, the natives appear to have an almost evolutionary advantage, deriving satisfactions from the exchange that elude their transplanted counterparts, whose awakened desires exceed the possibility of fulfillment.

West gives us an extended case study of the results of the seductive and

destructive power of Hollywood culture on the transplanted "people who stare" in his portrait of Homer Simpson, the conscientious Iowan hotel clerk who moves to California on the advice of his doctor. Homer seems a case study in more ways than one; as the incalculably passive refugee of twenty years of "working ten hours, eating two, sleeping the rest" (86), this "poorly made automaton" with the oversized, disembodied hands of alienated labor, seems almost a Lukácsian cartoon of reified man, whose stance with regard to the mystified products of his commodified labor is increasingly contemplative (see Lukács 1971). More precisely, Homer's qualities harken back to an earlier model of capitalist development, apparently outside the circuit of desire and consumption that characterizes Hollywood's image industry. He arrives in California equipped with both substantial savings and an intact chastity that indicate his inexperience with the varied forms of spending, and which are defined as his ultimate defense "that . . . served him like the shell of a tortoise, as both spine and armor. He couldn't shed it even in thought. If he did, he would be destroyed" (102). Homer's lone encounter with profligacy and (unfulfilled) desire in the Romola Martin incident is depicted as a dangerous lapse ("he had escaped . . . but he wouldn't escape again"); having evaded the expenditures of desire, Homer begins his California life restored to a prelapsarian innocence: "Whether [Homer] was happy or not it is hard to say. Probably he was neither, just as a plant is neither. He had memories to disturb him and a plant hasn't, but after the first bad night his memories were quiet" (89). Prior to his infatuation with Faye, then, Homer appears insulated from the cravings for increasingly violent stimuli that the awakening of desire has produced in his fellow transplants (178). Appropriately, his fall for Faye is simultaneous with his being suckered into an exploitative exchange, in which he offers to buy two cans of Miracle Solvent he doesn't need at twice their normal price (101).

Following Homer's induction into desire and its painful aftermath, when Tod presages Faye's departure by forcing on him the perception of her as a commodity ("'She's a whore!'" [162]), Homer seems to "evolve" into a later stage of cultural development. It is almost as if he had imbibed, along with his knowledge of Faye's unattainability, a truncated version of her relationship to signs. Homer's sobs, which conventionally might express a depth of being, instead seem to signal its disruption, like a skipping record. His crying has "no progress in it. Each chunk was exactly like the one that preceded it. It would never reach a climax" (167). Beyond signaling the ways desire exceeds fulfillment in the novel, the description indicates a reorganization of Homer's subjectivity. His attempt to narrate Faye's final night collapses into a "circular flood" of language, that "wasn't jumbled so much as timeless. The words went behind each other instead of after. What he had taken for long strings were really one

thick word and not a sentence" (168). In Jameson's terms, Homer has become a schizophrenic. Building on Lacan's account of schizophrenia, but revising it to serve as a normative model of postmodern subjectivity, Jameson elaborates the particular linguistic character of this model, one which crucially involves the breakdown of the signifying chain: "What we generally call the signified—the meaning or conceptual content of an utterance—is now rather to be seen as a meaning-effect, as that objective mirage of signification generated and projected by the relationship of signifiers among themselves. . . . With the breakdown of the signifying chain, therefore, the schizophrenic is reduced to an experience of pure material signifiers, or, in other words, a series of pure and unrelated presents in time" (Jameson 1991, 26–27). Jameson's characterization of the schizophrenic's sense both of the independent materiality of language and its existence outside of measurable time uncannily fits Homer, with his "one thick word" and compromised temporality.[9] The difference between Homer and the natives, again, appears only to be a matter of degree, since like them he has come into a dizzying surfeit of signs but without yet acquiring their facility of manipulating them.

In contrast with Homer's vegetable existence at the time of his arrival, the Hollywood natives are vigorously engaged in a process of self-production. For the aging vaudevillian, Harry Greener, and his daughter, Faye, in particular, internalized commercial roles and materials have gradually taken on the contours of self: "When Harry had first begun his stage career, he had probably restricted his clowning to the boards, but now he clowned continuously" (77). Faye's daydreams arise, not from an individuated unconscious, but from the collection of cinematic conventions which substitute for it: "She had a large assortment of stories to choose from. After getting herself in the right mood, she would go over them in her mind, as though they were a pack of cards, discarding one after another until she found the one that suited. . . . While she admitted that the method was too mechanical for the best results and that it was better to slip into a dream naturally, she said that any dream was better than no dream and beggars couldn't be choosers" (104). Tod notes that a Tarzan movie poster is the raw material from which she "manufactur[es] another dream to add to her already very thick pack" (105). West's representation of Faye's dreams as a process of successful "manufacturing" contrasts sharply with his description of Homer as "the poorly made automaton,"

[9] Thomas F. Strychacz reads Homer's "one thick word" as a figure for the symbolic density and displaced linearity of the modernist text, to which Tod's subsequent translation into "the usual kind of sense" does violence (West 1962, 168; Strychacz 1993, 185); but this reading, I am arguing, underestimates the degree to which language ceases to be an expression of the individual subject—what would amount to a modernist understanding of its function—as it acquires its own independent momentum.

or the naturalistic "plant." Collectively, the natives function as productive machines as well as avid consumers, although, to be sure, their functioning isn't always purely autonomous. While Harry is making a sales pitch to Homer, "Suddenly, like a mechanical toy that had been overwound, something snapped inside of him and he began to spin through his entire repertoire. The effort was purely muscular, like the dance of a paralytic" (92); when Harry can no longer control the stage laugh that forms part of his pop cultural duet with his daughter, Faye hits him once in the face, making him "relaxed and quiet"—in effect, turning him off (96–97). West's machine metaphors both depict the natives as small factories, manufacturing themselves from a stock of available cultural images, and remind us that they are only components in a larger cultural machine which exerts ultimate control. Like gender in Judith Butler, selfhood in West— for the natives at least—is purely performative, its conventions made legible, if not plausible, through the endlessly productive efforts of mass culture to create a shared vocabulary of meaning.[10]

The question of the plausibility of the natives' energetic "doing" rather than "being" of themselves is a crucial one in *The Day of the Locust*, precisely because the natives, and particularly Faye, are credited with so much seductive power. The fact that our evaluation must ultimately devolve onto Faye, as the principle force of seduction in the novel, leads to a second, equally significant question about the ways gender broadly inflects the opposition between transplants and natives that I've been tracing. The basis for Faye's metonymic linkage with the image culture which fascinates the transplants and Tod is not self-evident, when we consider that, as aspiring actress-turned-prostitute, she can represent that culture only in an apparently degraded form. Tod's assessment of Faye's disjointed affect emphasizes the flawed nature of her performance. He tells us: "Being with her was like being backstage during an amateurish, ridiculous play. From in front, the stupid lines and grotesque situations would have made him squirm with annoyance, but because he saw the perspiring stage hands and the wires that held up the tawdry summerhouse with its tangle of paper flowers, he accepted everything and was anxious for it to succeed" (104). Tod's anxious witnessing of Faye's "production" of self

[10] Relevant here is Jonathan Veitch's "post-psychological" understanding of West's depiction of violence, one that operates by "leaving violent acts almost bald—that is to say, by choosing *not* to contain them, or explain them away within a traditionally accepted framework." As a consequence, Veitch argues, "the 'real' is shattered, not—as neo-naturalism would have it—in order to get at its heretofore undisclosed essence, but in order to perform an autopsy on its mangled parts" (1997, 64). Such a description supports viewing the characters in *The Day of the Locust* and their actions outside the rubric of depth models, with preference to a method more attentive to identifying the "mangled parts" from which, pastiche-like, they're constructed—this remains true, I would argue, despite Veitch's later caveat against such a postmodern reading (116).

inspires not only sympathy, but intrigue, suggesting that in spite of Faye's provision of a window on the internal mechanisms of illusion, Tod fails to be insulated from their effects. On the contrary, "All these little stories, these little daydreams of hers," he explains, "were what gave such extraordinary color and mystery to her movements" (106–7). Faye's ability to make mysterious the mechanisms of her own production aligns her with the close relative of pastiche, the commodity fetish.[11] Yet, insofar as she lacks a "real" character that the projections of others would obscure, Faye's form of selfhood goes beyond its scope. The ultimate source of Faye's allure, I would argue, is that she seems to make particular and accessible the mechanisms of mass culture administered "from above," which are otherwise invisible in the text, but without ever actually exposing their essential mystery. As Tod puts it: "The strange thing about her gestures and expressions was that they didn't really illustrate what she was saying. They were almost pure" (159).[12]

Faye's status as a fetishized commodity, however modified, is only made redundant by her foray into prostitution, where she becomes, to quote

[11] As Lukács puts it, "A commodity is therefore a mysterious thing, simply because in it the social character of men's labour appears to them as an objective character stamped upon the product of that labor" (1971, 86).

[12] Roberts identifies Faye as a personification of mass-mediated *desire* (1996, 66), but this designation doesn't go far enough, I would suggest, in understanding the particular form which desire takes in the novel. Significantly, Faye's allure is linked to the form of the image, a form which dictates the strategies by which desire may be conceived and pursued, if not fulfilled or mastered. Regardless of its form, however, the futility of the pursuit of desire, Roberts notes, leads inexorably to violence and destruction and, given its feminization, to an allegorical equation of "the inextricability of cultural critique and misogynistic rage" (67) in which even readers are complicit (although perhaps *female* readers may find themselves less thoroughly interpolated by this point of view).

Rita Barnard's approach makes a useful counterpoint to Roberts's, since she lays far more stress on the significance of the image as a privileged representational/ideological mode in the novel. Reversing a standard negative assessment made by West's early critics that the characters in *The Day of the Locust* were flawed clichés and cartoon characters that lack convincing depth, Barnard insists on the strategic value of their flat, iconographic status. In their elimination of critical contexts, she argues, these virtual billboards of dispossession alert us to the danger of spectacle, which reduces such images to their availability for consumption and exchange (Barnard 1995, 161). Following Benjamin's account of dialectical images, Barnard suggests that West's own trafficking in images is motivated by the hope to release their potential for transformation and redemption—a hope consistent with the perception that Hollywood is not just the creator of wishes but is itself their product. Barnard's reading of West's Hollywood through Benjamin's account of collective wish images—from its fairy tale architectural styles to Harry's "miracle" solvent—is extremely persuasive and indicates the range of utopian forms expressed in consumer culture (180–81). Yet, overall, I would argue that Barnard's attempt to equate West's Hollywood with Benjamin's arcades (163) overestimates West's optimism, an objection to which she herself later concedes when she notes that "West . . . never credited mass culture with the debunking capacities that Benjamin (if only for a while) regarded as inherent in the new media's very techniques of reproduction" (183). Instead, she concludes, much as Roberts does in his comparison of West with Adorno, that West's negativity about the redemptive possibilities of art distinguishes his cultural politics from high modernists overall (185).

Walter Benjamin, "saleswoman and wares in one" (1978, 157). Long before she enters the trade, Faye explains to Tod that she is only romantically available to a man with money (West 1962, 67); likewise, the financial support she gets from Homer, allegedly to underwrite her acting career, is never credibly sanitized by the promised contract assuring him of repayment (137). The role prostitution plays in the novel overall is a defining one, representing, in the form of the madam, Mrs. Jenning, the pinnacle of culture and refinement, and serving to launch the theme of unfulfillable desire in the cinematic miniature of Faye's life, the film *Le Predicament de Marie* (73–74). Prostitution is also the filter through which the complexities of Tod's desires are refracted, as he debates whether to purchase Faye's charms, only to discover that she's available to *him* neither for love nor money. West's emphasis on prostitution as the sine qua non of commodity culture only reinforces its equation with femininity and sexuality introduced singly by Faye. West's personification of mass culture as woman is by no means unique for the modernist period, as Huyssen, among others, has defined it. The constant fear of the modernist artist, he argues, "the nightmare of being devoured by mass culture through co-option, commodification, and the 'wrong' kind of success . . . is persistent[ly] gender[ed] feminine" (Huyssen 1986, 53). The equation of mass culture with femininity that Huyssen cites can perhaps also be traced to a wider register, in which the masses, as primary consumers of images, are feminized by the very nature of images as irrational, fetishized objects (see Mitchell 1986, 161).

The linkage between the feminine and the image has a broad discursive history in this period, traceable, as Rachel Bowlby has observed, in Marxist rhetoric about the narcissistic affinity between women and commodities as sources of seduction, to be possessed by men (Bowlby 1985, 27, 32); and culminating, in a psychoanalytic context, in Lacan's gendering of the imaginary and symbolic respectively as female and male domains. We can see this connection at work even in Jameson's emasculated description of pastiche as "a statue with blind eyeballs"—given what Freud has described as the "substitutive relation between the eye and the male member" (1958, 137–38). This is not to say that all the characters, or even all of the natives, are feminized by their contact with the image industry; rather, I am arguing, mass culture is merely epitomized or personified by femininity, a linkage which at once naturalizes its appeal and justifies the efforts of the male artist to facilitate its containment. In *The Day of the Locust*, Tod's anxieties about mass culture and femininity are inextricable from their increasing autonomy—that is, their ability to produce desires to which they remain indifferent. Tod's response to those anxieties is worked out on two parallel planes, traceable to the two registers in which the threat of an engulfing femininity and mass culture are waged;

and, in each case, his response can be understood as a version of icono-clasm, as an attempt to break through or master the image. Within the purely gendered trajectory of his desire for Faye, Tod attempts to domi-nate the image through a fantasy of violation and possession; in the aes-thetic trajectory of art, he seeks its stabilization and containment. The re-latedness of these two projects is suggested by their persistent juxtaposition in the text; but in both cases, the resistant nature of the "im-age" in question challenges Tod's best efforts.

The awakening of Tod's desire for Faye is structured through a series of rape fantasies, initially accompanied by meditations on his painting; the fantasies are fueled by his perception of her impenetrable autonomy. In the first of these, Tod responds to Faye's commercially inspired day-dreams: "She seemed always to be struggling in their soft grasp as though she were trying to run in a swamp. . . . His impulse wasn't to aid her to get free, but to throw her down in the soft, warm mud and to keep her there. . . . Nothing less violent than rape would do. The sensation he felt was like that he got when holding an egg in his hand. Not that she was fragile or even seemed fragile. It wasn't that. It was her completeness, her egglike self-sufficiency, that made him want to crush her" (106–7). When Faye proves "her egglike self-sufficiency" by refusing his advances, West tells us, "He barely heard her. He was thinking of the drawings he had made of her and of the new one he would do" (108). The drawing, in which a naked Faye is being chased by a mob of men and women, clearly displaces his desire, as it spatializes and aestheticizes it. Tod's second rape fantasy, initiated by Faye's flight from a group of male admirers, also leads to a meditation on his painting; this time, Faye is absent, but the image of destructive force—"the city burning at high noon"—remains (118). As Tod becomes more convinced of Faye's unattainability, he tries to free himself from her power as an image. Although "her self-sufficiency made him squirm and the desire to break its smooth surface with a blow . . . be-came irresistible" (141), Tod doesn't act on his impulse; instead he "shut the portfolio that held the drawings he had made of her, tied it with a string, and put it away in his trunk. It was a childish trick . . . yet it worked" (141–42). But Tod's inability to possess Faye—to break through or suc-cessfully to contain her as image—is suggested both by his final rape fan-tasy and his inability to sustain it. When the final fantasy, in which he plans to "wait for her some night and hit her with a bottle and rape her" is interrupted, he "trie[s] to start the rape going again, but he couldn't feel the bottle as he raised it to strike. He had to give it up" (174–75). Tod's loss of imaginative control validates his own perception of the impervi-ousness of "the smooth surface" of Faye's autonomy as image; and more broadly, it suggests the capacity of the image culture to resist individual at-tempts to penetrate its surfaces.

Paradoxically, given their widely disparate valuations of the image, West and Woolf share the conviction that the image is gendered feminine and both use it as a mediating third term in their respective depictions of audience and spectacle. Woolf, to recall, opposes the feminized image—one that is replete with the resources of the unconscious associated with the lily pool—to the conventional language of masculinity and its martial projects. *Between the Acts* furthermore links the image with the art of looking, which male characters are most likely to experience as the handmaiden of passivity or a fey aestheticism, but in which the female characters typically find the means to achieve a broader "visionary" purview. West's feminized image serves, far more conventionally, as a vector of contamination in which images, having been conscripted by mass culture as the visible form of commodities, undermine the male artist's efforts of authentic image production through their powers of seduction. The feminine in West is not only a bad copy, but one, as we'll see, with the capacity to undermine the mode of visionary artistry altogether. If both texts address the likely exhaustion of a masculinist (and modernist) tradition of arts and letters, then, whether as the outcome of war or commerce, only Woolf finds the possibility of a feminine alternative to that masculine tradition appealing. Because images seduce and engulf in *The Day of the Locust*, as opposed to momentarily crystallizing a dialectical way of seeing, as they do in *Between the Acts*, the collectivity they work to forge is precisely the kind of mass unification anticipated by Walter Benjamin's warning of the apocalyptic consequences of the aestheticization of politics.

The novel's depiction of men occupying conventionally feminine roles, a pattern that extends metaphorically beyond the (paradigmatic) transvestite scene, provides further evidence of West's gynophobic linkage of mass culture's influence with a degrading feminization. Susan Edmunds, noting the desire that Tod and the other male characters evince to *be* Faye (to attain, that is, her sexual and social charisma) as much as to possess her, shrewdly observes the myriad forms of feminization that apparently follow from this narrative logic: Harry makes a domestic product, silver polish, in the conventional space of female metamorphosis, the bathroom (where Tod, Abe, and Homer also spend a lot of time, devoting themselves to rituals of transformation); Harry, Homer, Tod, and even Earl (but conspicuously not Faye) take on the domestic duties of caretaking, cooking, and cleaning, largely to further Faye's maintenance; Homer, Tod, and Harry (after his wife leaves him for another man) are chaste, compared with the sexually active Faye; and so on (Edmunds 1998, 318–20). From this perspective, Edmunds argues, the rape fantasies in the text can be comprehended as male punishment for female artistic ambitions, and as the impulse to violently wrest back cultural prerogatives usurped by the feminine and restore conventional gender roles. However, the evidence of Tod's

feminizing scream, with which West closes *The Day of the Locust,* equally illustrates Tod's failure to recover masculinity and "the real" that the seductive image has obscured. Tod's scream suggests his conscription into female modes of subjectivity himself, confirming Edmunds's point that the (feminized) masses in Tod's final painting prevail by taking up the task of cultural purification normally reserved for the male high-culture artist—albeit through the destructive ritual of burning (320–21); moreover, because the scream is conflated with a mechanical object, the police car siren, it reifies Tod as much as it feminizes him.[13]

This devolution of Tod's mastery with respect to the image is acknowledged in a completely different register of the novel, in his rededication of his artistic project to a new, still earlier group of artistic models; in this context, however, the feminized nature of those images is obscured in favor of a gender-neutral, strictly visual model of resistance. Tod replaces the satirists, whose appropriateness seemed questionable from the beginning, with "certain Italian artists of the seventeenth and eighteenth centuries, . . . Salvator Rosa, Francesco Guardi, and Monsu Desiderio, the painters of Decay and Mystery." From his vantage point amidst the castoffs of old movie sets, Tod makes this new, and arguably more pertinent, connection between past and present artistic materials:

> There were partially demolished buildings and broken monuments, half hidden by great, tortured trees, whose exposed roots writhed dramatically in the arid ground, and by shrubs that carried, not flowers or berries, but armories of spikes, hooks and swords. For Guardi and Desiderio there were bridges which bridged nothing, sculpture in trees, palaces that seemed made of marble until a whole stone portico began to flap in the light breeze. (West 1962, 132)

Tod's attribution of a Baroque sensibility to the fragmented remains of Hollywood sets depends on two central features: first, the blurred boundaries between the natural and the artificial in the assemblage of the landscape, which sustains "shrubs that carried . . . armories of spikes, hooks and swords"; and second, its illusionistic or trompe l'oeil elements—"bridges which bridged nothing, sculpture in trees"—elements which, like the false marble of the flapping stone portico, evade rather than serve the dominion of the perceiving eye. In his account of trompe l'oeil, Jean Baudrillard describes the effect of this reorientation of the visual field toward objects:

> The perspective effect of the trompe-l'oeil is in a sense a forward projection. Instead of fleeing panoramically before the scrutinizing eye (the privilege of

[13] Tod's "fall" into the feminine in *The Day of the Locust* may be regarded as a kind of imaginary prehistory for the feminized protagonist of *Miss Lonelyhearts*; see West 1962.

the panoptic eye), objects here "fool" the eye (*"trompent" l'oeil*) by some sort of internal depth: not by creating the illusion of the real world, but by eluding the privileged position of the gaze. The eye, instead of being the source of structured space, is merely the internal point of flight for the convergence of objects. Another universe whirls forward, an opaque mirror placed before the eye, with nothing behind it—*no horizon*, no horizontality. This is specifically the realm of appearances where there is nothing to see, where things see you. (1988a, 157)

The failure of the panoptic gaze that Baudrillard describes in trompe l'oeil echoes the failure of the satiric detachment, with its pretense of sovereign visual agency, which Tod was forced to discard with his earlier artistic models. By reducing the observer from "the source of structured space" to "the internal point of flight for the convergence of objects," trompe l'oeil in effect turns the tables on the subject and object positions of the gaze, redistributing visual primacy to the image in a landscape "where things see you." Such a reversal, of course, must mark the end of interior gaze. Trompe l'oeil, moreover, can be seen to function as the visual analogue of pastiche when it mimics, in a distorted but convincing form, an absent, authentic original.[14] If we extrapolate from this model to Faye—recalling her absence of conventional depth, her smooth, resistant surfaces, and her misleading external signs—we can begin to explain her capacity to resist the mastering gaze Tod aspires to embody as artist. Faye, then, can be understood as the "opaque mirror" who resists "the illusion of self-mirroring" that characterizes the Cartesian tradition of the subject's self-reflection.[15] Baudrillard's figure for trompe l'oeil, the "opaque mirror," in fact closely approximates the one West employs to convey the terms of Faye's triumphant survival at the novel's conclusion. As Tod puts it: "Nothing could hurt her. She was like a cork. No matter how rough the sea got, she would go dancing over the same waves that sank iron ships and tore away piers of reinforced concrete. . . . It was a very pretty cork, gilt with a glittering fragment of mirror set in its top. The sea in which it danced was beautiful, green in the trough of the waves and silver at their tips. But for all their

[14] Tod's equation of the detritus of the modern movie set with the Baroque anticipates a broader connection between modern "scopic regimes" and the Baroque traced by theorists of the modern like Christine Buci-Glucksmann and Martin Jay, who show how the ascendancy of the disorienting surplus of images in the Baroque, its opacity and indecipherability, poses a challenge to the rationalized, monocular, and transcendent model of vision associated with Descartes and Renaissance perspective. As an assemblage of deceptive surfaces, the Baroque can be understood as the art historical predecessor of pastiche, though with a crucial difference. Unlike in the Baroque, where juxtaposed elements produce an excess of signification, in Jameson's version of pastiche, elements are *drained* of signification by virtue of excess; but arguably, in both cases, they resist cognition by the privileged gaze of the viewer. See Buci-Glucksmann 1986; Jay 1988a, 16–19.

[15] For Slavoj Žižek's account of Lacan's antinomy between the eye and the gaze, see Žižek 1989, 43.

moondriven power, they could do no more than net the bright cork for a moment in a spume of intricate lace" (West 1962, 173–74). Remaining resolutely on surfaces, Faye's fragmented, mirroring cork likewise resists and returns the gaze in favor of its own perspectival agenda.

Whereas Tod fails in his attempt to break through the illusionistic matrix of the image, the image culture succeeds in breaking up the network of assumptions that governs the illusion making or representational practices of the modernist text: first, by dismantling the postures of artistic sovereignty, and second, by exposing the belief in the autonomy of the work of art as just another deceptive facade. Toward the end of the novel, however, Tod attempts to distance himself from the diminished visual agency epitomized by his rape fantasies, by burying it under the weight of his competing claim to the visionary prerogatives of the artist. In a key scene, Tod overcomes his doubts about his autonomy not by evidence so much as self-assertion. About the people who "come to California to die" he wonders: "Maybe they weren't really desperate enough to set a single city on fire, let alone the whole country. Maybe they were only the pick of America's madmen and not at all typical of the rest of the land. He told himself that it didn't make any difference because he was an artist, not a prophet. His work would not be judged by the accuracy with which it foretold a future event but by its merit as painting. Nevertheless, he refused to give up the role of Jeremiah. . . . The Angelenos would be first [to erupt in violence], but their comrades all over the country would follow. There would be civil war" (118). Tod's initial concession that his chosen subjects might not conform to the vision he has imposed on them coincides with his appeal to purely formal elements— "its merit as painting"—to justify his work. But ultimately, Tod is unwilling to separate the formal from the conceptual or prophetic dimensions of his work, presumably because exclusive emphasis on the former would reduce his compass to relatively mechanical operations. Without their prophetic component, in other words, Tod's images begin to look less like the coherent articulation of a personal vision and more like the machine productions otherwise called commodities. Tod's attempt to rescue his jeopardized visionary independence is best expressed in his final choice of artistic models, the Italian Renaissance painter Alessandro Magnasco. His selection of the theologically preoccupied Magnasco underscores Tod's renewed aspiration to a messianic role: "He would not satirize [his subjects] as Hogarth or Daumier might, nor would he pity them. He would paint their fury with respect, appreciating its awful, anarchic power and aware that they had it in them to destroy civilization" (142). Tod's final invocation and embrace of prophesy, rather than a more dispassionate visual orientation in the present, allows him to overcome many of the key obstacles to his attempt to represent the image industry which he was forced to confront in relation

to Faye. As an inspired utterance, prophesy allows Tod to transcend or ex-
pand the parameters of his particular subject position; to the extent that
it foretells the future, it enables him to reassert a depth-model of tempo-
rality by connecting up past, present, and future; and, insofar as it dimin-
ishes material significance in the face of spiritual truth, it helps Tod to
evade the resistant and deceptive materiality of his subjects.

It is through these competing interpretive frameworks that we must try
to evaluate Tod's final and unfinished painting, *The Burning of Los Ange-
les*—a prophetic model which reestablishes the self-sufficiency of the work
of art as the inspired expression of the individual artist; or the trompe
l'oeil model which grants perspectival primacy to images over which the
artist can exert little control. Tod describes the "rough charcoal strokes"
in which the painting is imaginatively blocked out:

> Across the top . . . he had drawn the burning city, a great bonfire of archi-
> tectural styles, ranging from Egyptian to Cape Cod colonial. Through the
> center . . . was a long hill street and down it . . . came the mob carrying base-
> ball bats and torches. For the faces of its members, he was using the innu-
> merable sketches he had made of the people who come to California to
> die. . . .
>
> In the lower foreground, men and women fled wildly before the vanguard
> of the crusading mob. Among them were Faye, Harry, Homer, Claude and
> himself. Faye ran proudly, throwing her knees high. Harry stumbled along
> behind her, holding on to his beloved derby hat with both hands. Homer
> seemed to be falling out of the canvas, his face half-asleep, his big hands claw-
> ing the air in anguished pantomime. Claude turned his head as he ran to
> thumb his nose at his pursuers. Tod himself picked up a small stone to throw
> before continuing his flight. (184–85)

The context of mob violence in which Tod recollects the painting is, of
course, a virtual analogue of the scene that the painting depicts; seen in
this light, the painting clearly takes on the cast of realized prophesy. How-
ever, the violence in the painting exceeds the violence of the scene Tod
inhabits—no one is really carrying "baseball bats and torches," nor is the
city actually burning; this is not the revolution. Moreover, since Tod con-
tinues to work on the painting in his mind while observing the angry
crowd, his efforts can equally be construed, not just in the neutral sense of
documentary, but in terms similar to the natives' assimilation of cultural
images, in which Tod is reduced to an expressive medium or machine for
the reproduction of mass culture. Finally, like Tod's earlier rape fantasies,
the painting can be understood to stage Tod's own iconoclastic desire for
violence in the face of the desires created but unfulfilled by the image cul-
ture which is here personified by the (absent) celebrities who are sched-
uled to appear at Kahn's Persian Palace Theatre. The fact that the paint-

ing is a work in progress compounds the difficulty of assigning to it any of these meanings definitively, at the same time as it allows West to raise questions about whether Tod is producing or inhabiting a self-contained world of illusion. Such ambiguities are reproduced at the level of character as well: while Tod maintains the differences between himself, Faye, Homer, and the others through their distinctive affective postures, the way he's grouped them together as the cumulative focus of the mob's wrath tends to erase or at least minimize those distinctions. Tod's positioning between Faye and Homer, native and transplant, makes it impossible to read this image as testimony either of Tod's resistance or incorporation into the image culture; thus, the painting's iconography internally recapitulates the interpretive problems posed by its relation to the external world.

Tod's painting, then, can be seen to bring into conflict, rather than resolve, the interpretive frameworks I bring to bear. The fact that the painting overwhelmingly invites and yet resists symbolic or allegorical decoding perhaps says as much about "allegorical signification" as it does about the painting itself. The arbitrary equation of meanings between disparate objects that forms the structural basis for allegory operates very much like the meanings attributed to commodities in exchange value; in each case, excess meanings threaten to overreach the symmetrically imposed borders of the equation and destabilize it.[16] The attempt to contain the chaos of the commodity form through a competing form which is nonetheless modeled on it does seem to neatly summarize the effect, if not the intent, of Tod's project. But if it seems too easy a way out of the painting's complexities to read it symbolically as an allegorical object, West offers another possible interpretive frame in his vision of the "dream dump," in which Tod's painting seems destined to take its place alongside, not the canvases of Alessandro Magnasco, but other commodities: "A Sargasso of the imagination! And the dump grew continually, for there wasn't a dream afloat somewhere which wouldn't sooner or later turn up on it, having first been made photographic by plaster, canvas, lath and paint. Many boats sink and never reach the Sargasso, but no dream ever entirely disappears. Somewhere it troubles some unfortunate person and some day, when that person has been sufficiently troubled, it will be reproduced on the lot" (132). With a criterion of selection as broad as the troubled imagination, the dream dump seems the likely resting place for artifacts as disparate as Tod's painting and the collapsed Waterloo set of Mont St. Jean, making no distinction between the products of high or low culture. Whether or not we believe that Tod has the potential to embody the autonomous stance of visionary artist, the very fact of the dream

[16] Walter Benjamin, of course, gives the fullest account of the affinity between allegory and the commodity form. See Benjamin 1977; see also Eagleton 1990, 320.

dump reminds us of the image industry's resourceful ability to absorb and reimagine—to make "photographic by plaster, canvas, lath and paint"—the cultural materials he might produce.[17]

Ultimately, West's inability fully to embrace or discredit the modernist values of authentic artistic expression and the autonomy of the work of art may be traced to his own stake in the outcome, even as his text works to acknowledge the changing socioeconomic conditions that call those values into question. If we take stock of the nature of those changes as they appear in *The Day of the Locust*, however—the postulation of new, fractured, and depthless forms of subjectivity, history, and language, which derive from the random and drained signification of pastiche—the consequences for modernist representation loom large. What we potentially confront in Tod as a late version of the modernist observer is not just the fact of his desiring subjectivity and the ways it compromises his detachment, but its increasing irrelevance in relation to the growing dominance of the image. That growing dominance is what Guy Debord had in mind when he described the "society of the spectacle" as "capital to such a degree of accumulation that it becomes an image" (1983, para. 34). To the extent that it anticipates and anatomizes that set of conditions, perhaps West's book can be understood to be prophetic.

[17] Although we arrive at this conclusion by different routes, I'm nevertheless in agreement with Strychacz's positioning of *The Day of the Locust* "on the cusp of post/modernism," where it stages cultural boundaries on the brink of collapse (Strychacz 1993, 200).

From "Our Glass Lake" to "Hourglass Lake"

Photo/graphic Memory in Nabokov's *Lolita*

At least since Walter Benjamin's 1936 essay "The Work of Art in the Age of Mechanical Reproduction," we have become accustomed to viewing the photograph as something more complex than merely the agent of a mimetic transparency so successful that its most significant challenge was to assert itself as a properly *aesthetic* medium. The problem for Benjamin was not whether photographs really *were* art, but rather, how they changed its very nature by putting into circulation images newly liberated for adoption into unforeseeable discursive contexts. Photographs conspicuously live out this radical potential in Nabokov's 1955 text, *Lolita*, a novel devoted to elaborating a range of spectatorial positions—voyeurism, consumerism, tourism, aestheticism—which the photograph historically helped to redefine.[1] A central irony in the reluctance of American distributors to release Adrian Lyne's film version of *Lolita*, because of its allegedly scandalous representation of pedophilia, must be registered through the original text's relentless assault on our propensity to mistake images of the real for the real itself, a theme elaborated at per-

[1] Alfred Appel was the first to note the pervasiveness of cinematic references in nearly all of Nabokov's novels, as well as the film allusions found specifically in *Lolita* (Appel 1974, 35ff., 74ff.); his discussions of these visual forms, and their connections with larger trends in American popular culture, remain the most comprehensive to date. Gavriel Moses's work (1995) is also extensive and valuable, although he doesn't comment specifically on *Lolita*; Moses contends that the processes of writing, memory, and the imagination globally in Nabokov should be regarded as "akin to the mechanisms of photography and cinematography," and that his works comprise "a veritable anatomy of modern optical technologies and plumbs their fictional, conceptual and figurative implications" (40, 44), among which must be counted Nabokov's stints of "objective observation" as a lepidopterist.

haps greater length than the novel's nominal exploration of sexual license and convention.[2]

"I am going to pass around in a minute some lovely, glossy-blue picture-postcards," Humbert Humbert announces to the ladies and gentlemen of the jury at the presumed opening both of his trial and the novel (Nabokov 1989b, 9). By reconstituting the jurors as touristic rather than investigative subjects who may be prepared aesthetically to appreciate the European settings of his youth, Humbert Humbert momentarily repositions himself from abject defendant to graciously urbane tour guide, thus inaugurating a persistently disjunctive relation between photographic discourses in the text—in this case, between the photograph's aesthetic and documentary aspects, lending themselves alternatively to the production of nationalistic icons and criminal evidence. The function of such disjunctions in *Lolita* is to insist that photographs, once joined with the broader discursive contexts that lend them legibility, become arguments, as well as elements of exchange in strategies of narrative construction.[3] Images themselves, Nabokov suggests, are meaningless outside of such contexts of narrative construction—to which Humbert Humbert's recollection of his "very photogenic mother" testifies, since "nothing . . . subsists within the hollows and dells of memory" about her (10), despite the preservation of her compelling image. Lolita herself is memorable to Humbert Humbert because her image may be so easily adapted to the discursive frameworks he favors, from the case history and the romance to the seduction of a suggestible European by America's relentless pictorial and cinematic imagination.[4]

The photographic process is instrumental from the start in the construction—and destabilization—of the discourse of the case history that the novel dangles suggestively before us, first, by making photography the basis of Humbert Humbert's formative early sexual experience, about which he reports "some interesting reactions on the part of my organism to certain photographs . . . in Pichon's sumptuous *La Beauté Humaine*" (11); and second, by intimating an etiology of "pederosis" on the model of the psychosexual imprint which is both analogized to the photographic process and expedited by it: "there might have been no Lolita at all,"

[2] *Lolita*, directed by Adrian Lyne and starring Jeremy Irons and Dominique Swain, was finally released in the United States after a protracted battle in August 1998.

[3] Much has been written about the linguistic play in the novel and the kinds of discourses it by turns enables and destabilizes. For an exemplary discussion, see Wood 1994.

[4] I agree up to a point with David Packman's argument (1982) that *Lolita*, with its interests in crime and investigation, replays elements of the detective genre, but I would argue that those elements are still more drastically reduced than they were in *The Eye*, where they yielded only self-reflexive truths. In *Lolita*, I would suggest, the sheer accretion of generic possibilities—detective novel, case history, romance, memoir, and so on—works against the novel's crystallization into any of them.

Humbert Humbert explains, "if I had not loved, one summer, a certain initial girlchild" (9), whose physical contours provide the basis for his later obsession. After her death, Humbert Humbert describes his search for a replica of her in a photo album of prostitutes, speculating: "I do not know if the pimp's album may not have been another link in the daisy-chain" of his pedophilic development (24). Humbert Humbert thus links photographs with eroticism and, conversely, imagines his obsession with nymphets photographically. As if his eye were a camera lens, he describes the rite of erotic succession from Annabel Leigh to Dolores Haze as a "flash . . . of passionate recognition" (39), and early imagines the transition between the two girls—from prototype to replica, a distinction itself resonant with photography's production of traces or copies of the real— as an accession to a more technologically advanced and technically perfect apprehension:

> There are two kinds of visual memory: one when you skillfully recreate an image in the laboratory of your mind, with your eyes open (and then I see Annabel in such general terms as: "honey-colored skin," "thin arms," "brown bobbed hair," "long lashes," "big bright mouth"); and the other when you instantly evoke, with shut eyes, on the dark innerside of your eyelids, the objective, absolutely optical replica of a beloved face, a little ghost in natural colors (and this is how I see Lolita). (11)

Whereas Humbert Humbert views Annabel along crude, synecdochical lines in discrete parts, he reconstitutes Lolita as a perfect copy, an image the success of which is measurable through its incarnate completeness; it's a testimony to her success as image that she "was to eclipse completely her prototype" in Humbert Humbert's mind (40). Lolita thus serves as an odd personification of what Baudrillard has called "the precession of simulacra," in which *images* of the real precede and mediate our perception of it to the degree that the real fades before the primacy of their autonomous intercourse.[5]

Of course, such a sublimation of Lolita as copy is only made possible by the insertion of her image into the narrative structure that is the story of Humbert Humbert's erotic life. Nabokov underscores the solipsistic basis of this narrativizing procedure on several levels: first, by representing Humbert Humbert's consciousness as a photographic lens capable of producing both "optical replicas" and the "focal adjustment" necessary to discern nymphets in group photographs of otherwise unremarkable school girls (17); second, by drafting the structure of his "miserable memories"

[5] To be sure, Annabel is herself a copy of Edgar Allan Poe's "Annabel Lee," the difference being that the "original" Annabel from the "princedom by the sea," as Humbert Humbert quotes from Poe (Nabokov 1989b, 9), is explicitly textual.

on the model of a photographic album through which he "leaf[s] again and again" (13), producing no less than preserving the elements of his erotic autobiography;[6] and, finally, by ending Humbert Humbert's first autoerotic sequence in which Lolita appears as a virtual prop with a conclusion that equates her with photographs: "Lolita had been safely solipsized," Humbert Humbert explains, in a performance that "affected her as little as if she were a photographic image rippling upon a screen" (60, 62).[7] In this strata of self-reflexive narrative construction, Humbert Humbert's relationship with Annabel Leigh again serves as prototype, as his description of a long lost snapshot of the two of them makes clear: "Annabel did not come out well," he tells us, her face being obscured by her bowed position, but Humbert Humbert himself "came out with a kind of dramatic conspicuousness" (13). Humbert Humbert's prominence in this recollected image certainly serves as a form of evidence, but not of the documentary sort; rather, it demonstrates what might be called a "photographic consciousness"—a tool of representation which constructs from images of its own making a self-reflexive narrative of the real.[8] As the novel progresses we encounter mounting evidence of Humbert Humbert's canny employment of that consciousness, in such cases as when, following the death of Lolita's mother, he presents a photograph of a youthful Charlotte to "the kind and credulous Farlows" which he uses as proof of "a mad love affair," the issue of which was Lolita, and which establishes a false paternity and basis for custody (99–100). Humbert Humbert thus inserts Lolita's and her mother's images into such discursive frameworks as the pornographic and the family history in ways that give fresh meaning to his invocation of "photographic memory" (40) as his favored technique; beyond the immediate joke Nabokov is making on representation and its instabilities, we may regard the phrase as an apt condensation of how intractably wedded imagistic and narrative structures are in the novel.

[6] It's interesting to compare Humbert's recollections with Nabokov's own photographically illustrated memoir, *Speak, Memory;* Moses compares the distancing and estranging effects of photography to the emotional experience of exile, in ways resonant with Nabokov's biography (1995, 59).

[7] Packman (1982, 232) argues that Humbert Humbert's expressed wish for a celluloid record of Lolita in preference to snapshots (which he has burned) is evidence of his moral development. Following Metz, Packman characterizes photography as "ontologically alien" to the principles of narrative flow as compared with film (49–50); linking photographic representation with fragmentation and fetishization, he contrasts it to the sustained depth and intimacy he associates (following Leo Bersani) with love. Suggestive as this discussion is, I'm not convinced that filmic forms of knowing enjoy a greater prestige in *Lolita*, despite my agreement that Humbert Humbert does begin to glimpse horizons beyond solipsism toward the end of the novel.

[8] There are precedents for this view: Alfred Appel remarks that "consciousness is an optical instrument to Nabokov" (1974, 265); and Nabokov's son Dmitri described his father's writing as "all there, ready inside his mind, like film waiting to be developed" (quoted in Moses 1995, 40).

If the immediate narrativizing contexts for photographic images appear to be located in consciousness, the novel defines their broader constitutive frameworks clearly as cultural, the melancholy fruits of a "society of the spectacle," as Guy Debord has called it, in which *all* social relations are mediated by images. In *Lolita*, everyone turns out to be a student of Hollywood. Even prior to his arrival in America, Humbert Humbert reports, about a jealous rage inspired by his faithless first wife, Valeria, that he "ought to have hit her across the cheekbone according to the rules of the movies" (29–30); he later expects Lolita to allow him a kiss, "and even close her eyes as Hollywood teaches" (48). Lolita's room, graced by a "full-page ad ripped out of a slick magazine" on which Lolita has inscribed "HH" (69), merely confirms Humbert Humbert's self-description as "a great big handsome hunk of movieland manhood" (39), as does a "queerly observant" schoolmate of Lolita's, who comments: " 'I've never seen a man wearing a smoking jacket, sir—except in movies' " (189). If Lolita is she "to whom ads were dedicated" (148)—that is, the consummate consumer subject—Humbert Humbert develops apace. Describing the imperative to keep wife Charlotte happy "with an illustrated catalogue of [former mistresses], all nicely differentiated, according to the rules of American ads," he concedes that although Charlotte Haze's romantic stories are remarkable for their "sincerity and artlessness" compared with his own, they are technically "congeneric since both were affected by the same stuff (soap operas, psychoanalysis and cheap novelettes)" (80). From this vantage point, any temptation to regard Humbert Humbert as the representative of an Old World culture devoted, however decadently, to "educating" a Lolita identified with American vulgarity and innocence, misses the crucial point that *both* worlds are imaginary constructions, produced apparently from the same source; indeed, Lolita's dismissive reaction to a postcard Humbert Humbert discovers of his father's palatial European hotel—"So what?" she says (155)—suggests that the imagistic construction of Europe can hardly compete with the superior imaginary wonderland that is America.

The European imagination has been colonized, in "a paradox of pictorial thought," as Humbert Humbert puts it, by images Made in USA. On his first American tour, Humbert notes: "The average lowland North-American countryside had at first seemed to me something I accepted with a shock of amused recognition because of those painted oilcloths which were imported from America in the old days to be hung above washstands in Central-European nurseries. . . . But gradually the models of those elementary rusticities became stranger and stranger to the eye, the nearer I came to know them" (152). Whatever gap may open up between these "models," as Humbert Humbert names the actual American landscape, and the oilcloth images which precede and mediate them,

here impugns the authenticity of the models—the original landscape, that is—alone. Humbert Humbert's attempts to recontain or recolonize the landscape through the mediation of European aesthetic forms, identifying "Claude Lorrain clouds" inscribed on an "El Greco horizon" (152) appear quaint, but futile. As we saw in Humbert's transition from Annabel to Lolita, copies rather than originals emerge as definitive forms, the better to serve the discourses into which they're inevitably pressed and circulated. It's not the corruption of America by Europe, then, but the seduction of Europe by America that emerges as the central problem of the text. That seduction is precipitated and sustained by images whose power, generated by larger cultural discourses, brackets and ultimately supersedes any question of individual and local agency, with the implication that Lolita, as an American icon, is no more a seductress in and of herself than any image is, deprived of the narrative conditions of its legibility. Of course, by feminizing the image in this way, Nabokov at once naturalizes its seductive power and rationalizes its (sexual) consumption. The road trip across America provides some of the conditions for reading and consuming images by drawing out the forms of sexual tourism implicit in Humbert's obsession with Lolita to geographical proportions, in which images of Lolita and America are linked into a virtual photo-montage of the scenes of his gratification—"Sunset Motels, U-Beam Cottages, Hillcrest Courts, Pine View Courts, Mountain View Courts, Skyline Courts," and so on—in a "teleological growth . . . from kiss to kiss" (154).[9]

The devolution of the real into the simulacrum, of which the photograph serves as the preeminent model, performs also an elegiac function as a means of marking the absence for which the image itself stands in. The whole novel may be regarded as a form of memento mori, the death mask of a Lolita identified, as Humbert Humbert says following their sexual consummation, as "the small ghost of somebody I had just killed" (140). The photographic and cinematic qualities of Humbert Humbert's rendering of both Charlotte's death and Clare Quilty's as a sequence of movie stills (97–98, 296–304) are but the inevitable extension of this representational logic, in which the presence of the image paradoxically asserts a world through absence—absences most profoundly marked in death. Such an intimate linkage between the image and loss helps explain its imbrication with the discourses of desire in the text, the defining excess of which also points inescapably to loss. Lolita's eventual disappearance, and the impossibility of Humbert Humbert's reclaiming her even after she resurfaces as the pregnant Mrs. Richard Schiller, narrativizes this constellation, and particularly the ways in which desire, along with the

[9] Of course, the recurrent references to "courts" evokes quite a different discursive context, namely, the carceral.

pictorial imagination that fuels and solidifies it, is the begetter of loss. Humbert Humbert seems to acknowledge this when he reveals, in a significant moment, that "I simply did not know a thing about my darling's mind and that quite possibly . . . there was in her a garden and a twilight, and a palace gate" (284)—all beyond his reach.[10]

Nabokov further exploits the power of the associations of desire, loss, and the photographic imagination through his cultivation of the reader's powers of visualization, in which the tenuous boundaries between the reader's imaginative capacities, investigative gaze, critical acumen, and voyeuristic prurience are cleverly conflated. Observing in the novel's final paragraph that "neither [Humbert nor Lolita] is alive when the reader opens this book," Humbert Humbert tacitly enjoins the reader to partake in an imaginative reconstruction to redress those losses over which he'll hover, a posthumous spectral presence of "black smoke"; he'll thus ensure the completion of the project of memorialization in which Lolita may "live in the minds of later generations" (309) as image. The novel thus aspires to turn the reader into a photographic lens on a par with Humbert Humbert's own projective powers, at the same time that it also turns the lens upon the reader. It's no coincidence that the two most conspicuous moments of Humbert Humbert's direct appeals to the reader's powers of visualization precede the novel's two most sexually explicit scenes, those most opportune both for juridical assessment and for voyeuristic pleasure. "I want my learned readers to participate in the scene I am about to replay; I want them to examine its every detail and see for themselves" (57), Humbert Humbert explains, just prior to relating his first sexual encounter with an unknowing Lolita; and before the consummation of their sexual relationship, he appeals: "Please, reader . . . do not skip these essential pages! Imagine me; I shall not exist if you do not imagine me" (129).

In the novel's embrace of the discursive dimensions of the photograph—those which foreground the ways the photographic image's claims to objectivity and mimeticism are necessarily mediated by interpretive and narrative frames—we can find evidence of Nabokov's playful derision of the realist mirror as a representational model.[11] With the novel's fracturing of this mirror and embrace of its attendant distortions comes

[10] Dana Brand has argued that photography functions as a mode of aesthetic appropriation in *Lolita*, and as one index of the ways that Humbert Humbert's aestheticism degenerates "into a version of the consumerism against which it served as a shield" (Brand 1987, 15). Noting the deaths of all of the novel's principle characters, Brand suggests that Lolita's mission, like the photograph's, is to "reduce American reality to the status of a photograph" or lifeless images (17–18).

[11] Lance Olsen comments in detail on the tensions between the realist and aesthetic dimensions of *Lolita*, arguing that this "trompe l'oeil fiction" or "Janus-text" (Olsen 1995, 93, 116) subverts all interpretive paradigms and, in effect, deconstructs itself—a view echoed by

the birth of the doppelgänger as a new representational figure, personified by Humbert Humbert's near-double, Clare Quilty, whose name juxtaposes seamless clarity—Clare—with pastiche—Quilty—suggesting their uneasy conjunction. Both like and unlike his prototype, Quilty is a labile copy aptly named the "Proteus of the highway" (227) as he lives out the discursive possibilities of the image in circulation. Humbert Humbert's name itself serves as a mirrored structure, the reflection of which, however, points to a Lacanian rather than self-identical model of subjectivity, to which the endless versions of his name—Humbird, Humberg, Humbertson, etc.—testify. As copies proliferate in the text—from Poe's Annabel Lee to Humbert's, from Humbert's Annabel to Lolita, from the first road trip and the reign of the Enchanted Hunter to the second with the ascendance of the Hunted Enchanter—it's clear that interpretive contexts rather than mimetic likenesses determine the meaning of particular figures. This point is elegantly epitomized by the linguistic and visual trope "Our Glass Lake." Humbert Humbert's discovery that "Our Glass Lake," an image of transparency and reflection, is actually "Hourglass Lake" (81), a figure rather of temporal instability and female corporeality, prefigures our own comprehension that behind the "innocent" face of any representational mirror stands an intractably embodied, interpretive center. In this restaging of an essentially modernist revelation about the subjective underpinnings of perception in new ways, *Lolita* marks a moment of changing visual codes and visual relations, one that cannily anticipates a postmodern view.

Lolita, that is, erodes the very distinction between self and world upon which the modernist novels I've examined here depend, even, or especially, as they strive to interrogate that divide. Narrative vision is not merely subjective and subjectively embodied in *Lolita* as it is in late James or in Nabokov's modernist *The Eye*, nor does the embodiment of the gaze really constitute a revelation or scandal for the later text. Rather, *Lolita* calls into question the very concept of *self* implicit in modernist explorations of self-consciousness, self-scrutiny, and self-reflexivity. In order to delineate more precisely *Lolita*'s departure from modernist visual economies, by way of conclusion, I want first to compare *Lolita* with two Nabokov novels com-

David Rampton (1984; 1993). Elizabeth Deeds Ermarth is the most explicit proponent of a synthetic approach to *Lolita*'s formal innovations and "scandalous" themes, characterizing the realist/antirealist debate that has swirled about *Lolita* since its publication as a false opposition, since signs both refer to and unsettle meaning (Ermarth 1988, 330–39). Leona Toker seems to concur when she describes "the self-reflexive Möbius-strip narration" of most of Nabokov's late novels (Toker 1995, 369). Although I agree with these approaches, I want to note how directly *Lolita* addresses the terms of this literary debate through its mechanisms of (false) doubling. For a detailed discussion of the novel's propensity for doubling see also Pifer 1980, 106–11.

posed (like *The Eye*) in the 1930s, out of which *Lolita* arguably emerged, and which provide a useful modernist prehistory to *Lolita*'s postmodernist engagement with issues of transparency, displaced embodiment, self-scrutiny, and self-production through images. Second, I'll briefly situate *Lolita*'s treatment of the visual discourses of social science relative to Hurston's, Ellison's, and Woolf's deployment of them, as well as *Lolita*'s intervention in the modernist dialectic of feminized embodiment and male cultural transparency that we encountered in its most developed form in West. While *Lolita* shares with these two groups of modernist texts an acknowledgment of the slippery self-reflexivity of embodied ontology, I will suggest, it moves beyond the confines of spectacle and surveillance that helped to designate subjectivity basically as intact and available—albeit *subject to* a range of disciplinary and imagistic "internalizations." Instead, and much as West anticipates in *The Day of the Locust*'s prescient portrait of Faye Greener's depthless layers, *Lolita* regards the subject as no more than a system of (chiefly linguistic and imagistic) signs. Conceiving of subjectivity as permeable and fractured in ways that are distant from the rubric of depth models, Nabokov's novel renders questionable the very concept of interiority that is so crucial to modernist understandings of the subject. In moving beyond a modernist conception of the subject in the direction of linguistic and imagistic plenitude, paradigms of observation and spectatorship must break down. That is, there can be no "interior gaze" in this new, postmodern visual economy, for the simple reason that there is no longer any viable interior.

Both *Invitation to a Beheading*, serialized in 1938 in Russian, and *Laughter in the Dark*, first published in Russian as *Kamera Obskura* in 1932, prefigure enough of *Lolita*'s preoccupations and plot to qualify as early versions of the text.[12] Like *Lolita*, *Invitation to a Beheading* follows an incarcerated man, Cincinnatus C., who writes a chronicle of his experiences; and it includes a constellation of features reworked in the later novel: a flirtatious girl child (Emmie), sexual betrayal (by wife Marthe), an absent/distant mother, and the use of doubles to explore real versus fantasy selves. *Laughter in the Dark* still more fully anticipates *Lolita*'s characters and themes: Albinus's alter ego Udo Conrad, author of *The Vanishing Trick*, is an identifiable ancestor of Clare Quilty. Margot and Albinus's road trip through Europe foreshadows Humbert Humbert's American road trip with Lolita, complete with her betrayal of him with another man. Just as Humbert Humbert attempts to sedate Lolita with a sleeping draught to aid in his seduction of her, Margot, in a gender role reversal,

[12] *Invitation to a Beheading* was serialized in 1938 in Russian and first appeared in English in 1959; see Nabokov 1989a; Connolly 1997. *Laughter in the Dark* was first published in Russian as *Kamera Obskura* in 1932 and appeared in English in 1938 (rev. ed., 1960); see Nabokov 1991.

attempts to dispatch Albinus by similar means and also fails. Like Humbert Humbert, Albinus stars in a vengeance sequence where the wronged man stalks his tormentor with a gun in a scene which features a stagy, theatrical dénouement (292).

But, like *The Eye*, these earlier texts make use of visual metaphor to make points about the political nature of self-scrutiny and characters' vulnerability to the seductive power of images—modernist points, in other words, that mark their distance from *Lolita*'s demonstration of the triumph of visual discourses *over* centered or stable conceptions of subjectivity. In *Invitation to a Beheading*, Cincinnatus C. has been incarcerated for the crime of opacity, a trait he apparently has manifested since childhood (Nabokov 1989a, 24, 72). His condition suggests an embodiment so anathematized it is unnamable (" 'Citizens, there is among us a ———' " [32]) and possibly racialized (seeming at times "pitch-black" [25]). Cincinnatus makes several attempts to relieve himself of the burden of his excessive embodiment, as he does in the prison scene in which he sequentially removes his head, collarbones, and so on, achieving a momentary transparency as a "radiant point" of light (90). The iconography of transparency and opacity is recapitulated through the trope of photography, with the production and control of photographic images linked with transparency's prerogatives and social power: Cincinnatus's jailers excise photographs from the newspaper which pertain to his life or future execution; his executioner, M'sieur Pierre, is himself an avid photographic hobbyist (82–83, 186) and the creator of a "photohoroscope," which wondrously conveys the trajectory of an entire life (170–71); the execution scene is teeming with photographers intent on capturing the event for the morning papers (217). Finally, authorship itself is likened to photographic production, with Cincinnatus describing the author of his novel as if he "were sitting with his camera somewhere among the topmost branches of the Quercus, spying out and catching his prey" (123). In these ways, photographic vision is equated with the project of surveillance, one committed to producing and maintaining Cincinnatus's total visibility while preserving its own transparent presence. Nabokov indicates the success of that project by portraying Cincinnatus's internalization of its mechanisms, reflected in the "golden cage" he exhibits "in each of his mirrorlike pupils" (29).

Invitation to a Beheading makes two attempts to turn the tables on the conventional meanings of transparency versus opacity that are established by Cincinnatus's crime and buttressed by photographic imagery. First, the novel uses the figure of the double to express the split between imaginary and actual experience, with the "real" repeatedly represented as a crude stage set compared with the richness of the imaginary (25, 92); this innovation allows Cincinnatus to redefine transparency as a quality which he,

more so than most of his community, possesses in abundance. Second, at the scene of his execution (where embodiment must prove so ultimately hazardous) Cincinnatus literalizes the privileged transparency of the social world that has condemned him by making it disappear; in so doing, he implicitly reimagines his own opacity as the material basis for *his* newly acquired social power (219–23). However, beyond the objection that this latter solution may take place only in the register of surrealist fantasy, it must be noted that the two strategies in effect cancel each other out. Moreover, the only alternative to a dualistic conception of visual relations the novel proposes, wherein the world is divided into either the transparent or the opaque, is solipsism: here, Cincinnatus may simply exercise his option not to believe in the reality of others, the same alternative to which *The Eye* tenuously clings. The spheres of visuality explored by *Invitation to a Beheading*, then, still orbit a subject who aspires to the privileged Cartesian detachment of transparency, however compromised by partiality and embodiment that aspiration proves to be. Such an aspiration represents a far more modest project than the sustained visual indeterminacy of *Lolita*, where transparency and centered subjectivity both appear to be exploded.

Where *Invitation to a Beheading* uses photography as a figure for surveillance, *Laughter in the Dark* employs film to stress the illusionistic mediations of spectacle (as its original title, *Kamera Obskura*, indicates). The novel opens with art historian Albinus's "beautiful idea," borrowed from Udo Conrad, to bring paintings to life on the screen (Nabokov 1991, 8). His vision proves portentous in its most negative construction, as a transmutation of high culture into low: that downfall is first echoed in Albinus's infatuation with the vulgar Margot Peters, the youthful mistress for whom he abandons his elegant wife and bourgeois respectability; and it is reflected in Margot's own career, a descent from artist's model to movie theater usher (Margot does go on to realize her dream of becoming a film actress, but she accomplishes this in a performance even she acknowledges as awful). Margot's betrayal of Albinus with Axel Rex, a hack artist whom Albinus counts a friend, makes complete Albinus's seduction by images in general and by the feminine as their particular personification (here Nabokov anticipates West's depiction of Faye Greener's seduction of Tod Hackett). Albinus's dawning moment of demystification about Margot's infidelity is foreclosed when he is blinded in a car accident. With that blinding, Albinus seems definitively to internalize the cinematic apparatus, much as Cincinnatus did the camera lens, but Albinus augments the function of self-scrutiny with that of illusion making. Thus, the blind Albinus's dark mind is likened "to the darkness of the little cinema" where he first met Margot (257), and his face, as much a projection screen as a window on his soul, mirrors his thoughts "as if that face had

become one big eye" (276).[13] *Laughter in the Dark* thus employs an image of the self comparable to *The Eye* (if slightly more cosmetic than *The Eye's* bloodshot version of the orb), and it seems to share with that earlier text, and with *Invitation to a Beheading,* an acknowledgment of the self-reflexivity of embodied ontology (as transparent subject and embodied object in one). Although it signals more aggressively than Nabokov's other novels from the 1930s the potential dissolve between an autonomous self and the image-narratives that penetrate and construct it, however, *Laughter in the Dark* still restricts its protagonist to the machinations of surveillance and spectacle in ways that leave the contours of modernist subjectivity more or less intact.

In *Lolita,* on the other hand, we find a subjective model that seems to anticipate Baudrillard's critique of those modernist parameters. Heralding the "nuclear and genetic, and no longer specular and discursive" age of simulation (Baudrillard 1988a, 343), Baudrillard distinguishes his view of subject/object relations from Foucault's panoptic model of surveillance. Baudrillard's pronouncement of the demise of Foucault's model is anchored in his critique of its dependence upon a (relatively) clear subject/object division,[14] one characterized by a gaze of power and its (ideally) transparent object—an object whose boundaries themselves, moreover, may still be described within the rubric of inside/outside. For Baudrillard, recent image technologies have instigated the collapse of the opposition between seeing and being seen: "The eye of the TV is no longer the source of an absolute gaze, and the ideal of control is no longer that of transparency" (Baudrillard 1988a, 364). Such a collapse, Baudrillard contends, leads to the destruction of the *relation,* through a

> turnabout of affairs by which it becomes impossible to locate an instance of the model, of power, of the gaze, of the medium itself, since *you* are always already on the other side. No more subject, focal point, center, or periphery. . . . The whole traditional mode of causality is brought into question: the perspective, deterministic mode, the "active" critical mode, the analytical mode—the distinction between cause and effect, between active and passive, between subject and object, between ends and means. (Baudrillard 1988a, 364–65)

[13] In his useful chapter on *Laughter in the Dark,* Gavriel Moses describes Albinus as an "average moviegoer, the typical prisoner in Plato's cave" (1995, 80). The whiteness signified by Albinus's name along with the darkness of his blindness, I would add, also conjures the perceptual mediations of Marx's camera obscura model of ideology, to which the original title undoubtedly refers.

[14] The clarity of that division is, of course, a matter of dispute; in Foucault, the subject plays both roles, while his "inscription" of the gaze of power, as Judith Butler has reminded us, isn't a true "internalization," with the implications of a viable depth model, at all. See Butler 1990b, 334.

The new "schizophrenic" subject Baudrillard anatomizes suffers from a virtual hemorrhaging of subjective borders: "He can no longer produce himself as mirror. He becomes a pure screen, a pure absorption and re-sorption surface" (Baudrillard 1988b, 27). The devolution of the subject from "mirror" to "screen" marks the demise of a long philosophical tradition in which the mind is regarded, to recall Richard Rorty's phrase, as a "Mirror of Nature"—one containing representations which, through the application of objective cognition, may come accurately to reflect the real (see Rorty 1979, 12–13). Baudrillard's recasting of the subject as a depth-less, image-sensitive screen effectively dissolves the boundaries between self and world, with the effect that there is no privileged subject of knowl-edge able to adjudicate a representation's verisimilitude. To see the im-age is to be penetrated by it, to *become* it via an erotic conquest or "foul promiscuity" (27), not to achieve either knowledge of or mastery over it. It's precisely this transmutation of the subject from mirror to screen that we find in *Lolita*'s photographic consciousness. Rather than an "interior gaze" governed by a rhetoric and exercise of expertise, *Lolita* deploys a vi-sual code that sustains at once hypervisibility and unreadability.

From the vantage point of *Lolita*, too, we can measure the conceptual distance traversed from the visual discourses of social science with which Hurston and Ellison struggled from the 1930s to the 1950s, and within which Woolf also worked to imagine alternative narratives of social orga-nization. Both Hurston's and Ellison's levels of engagement with those dis-courses, as I've attempted to show, were sustained and intense, a fact to which the very range of innovations they undertake within them amply tes-tifies. Although they both aspire to ontological locations beyond the ob-jectifying and deterministic reach of, respectively, the "spyglass of anthro-pology" associated with the participant-observer method of Franz Boas and the theories of racial temperament, development, and "high visibility" contoured by Robert E. Park, Hurston and Ellison remain uneasily wed-ded to the frameworks within which they construct their defections. The influence of anthropologists Jane Harrison and Ruth Benedict on Woolf's *Between the Acts* has also been well documented, with Woolf parlaying their insights on matriarchy, the cultural origins of racial typology, goddess cults, etc., into visions of nonpatriarchal (and antifascist) cultural configu-rations (see Cramer 1993; Maika 1987). While Woolf doesn't innovate against so much as borrow from these discourses (which may be attributed to her basic sympathy with Harrison's and Benedict's gender politics), she does so in the service of aims not discontinuous with Hurston's and Elli-son's, despite their relative emphases on race versus gender relations: that is, she uses anthropological paradigms to help her understand the recip-rocal bonds uniting individuals with group structures, along with the dan-gerously asymmetrical subject/object relations they yield. For all three

novelists, studying the organization of human society within and across historical and cultural formations remained a vital means of subverting the racist and misogynist social scripts that were always subject to naturalization, and to which they all remained, however disparately, vulnerable.

But whereas Hurston, Ellison, and Woolf of necessity take social science discourses seriously as both their nominal objects and seditious subjects, in *Lolita*, Nabokov tellingly reduces them to a lighthearted caricature. Early in the novel, Humbert Humbert perorates on the fate of his former wife, Valeria, following her departure for America with her betrothed. Valeria and her new husband:

> had somehow got over to California and had been used there, for an excellent salary, in a year-long experiment conducted by a distinguished American ethnologist. The experiment dealt with human and racial reactions to a diet of bananas and dates in a constant position of all fours. My informant, a doctor, swore he had seen with his own eyes obese Valechka and her colonel . . . diligently crawling about the well-swept floors . . . in the company of several other hired quadrupeds, selected from indigent and helpless groups. I tried to find the results of these tests in the *Review of Anthropology*, but they appear not to have been published yet. . . . I hope they will be illustrated with good photographs when they do get printed. (Nabokov 1989b, 30–31)

Although it's tempting to suggest that Humbert Humbert's description is itself too much a cheaply purchased lampoon launched by a privileged observer to be taken seriously, such a dismissal must miss the density of Nabokov's critique. In a few deft strokes, the passage marks the economic motives of the "hired quadrupeds" and the ethnocentric biases and absurd methodologies of the "distinguished American ethnologist"; and, by insisting on the inscrutability of its goals despite "seeing with our own eyes" its practices, the scene successfully defamiliarizes the entire ethnographic enterprise. By showing, furthermore, the ways in which photography characteristically is enlisted to legitimize ethnographic procedures through the reification of otherwise unstable subject/object positions, Nabokov also exposes the collaborative roots of visual techniques and technologies.

In an adjacent scene, Humbert Humbert takes his own turn as a social scientist working as a "recorder of psychic reactions" on an expedition to arctic Canada. Although the expedition's larger mission remains steeped in mystery, Humbert has been retained in order:

> to quiz my various companions on a number of important matters, such as nostalgia, fear of unknown animals, food-fantasies, nocturnal emissions, hobbies, choice of radio programs, changes in outlook and so forth. Everybody got so fed up with this that I soon dropped the project completely, and . . .

277

> concocted a perfectly spurious and very racy report that the reader will find
> published in the *Annals of Adult Psychophysics* for 1945 or 1946, as well as in
> the the issue of *Arctic Explorations* devoted to that particular expedition. (34)

Compared with his nonsensical official agenda, Humbert's innovations may offer a modest improvement. If not more plausible than "the real" precisely, his invented account of human behavior is at least better equipped to deliver the voyeuristic pleasures inherent in his project's design. Consistent with his notorious hostility to the explanatory pretentious of psychoanalysis, then, Nabokov's treatment of social science likewise appears intent on exposing it as an untenable metanarrative, the ludicrous presumptions and methods of which hardly merit sustained critique. Unlike Hurston and Ellison, I would contend, for whom social science discourses appeared to be fundamentally viable when sufficiently purged of bias, or Woolf, for whom they offered a reliable window into alternative cultural formations, Nabokov seems to have viewed its techniques for exploring cultural relativism as a thinly veiled exercise in cultural charlatanism.

Whatever degree of cultural transparency and privilege may underpin Nabokov's derisive depiction of the social sciences in *Lolita*, tellingly, that transparency does not derive its primary sustenance from the characteristic male modernist aspiration to disavow feminized embodiment (the aspiration which ultimately founders in James and Ellison, but nearly succeeds in West). To be sure, there survives in the character of Lolita a "family resemblance" to the model of female embodiment personified by West's Faye Greener, whose identification with/as mass culture enables a fantasy of male modernist purity that may be acquired through her mastery or repudiation. (Faye Greener's ancestry may itself be traced back to Carrie Meeber, a turn-of-the-century representative of the feminized seductions of spectacle and the dangers they pose to traditional masculinity, in Dreiser's 1900 novel, *Sister Carrie*). But the differences that distinguish the "seductions" of Faye Greener and Dolores Haze, and the responses of the two high-culture men who struggle in their grasp, are significant. In West, Faye's identification with/as mass culture, and particularly with the seductive power of the *image*, is an index of her resilient autonomy, and means that fundamentally she cannot be possessed or known. On the contrary, the resistance that she poses to male mastery supplies the nominal motive for Tod's rape fantasies, symptoms of the male artist's desire to capture, make use of, and even apotheosize mass cultural forms without being penetrated or contaminated—in other words, feminized—by them. As I argued in Chapter 7, Tod's conquest by mass mediated desire, signaled by his reification and feminization at the close of *The Day of the Locust*, comprises the text's pained "resolution downward" of its central conflicts, in a staging of dangerously compromised subjective borders.

Consistent with the mechanisms of Humbert Humbert's photographic consciousness described above, however, *Lolita* decisively eradicates the kind of subject/object relations upon which West's narrative of (failed) male, high-culture mastery depends. Nabokov presumes from the start that Lolita's *and* Humbert Humbert's subjective parameters equally must be counted among mass culture's effects, rather than depicting the envelopment of either of them as the tragic crisis point of the narrative. The borders separating high from low are insistently permeable in the novel, with Lolita's "identities" spanning preteen vulgarian to guardian of "the palace gate," and Humbert's multiplying still more dizzyingly from scholar to fraud, cultivated European to "handsome hunk of movieland manhood," aesthete to criminal; more significantly still, the borders separating Lolita from Humbert themselves are slippery. To invoke Baudrillard's terms once again: as copy, Lolita does not merely personify the dangers of the eroding distinction between the real and representational, the high (authentic original) and low (degraded reproduction), as Faye Greener does; rather, she functions as the simulacrum which precedes the real and renders the distinction between the real and representational, high and low, undecidable. Unlike Faye Greener, then, Lolita may in some sense be susceptible to "possession"; but the terms of Humbert Humbert's strictly *solipsistic* possession of her as copy jeopardize the boundaries separating self and other, and make it necessary to ask whether Lolita should ever be regarded as more than a fractal extension of Humbert Humbert's own self-referential, aesthetic production. Indeed, one must question whether the rubric of possession can even answer to the demand of describing the construction and circulation of desire in the text—a desire which at once exceeds the possibility of fulfillment, as it does in West, and also registers its own fluidity and instability in ways that suggest its irreducibility to a model of production administered only from above.

If desire, like meaning, seems to come from everywhere in *Lolita*, that is because it is so nearly aligned with textuality (in its broadest sense, including imagistic and verbal texts). *Lolita*'s commitment is above all to the rendering of linguistic pleasure and excess, a point upon which Nabokov's enraptured parsing of Lolita's name in the famous opening segment insists: "Lo-lee-ta: the tip of the tongue taking a trip of three steps down the palate to tap, at three on the teeth. Lo. Lee. Ta" (9). The novel's construction of Lolita as sacrificial muse thus finally begs comparison with Blanchot's "Gaze of Orpheus," published in the same year, since it glances back toward the modernist propensity to dispose of feminized embodiment as the precondition of male aesthetic production, retaining that impulse vestigially; but it also looks forward to a more primary commitment to language that in effect eclipses the gendered subject, incar-

nated now as an absence that at once universalizes embodiment and re-constitutes it as a system of signs. Foucault's characterization of the subject in Blanchot resonates uncannily with Nabokov's *Lolita* when he contends that "the subject that speaks is less the responsible agent of a discourse . . . than a non-existence in whose emptiness the unending outpouring of language uninterruptedly continues" (Foucault 1987, 11). Humbert Humbert may well be one of the American novel's most promiscuously irresponsible "men of many discourses"—a point underscored by the discursive plenitude evoked by the "author of the 'Forward,' " the versatile John Ray, Jr. (a name which itself has a doubled structure, and is a homonym for genre [6]), which presages and echoes Humbert Humbert's own "testimony." In Humbert's issuance through so *many* discourses, Nabokov indicates his precarious dependence on them all for his (always partial) constitution, along with his inevitable sublimation back into "black smoke" (309); we must understand him, then, chiefly as a conduit for the production of language. Without insisting on too neat a convergence between Blanchot's and Nabokov's otherwise distant works, it remains possible, if perhaps startling, to say that the act of writing begins, too, with Humbert Humbert's gaze. As with Blanchot's Orpheus, so with Nabokov's Humbert: he is destined to survive neither Lolita nor his song for very long.

Bibliography

Aaron, Daniel. 1992. *Writers on the Left: Episodes in American Literary Communism.* New York: Columbia University Press.

Abbas, Ackbar. 1989. "On Fascination: Walter Benjamin's Images." *New German Critique* 48:43–62.

Abel, Elizabeth. 1989. *Virginia Woolf and the Fictions of Psychoanalysis.* Chicago: University of Chicago Press.

Adorno, Theodore. 1977. *Aesthetics and Politics.* London: Verso.

Agnew, Jean-Christophe. 1983. "The Consuming Vision of Henry James." In *The Culture of Consumption: Critical Essays in American History, 1880–1980,* edited by Richard Wightman Fox and T. J. Jackson Lears, 65–100. New York: Pantheon Books.

Allert, Beate, ed. 1996. *Languages of Visuality: Crossings between Science, Art, Politics and Literature.* Detroit: Wayne State University Press.

Allmendinger, Blake. 1988. "The Death of a Mute Mythology: From Silent Movies to Talkies in *Day of the Locust.*" *Literature/Film Quarterly* 16, no. 2:107–11.

Althusser, Louis. 1971. "Ideology and Ideological State Apparatuses." In *Lenin and Philosophy and Other Essays,* translated by Ben Brewster, 53–61. New York: Monthly Review.

Altieri, Charles. 1989. *Painterly Abstraction in Modernist American Poetry: The Contemporary of Modernism.* New York: Cambridge University Press.

Appel, Alfred, Jr. 1974. *Nabokov's Dark Cinema.* New York: Oxford University Press.

Apter, Emily. 1991. *Feminizing the Fetish: Psychoanalysis and Narrative Obsession in Turn-of-the-Century France.* Ithaca: Cornell University Press.

Armstrong, Nancy. 1998. "Modernism's Iconophobia and What It Did to Gender." *Modernism/modernity* 5, no. 2:47–75.

Armstrong, Tim. 1998. *Modernism, Technology and the Body.* Cambridge: Cambridge University Press.

Awkward, Michael, ed. 1990. *New Essays on Zora Neale Hurston.* Cambridge: Cambridge University Press.

Babcock, Barbara A. 1990. "Mud, Mirrors, and Making Up: Liminality and Reflexivity in *Between the Acts*." In *Victor Turner and the Construction of Cultural Criticism*, edited by Kathleen M. Ashley, 86–116. Bloomington: Indiana University Press.

Baker, Houston A., Jr. 1984. *Blues, Ideology, and Afro-American Literature*. Chicago: University of Chicago Press.

———. 1987. *Modernism and the Harlem Renaissance*. Chicago: University of Chicago Press.

Bakhtin, M. M. 1981. *The Dialogic Imagination*, edited by Michael Holquist. Translated by Caryl Emerson and Michael Holquist. Austin: University of Texas Press.

Banks, Marcus, and Howard Morphy, eds. 1997. *Rethinking Visual Anthropology*. New Haven: Yale University Press.

Barkan, Elazar, and Ronald Bush, eds. 1995. *Prehistories of the Future: The Primitivist Project and the Culture of Modernism*. Stanford: Stanford University Press.

Barnard, Rita. 1995. *The Great Depression and the Culture of Abundance: Kenneth Fearing, Nathanael West, and Mass Culture in the 1930s*. Cambridge: Cambridge University Press.

Barrett, Eileen. 1987. "Matriarchal Myth on a Patriarchal Stage: Virginia Woolf's *Between the Acts*." *Twentieth Century Literature* 33, no. 1:18–37.

Barthes, Roland. 1972. "The Metaphor of the Eye." In *Critical Essays*, translated by Richard Howard, 239–47. Evanston: Northwestern University Press.

———. 1977. *Image, Music, Text*. Translated by Stephen Heath. New York: Farrar, Straus & Giroux.

———. 1981. *Camera Lucida: Reflections on Photography*. Translated by Richard Howard. New York: Hill & Wang.

———. 1982. "The Photographic Message." In *A Barthes Reader*, edited by Susan Sontag, 195–210. New York: Hill and Wang.

Bataille, Georges. 1987. *Story of the Eye*. Translated by Joachim Neugroschel. San Francisco: City Lights Books.

Batchen, Geoffrey. 1997. *Burning with Desire: The Conception of Photography*. Cambridge: MIT Press.

Baudrillard, Jean. 1988a. *Selected Writings*. Edited by Mark Poster. Stanford: Stanford University Press.

———. 1988b. *The Ecstasy of Communication*. Edited by Sylvere Lotringer. Translated by Bernard and Caroline Schutze. New York: Semiotext(e).

Baym, Nina, et al., eds. 1994. *The Norton Anthology of American Literature*. 4th ed. Vol. 1. New York: W. W. Norton.

Bazin, André. 1975. "The Ontology of the Photographic Image." In *The Camera Viewed: Writings on Twentieth-Century Photography*, vol. 2, edited by Peninah R. Petruck, 140–46. New York: E. P. Dutton.

Behar, Ruth, and Deborah A. Gordon, eds. 1995. *Women Writing Culture*. Berkeley: University of California Press.

Benjamin, Jessica. 1988. *The Bonds of Love: Psychoanalysis, Feminism, and the Problem of Domination*. New York: Pantheon.

Benjamin, Walter. 1969. *Illuminations*. Edited by Hannah Arendt. Translated by Harry Zohn. New York: Schocken Books.

———. 1972–. *Gesammelte Schriften*. Vols. 1–7. Edited by Rolf Tiedemann and Hermann Schweppenhäuser, with the collaboration of Theodor W. Adorno and Gershom Scholem. Frankfurt am Main: Suhrkamp Verlag.

———. 1973a. *Charles Baudelaire: A Lyric Poet in the Era of High Capitalism.* Translated by Harry Zohn. London: New Left Books.

———. 1973b. *Understanding Brecht.* Translated by Anna Bostock. London: New Left Books.

———. 1977. *The Origin of German Tragic Drama.* Translated by John Osborne. London: Verso.

———. 1978. *Reflections.* Edited by Peter Demetz. Translated by Edmund Jephcott. New York: Schocken Books.

———. 1979. *One Way Street.* Translated by Edmund Jephcott and Kingsley Shorter. London: New Left Books.

———. 1999. *The Arcades Project.* Translated by Howard Eiland and Kevin McLaughlin. Cambridge: Belknap Press of Harvard University Press.

Bennett, Stephen B., and William W. Nichols. 1974. "Violence in Afro-American Fiction." In *Ralph Ellison,* edited by John Hershey, 171–75. Englewood Cliffs, N.J.: Prentice-Hall.

Bergson, Henri. 1991. *Matter and Memory.* Translated by N. M. Paul and W. S. Palmer. New York: Zone Books.

Bergstrom, Janet, and Mary Ann Doane, eds. 1989. *The Spectatrix:* Special issue of *Camera Obscura: A Journal of Feminism and Film Theory,* vol. 20–21.

Bhabha, Homi. 1994. *The Location of Culture.* London: Routledge.

Bird, Jon, et al. 1996. *The BLOCK Reader in Visual Culture.* London: Routledge.

Blackall, Jean Frantz. 1965. *Jamesian Ambiguity and "The Sacred Fount."* Ithaca: Cornell University Press.

Blair, Sara. 1996. *Henry James and the Writing of Race and Nation.* Cambridge: Cambridge University Press.

Blanchot, Maurice. 1981. *The Gaze of Orpheus and Other Literary Essays.* Edited by P. Adams Sitney. Translated by Lydia Davis. Barrytown, N.Y.: Station Hill.

———. 1982a. *The Space of Literature.* Translated by Ann Smock. Lincoln: University of Nebraska Press.

———. 1982b. *The Step Not Beyond.* Translated by Lycette Nelson. New York: State University of New York Press.

———. 1986. *The Writing of Disaster.* Translated by Ann Smock. Lincoln: University of Nebraska Press.

———. 1993. *The Infinite Conversation.* Translated by Susan Hanson. Minneapolis: University of Minnesota Press.

Bloom, Harold, ed. 1986. *Nathanael West.* New York: Chelsea House.

Boas, Franz. 1931. *The Mind of Primitive Man.* New York: Macmillan.

———. 1940. "The Study of Geography." In *Race, Language and Culture,* 639–47. New York: Macmillan.

Bordo, Susan. 1987. *The Flight to Objectivity: Essays on Cartesianism and Culture.* Albany: State University of New York Press.

Bourdieu, Pierre. 1990. *Photography: A Middle-Brow Art.* Translated by Shaun Whiteside. Stanford: Stanford University Press.

Bowlby, Rachel. 1985. *Just Looking: Consumer Culture in Dreiser, Gissing, and Zola.* New York: Methuen.

Boxwell, D. A. 1992. " 'Sis Cat' as Ethnographer: Self-Presentation and Self-Inscription in Zora Neale Hurston's *Mules and Men.*" *African American Review* 26, no. 4:605–17.

Bradbury, Malcolm, and James McFarlane, eds. 1976. *Modernism 1890–1930*. Harmondsworth, England: Penguin Books.

Bradbury, Nicola. 1979. *Henry James: The Later Novels*. Oxford: Clarendon.

Braithwaite, William Stanley. 1992. "The Negro in American Literature." In *The New Negro*, edited by Alain Locke, 29–46. New York: Atheneum.

Brand, Dana. 1987. "The Interaction of Aestheticism and American Consumer Culture in Nabokov's *Lolita*." *Modern Language Studies* 17, no. 2:14–21.

Brennan, Teresa, and Martin Jay, eds. 1996. *Vision in Context: Historical and Contemporary Perspectives on Sight*. New York: Routledge.

Brooks, Peter. 1976. *The Melodramatic Imagination: Balzac, Henry James, Melodrama and the Mode of Excess*. New Haven: Yale University Press.

Bruns, Gerald L. 1984. "Language and Power." *Chicago Review* 34, no. 2:24–43.

———. 1997. *Maurice Blanchot: The Refusal of Philosophy*. Baltimore: Johns Hopkins University Press.

Bryson, Norman. 1983. *Vision and Painting: The Logic of the Gaze*. New Haven: Yale University Press.

———. 1988. "The Gaze in the Expanded Field." In *Vision and Visuality*, edited by Hal Foster, 87–114. Seattle: Bay.

Bryson, Norman, Michael Ann Holly, and Keith Moxey, eds. 1991. *Visual Theory: Painting and Interpretation*. Cambridge: Polity.

Buchloh, Benjamin H. D., et al., eds. 1983. *Modernism and Modernity*. Halifax: Press of the Nova Scotia College of Art and Design.

Buci-Glucksmann, Christine. 1986. *La folie du voir: de l'esthétique baroque*. Paris: Editions Galilée.

———. 1994. *Baroque Reason: The Aesthetics of Modernity*. Translated by Patrick Camiller. London: Sage.

Buck-Morss, Susan. 1991. *The Dialectics of Seeing: Walter Benjamin and the Arcades Project*. Cambridge: MIT Press.

Burgess, Ernest W., and Robert E. Park, eds. 1921. *Introduction to the Science of Sociology*. Chicago: University of Chicago Press.

Burgin, Victor. 1982. *Thinking Photography*. London: Macmillan.

Burnett, Ron. 1995. *Cultures of Vision: Images, Media and the Imaginary*. Bloomington: Indiana University Press.

Busby, Mark. 1991. *Ralph Ellison*. Boston: Twayne.

Butler, Judith. 1990a. *Gender Trouble: Feminism and the Subversion of Identity*. New York: Routledge.

———. 1990b. "Gender Trouble, Feminist Theory and Psychoanalytic Discourse." In *Feminism/Postmodernism*, edited by Linda J. Nicholson, 324–40. New York: Routledge.

Calland, Robin. 1996. "Fighting Father Science with 'Mother Folklore': Peter Wheatstraw's Limited Resistance to Racist Social Construction in Ellison's *Invisible Man*." Department of English, University of Colorado at Boulder. Unpublished.

Cameron, Sharon. 1989. *Thinking in Henry James*. Chicago: University of Chicago Press.

Carby, Hazel V. 1990. "The Politics of Fiction, Anthropology and the Folk: Zora Neale Hurston." In *New Essays on Zora Neale Hurston*, edited by Michael Awkward, 71–93. Cambridge: Cambridge University Press.

Carlston, Erin. 1998. *Thinking Fascism: Sapphic Modernism and Fascist Modernity*. Stanford: Stanford University Press.

Case, Sue Ellen. 1991. "Tracking the Vampire." *differences* 3, no. 2:1–20.

Caulfield, Mina Davis. 1969. "Culture and Imperialism: Proposing a New Dialectic." In *Reinventing Anthropology*, edited by Dell Hymes, 182–212. New York: Pantheon Books.

Cavell, Stanley. 1979. *The World Viewed: Reflections on the Ontology of Film*. Cambridge: Harvard University Press.

Caws, Maryann. 1981. *The Eye in the Text: Essays on Perception, Mannerist to Modern.* Princeton: Princeton University Press.

———. 1989. *The Art of Interference: Stressed Readings in Visual and Verbal Texts*. Princeton: Princeton University Press.

Cayton, Horace, and St. Clair Drake. 1945. *Black Metropolis*. New York: Harcourt Brace.

Charney, Leo, and Vanessa Schwartz, eds. 1995. *Cinema and the Invention of Modern Life*. Berkeley: University of California Press.

Chefdor, Monique, Ricardo Quinones, and Albert Wachtel, eds. 1986. *Modernism: Challenges and Perspectives*. Urbana: University of Illinois Press.

Cixous, Hélène. 1986. *The Newly Born Woman*. Translated by Betsy Wing. Minneapolis: University of Minnesota Press.

Clark, T. J. 1984. *The Painting of Modern Life: Paris in the Art of Manet and His Followers*. Princeton: Princeton University Press.

Clifford, James. 1983. "On Ethnographic Authority." *Representations* 1, no. 2:118–46.

———. 1986. "On Ethnographic Allegory." In *Writing Culture: The Poetics and Politics of Ethnography*, edited by James Clifford and George E. Marcus, 98–121. Berkeley: University of California Press.

———. 1988. *The Predicament of Culture*. Cambridge: Harvard University Press.

Clipping, Douglas Gilbert. 1943. "When Negro Succeeds, South Is Proud, Zora Hurston Says." *New York World Telegram*, 1 February.

Cohen, Josh. 1998. *Spectacular Allegories: Postmodern American Writing and the Politics of Seeing*. London: Pluto.

Collier, John Jr. 1967. *Visual Anthropology: Photography as a Research Method*. New York: Holt, Rinehart and Winston.

Comolli, Jean-Louis. 1980. "Machines of the Visible." In *The Cinematic Apparatus*, edited by Teresa de Lauretis and Stephen Heath, 121–42. New York: St. Martin's.

Connolly, Julian W. 1990. "Madness and Doubling: From Dostoevsky's *The Double* to Nabokov's *The Eye*." *Russian Literature Triquarterly* 24:129–39.

———. 1992. *Nabokov's Early Fiction*. Cambridge: Cambridge University Press.

———, ed. 1997. *Nabokov's "Invitation to a Beheading": A Critical Companion*. Evanston: Northwestern University Press.

Cooley, Charles Horton. 1909. *Social Organization*. New York: Charles Scribner's Sons.

Cramer, Patricia. 1993. "Virginia Woolf's Matriarchal Family of Origins in *Between the Acts*." *Twentieth Century Literature* 39, no. 2:166–84.

Crary, Jonathan. 1988a. "Modernizing Vision." In *Vision and Visuality*, edited by Hal Foster, 29–50. Seattle: Bay.

———. 1988b. "Spectacle, Attention, Counter-Memory," *October* 50:97–107.

———. 1990. *Techniques of the Observer: On Vision and Modernity in the Nineteenth Century*. Cambridge: MIT Press.

——. 1999. *Suspensions of Perception: Attention, Spectacle, and Modern Culture.* Cambridge: MIT Press.

Crews, Frederick. 1957. *The Tragedy of Manners: Moral Drama in the Later Novels of Henry James.* New Haven: Yale University Press.

Cruse, Harold. 1967. *The Crisis of the Negro Intellectual.* New York: William Morrow.

Cuddy-Keane, Melba. 1990. "The Politics of Comic Modes in Virginia Woolf's *Between the Acts.*" *PMLA* 105, no. 2:273–85.

——. 1997. "Virginia Woolf and the Varieties of Historicist Experience." In *Virginia Woolf and the Essay,* edited by Beth Carole Rosenberg and Jeanne Dubino, 59–77. New York: St. Martin's.

Davie, Sharon. 1993. "Free Mules, Talking Buzzards, and Cracked Plates: The Politics of Dislocation in *Their Eyes Were Watching God.*" *PMLA* 108, no. 3:446–59.

De Lauretis, Teresa, and Stephen Heath, eds. 1980. *The Cinematic Apparatus.* New York: St. Martin's.

De Man, Paul. 1983. *Blindness and Insight: Essays in the Rhetoric of Contemporary Criticism.* Minneapolis: University of Minnesota Press.

Debord, Guy. 1983. *Society of the Spectacle.* Detroit: Black and Red.

——. 1990. *Comments on the Society of the Spectacle.* Translated by Malcolm Imrie. London: Verso.

DeKoven, Marianne. 1991. *Rich and Strange: Gender, History, Modernism.* Princeton: Princeton University Press.

Deleuze, Gilles. 1988. *Foucault.* Translated by Seán Hand. Minneapolis: University of Minnesota Press.

Descartes, René. 1965. *Discourse on Method, Optics, Geometry, and Meteorology.* Translated by Paul J. Olscamp. Indianapolis: Bobbs-Merrill.

Deutsch, Leonard. 1972. "Ralph Waldo Ellison and Ralph Waldo Emerson: A Shared Moral Vision." *College Language Association Journal* 16:159–60.

Dietze, Rudolph F. 1982. *Ralph Ellison: The Genesis of an Artist.* Nürnberg: Verlag Hans Carl.

Doane, Mary Ann. 1987. *The Desire to Desire.* Bloomington: Indiana University Press.

Dolby-Stahl, Sandra. 1992. "Literary Objectives: Hurston's Use of Personal Narrative in *Mules and Men.*" *Western Folklore* 51:51–63.

Dollard, John. 1949. *Caste and Class.* New York: Harper.

Douglass, Frederick. 1969. *My Bondage and My Freedom.* New York: Dover.

Doyle, Laura. 1984. *Bordering on the Body: The Racial Matrix of Modern Fiction and Culture.* New York: Oxford University Press.

Drabble, Margaret, ed. 1985. *Oxford Companion to English Literature.* 5th ed. Oxford: Oxford University Press.

Eagleton, Terry. 1990. *The Ideology of the Aesthetic.* Oxford: Basil Blackwell.

——. 1991. *Walter Benjamin, or towards a Revolutionary Criticism.* London: Verso.

Edmunds, Susan. 1998. "Modern Taste and the Body Beautiful in Nathanael West's *The Day of the Locust.*" *Modern Fiction Studies* 44, no. 2:306–30.

Edwards, Elizabeth, ed. 1992. *Anthropology and Photography, 1860–1920.* New Haven: Yale University Press.

Eisinger, Joel. 1995. *Trace and Transformation: American Criticism of Photography in the Modernist Period.* Albuquerque: University of New Mexico Press.

Eliot, T. S. 1965. "Tradition and the Individual Talent." In *Modern Poetics,* edited by James Scully, 61–70. New York: McGraw-Hill.

Ellison, James. 1974. *Black Sociologists: Historical and Contemporary Perspectives.* Edited by Blackwell and Morris Janowitz. Chicago: University of Chicago Press.

Ellison, Ralph. 1937. "Creative and Cultural Lag." *New Challenge* 2:90–91.

———. 1952. *Invisible Man.* New York: Vintage Books.

———. 1963. "Out of the Hospital and under the Bar." In *Soon, One Morning: New Writing by American Negroes, 1940–1962,* edited by Herbert Hill, 242–90. New York: Alfred A. Knopf.

———. 1995. *The Collected Essays of Ralph Ellison.* Edited by John F. Callahan. New York: Modern Library.

———. 1996. *Flying Home and Other Stories.* Edited by John F. Callahan. New York: Random House.

Emerson, Ralph Waldo. 1992. *The Selected Writings of Ralph Waldo Emerson.* Edited by Brooks Atkinson. New York: Modern Library.

English, James F. 1994. *Comic Transactions.* Ithaca: Cornell University Press.

Ermarth, Elizabeth Deeds. 1988. "Conspicuous Construction; or, Kristeva, Nabokov, and the Anti-Realist Critique." *Novel* 21:2–3.

Eysteinsson, Astradur. 1991. *The Concept of Modernism.* Ithaca: Cornell University Press.

Fabre, Michel. 1982. "Richard Wright, French Existentialism, and *The Outsider.*" In *Critical Essays on Richard Wright,* edited by Yoshinobu Hakutani, 182–98. Boston: G. K. Hall.

Fanon, Frantz. 1967. *Black Skin, White Masks.* Translated by Charles Lam Markmann. New York: Grove Weidenfeld.

Faris, James C. 1992. "A Political Primer in Anthropology/ Photography." In *Anthropology and Photography, 1860–1920,* edited by Elizabeth Edwards, 253–63. New Haven: Yale University Press.

Faulkner, Peter. 1977. *Modernism.* London: Methuen.

Felski, Rita. 1995. *The Gender of Modernity.* Cambridge: Harvard University Press.

Flint, F. S. 1913. "Imagisme," *Poetry* 1, no. 6:198–200.

Foner, Philip S., and Herbert Shapiro, eds. 1991. *American Communism and Black Americans.* Philadelphia: Temple University Press.

Foster, Frances. 1970. "The Black and White Masks of Frantz Fanon and Ralph Ellison." *Black Academy Review* 1, no. 4:46–58.

Foster, Hal, ed. 1988. *Vision and Visuality.* Seattle: Bay.

Foucault, Michel. 1975. *The Birth of the Clinic: An Archaeology of Medical Perception.* Translated by A. M. Sheridan Smith. New York: Vintage.

———. 1977. *Discipline and Punish: The Birth of the Prison.* Translated by Alan Sheridan. New York: Vintage.

———. 1987. *Foucault/Blanchot.* Translated by Brian Massumi and Jeffrey Mehlman. New York: Zone Books.

———. 1988. *Madness and Civilization: A History of Insanity in the Age of Reason.* Translated by Richard Howard. New York: Vintage.

Frazier, Edward Franklin. 1966. *Negro Family in the United States.* Chicago: University of Chicago Press.

Freedman, Jonathan. 1990. *Professions of Taste: Henry James, British Aestheticism, and Commodity Culture.* Stanford: Stanford University Press.

Freud, Sigmund. 1928. "Fetishism." Translated by Joan Rivière. *International Journal of Psycho-Analysis* 9:161–80.

———. 1950. *Totem and Taboo.* Translated by James Strachey. New York: W. W. Norton.

———. 1955. "Group Psychology and the Analysis of the Ego." In *The Standard Edition of the Complete Psychoanalytic Works of Sigmund Freud*, translated by James Strachey, 18:69–143. London: Hogarth.

———. 1958. "The Uncanny." In *On Creativity and the Unconscious: Papers on the Psychology of Art, Literature, Love, Religion*, edited by Benjamin Nelson, 368–407. New York: HarperTorchbooks.

———. 1959. "The Passing of the Oedipus Complex"; "On Narcissism." In *Collected Papers*, edited by Ernest Jones, translated by Joan Riviere, 2:269–76. New York: Basic Books.

———. 1965. "Femininity." In *New Introductory Lectures on Psychoanalysis*, translated by James Strachey, 73–93. New York: Norton.

Friedberg, Anne. 1993. *Window Shopping: Cinema and the Postmodern*. Berkeley: University of California Press.

Fry, Roger. 1920. *Vision and Design*. New York: Brentano's.

Gallagher, Jean. 1998. *The World Wars through the Female Gaze*. Carbondale: Southern Illinois University Press.

Gargano, James W. 1987. *Critical Essays on Henry James: The Late Novels*. Boston: G. K. Hall.

Gates, Henry Louis, Jr. 1988. *The Signifying Monkey*. Oxford: Oxford University Press.

———, ed. 1985. *"Race," Writing and Difference*. Chicago: University of Chicago Press.

Gilbert, Sandra, and Susan Gubar. 1988. *No Man's Land: The Place of the Woman Writer in the Twentieth Century*, vol, 1, *The War of the Words*. New Haven: Yale University Press.

———. 1989. *No Man's Land: The Place of the Woman Writer in the Twentieth Century*, vol. 2, *Sexchanges*. New Haven: Yale University Press.

Gilman, Sander L. 1985. "Black Bodies, White Bodies: Toward an Iconography of Female Sexuality in Late Nineteenth-Century Art, Medicine, and Literature." In *"Race," Writing and Difference*, edited by Henry Louis Gates, Jr., 223–61. Chicago: University of Chicago Press.

Gilman, Sander L., and Nancy Leys Stepan. 1991. "Appropriating the Idioms of Science: The Rejection of Scientific Racism." In *The Bounds of Race: Perspectives on Hegemony and Resistance*, edited by Dominick LaCapra, 72–103. Ithaca: Cornell University Press.

Glicksberg, Charles I. 1970. "The Symbolism of Vision." In *Twentieth Century Interpretations of Invisible Man*, edited by John M. Reilly, 48–55. Englewood Cliffs, N.J.: Prentice-Hall.

Goldberg, David Theo. 1996. "In/Visibility and Super/Vision: Fanon on Race, Veils and Discourses of Resistance." In *Fanon: A Critical Reader*, edited by Lewis R. Gordon et al., 179–200. Oxford: Blackwell.

Goldman, Jane. 1998. *The Feminist Aesthetics of Virginia Woolf: Modernism, Post-Impressionism and the Politics of the Visual*. Cambridge: Cambridge University Press.

Gorak, Jan. 1987. *God the Artist: American Novelists in a Post-Realist Age*. Urbana: University of Illinois Press.

Gordon, Deborah. 1990. "The Politics of Ethnographic Authority: Race and Writing in the Ethnography of Margaret Mead and Zora Neale Hurston." In *Modernist Anthropology*, edited by Marc Manganaro, 146–62. Princeton: Princeton University Press.

Gordon, Lewis R., ed. 1997. *Existence in Black*. New York: Routledge.

Graves, Robert. 1955. *The Greek Myths.* Vols. 1–2. New York: Penguin Books.

Greenberg, Clement. 1946. "The Camera's Glass Eye." *The Nation,* 9 March, 294–96.

Gregg, John. 1988. "Blanchot's Suicidal Artist: Writing the (Im)Possibility of Death." *Sub-Stance: A Review of Theory and Literary Criticism* 17, no. 1:47–58.

——. 1994. *Maurice Blanchot and the Literature of Transgression.* Princeton: Princeton University Press.

Griffin, Susan M. 1991. *The Historical Eye: The Texture of the Visual in Late James.* Boston: Northeastern University Press.

Griffin, Susan M., and William Veeder, eds. 1986. *The Art of Criticism: Henry James on the Theory and Practice of Fiction.* Chicago: University of Chicago Press.

Grimshaw, Anne. 1997. "The Eye in the Door." In *Rethinking Visual Anthropology,* edited by Marcus Banks and Howard Morphy, 36–52. New Haven: Yale University Press.

Gubar, Susan. 1980. " 'The Blank Page' and the Issues of Female Creativity." In *Writing and Sexual Difference,* edited by Elizabeth Abel, 73–94. Chicago: University of Chicago Press.

Gunning, Tom. 1995. "Tracing the Individual Body." In *Cinema and the Invention of Modern Life,* edited by Leo Charney and Vanessa Schwartz, 15–45. Berkeley: University of California Press.

Hakutani, Yoshinobu, ed. 1982. *Critical Essays on Richard Wright.* Boston: G. K. Hall.

Hale, Dorothy J. 1998. *Social Formalism: The Novel in Theory from Henry James to the Present.* Stanford: Stanford University Press.

Hall, Stuart, and Tony Jefferson, eds. 1975. *Resistance through Rituals.* New York: Holmes & Meier.

Hardack, Richard. 1996a. " 'Infinitely Repellent Orbs': Visions of the Self in the American Renaissance." In *Languages of Visuality: Crossings between Science, Art, Politics and Literature,* edited by Beate Allert, 89–110. Detroit: Wayne State University Press.

——. 1996b. " 'Infinitely Repellent Orbs': Visions of the Self in the American Renaissance" (longer version). University of California, Berkeley. Unpublished.

Harold Cruse. 1967. *The Crisis of the Negro Intellectual.* New York: William Morrow.

Heath, Stephen. 1978. "Difference." *Screen* 19, no. 3:51–112.

Heidegger, Martin. 1977. "The Age of the World Picture." In *The Question Concerning Technology and Other Essays,* translated by William Lovitt, 115–54. New York, Garland.

Hemenway, Robert E. 1977. *Zora Neale Hurston: A Literary Biography.* Urbana: University of Illinois Press.

Hernández, Graciela. 1995. "Multiple Subjectivities and Strategic Positionality: Zora Neale Hurston's Experimental Ethnographies." In *Women Writing Culture,* edited by Ruth Behar and Deborah A. Gordon, 148–65. Berkeley: University of California Press.

Heywood, Ian, and Barry Sandywell, eds. 1999. *Interpreting Visual Culture: Explorations in the Hermeneutics of the Visual.* London: Routledge.

Holland, Michael, ed. 1995. *The Blanchot Reader.* Oxford: Blackwell.

Horkheimer, Max, and Theodor W. Adorno. 1969. *Dialectic of Enlightenment.* Translated by John Cumming. New York: Continuum.

Houlgate, Stephen. 1993. "Vision, Reflection, and Openness: The 'Hegemony of

Vision' from a Hegelian Point of View." In *Modernity and the Hegemony of Vision,* edited by David Michael Levin, 87–123. Berkeley: University of California Press.

Hoy, David Couzens, ed. 1986. *Foucault: A Critical Reader.* Oxford: Basil Blackwell.

Hughes, Everett C. 1984. *The Sociological Eye.* New Brunswick, N.J.: Transaction.

Hurston, Zora Neale. 1990a. "Characteristics of Negro Expression." In *The Gender of of Modernism,* edited by Bonnie Kime Scott, 175–87. Bloomington: Indiana University Press.

——. 1990b. *Mules and Men.* New York: 1935. Reprint, HarperPerennial.

——. 1990c. *Tell My Horse.* 1938. Reprint, New York: HarperPerennial.

——. 1990d. *Their Eyes Were Watching God.* 1937. Reprint, New York: HarperPerennial.

——. 1991. *Dust Tracks on a Road.* 1942. Reprint, New York: HarperPerennial.

——. 1995. "What White Publishers Won't Print." In *Zora Neale Hurston: Folklore, Memoirs, and Other Writings,* edited by Cheryl A. Wall, 830–46. New York: Library of America.

Hutchinson, George. 1995. *The Harlem Renaissance in Black and White.* Cambridge: Belknap Press of Harvard University Press.

Huyssen, Andreas. 1986. *After the Great Divide: Modernism, Mass Culture, Postmodernism.* Bloomington: Indiana University Press.

Hymes, Dell, ed. 1969. *Reinventing Anthropology._* New York: Pantheon Books.

Irigaray, Luce. 1985. *Speculum of the Other Woman.* Translated by Gillian C. Gill. Ithaca: Cornell University Press.

James, Henry. 1940. *Stories of Writers and Artists.* Edited by F. O. Matthiessen. New York: New Directions.

——. 1953. *The Sacred Fount.* New York: Grove.

——. 1962. *The Golden Bowl.* New York: Grove.

——. 1965. *The Wings of the Dove.* New York: Penguin.

——. 1986. *The Art of Criticism: Henry James on the Theory and Practice of Fiction,* edited by William Veeder and Susan M. Griffin. Chicago: University of Chicago Press.

——. 1987. *The Complete Notebooks of Henry James,* edited by Leon Edel and Lyall H. Powers. New York: Oxford University Press.

——. 1989. *The Painter's Eye: Notes and Essays on the Pictorial Arts,* edited by John L. Sweeney. Madison: University of Wisconsin Pss.

Jameson, Fredric. 1981. *The Political Unconscious.* Ithaca: Cornell University Press.

——. 1990. *Signatures of the Visible.* New York: Routledge.

——. 1991. *Postmodernism, or, the Cultural Logic of Late Capitalism.* Durham: Duke University Press.

Jardine, Alice A. 1985. *Gynesis: Configurations of Woman and Modernity.* Ithaca: Cornell University Press.

Jay, Martin. 1986. "In the Empire of the Gaze: Foucault and the Denigration of Vision in Twentieth-Century French Thought." In *Foucault: A Critical Reader,* edited by David Couzens Hoy, 175–204. Oxford: Basil Blackwell.

——. 1988a. "Scopic Regimes of Modernity." In *Vision and Visuality,* edited by Hal Foster, 3–28. Seattle: Bay.

——. 1988b. "The Rise of Hermeneutics and the Crisis of Ocularcentrism," *Poetics Today* 9, no. 2:307–26.

——. 1991. "The Disenchantment of the Eye: Surrealism and the Crisis of Ocularcentrism." *Visual Anthropology Review* 7, no. 1:15–38.

———. 1993. *Downcast Eyes: The Denigration of Vision in Twentieth-Century French Thought*. Berkeley: University of California Press.

Jenks, Chris, ed. 1995. *Visual Culture*. London: Routledge.

Jennings, Michael W. 1987. *Dialectical Images: Walter Benjamin's Theory of Literary Criticism*. Ithaca: Cornell University Press.

Johnson, Barbara. 1987. *A World of Difference*. Baltimore: Johns Hopkins University Press.

Johnson, Charles S., ed. 1927. *Ebony and Topaz*. New York: National Urban League.

Johnson, D. Barton. 1985a. "Eyeing Nabokov's *Eye*." *Canadian-American Slavic Studies* 19:328–50.

———. 1985b. "The Books Reflected in Nabokov's *Eye*." *Slavic and East European Journal* 29:393–404.

Johnston, Judith L. 1987. "The Remediable Flaw: Revisioning Cultural History in *Between the Acts*." In *Virginia Woolf and Bloomsbury: A Centenary Celebration*, edited by Jane Marcus, 253–77. Bloomington: Indiana University Press.

Jonas, Hans. 1966. *The Phenomenon of Life: Toward a Philosophical Biology*. New York: Harper & Row.

Joplin, Patricia Klindienst. 1989. "The Authority of Illusion: Feminism and Fascism in Virginia Woolf's *Between the Acts*." *South Central Review* 6, no. 2:88–104.

Judovitz, Dalia. 1993. "Vision, Representation, and Technology in Descartes." In *Modernity and the Hegemony of Vision*, edited by David Michael Levin, 63–86. Berkeley: University of California Press.

Keller, Evelyn Fox, and Christine R. Grontkowski. 1983. "The Mind's Eye." In *Discovering Reality*, edited by Sandra Harding and Merrill B. Hintikka: 207–24. Boston: D. Reidel.

Kent, George E. 1974. "Ralph Ellison and the Afro-American Folk and Cultural Tradition." In *Ralph Ellison*, edited by John Hershey, 169–70. Englewood Cliffs, N.J.: Prentice-Hall.

Kim, Daniel Y. 1997. "Invisible Desires: Homoerotic Racism and Its Homophobic Critique in Ralph Ellison's *Invisible Man*," *NOVEL* 30, no. 3:309–28.

Klineberg, Otto. 1944. *Characteristics of the American Negro*. New York: Harper & Brothers.

Kostelanetz, Richard. 1991. *Politics in the African-American Novel*. New York: Greenwood.

Krauss, Rosalind. 1986. *The Originality of the Avant-Garde and Other Modernist Myths*. Cambridge: MIT Press.

———. 1988. "The Im/pulse to See." In *Vision and Visuality*, edited by Hal Foster, 51–78. Seattle: Bay.

———. 1993. *The Optical Unconscious*. Cambridge: MIT Press.

Kristeva, Julia. 1977. *Polylogue*. Paris: Seuil.

———. 1980. *Desire in Language: A Semiotic Approach to Literature and Art*. Translated by Thomas Gora, Alice Jardine, and Leon S. Roudiez. New York: Columbia University Press.

———. 1984. *Revolution in Poetic Language*. Translated by Margaret Walker. New York: Columbia University Press.

Kruks, Sonia. 1996. "Fanon, Sartre, and Identity Politics." In *Fanon: A Critical Reader*, edited by Lewis R. Gordon, T. Denean Sharpley-Whiting, and Rénee T. White, 122–33. Cambridge: Blackwell.

Krupat, Arnold. 1990. "Irony in Anthropology: The Work of Franz Boas." In *Modernist Anthropology*, edited by Marc Manganaro, 133–45. Princeton: Princeton University Press.

Kuper, Adam. 1988. *The Invention of Primitive Society*. London: Routledge.

Lacan, Jacques. 1977. *Ecrits: A Selection*. Translated by Alan Sheridan. New York: Norton.

——. 1982. *Feminine Sexuality: Jacques Lacan and the Ecole Freudienne*, edited by Juliet Mitchell and Jacqueline Rose. Translated by Jacqueline Rose. New York: W. W. Norton.

Lalvani, Suren. 1996. *Photography, Vision, and the Production of Modern Bodies*. Albany: State University of New York Press.

Laurence, Patricia. 1991. "The Facts and Fugue of War: From *Three Guineas* to *Between the Acts*." In *Virginia Woolf and War: Fiction, Reality and Myth*, edited by Mark Hussey, 225–45. Syracuse: Syracuse University Press.

Lee, Kun Jong. 1992. "Ellison's *Invisible Man*: Emersonianism Revised." *PMLA* 107, no. 2:331–44.

——. 1996. "Ellison's Racial Variations on American Themes." *African American Review* 30, no. 3:421–40.

Levenson, Michael. 1984. *A Genealogy of Modernism: A Study of English Literary Doctrine, 1908–1922*. Cambridge: Cambridge University Press.

Leverenz, David. 1989. "The Politics of Emerson's Man-Making Words." In *Speaking of Gender*, edited by Elaine Showalter, 134–62. London: Routledge.

Levin, David Michael. 1988. *The Opening of Vision: Nihilism and the Postmodern Situation*. London: Routledge.

——, ed. 1993. *Modernity and the Hegemony of Vision*. Berkeley: University of California Press.

Levinas, Emmanuel. 1986. "The Trace of the Other." In *Deconstruction in Context*, edited by Mark C. Taylor, 345–60. Chicago: University of Chicago Press.

Levine, Lawrence W. 1993. *The Unpredictable Past*. New York: Oxford University Press.

Lévi-Strauss, Claude. 1963. *Structural Anthropology*. Translated by Claire Jacobson and Brooke Grundfest Schoepf. New York: Basic Books.

Locke, Alain, ed. 1992. *The New Negro*. New York: Atheneum.

Long, Madeleine J. 1967. *Sartrean Themes in Contemporary American Literature*. Ph.D. diss., Columbia University.

Love, Nancy S. 1991. "Politics and Voice(s): An Empowerment/Knowledge Regime." *Differences* 3, no. 1:85–103.

Lowe, Donald M. 1982. *History of Bourgeois Perception*. Chicago: University of Chicago Press.

Lukács, Georg. 1963. *The Meaning of Contemporary Realism*. Translated by John and Necke Mander. London: Merlin.

——. 1971. *History and Class Consciousness*. Translated by Rodney Livingstone. Cambridge: MIT Press.

Lunn, Eugene. 1982. *Marxism and Modernism: An Historical Study of Lukács, Brecht, Benjamin and Adorno*. Berkeley: University of California Press.

Lury, Celia. 1998. *Prosthetic Culture: Photography, Memory and Identity*. London: Routledge.

Lyman, Stanford M. 1972. *The Black American in Sociological Thought*. New York: G. P. Putnam's Sons.

Lyons, Eleanor. 1989. "Ellison and the Twentieth-Century American Scholar." *Studies in American Fiction* 17, no. 1:93–106.

Maika, Patricia. 1987. *Virginia Woolf's "Between the Acts" and Jane Harrison's "Conspiracy."* Ann Arbor: U.M.I. Research Press.

Manganaro, Marc, ed. 1990. *Modernist Anthropology: From Fieldwork to Text.* Princeton: Princeton University Press.

Marcus, Janc. 1981. "Thinking Back through Our Mothers." In *New Feminist Essays on Virgina Woolf,* edited by Jane Marcus, 1–30. Lincoln: University of Nebraska Press.

Martin, Jay. 1970. *Nathanael West: The Art of His Life.* New York: Farrar, Straus & Giroux.

Marvin, Thomas F. 1996. "Children of Legba: Musicians at the Crossroads in Ralph Ellison's *Invisible Man.*" *American Literature* 68, no. 3:594.

McCole, John. 1993. *Walter Benjamin and the Antinomies of Tradition.* Ithaca: Cornell University Press.

McKee, James B. 1993. *Sociology and the Race Problem: The Failure of a Perspective.* Urbana: University of Illinois Press.

McWhirter, David. 1993. "The Novel, the Play, and the Book: *Between the Acts* and the Tragicomedy of History." *ELH* 60:787–812.

Mellard, James M. 1980. *The Exploded Form: The Modernist Novel in America.* Urbana: University of Illinois Press.

Melville, Stephen W. 1986. *Philosophy beside Itself: On Deconstruction and Modernism.* Minneapolis: University of Minnesota Press.

Merleau-Ponty, Maurice. 1968. *The Visible and the Invisible.* Translated by Alfonso Lingis. Edited by Claude Lefort. Evanston: Northwestern University Press.

———. 1981. *Phenomenology of Perception.* Translated by Colin Smith. London: Routledge & Kegan Paul Humanities.

Miller, D. A. 1980. "Language of Detective Fiction: Fiction of Detective Language." In *The State of the Language,* edited by Leonard Michaels and Christopher Ricks, 478–85. Berkeley: University of California Press.

———. 1988. *The Novel and the Police.* Berkeley: University of California Press.

Minter, David. 1994. *A Cultural History of the American Novel.* Cambridge: Cambridge University Press.

Mirzoeff, Nicholas, ed. 1998. *The Visual Culture Reader.* London: Routledge.

Mitchell, W. J. T. 1986. *Iconology: Image, Text, Ideology.* Chicago: University of Chicago Press.

———. 1994. *Picture Theory: Essays on Verbal and Visual Representation.* Chicago: University of Chicago Press.

———. 1995. "What Is Visual Culture?" In *Meaning in the Visual Arts: Views from the Outside,* edited by Irving Lavin, 207–17. Princeton: Institute for Advanced Study.

Modleski, Tania. 1988. *The Woman Who Knew Too Much: Hitchcock and Feminist Film Theory.* New York: Methuen.

Moi, Toril. 1985. *Sexual/Textual Politics.* London: Methuen.

Moon, Heath. 1988. "Saving James from Modernism: How to Read *The Sacred Fount.*" *Modern Language Quarterly* 49, no. 2:120–41.

Moses, Gavriel. 1995. *The Nickel Was for the Movies.* Berkeley: University of California Press.

Mulvey, Laura. 1975. "Visual Pleasure and Narrative Cinema." *Screen* 16, no. 3:412–13.

——. 1989. *Visual and Other Pleasures*. Bloomington: Indiana University Press.

Mumford, Lewis 1926. *The Golden Day*. New York: Boni and Liveright.

Mykyta, Larysa. 1988. "Blanchot's *Au moment voulu*: Woman as the Eternally Recurring Figure of Writing." In *Gendered Agents: Women and Institutional Knowledge*, edited by Silvestra Mariniello and Paul A. Bove, 349–70. Durham: Duke University Press.

Myrdal, Gunnar. 1944. *An American Dilemma*. New York: Harper & Row.

Nabokov, Vladimir. 1966. *Speak, Memory*. New York: G. P. Putnam's Sons.

——. 1989a. *Invitation to a Beheading*. Translated by Dmitri Nabokov. New York: Vintage Books.

——. 1989b. *Lolita*. New York: Vintage.

——. 1990. *The Eye*. Translated by Dmitri Nabokov in collaboration with the author. New York: Vintage Books.

——. 1991. *Laughter in the Dark*. New York: New Directions Books.

Naison, Mark. 1983. *Communists in Harlem during the Depression*. Urbana: University of Illinois Press.

Newfield, Christopher. 1996 *The Emerson Effect*. Chicago: University of Chicago Press.

Newman, Michael. 1996. "The Trace of Trauma: Blindness, Testimony and the Gaze in Blanchot and Derrida." In *Maurice Blanchot: The Demand of Writing*, edited by Carolyn Bailey Gill, 153–73. London: Routledge.

Nichols, William. 1970. "Ralph Ellison's Black American Scholar." *Phylon* 31:70–75.

Nicholson, Linda J., ed. 1990. *Feminism/Postmodernism*. New York: Routledge.

Nicoloff, Philip L. 1961. *Emerson on Race and History*. New York: Columbia University Press.

North, Michael. 1994. *The Dialect of Modernism*. New York: Oxford University Press.

Olsen, Lance. 1995. *Lolita: A Janus Text*. New York: Twayne.

Ostendorf, Berndt. 1982. *Black Literature in White America*. Totowa, N.J.: Barnes and Noble.

——. 1986. "Anthropology, Modernism, and Jazz." In *Ralph Ellison*, edited by Harold Bloom, 145–72. New York: Chelsea House.

Ostendorf, Bernhard. 1976. "Ralph Ellison's 'Flying Home': From Folk Tale to Short Story," *Journal of the Folklore Institute* 13, no. 2:185–99.

Ovid. 1955. *Metamorphoses*. Translated by Rolfe Humphries. Bloomington: Indiana University Press.

Packman, David. 1982. *Vladimir Nabokov: The Structure of Literary Desire*. Columbia: University of Missouri Press.

Palyi, Melchior. 1972. *The Twilight of Gold, 1914–1936*. Chicago: Henry Regnery.

Panichas, George A., ed. 1971. *The Politics of Twentieth-Century Novelists*. New York: Hawthorn Books.

Park, Robert E. 1950. *Race and Culture*. New York: Free Press.

Park, Robert E., and Ernest W. Burgess, eds. 1921. *Introduction to the Science of Sociology*. Chicago: University of Chicago Press.

Pensky, Max. 1996. "Tactics of Remembrance: Proust, Surrealism, and the Origin of the Passagenwerk." In *Walter Benjamin and the Demands of History*, edited by Michael P. Steinberg, 165–89. Ithaca: Cornell University Press.

Persons, Stow. 1987. *Ethnic Studies at Chicago, 1905–45*. Urbana: University of Illinois Press.

Pettigrew, Thomas F, ed. 1980. *The Sociology of Race Relations: Reflection and Reform.* New York: Free Press.

Pifer, Ellen. 1980. *Nabokov and the Novel.* Cambridge: Harvard University Press.

Pinney, Christopher. 1992. "The Parallel Histories of Anthropology and Photography." In *Anthropology and Photography, 1860–1920,* edited by Elizabeth Edwards, 74–95. New Haven: Yale University Press.

Poe, Edgar Allan. 1970. *Great Short Works of Edgar Allan Poe,* edited by G. R. Thompson. New York: Harper & Row.

Poovey, Mary. 1986. " 'Scenes of an Indelicate Character': The Medical 'Treatment' of Victorian Women." *Representations* 14:137–68.

Porter, Carolyn. 1981. *Seeing and Being: The Plight of the Participant Observer in Emerson, James, Adams, and Faulkner.* Middletown, Conn.: Wesleyan University Press.

Posnock, Ross. 1987. "Henry James, Veblen, and Adorno: The Crisis of the Modern Self." *Journal of American Studies* 21, no. 1:31–54.

———. 1998. *Color and Culture: Black Writers and the Making of the Modern Intellectual.* Cambridge: Harvard University Press.

Pound, Ezra. 1913. "A Few Don'ts by an Imagiste." *Poetry* 1, no. 6:200–206.

Pridmore-Brown, Michele. 1998. "1939–40: Of Virginia Woolf, Gramaphones, and Fascism." *PMLA* 113, no. 3:408–21.

Pucket, Niles Newbell. 1926. *Folk Beliefs of the Southern Negro.* Chapel Hill: University of North Carolina Press.

Rajchman, John. 1988. "Foucault's Art of Seeing." *October* 44:89–199.

Rampton, David. 1984. *Vladimir Nabokov: A Critical Study of the Novels.* New York: Cambridge University Press.

———. 1993. *Vladimir Nabokov.* New York: St. Martin's.

Ray, Sangeeta. 1990. "The Discourse of Silence: Narrative Interruption and Female Speech in Woolf's *Between the Acts.*" *Works and Days: Essays in the Socio-Historical Dimensions of Literature and the Arts* 8, no. 1:37–50.

Reany, James. 1962. "The Condition of Light: Henry James's *The Sacred Fount,*" *University of Toronto Quarterly* 31:136–51.

Record, Wilson. 1951. *The Negro and the Communist Party.* Chapel Hill: University of North Carolina Press.

Reed, Alan, ed. 1996. *The Fact of Blackness: Frantz Fanon and Visual Representation.* Seattle: Bay.

Reed, David. 1997. *The Popular Magazine in Britain and the United States, 1880–1960.* Toronto: University of Toronto Press.

Reynaud, Claudine. 1992. " 'Rubbing a Paragraph with a Soft Cloth'? Muted Voices and Editorial Constraints in *Dust Tracks on the Road.*" In *De/Colonizing the Subject,* edited by Sidonie Smith and Julie Watson, 34–64. Minneapolis: University of Minnesota Press.

Richman, Michèle. 1990. "Anthropology and Modernism in France: From Durkheim to the *Collège de sociologie.*" In *Modernist Anthropology: From Fieldwork to Text,* edited by Marc Manganaro, 183–214. Princeton: Princeton University Press.

Ricoeur, Paul. 1974. *The Conflict of Interpretations.* Translated by Don Ihde. Evanston: Northwestern University Press.

Robbins, Richard. 1974. "Charles S. Johnson." In *Black Sociologists: Historical and Contemporary Perspectives,* edited by James E. Blackwell and Morris Janowitz, 56–84. Chicago: University of Chicago Press.

Roberts, Brian. 1975. "Naturalistic Research into Subcultures and Deviance." In *Resistance through Rituals,* edited by Stuart Hall and Tony Jefferson, 243–52. New York: Holmes & Meier.

Roberts, Mathew. 1996. "Bonfire of the Avant-Garde: Cultural Rage and Readerly Complicity in *The Day of the Locust.*" *Modern Fiction Studies* 42, no. 1:61–90.

Roberts, Ruth. 1983. *Arnold and God.* Berkeley: University of California Press.

Rohrberger, Mary. 1989. " 'Ball the Jack': Surreality, Sexuality, and the Role of Women in *Invisible Man.*" In *Approaches to Teaching Ellison's "Invisible Man,"* edited by Susan Resneck Parr and Pancho Savery, 124–32. New York: Modern Language Association of America.

Rolleston, James L. 1989. "The Politics of Quotation: Walter Benjamin's Arcades Project." *PMLA* 104, no.1:13–27.

Rony, Fatimah Tobing. 1996. *The Third Eye: Race, Cinema, and Ethnographic Spectacle.* Durham: Duke University Press.

Rorty, Richard. 1979. *Philosophy and the Mirror of Nature.* Princeton: Princeton University Press.

Rose, Jacqueline. 1982. "Introduction-II." In *Feminine Sexuality: Jacques Lacan and the Ecole Freudienne,* edited by Juliet Mitchell and Jacqueline Rose, translated by Jacqueline Rose, 27–58. New York: W. W. Norton.

———. 1986. *Sexuality in the Field of Vision.* London: Verso.

Ross, Dorothy, ed. 1994. *Modernist Impulses in the Human Sciences, 1870–1930.* Baltimore: Johns Hopkins University Press.

Rourke, Constance. 1931. *American Humor.* New York: Harcourt, Brace.

———. 1942. *The Roots of American Culture.* New York: Harcourt, Brace.

Rovit, Earl. 1960. " Ralph Ellison and the American Comic Tradition." *Wisconsin Studies in Contemporary Literature* 1, no. 3:34–42.

Rowe, John Carlos. 1982. *Through the Custom House.* Baltimore: Johns Hopkins University Press.

Rubin, Joan Shelley. 1980. *Constance Rourke and American Culture.* Chapel Hill: University of North Carolina Press.

Rubin, Steven J. 1969. *Richard Wright and Ralph Ellison: Black Existential Attitudes.* Ph.D. diss., University of Michigan.

Ryan, Judith. 1991. *The Vanishing Subject: Early Psychology and Literary Modernism.* Chicago: University of Chicago Press.

Said, Edward W. 1975. *Beginnings: Intention and Method.* Baltimore: Johns Hopkins University Press.

———. 1993. *Culture and Imperialism.* New York: Vintage Books.

Sánchez-Eppler, Benigno. 1992. "Telling Anthropology: Zora Neale Hurston and Gilberto Freyre Disciplined in Their Field-Home-Work." *American Literary History* 4, no. 3:464–88.

Sandeen, Eric J. 1995. *Picturing an Exhibition: The Family of Man and 1950s America.* Albuquerque: University of New Mexico Press.

Sandywell, Barry. 1999. "Specular Grammar: The Visual Rhetoric of Modernity." In *Interpreting Visual Culture: Explorations in the Hermeneutics of the Visual,* edited by Ian Heywood and Barry Sandywell, 30–56. London: Routledge.

Sartre, Jean-Paul. 1947. *Existentialism.* Translated by Bernard Frechtman. New York: Philosophical Library.

———. 1956. *Being and Nothingness.* Translated by Hazel E. Barnes. New York: Washington Square.

———. 1963. *Black Orpheus*. Translated by S. W. Allen. Paris: Presence africaine.

———. 1988. *"What Is Literature?" and Other Essays*. Cambridge: Harvard University Press.

———. 1997. "Return from the United States: What I Learned about the Black Problem." In *Existence in Black*, edited by Lewis R. Gordon, translated by T. Denean Sharpley-Whiting, 83–89. New York: Routledge.

Sarver, Stephanie. 1996. "Homer Simpson Meets Frankenstein: Cinematic Influence in Nathanael West's *The Day of the Locust*." *Literature/Film Quarterly* 24, no. 2:217–22.

Savery, Pancho. 1989. " 'Not like an arrow, but a boomerang': Ellison's Existential Blues." In *Approaches to Teaching Ellison's "Invisible Man,"* edited by Susan Resneck Parr and Pancho Savery, 65–74. New York: Modern Language Association of America.

Schaeffer, Susan Fromberg. 1972. "The Editing Blinks of Vladimir Nabokov's *The Eye*." *University of Windsor Review* 8:5–30.

Schneider, Karen. 1989. "Of Two Minds: Woolf, the War, and *Between the Acts*." *Journal of Modern Literature* 16, no. 1:93–112.

Schulkind, Jeanne. 1976. *Moments of Being*. New York: Harcourt Brace Jovanovich.

Schwarz, Daniel R. 1997. *Reconfiguring Modernism: Explorations in the Relationship between Modern Art and Modern Literature*. New York: St. Martin's.

Scott, Bonnie Kime, ed. 1990. *The Gender of of Modernism*. Bloomington: Indiana University Press.

Sears, Sally. 1983. "Theater of War: Virginia Woolf's *Between the Acts*." In *Virginia Woolf: A Feminist Slant*, edited by Jane Marcus, 212–35. Lincoln: University of Nebraska Press.

Sedgwick, Eve. 1986. "The Beast in the Closet: James and the Writing of Homosexual Panic." In *Sex, Politics, and Science in the Nineteenth-Century Novel*, edited by Ruth Yeazell, 148–86. Baltimore: Johns Hopkins University Press.

Sekula, Allan. 1983. "The Traffic in Photographs." In *Modernism and Modernity*, edited by Benjamin H. D. Buchloh et al., 121–54. Halifax: Press of the Nova Scotia College of Art and Design.

Seltzer, Mark. 1984. *Henry James and the Art of Power*. Ithaca: Cornell University Press.

Shattuck, Sandra D. 1987. "The Stage of Scholarship: Crossing the Bridge from Harrison to Woolf." In *Virginia Woolf and Bloomsbury: A Centenary Celebration*, edited by Jane Marcus, 278–98. Bloomington: Indiana University Press.

Shaviro, Steven. 1990. *Passion and Excess: Blanchot, Bataille, and Literary Theory*. Tallahassee: Florida State University Press.

Shloss, Carol. 1987. *Invisible Light: Photography and the American Writer, 1840–1940*. New York: Oxford University Press.

Silverman, Kaja. 1988. *The Acoustic Mirror*. Bloomington: Indiana University Press.

Simon, Richard Keller. 1993. "Between Capra and Adorno: West's *Day of the Locust* and the Movies of the 1930s." *Modern Language Quarterly* 54, no. 4:513–34.

Sitney, P. Adams. 1990. *Modernist Montage: The Obscurity of Vision in Cinema and Literature*. New York: Columbia University Press.

Smith, Dennis. 1988. *The Chicago School: A Liberal Critique of Capitalism*. New York: St. Martin's.

Smith, Shawn Michelle. 1999. *American Archives: Gender, Race, and Class in Visual Culture*. Princeton: Princeton University Press.

Smith, Sidonie, and Julie Watson, eds. 1992. *De/Colonizing the Subject*. Minneapolis: University of Minnesota Press.

Smock, Ann. 1981. *Double Dealing*. Lincoln: University of Nebraska Press.

Sobchack, Vivian. 1997. "Phenomenology and the Film Experience." In *Viewing Positions: Ways of Seeing Film*, edited by Linda Williams, 36–58. New Brunswick, N.J.: Rutgers University Press.

Solomon-Godeau, Abigail. 1991. *Photography at the Dock*. Minneapolis: University of Minnesota Press.

Sontag, Susan. 1977. *On Photography*. New York: Farrar, Straus & Giroux.

——. 1996. *Against Interpretation*. New York: Farrar, Straus & Giroux.

Sophocles. 1942. *Oedipus the King*. Translated by David Grene. Chicago: Univerity of Chicago Press.

Spiegel, Alan. 1976. *Fiction and the Camera Eye: Visual Consciousness in Film and the Modern Novel*. Charlottesville: University Press of Virginia.

Spillers, Hortense. 1989. " 'The Permanent Obliquity of an In(pha)llibly Straight': In the Time of the Daughters and the Fathers." In *Changing Our Own Words*, edited by Cheryl Wall, 127–49. New Brunswick, N.J.: Rutgers University Press.

Stein, William Bysshe. 1971. "*The Sacred Fount* and British Aestheticism: The Artist as Clown and Pornographer." *Arizona Quarterly* 27:161–73.

Steiner, George. 1975. *After Babel*. London: Oxford University Press.

Steiner, Wendy. 1982. *The Colors of Rhetoric: Problems in the Relation of Modern Literature and Painting*. Chicago: University of Chicago Press.

Stepan, Nancy Leys, and Sander L. Gilman. 1991. "Appropriating the Idioms of Science: The Rejection of Scientific Racism." In *The Bounds of Race: Perspectives on Hegemony and Resistance*, edited by Dominick LaCapra, 72–103. Ithaca: Cornell University Press.

Stepto, Robert B. 1987. "Literacy and Hibernation: Ralph Ellison's *Invisible Man*." In *Speaking for You*, edited by Kimberly Benston, 360–85. Washington, D.C.: Howard University Press.

Stoddard, Lothrop. 1921. *The Rising Tide of Color*. New York, Charles Scribner's Sons.

Stoekl, Allan. 1985. *Politics, Writing, Mutilation*. Minneapolis: University of Minnesota Press.

Strand, Paul. 1980. "Photography." In *Classic Essays on Photography*, edited by Alan Trachtenberg, 141–53. New Haven: Leete's Island.

Strychacz, Thomas. 1993. *Modernism, Mass Culture, and Professionalism*. Cambridge: Cambridge University Press.

Sundquist, Eric J., ed. 1995. *Cultural Contexts for Ralph Ellison's "Invisible Man."* Boston: Bedford.

Sutherland, Judith L. 1984. *The Problematic Fictions of Poe, James, and Hawthorne*. Columbia: University of Missouri Press.

Szwed, John F. 1969. "An American Anthropological Dilemma: The Politics of Afro-American Culture." In *Reinventing Anthropology*, edited by Dell Hymes, 153–81. New York: Pantheon.

Tagg, John. 1988. *The Burden of Representation*. Amherst: University of Massachusetts Press.

Tate, Claudia. 1987. "Notes on the Invisible Women in Ralph Ellison's *Invisible Man*." In *Speaking for You*, edited by Kimberly Benston, 163–72. Washington, D.C.: Howard University Press.

Taylor, Lucien, ed. 1994. *Visualizing Theory: Selected Essays from V.A.R., 1990–1994.* New York: Routledge.

Taylor, Mark C. 1987. *Altarity.* Chicago: University of Chicago Press.

Theweleit, Klaus. 1987. *Male Fantasies*, vol. 1, *Women, Floods, Bodies, History.* Translated by Stephen Conway. Minneapolis: University of Minnesota Press.

Thomas, W. I. 1904. "The Psychology of Race Prejudice." *American Journal of Soci ology* 9:593–611.

Tiedemann, Rolf. 1999. "Dialectics at a Standstill: Approaches to the *Passagenwerk*," In *The Arcades Project*, by Walter Benjamin, 929–45. Cambridge: Belknap Press of Harvard University Press.

Tintner, Adeline R. 1995. "A Gay *Sacred Fount*: The Reader as Detective." *Twentieth Century Literature* 41:224–40.

Toker, Leona. 1995. "Nabokov and Bergson." In *The Garland Companion to Vladimir Nabokov*, edited by Vladimir E. Alexandrov, 367–73. New York: Garland.

Torgovnick, Marianna. 1985. *The Visual Arts, Pictorialism, and the Novel.* Princeton: Princeton University Press.

———. 1990. *Gone Primitive: Savage Intellects, Modern Lives.* Chicago: University of Chicago Press.

Tratner, Michael. 2000. "Why Isn't *Between the Acts* a Movie? Comparing the Anti-Fascist Aesthetics of Virginia Woolf and Walter Benjamin." In *Virginia Woolf in the Age of Mechanical Reproduction*, edited by Pamela L. Caughie, 115–34. New York: Garland.

Trimmer, Joseph F. 1972. "Ralph Ellison's 'Flying Home.' " *Studies in Short Fiction* 9:175–82.

Tyler, Parker. 1963. "*The Sacred Fount*: 'The Actuality Pretentious and Vain' vs. 'The Case Rich and Edifying,' " *Modern Fiction Studies* 9:127–38.

Veitch, Jonathan. 1997. *American Superrealism: Nathanael West and the Politics of Representation in the 1930s.* Madison: University of Wisconsin Press.

Virilio, Paul. 1989. *War and Cinema: The Logistics of Perception.* Translated by Patrick Camiller. London: Verso.

Walker, John A., and Sarah Chaplin, eds. 1997. *Visual Culture.* Manchester: Manchester University Press.

Wall, Cheryl A. 1995a. *Women of the Harlem Renaissance.* Bloomington: Indiana University Press.

———, ed. 1995b. *Zora Neale Hurston: Folklore, Memoirs, and Other Writings.* New York: Library of America.

Washington, Mary Helen. 1988. *Invented Lives: Narratives of Black Women, 1860–1960.* New York: Anchor-Doubleday.

Watts, Jerry Gafio. 1994. *Heroism and the Black Intellectual.* Chapel Hill: University of North Carolina Press.

Weed, Elizabeth, ed. 1989. *Coming to Terms: Feminism, Theory, Politics.* New York: Routledge.

Weinberger, Eliot. 1994. "The Camera People." In *Visualizing Theory: Selected Essays from V.A.R., 1990–1994*, edited by Lucien Taylor, 3–26. New York: Routledge.

Weinstein, Deena, and Michael Weinstein. 1984. "On the Visual Constitution of Society: The Contributions of Georg Simmel and Jean-Paul Sartre to a Sociology of the Senses." *History of European Ideas* 5, no. 4:349–62.

Weiss, Allen S. 1989. *The Aesthetics of Excess.* Albany: State University of New York Press.

West, Cornel. 1989. *The American Evasion of Philosophy.* Madison: University of Wisconsin Press.

West, Nathanael. 1962. *Miss Lonelyhearts & The Day of the Locust.* New York: New Directions.

——. 1963. *The Dream Life of Balso Snell, A Cool Million.* New York: Farrar, Straus.

West, Rebecca. 1953. Introduction to *The Sacred Fount,* by Henry James. New York: Grove.

Whicher, Stephen E. 1953. *Freedom and Fate: An Inner Life of Ralph Waldo Emerson.* Philadelphia: University of Pennsylvania Press.

Wiegman, Robyn. 1995. *American Anatomies: Theorizing Race and Gender.* Durham: Duke University Press.

Wiley, Catherine. 1995. "Making History Unrepeatable in Virginia Woolf's *Between the Acts.*" *CLIO* 25, no. 1:3–20.

Williams, Linda, ed. 1997. *Viewing Positions: Ways of Seeing Film.* New Brunswick, N.J.: Rutgers University Press.

Williams, Raymond. 1989. *The Politics of Modernism.* London: Verso.

Williams, Vernon J., Jr. 1989. *From a Caste to a Minority: Changing Attitudes of American Sociologists toward Afro-Americans, 1896–1945.* New York: Greenwood.

——. 1996. *Rethinking Race: Franz Boas and His Contemporaries.* Lexington: University Press of Kentucky.

Willis, William S. 1969. "Skeletons in the Anthropological Closet." In *Reinventing Anthropology,* edited by Dell Hymes, 121–52. New York: Pantheon Books.

Wolin, Richard. 1982. *Walter Benjamin: An Aesthetic of Redemption.* New York: Columbia University Press.

Wood, Michael. 1994. *The Magician's Doubts: Nabokov and the Risks of Fiction.* Princeton: Princeton University Press.

Woolf, Virginia. 1929. *A Room of One's Own.* New York: Harcourt, Brace & World.

——. 1941. *Between the Acts.* New York: Harcourt Brace Jovanovich.

——. 1942. *The Death of the Moth and Other Essays.* New York: Harcourt Brace Jovanovich.

——. 1953. *A Writer's Diary,* edited by Leonard Woolf. New York: Harcourt Brace.

——. 1966–67. *Collected Essays.* Vols. 1–4. London: Hogarth.

——. 1976. *Moments of Being.* Edited by Jeanne Schulkind. New York: Harcourt Brace Jovanovich.

——. 1977–84. *The Diaries of Virginia Woolf.* Edited by Anne Olivier Bell. Vols. 1–5. New York: Harcourt Brace Jovanovich.

——. 1979. "Anon." *Twentieth Century Literature* 25, nos. 3–4:356–426.

——. 1980. *The Letters of Virginia Woolf, 1936–41,* edited by Nigel Nicolson. London: Hogarth.

——. 1983. *Pointz Hall: The Earlier and Later Typescripts of "Between the Acts,"* edited by Mitchell A. Leaska. New York: University Publications.

Wright, John. 1980. "Dedicated Dreamer, Consecrated Acts: Shadowing Ellison." *Carleton Miscellany* 18, no. 3:142–99.

Wright, Richard. Papers. Bieneke Library, Yale University.

Young, Elizabeth. 1991. "Here Comes the Bride: Wedding Gender and Race in *Bride of Frankenstein.*" *Feminist Studies* 17, no. 3:423–26.

Žižek, Slavoj. 1989a. "Looking Awry." *October* 50:31–55.

——. 1989b. *The Sublime Object of Ideology*. London: Verso.

——. 1990. "How the Non-Duped Err." *Qui Parle* 4, no. 1:1–20.

——. 1993. *Tarrying with the Negative*. Durham: Duke University Press.

——. 1999. *The Ticklish Subject: The Absent Center of Political Ontology*. London: Verso.

Zwerdling, Alex. 1986. *Virginia Woolf and the Real World*. Berkeley: University of California Press.

Index

Absurd, the, 193
Adams, Ansel, 23–24
Adorno, Theodore, 213, 216, 248n
Aesthetic standards, 123–25, 140–41
Aestheticization, 21, 26, 61–64, 70
Aestheticization of politics, 43, 203–4, 207, 212, 257
Afterimage, 2, 19, 112
Alienated labor, 251
Allegory, 209, 211, 221–22, 262
Althusser, Louis, 16, 79
Ambassadors, The (James), 69
American Dilemma, An (Myrdal), 156–58
"American Scholar, The" (Emerson), 178
Animal relations, 161–62, 177
"Anon" (Woolf), 208, 215
Anthropology: Boasian, 116–19; and Hurston, 112–14, 125–26, 136–39, 144; native point of view, 115; and observation, 29–30; practices of, 115–16; and race, 40–41, 155–56; and Woolf, 276
Anti-Semite and Jew (Sartre), 192
Arcades Project (Benjamin), 42–43, 206–7, 212, 216–17, 223, 227–28
Armstrong, Nancy, 26
Armstrong, Tim, 28
Asch, Timothy, 32
Audience, 204, 221, 236. *See also* Spectatorship
Aura, 203, 212
"Author as Producer, The" (Benjamin), 21
Authorship, 39, 68–69, 72, 273

Autobiography of an Ex-Coloured Man (Johnson), 148
Ayer, A. J., 191

Bad faith, 193
Baker, Houston, 173
Bakhtin, M. M., 6
Balinese Character (Mead), 32
Baroque, 7, 211
Barter, 140
Barthes, Roland, 19–20
Bataille, Georges, 81, 87–88n
Batchen, Geoffrey, 24
Bateson, Gregory, 32
Baudelaire (Sartre), 192
Baudrillard, Jean: and the hyperreal, 21; and image technologies, 275–76; and the schizophrenic subject , 279; and simulacra, 266; and trompe l'oeil, 258–59
Bazin, André, 23
"Behind Our Masks" (Park), 156
Being and Nothingness (Sartre), 17, 94–95, 191–93
Benedict, Ruth, 114, 276
Benjamin, Walter: and the aestheticization of politics, 203–4, 257; and constellation, 209–11, 220–21, 241; and the dialectical image, 37, 209, 211–16, 234, 241; on the flaneur, 31; and the fragment, 42–43, 239; on photography, 21, 27, 264; and the politicization of art, 238; on prostitution, 255; and unconscious optics, 14; and the wish image 14–25, 227–28, 215,

Benjamin, Walter (continued)
231–32, 235; and Woolf, 205, 205n, 206,
223. Works: "Author as Producer, The,"
21; Das Passagen-Werk, 42–43, 206–7, 212,
216–17, 223, 227–28; "Epistemo-Critical
Prologue," 209; One-Way Street, 210;
"Paris—the Capital of the Nineteenth
Century," 214–16; "Theses on the Philos-
ophy of History," 212, 214, 234; Trauer-
spiel, 209–12; "The Work of Art in the
Age of Mechanical Reproduction," 203,
207, 212, 264
Bentham, Jeremy, 31
Between the Acts (Woolf): 42–43, 204–9,
217–42, 257; and "Anon," 207–8, 215;
and Benjamin, 203–217, 220–21, 223,
227–8, 234, 238–9, 241; and constella-
tion, 204, 218–20, 222, 226, 235, 237,
241; and the dialectical image, 42, 204,
237–38; and fascism, 221, 233–34; and
gender, 228–34, 237–38; and history,
206, 208–9, 223–42; and the lily pool,
216, 231–34, 241, 257; and time, 223–
25; and the village pageant, 42–43, 204,
208, 217–42; and war, 203–4, 218; and
Nathaniel West, 257
Bhabha, Homi, 1n, 167
Birth of a Nation (Griffith), 33
Black Metropolis (Cayton and Drake), 151
"Black Orpheus" (Sartre), 194–95
Black Skin, White Masks (Fanon), 195–96
Blanchot, Maurice, 1, 39–40, 80, 87–96,
100–109, 279–80
Boas, Franz: and Hurston, 111, 120; and
the independence of culture, 154; and
the participant-observer method, 40,
115–16; and race, 116–18, 153, 276
Bordo, Susan, 11–13
Bourdieu, Pierre, 23
Bowlby, Rachel, 15, 25, 255
Braithwaite, William Stanley, 118–19
Brecht, Bertolt, 205n, 207
Brooks, Van Wyck, 159
Brown, Sterling, 152
Bruns, Gerald L., 102
Buck-Morss, Susan, 207
Bunch, William (Peetie Wheatstraw), 177
Burgess, Ernest W., 28, 156
Burgin, Victor, 20
Burroughs, Edgar Rice, 35
Butler, Judith, 253

Camera Lucida (Barthes), 21
Camera obscura, 14–16, 55, 66
"Camera's Glass Eye, The" (Greenberg), 23
Cantos (Pound), 122
Capra, Frank, 246n

Carby, Hazel, 125–26, 135
Cartesian perspectivalism: critique of, 38;
and Day of the Locust, 259; erosion of, in
the modern period, 7–8; and The Eye, 78,
274; and Invisible Man, 187, 189; and
modernism, 52; and the new visual tech-
nologies, 36; and omniscience, 71; ori-
gins of, 9–10; and photography, 25, 55;
and realism, 47–51; and Renaissance per-
spective, 12; and the return of the body,
17–18; in The Sacred Fount, 55
Caste and Class (Dollard), 155n
Castration, 16, 83–86, 91–97
Cayton, Horace, 151, 161, 174, 176
"Change the Joke and Slip the Yoke" (Elli-
son), 160
"Characteristics of Negro Expression"
(Hurston), 121, 123, 132, 137–41
Chicago school of sociology, 155, 157
Chinese ideograms, 122
"Circles" (Emerson), 197
Clifford, James, 33, 115
Collected Essays (Ellison), 150, 158
Collective unconscious, 206, 212, 215–16,
221, 232
Collectivity, 188, 190, 204, 209, 215
Commodification, 63n, 64
Commodity, the: in Benjamin, 206, 211; in
Marx, 25, 255; in Nathanael West, 248,
251, 254–55, 260, 262
Communism, 151–52, 185, 203
Constellation, 204, 209–26, 235–42. See also
Benjamin, Walter
Consumerism: and Benjamin, 207; in
Lolita, 44, 264, 268–69; and Nathanael
West, 253; Sontag's critique of, 21; and
visual technologies, 2
Contemplation, aesthetic, 217, 227, 238
Cooley, Charles Horton, 153
Cooper, Merian, 35
Copy, the, 26, 75–76
Craniology, 155
Crary, Jonathan, 14–15, 66
"Creative and Cultural Lag" (Ellison), 159
Crowd, 204, 221. See also Spectatorship
Cuddy-Keane, Melba, 219
Cullen, Countee, 151
Cultural relativism, 116–19, 139, 151, 278

Daumier, Honoré, 248
Davie, Sharon, 125–26, 132
Day of the Locust, The (West): 43, 243–63,
278; and high and low culture, 244, 248,
258, 262; and gender, 253–58; and the in-
terior gaze, 259; and mass culture,
244–48, 253–61, 278–79; and pastiche,
245–46, 246n, 249, 254–55; and rape fan-

Day of the Locust, The (West) *(continued)*
 tasies, 256–57, 260–61, 278; and trompe
 l'oeil, 258–59, 261; and Woolf, 257
Debord, Guy, 14–15, 32, 76, 243, 263, 268
Deflowering, 95, 194
Descartes, René, 1, 10–13. *See also* Cartesian
 perspectivalism
Detective fiction: and James, 54, 70; and
 knowledge, 39, 49–51; and modernism,
 3n, 6–7; and Nabokov, 72
Deutsch, Leonard, 165
Dialect, black, 7, 40, 118, 127
Dialectical image: and Benjamin, 37, 207,
 209, 211–16, 234, 241; and Woolf, 37,
 42, 204, 237–38. *See also* Flash, the
Disciplinary schemas, 22, 38, 48, 52, 74. *See
 also* Panopticism; Surveillance
Discipline and Punish (Foucault), 13–14
Disembodied eye, 53, 74–75, 114, 182, 197
Disembodiment, 7, 9, 48, 72, 170, 197
Doane, Mary Ann, 16
Dollard, John, 155n
Domesday Book, 224–25
Dostoevsky, Fyodor, 73n, 190
Double, The (Dostoevsky), 73n
Double-consciousness, 146, 147
Drake, St. Clair, 151
Dreiser, Theodore, 278
Dualism, 10–11
DuBois, W. E. B., 146–47
Dust Tracks on a Road (Hurston), 124

Eagleton, Terry, 210, 217, 220
Ebony and Topaz (Johnson and Cullen), 151
Economic exchange, 64. *See also* Monetary
 metaphors; Property
Edmunds, Susan, 257–58
Einstein, Albert, 218n
Eisinger, Joel, 22
El Greco, 269
Eliot, T. S., 27, 216–17, 249
Ellison, Ralph W., 41, 145–99. Works: *Col-
 lected Essays*, 150, 158; "Flying Home,"
 162; "Hidden Name and Complex Fate,"
 145, 145, 148, 182; *Invisible Man*, 147–99
Emerson, Ralph W.: and Ellison, 146,
 168–72, 197–98; and Hurston, 126,
 137–44; and modernism, 40; and race,
 114, 137–41, 164–65; and self-determi-
 nation, 190; and the transparent eyeball,
 163–64, 168; and vision, 188; and the
 visionary, 142. *Works:* "The American
 Scholar," 178; "Fate," 138, 164; "Nature,"
 138–41, 147, 163, 172; "Self-Reliance,"
 163, 171–72; "Transcendentalist," 163
Emersonian ideals, 148–50, 166–80, 196
Emersonian Romanticism, 41, 113

Emotions, The (Sartre), 192
"Epistemo-Critical Prologue" (Benjamin),
 209
Estrangement, 203, 205n
Eternal recurrence, 216, 224–27
Ethnographic film, 8–9, 33, 36
Ethnography, 115–16, 124, 277. *See also* An-
 thropology; Race science; Sociology
Eugenics movement, 153
Evolutionary theory, 118–19, 123, 152–53,
 174, 183–84, 195
Existentialism, 2, 41, 190–94
Existentialism (Sartre), 192
Expertise, 68, 75, 203. *See also* Interior gaze
Eye, The (Nabokov): and authorship, 72; and
 detective fiction, 51, 72; and gender, 74,
 76; and the interior gaze, 76; and mod-
 ernism, 271–74; and the science of his-
 tory, 77–78; and self-made worlds, 73; and
 surveillance, 39, 52–53, 71–72, 74–76

Fabre, Michel, 190
Family of Man exhibition (Steichen), 24
Fanon, Frantz, 150, 195–96
Fascism: and Benjamin, 203, 206–7,
 210–12, 217; and Blanchot, 81; and
 Woolf, 221, 233–34
"Fate" (Emerson), 138, 164
Federal Writers Project, 151
Feminine, the: and the body, 13; and Carte-
 sian rationality, 13; and the image, 25–
 26, 257; in *Invisible Man*, 170–71, 178,
 194, 198–99; and Kristeva, 5; and Mer-
 leau-Ponty, 101; and modernist form, 5;
 and Nabokov, 272, 278–79; in Ovid, 99;
 and race, 28–29, 36, 157–58, 171, 194;
 in West, 257–58; in Woolf, 228–34,
 237–38. *See also* Gender
"Femininity" (Freud), 83
Fenollosa, Ernest, 122
Fetishism, 16–17, 19, 206, 254
Film: and Benjamin, 14, 212; in *The Eye*, 76;
 in *Laughter in the Dark*, 274; and literary
 modernism, 36; and Nathanael West,
 252; and race, 30–36
First-person narration, 69, 81, 107
Fitzgerald, F. Scott, 243
Flaherty, Robert, 32, 34–35
Flaneur, the, 26, 31, 207n
Flash, the, 204, 208, 214–19, 241
"Flying Home" (Ellison), 162
Folk Beliefs of the Southern Negro (Pucket),
 119
Folk materials: and Ellison, 149–51,
 159–62, 166–84, 189–90, 196; and
 Hurston, 40–41, 113, 119–20, 126–44,
 161–63

Foucault, Michel: on Blanchot, 106, 280; and panopticism, 13–15, 22, 275; and surveillance, 31–32, 39, 48
Fragment, the, 206, 212–21, 226, 237–40, 260
Frankenstein films, 35, 181n
Frazer, James, 27
Frazier, E. Franklin, 152, 154–55n
Freedman, Jonathan, 68
Freedom, 191–98
Freud, Sigmund: and castration, 83–86; and metanarrative, 38, 86, 106; and the Oedipus myth, 80–81; specular logic of, 82–83; and visual appropriation, 87; and the wish image, 215; and Woolf, 221. Works: "Group Psychology and the Analysis of the Ego," 221; "On Narcissism," 62–63; "The Passing of the Oedipus Complex," 83; *Totem and Taboo*, 116, 179; "The Uncanny," 85
Friedberg, Anne, 15, 25–26, 31–32
Fry, Roger, 118

Gates, Henry Louis, Jr., 125–27
"Gaze of Orpheus, The" (Blanchot): 1, 39–40, 87–96, 100–107, 279–80; and castration, 91–96; and the dark point, 89–91; and Freud, 80–86, 91–95; and gender, 80, 82–86, 88–101; and the haptic, 86, 87, 87–88n, 100–104; and the interior gaze, 107; and language, 105–7; and Levinas, 104–5; and Merleau-Ponty, 100–101; and modernism, 106–7, 279–80; and Ovid, 96–101; and Sartre, 81, 94–96; and the scopic, 103–4; and the work, 89–90, 92–94
Gender: and Blanchot, 88–101; and consumer culture, 25–26; and Descartes, 11–13; and feminist film theory, 16–17; and Freud, 80–86, 91–95; and Ellison, 149, 155–58, 168–71, 178–79, 181, 189, 198–99; and Hurston, 112, 115, 129–131, 133–34, 142; and the image, 25–27, 36; and James, 62, 65, 71; and modernism, 4–5; and Nabokov, 74, 76, 278–79; and Ovid, 97–100; and Sartre, 17, 94–95, 194; and the scientific gaze, 28–29; and West, 253–58; and Woolf, 228–34, 237–38. *See also*: Feminine, the
God's-eye-view, 48. *See also* Cartesian perspectivalism
Gold standard, 121–22, 140
Golden Bough, The (Frazer), 27
Golden Bowl, The (James), 69
Golden Day, The (Mumford), 173–76
Gordon, Deborah, 120
Goya, Francisco de, 248

Greenberg, Clement, 23
Gregg, John, 102
Griffith, D. W., 33
Grimshaw, Anne, 33
"Group Psychology and the Analysis of the Ego" (Freud), 221
Growing Up in the Black Belt (Johnson), 152
Guedé, 125
Gunning, Tom, 30–31

H.D., 122
Haptic, the, 86, 87, 87–88n, 100–104
Hardack, Richard, 198
Harlem Renaissance, 118–19, 122, 151
Harrison, Jane, 276
Heath, Stephen, 82
Heidegger, Martin, 18–19
Herndon, Angelo, 152
Herskovits, Melville, 153
"Hidden Name and Complex Fate" (Ellison), 145, 148, 182
Hierarchy, racial: and Ellison, 161, 167, 176–77, 181, 185, 196; and Emerson, 165; and Hurston, 125–26, 132–36
High and low culture: and Ellison, 160–61; and folk materials, 120; and Hurston, 125–26; in modernism, 42–43; and Nabokov, 274; and Nathanael West, 244, 248, 258, 262, 274, 279
"High visibility," 156, 276
History, 77, 206, 208–9, 213, 223–42
Hollywood culture, 244–52. *See also* Image culture
Homer, Winslow, 248
Homosexuality, 54–55n, 76, 179, 223
Horizon, 191
Howe, Irving, 150n, 186
"Hugh Selwyn Mauberley" (Pound), 122
Hughes, Langston, 152
Hurston, Zora Neale, 40–41, 111–44. Works: "Characteristics of Negro Expression," 121–23, 132, 137–41; *Dust Tracks on a Road*, 124; *Mules and Men*, 111, 113–14, 120, 124–25; *Tell My Horse*, 113–14, 124–25, 139; *Their Eyes Were Watching God*, 113, 125–44
Huyssen, Andreas, 5, 26, 244, 255
Hyman, Stanley Edgar, 160, 161

Ideology, 6–7, 79, 214
Image culture, 243–63
Imaginary, the, 84, 92–93
Imagism, 122
Indeterminacy, 59–61, 64, 103–5
Infinite Conversation, The (Blanchot), 81, 104
Inspiration, 89–90, 92–93

Interior gaze: in Benjamin, 216; in Blanchot, 107; defined, 19; and film, 36; in Freud's metanarratives, 86; and Hurston, 131; and James, 67–68; and modernist writing, 27, 38; and Nabokov, 52, 76, 272, 276; and West, 259. *See also* Expertise
"Intertwining—the Chiasm, The" (Merleau-Ponty), 17–18, 100–101
Introduction to the Science of Sociology (Park and Burgess), 28, 156
Invisible Man (Ellison): 147–99; and comparative anatomy, 149, 156, 176–77, 195; and Emerson, 146, 163–64, 168–72, 197–98; and the factory hospital episode, 181–85, 193–96; and Fanon, 195–96; and folklore, 158–64, 173–80, 183–84, 188; and "Flying Home," 162; and gender, 149, 155–58, 168–71, 178–79, 181, 189, 198–99; and the Golden Day, 173–76; and invisibility, 41, 148, 182, 192, 199; and Marxism, 151, 180, 185–86, 193; and race science, 167, 173, 176–77, 180–84, 190, 196; and racial hierarchy, 161, 167, 176–77, 181, 185, 196; and Rourke, 158–61; and Sartre, 190–96; and three-eyed monster, 146–47, 182; and the transparent eyeball, 149, 163–64, 168, 197–98; and trickster figure, 160, 162, 173, 184
Invitation to a Beheading (Nabokov), 272–75
Irigaray, Luce, 16, 82

"Jack and the Bean-stalk," 178
James, Henry, 38–39, 51–69
Jameson, Fredric: on ideology, 79, 81; on pastiche, 245–46, 249, 255; on the postmodern, 252; on realism, 47–48
Jay, Martin, 2, 7, 10, 14–15, 48
Jazz, 159–60
Jefferson and/or Mussolini (Pound), 122
Johnson, Barbara, 111
Johnson, Charles S., 151–52, 154n
Johnson, James Weldon, 148
Joplin, Patricia, 208–9
Jouissance, 85
Judovitz, Dalia, 10–11
Jung, Carl, 215

Kamera Obskura (Nabokov), 272, 274–75. *See also Laughter in the Dark*
Kierkegaard, Søren, 190
Kim, Daniel, 168
King, Rodney, 243
King Kong, 35, 181n
Knowledge, 3, 9, 18–19, 63
Krauss, Rosalind, 22
Kristeva, Julia, 5, 98n
Krupat, Arnold, 117

L'Espace littéraire (Blanchot), 81
La Dioptrique (Descartes), 11
Lacan, Jacques, 16, 81–84, 106, 252
Lalvani, Suren, 22
Laughter in the Dark (Nabokov), 272, 274–75
Law of the Father, 83, 91
Lee, Kun Jong, 164–65
Legba, 177
Lens. *See* Photographic lens
Levin, David Michael, 7
Levinas, Emmanuel, 82n, 104–5
Levine, Lawrence, W., 161–62
Lévi-Strauss, Claude, 117–18
Life magazine, 24
Linnaeus, Carolus, 75–76
Locatedness, 12
Locke, Alain, 118, 151
Lolita (Nabokov): 44, 53, 264–80; 274–75; and gender, 278–9; and high and low culture, 274; and the interior gaze, 272, 276; and *Invitation to a Beheading*, 272–74; and *Laughter in the Dark*, 272, and photography, 264–70, 273, 279; and the postmodern, 44, 272, 276, 279; and social science, 276–78; and surveillance, 272; and tourism, 44, 264–65, 269
London Blitz, 204
Long, Edward, 177
Look, the, 90, 193
Lorrain, Claude, 269
Lukács, Georg, 221, 244
Lyne, Adrian, 264
Lyons, Eleanor, 165
Lyotard, Jean-François, 106

Madonna, 243
Magnasco, Alessandro, 260, 262
Malraux, André, 190
Man with the Mask, The, 59–61, 64
Marvin, Thomas, 177
Marx, Karl, 25, 38, 77, 152
Marxism: and Benjamin, 206, 216; and the commodity, 255; and Ellison, 151, 180, 185–86, 193; and the folk, 190; and modernism, 2; and Nabokov, 77; and race, 151, 153; and visuality, 15–17; and Woolf, 221
Mason, Mrs. Charlotte, 120
Mass culture, 244–48, 253–61, 278–79. *See also* High and low culture
Masson, André, 191
McKay, Claude, 152
McKee, James B., 154
Mead, Margaret, 32, 114
Medieval art, 12
Meditations (Descartes), 11
Memento mori, 21, 269–70

Merleau-Ponty, Maurice, 13, 17–18, 38, 87, 100–101
Metamorphoses (Ovid), 96–100
Metanarrative: defined, 38; Freud's developmental stories as, 86; "The Gaze of Orpheus" as, 81; Lyotard on, 106; *The Sacred Fount* as, 52, 68
Miller, D. A., 6–7, 49
Milton, John, 121
Mind of Primitive Man, The (Boas), 117, 153
Minter, David, 6
Mirror: and Merleau-Ponty, 100; and Nabokov, 271; and Nathanael West, 259–60; and realist representation, 44; and Rorty, 276; and Woolf, 238–39
Mirror stage, 16, 83, 92, 92n
Mitchell, W. J. T., 18
Moana (Flaherty), 32
Modernism, literary: and authorship, 68; and the body, 2; and cultural transparency, 36–37; and detective fiction, 51; and Ellison, 149–50; and folklore, 160; and fragmentation, 220; and the gaze, 1, 3, 37, 49; and gendering and racing of, 4; and James, 70; and mass culture, 255; and multiple perspectives, 9; and Na-thanael West, 244, 247, 248n; and photography, 2, 8–9, 14, 18–20, 23, 25; and politics, 5; and popular subgenres, 6–7; and self-referentiality, 107; and surveillance, 71
Moi, Toril, 85
Monetary metaphors, 64, 121–22, 140
Monocularity, 7, 187–89. *See also* Cartesian perspectivalism
Mr. Deeds Goes to Town (Capra and Riskin), 246n
Mules and Men (Hurston), 111, 113–14, 120, 124–25
Multiperspectivalism, 9
Mulvey, Laura, 16, 84
Mumford, Lewis, 159, 173
Myrdal, Gunnar, 156–58
Mythical thought, 117–18

Nabokov, Vladimir: *The Eye*, 39, 51–53, 71–78, 271–74; *Invitation to a Beheading*, 272–75; *Laughter in the Dark*, 272, 274–75; *Lolita*, 44, 53, 264–80
Nanook of the North (Flaherty), 34–35
Narcissism, 62–65, 72–73, 96n
Native Son (Wright), 148
Naturalism, 9, 147, 150, 152
Nature, 225–26, 235–41
"Nature" (Emerson), 138–41, 147, 163, 172
Nausea (Sartre), 81
Negro Family in the United States, The (Frazier), 154n

Negro Quarterly, The, 152
New Negro, The (Locke), 118, 151
New York World Telegram, 144
Newfield, Christopher, 142
Newman, Michael, 87, 102
Nichols, William, 165
North, Michael, 118
Novel, the, 5–7

Objectivity, 23–24, 48, 119–20
Odin, 144
Oedipal complex, 79, 83–85, 92, 179
Oedipus the King (Sophocles), 79–80
Omniscient narration, 9, 39, 48–51, 70–71
"On Narcissism" (Freud), 62
On Photography (Sontag), 20–21
One-eyed perspective, 7, 187–89. *See also* Cartesian perspectivalism; Monocularity
One-Way Street (Benjamin), 210
"Ontology of the Photographic Image, The" (Bazin), 23
Opportunity: A Journal of Negro Life, 151
Optical instruments, 28, 190. *See also specific instruments*
Optical unconscious, 22
Origin of German Tragic Drama, The (Benjamin), 209–12
Orpheus, 52–53, 96–99; myth of, 64–66, 70–71, 80, 87–88
Ostendorf, Berndt, 178
Ovid, 69n, 87, 96–100
Ownership. *See* Property

Painting, 8, 59–61, 64
Palyi, Melchior, 121–22
Panoptic eye, 48–51, 55–56
Panopticism, 13–15, 22–23, 31, 74, 275. *See also* Surveillance
Paradise Lost (Milton), 121
"Paris—the Capital of the Nineteenth Century" (Benjamin), 214–16
Park, Robert E., 28, 40, 154n, 155–56, 158, 276
Participant-observer method, 29, 114–19, 124–26, 136–37, 155, 276
Passagen-Werk, Das, (Benjamin), 42–43, 206–7, 212, 216–17, 223, 227–28
"Passing of the Oedipus Complex, The" (Freud), 83
Pastiche, 245–46, 246n, 249, 254–55
Paternalism, 186–87
Pedophilia, 264, 266
Penis envy, 16. *See also* Castration
Perspective. *See* Cartesian perspectivalism; Renaissance perspective
Pettigrew, Thomas, 154
Phallus, 83–85, 93, 106

Photographic lens, 1, 9, 44, 145–47, 266, 270
Photography: and aestheticization, 21, 26; and anthropology, 29–30; and Benjamin, 14, 27, 212; and the body, 22–23, 27; and the feminine, 26; and the gaze, 19; and medical science, 8; as mirror and text, 44; and modernism, 2, 8–9, 14, 18–20, 23, 25; and Nabokov, 264–70, 273, 279; and objectivity, 18; and propaganda, 24; and Sontag, 19–21
Pictorialism, 23
Picture Post, 24
Picturesque language, 140–43
Pinney, Christopher, 29–30
Poe, Edgar Allen, 266n
Politicization of art, 203–4, 207, 212, 238
Pornography, 3n, 8, 267
Porter, Carolyn, 187–88
Postmodernism: and gender differences, 106–7; and Hurston, 124; versus modernism, 2n, 7; and Nabokov, 44, 272, 276, 279; and Nathanael West, 246–47, 248n
Pound, Ezra, 122
Prefaces (James), 69–70
Pre-Oedipal, the, 83, 93, 98
Présence Africaine, 191
Primitive, the: Boas's notion of, 117–18; and Ellison, 184; and Emerson, 143; and ethnography, 116; for Freud, 89n, 179; and Hurston, 112–14, 121–23, 137, 139, 143; and the modern, 35–36; and poetry, 140, 143; Pucket on, 119; and Woolf, 227, 233
Primitivism, modernist, 19, 138, 170, 173
Private eye, 39, 70
Progress, 27, 213, 227, 234, 237. *See also* History
Projection. *See* Screen
Property, 130, 135, 142, 228
Prophesy, 260–61
Prostitution, 254–55
Psychoanalysis, 2, 15–17
Psychology of the Imagination (Sartre), 192
Pucket, Niles Newbell, 119

Quotation, 206, 216, 219–20, 246n

Race science: and animal relations, 161–62, 184; and Ellison, 167, 173, 176–77, 196, 180–84, 186, 190, 196; and Emerson, 165; and existentialism, 192; and the penetration of the body, 27–29, 155–58
Racial determinism, 41, 138, 156, 164
Racial obsolescence theory, 138, 164

Rape fantasies, 256–57, 260–61, 278
Realism, 8–9, 47–51, 70, 74, 147, 270–71
Récit, 7, 81
Redemptive aesthetics, 206, 210–11, 216
Redemptive optics, 204, 209
Reed, Donna, 243
Regnault, Félix-Louis, 33
Renaissance perspective, 7, 12–13, 187
Richman, Michèle, 27
Ricoeur, Paul, 48
Riots: Los Angeles, 243; Watts, 243
Rising Tide of Color, The (Stoddard), 116
Riskin, Robert, 246n
Rockefeller, Nelson, 24
Romanticism, 126, 137, 139, 146–47
Rony, Fatimah Tobing, 30, 33–35
Roots of American Culture, The (Rourke), 159
Rorty, Richard, 48, 276
Rose, Jacqueline, 84–85
Rourke, Constance, 158–61, 163, 178
Rovit, Earl, 165
Ryder, Thomas, 248

Sacred fount, 54, 62, 66–67
Sacred Fount, The (James): 38–39, 51–71; and aestheticization, 61–64, 70; and the camera obscura, 55, 66; and the crystal cage, 54–55, 58, 69; and the crystal palace, 56, 65; and detective fiction, 54, 70; and gender, 62, 65, 71; and indeterminacy, 59–61, 64; and the interior gaze, 67–68; and *The Man with the Mask*, 59–61, 64; and narcissism, 62–63; and omniscient narration, 51, 70–71; and Orpheus, 52–53, 64–66, 70–71; and the sacred fount, 54, 62, 66–67; and voyeurism, 51, 62
Sacred, the, 94
"Sade's Reason" (Blanchot), 81
Sartre, Jean-Paul: and agency, 41; and Blanchot, 81; and Ellison, 190–94; and embodiment, 17–18; *En-soi*, 191; existentialism of, 149; and Fanon, 196; and the look, 94–95; *Pour-soi*, 191; and the racialization of the gaze, 195; and responsibility, 17, 192–96; and shame, 193–94, 196; and the transparency of the subject, 13; and visual appropriation, 87; Works: *Being and Nothingness*, 17, 94–95, 191–93; "Black Orpheus," 194–95
Satire, 7, 249
Savage. *See* Primitive, the
Schoedsack, Ernest, 35
Science, 8, 64, 75, 185. *See also* Anthropology; Race Science; Social science; Sociology

Science of history, 77, 137n, 185, 189, 193.
 See also Marxism
Scopic regime: and Blanchot, 102–4; and
 Descartes, 10; and embodiment, 12; and
 Merleau-Ponty, 101; and modernity, 7, 12
Scopophilia, 16, 95, 168
Screen, 57–58, 76, 169, 175
Seeing, 3, 7, 9, 18–19, 63. *See also* Scopic
 regime; Cartesian perspectivalism
Sekula, Allan, 24–25
Self-determination, 80, 190
Self-objectification, 196
Self-referentiality, 107
Self-reflexivity, 72–74, 120, 139, 267, 271,
 275
Self-regulation, 13–14, 23, 272–74
Self-reliance, 167, 180
"Self-Reliance" (Emerson), 163, 171–72
Self-scrutiny, 13–14, 23, 74–75, 272–74
Seltzer, Mark, 48, 51
Sexual difference. *See* Castration; Feminine,
 the; Gender
Shadow of the Plantation (Johnson), 152
Shaviro, Steven, 102
Signatures of the Visible (Jameson), 47–48
Sister Carrie (Dreiser), 278
Slave society, 196n
Sleep (Warhol), 33
Social Darwinism, 154
Social realism, 147, 152
Social science, 111–12, 161, 276–78. *See also*
 Anthropology; Race science; Sociology
Society of the Spectacle (Debord), 243, 263
Sociology, 146–161, 173, 185–86, 190. *See
 also* Anthropology; Race science
Sontag, Susan, 19–21
Sophocles, 79–80
Space of Literature, The (Blanchot), 102
Spectacle, 14–15, 32, 236, 272, 275
Spectatorship, 36, 38, 42, 47–48, 54, 204
Spyglass of anthropology, 40, 111–14, 134,
 276
Steichen, Edward, 24
Stepto, Robert, 162
Stieglitz, Alfred, 24n
Stoddard, Lothrop, 116
Straight Photography, 23, 26
Strand, Paul, 23
Strychacz, Thomas, 68
Sundquist, Eric, 147
Super-ego, 83–84
Surveillance: in *The Eye*, 52–53, 71–72,
 74–76, 78; and *Lolita*, 272; and mod-
 ernism, 32; in Nabokov's novels of the
 1930s, 275; and photography, 20–23;
 and the realist novel, 48; and spectacle,
 15. *See also* Panopticism; Self-scrutiny

Symbolic, the, 83–86, 92, 93
Szwed, John, 119

Tagg, John, 20
Tarzan books, 35
Tell My Horse (Hurston), 113–14, 124–25,
 139
Temps Modernes, Les, 81, 191
Their Eyes Were Watching God (Hurston): 113,
 125–39; and anthropology, 113, 125–26,
 136–39; and "Characteristics of Negro Ex-
 pression," 121–23; and Emerson, 137–44;
 free indirect discourse, 126–27; and gen-
 der, 112, 115, 129–131, 133–34, 142; and
 the horizon, 127–28, 136, 138; and the in-
 terior gaze, 131; and the muck, 132–35;
 and the pear tree, 127–28, 132–33, 141;
 and the primitive, 137, 139; and racial hi-
 erarchy, 125–26, 132–36; and the spy-
 glass, 111–12; and status, 129–36
"Theses on the Philosophy of History"
 (Benjamin), 212, 214, 234
Third eye, 146, 182, 186
Third-person narration, 81, 107
Thomas, W. I., 153
"Thoughts on Peace in an Air Raid"
 (Woolf), 234
Time-motion studies, 33–34
Torgovnick, Marianna, 35, 118
Totality and Infinity (Levinas), 104
Totem and Taboo (Freud), 116, 179
Tourism, 44, 264–65, 269
Transcendence, 113, 198–99
"Transcendentalist" (Emerson), 163
Transparent eyeball, 141, 146, 149,
 163–64, 168, 197–98
Trauerspiel (Benjamin), 209–12
Trompe l'oeil, 258–59, 261. *See also* Bau-
 drillard, Jean
Tuskegee Institute, 155, 157

"Uncanny, The" (Freud), 85
Uncertainty Principle, 116
Unconscious optics, 14, 212
Universal Being, 113–14, 138, 141–42,
 164. *See also* Emerson, Ralph W.
Unreliable narrator, 39, 54
Usury Cantos (Pound), 122

Vico, Giambattista, 137n
Victorian novel, 6–7
Visual culture, 4, 4n, 8
Visual language, 230
Voyeurism, 51, 62, 264, 270, 278

Warhol, Andy, 33
Washington, Booker T., 155, 157

"Wasteland" (Eliot), 217
Watts, Jerry, 161
Weinberger, Eliot, 32–33
West, Cornel, 138, 164
West, Nathanael, 42–43, 243–63, 279
West, Rebecca, 54
Weston, Edward, 23–24
Wiegman, Robyn, 15, 27–28, 155–56
Williams, William Carlos, 209–10
Wings of the Dove (James), 60–61n, 70
Wish image. *See* Benjamin, Walter
Wolin, Richard, 211, 212, 214

Woolf, Virginia, 42–43, 204–8, 217–42, 276
"Work of Art in the Age of Mechanical Reproduction, The" (Benjamin), 203, 207, 211–212, 264
Wray, Fay, 35
Wright, Richard, 148, 150n, 151, 152, 190, 191

Young, Elizabeth, 35

Žižek, Slavoj, 50, 58